INTERIOR DESIGN ON EDGE

Interior Design on Edge explores ways that interiors both constitute and upset our edges, whether physical, conceptual or psychological, imagined, implied, necessary or discriminatory.

The essays in this volume explore these questions in history, theory, and praxis through a focus on different periods, cultures, and places. *Interior Design on Edge* showcases new scholarship that expands and contests traditional relationships between architecture, interiors, and the people that use and design them, provoking readers to consider the interior differently, moving beyond its traditional, architectural definition. Focusing on the concept of interiority considered in a wider sense, it draws on interdisciplinary modes of investigation and analysis and reflects the latest theoretical developments in the fields of interior design history and practice.

With new research from both established and emerging authors, this volume will make a valuable contribution to the fields of Interior Design, Architecture, Art and Design History, Cultural History, Visual Culture Studies, and Urban Studies.

Erica Morawski, Ph.D., is an assistant professor in the Department of Art and Design History at the Pratt Institute in New York.

Deborah Schneiderman, RA, LEED AP, is a professor of Interior Design at the Pratt Institute and principal/founder of deSc: architecture/design/research.

Keena Suh is a professor in the Interior Design department at the Pratt Institute where she teaches design studios, electives, and construction

courses at the undergraduate and graduate levels while coordinating the department's construction-related courses.

Karin Tehve is a professor of Interior Design at the Pratt Institute, where she coordinates the theory and undergraduate thesis curriculum in Interior Design.

Karyn Zieve, Ph.D., is an assistant dean of the School of Liberal Arts and Sciences and Adjunct Assistant Professor CCE in the History of Art and Design Department at the Pratt Institute. She earned her MA from University of Pennsylvania and her Ph.D from Institute of Fine Arts, NYU.

INTERIOR DESIGN ON EDGE

History, Theory, Praxis

*Edited by Erica Morawski,
Deborah Schneiderman,
Keena Suh, Karin Tehve
and Karyn Zieve*

Routledge
Taylor & Francis Group

LONDON AND NEW YORK

Designed cover image: Sheets of fabric used as an improvised sniper barrier. Photo courtesy of Paul Lowe.

First published 2024
by Routledge
4 Park Square, Milton Park, Abingdon, Oxon OX14 4RN

and by Routledge
605 Third Avenue, New York, NY 10158

Routledge is an imprint of the Taylor & Francis Group, an informa business

British Library Cataloguing-in-Publication Data
A catalogue record for this book is available from the British Library

Library of Congress Cataloging-in-Publication Data
Names: Morawski, Erica, editor.
Title: Interior design on edge : history, theory, praxis / edited by Erica Morawski, Deborah Schneiderman, Keena Suh, Karin Tehve and Karyn Zieve.
Description: Abingdon, Oxon : Routledge, 2024. |
Includes bibliographical references and index. |
Identifiers: LCCN 2023047923 | ISBN 9781032601465 (hardback) |
ISBN 9781032601410 (paperback) | ISBN 9781003457749 (ebook)
Subjects: LCSH: Interior architecture--Psychological aspects.
Classification: LCC NA2850 .I567 2064 | DDC 729--dc23/eng/20240103
LC record available at https://lccn.loc.gov/2023047923

ISBN: 978-1-032-60146-5 (hbk)
ISBN: 978-1-032-60141-0 (pbk)
ISBN: 978-1-003-45774-9 (ebk)

DOI: 10.4324/9781003457749

Typeset in Sabon
by KnowledgeWorks Global Ltd.

CONTENTS

LIST OF FIGURES

ABOUT THE EDITORS

Erica Morawski, Ph.D., is an assistant professor in the Department of Art and Design History at the Pratt Institute in New York. Her research investigates how design mediates relationships between state and populace through approaches that seek to privilege underrepresented histories through a focus on the Hispanic Caribbean within a global context. She is currently completing a book that explores the role of tourism design, particularly hotels, played in shaping domestic and international politics and questions of national sovereignty in Puerto Rico, the Dominican Republic, and Cuba. She has published in the *Journal of Design History* and *Journal of the Society of Architectural Historians*, and has essays in *The Politics of Furniture: Identity, Diplomacy and Persuasion, Design History Beyond the Canon, Imperial Islands: Art, Architecture and Visual Experience in the US Insular Empire after 1898*, and *Coastal Architectures and the Politics of Tourism: Leisurescapes in the Global South*.

Deborah Schneiderman, RA, LEED AP, is a professor of Interior Design at the Pratt Institute and principal/founder of deSc: architecture/design/research. Her praxis explores the emerging fabricated interior environment and its materiality. Schneiderman's published research includes the books *Inside Prefab: The Ready-Made Interior, The Prefab Bathroom, Textile, Technology and Design: From Interior Space to Outer Space* (with Alexa Griffith Winton), *Interiors Beyond Architecture* (with Amy Campos), and *Interior Provocations: History, Theory, and Practice of Autonomous Interiors* (with Anca I. Lasc, et al.). She has exhibited work

and lectured internationally, including the Storefront for Art and Architecture, The Center for Architecture, and Van Alen Institute. Schneiderman earned her BS in Design and Environmental Analysis from Cornell University and MArch from SCI-Arc.

Keena Suh is a professor in the Interior Design department at the Pratt Institute where she teaches design studios, electives, and construction courses at the undergraduate and graduate levels while coordinating the department's construction-related courses. Her pedagogical focus is in fostering innovative learning and teaching opportunities through community-based, cross-disciplinary, and collaborative learning. She is a co-editor of *Interior Provocations: History, Theory and Practice of Autonomous Interiors* and section editor of *Interior Provocations: Appropriate(d) Interiors*. She earned her M.Arch. from Columbia University.

Karin Tehve is a professor of Interior Design at the Pratt Institute, where she coordinates the theory and undergraduate thesis curriculum in Interior Design. She earned her Master of Architecture degree at the Harvard Graduate School of Design. Her experience includes architecture, interiors, and site-specific art, her research and writing concentrates on taste, media and identity, and their intersection with the public realm. Conference presentations include IDEC, ACSA and *Common Ground*. She has published in the *Journal of Design History, The Journal of Interior Design, The International Journal of Interior Architecture + Spatial Design*, contributed to *Interiors Beyond Architecture*, and is co-editor and contributor for *Interior Provocations: History, Theory and Practice of Autonomous Interiors* and *Appropriate(d) Interiors*. Her book, *Taste, Media and Interior Design*, was published by Routledge in 2023.

Karyn Zieve, Ph.D., is an assistant dean of the School of Liberal Arts and Sciences and adjunct assistant professor CCE in the History of Art and Design Department at the Pratt Institute. She earned her MA from University of Pennsylvania and her PhD from Institute of Fine Arts, NYU. Her work investigates cross-cultural communications and miscommunications, particularly those of nineteenth-century France and the Eastern Mediterranean and Northern Africa, as well as questions of historiography, museums, and collecting. She is a co-editor of *Interior Provocations: History, Theory and Practice of Autonomous Interiors* (with Anca Lasc, et al.) and section editor of *Interior Provocations: Appropriate(d) Interiors*.

CONTRIBUTORS

Severino Alfonso, MSAAD | Assistant Professor | Thomas Jefferson University
Severino Alfonoso is an assistant professor at the College of Architecture and the Built Environment at Thomas Jefferson University. He co-directs the *Synesthetic Research and Design Lab*, where he partners with self-advocacy communities and industry experts to build collective knowledge around all-inclusive ways of perceptually experiencing our spaces. His creative work as part of the Lab has been exhibited in international design venues such as the Trajan Market Museum of the Imperial Fora in Rome, the European Cultural Center 2021 Venice Biennial, the Municipal Theater of Piraeus in Athens, Greece, and the IE Creativity Center in Segovia, Spain. He holds an MSAAD from Columbia University in NYC and two MS in Urban Design and Advanced Architecture from the ETSAM, where he is a Ph.D. candidate.

Eric Anderson, Ph.D. | Associate Professor | Rhode Island School of Design (RISD)
Eric Anderson is an associate professor in the Theory and History of Art and Design department at Rhode Island School of Design. His teaching and research engage the history of modern design, including interiors, furniture, and product design, exhibitions and media, domesticity and psychology, and the global history of modernism in post-WWII and post-colonial contexts. He has recently served as director of RISD's graduate program in Global Arts and Cultures and held a Fulbright Fellowship at the Sigmund Freud Museum and University of Applied Arts in Vienna.

Elliot Camarra, MA student and artist | Bard Graduate Center
Elliot Camarra is an artist and researcher based in New York. Her inter-disciplinary practice engages themes of record keeping and memory. She is currently completing a master's degree at Bard Graduate Center in the History of Design and Material Culture, with a focus on the ancient world.

Amy Campos, MSAAD | California College of the Arts
Amy Campos is a professor of Interior Design at California College of the Arts in San Francisco. Her work focuses on durability and design with special interest in the migratory potentials of the interior. The work spans a variety of scales and platforms, from inhabited urban and architectural spaces to object and furniture design. Recent publications include the book, *Interiors Beyond Architecture* (Routledge, 2018), and the chapters "Survivalism, interiorization and exclusivity" in *Interior Futures* (Crucible Press, 2019) and "Territory and Inhabitation" in the *Interior Architecture Theory Reader* (Routledge, 2017). She founded ACA—Amy Campos Architect in 2009 and is LEED Certified.

Annie Coggan, M.Arch. | Associate Professor | Pratt Institute| Founder Chairs and Buildings Studio, Brooklyn, NY
Annie Coggan is a designer, educator, and principal at Chairs + Buildings Studio, a multiscale design studio based in Brooklyn. She is a full time associate professor at Pratt Institute School of Design. Coggan's practice involves textiles, furniture, and drawings to create a haptic research agenda. She has recently been awarded the Lee B. Anderson Fields of Future research fellowship, Spring 2023 at the Bard Graduate Center, a 2018–2019 Winterthur Museum Creator/Maker Fellowship for 2018–2019 and an Artist in Residence position at Boisbuchet, Domaine Boisbuchet, France in 2021. She has recently published with A Public Space Books, *The Book of Errors*, a book of illustrated essays looking at the complicated preservation of three American historic houses through drawings and ephemera. She received her B.A. from Bennington College in Vermont and her Master of Architecture from SCI-Arc in Los Angeles.

Els De Vos, Ph.D. | Professor in History and Theory of Interior Architecture and Architecture | University of Antwerp
Els De Vos is a Professor at the University of Antwerp, where she chairs the interior architecture program. Her research is situated in the field of history and theory of (interior) architecture, home culture, gender, and public space in the second half of the twentieth century. Her Ph.D. on the architectural, social and gender-differentiated mediation of dwelling in 1960s–1970s Belgian Flanders is published in 2012 by Leuven University Press. De Vos

has published in several journals and is co-editor of several books and special issues, including *Theory by Design: Architectural Research made Explicit in the Design Studio* (Antwerp University Press, 2013) and *European Middle-Class Mass Housing LEXICON* (2023, Dinamia'cet-ISCTE) and Middle Class Mass Housing (*Docomomo Journal,* 2023). She has co-curated several exhibitions, most recently Female Symbols and Urban Space (Brussels 2020-2021).

Nerea Feliz, M.Arch. | Associate Professor | The University of Texas at Austin
Nerea Feliz is an associate professor at the School of Architecture at The University of Texas at Austin. Her work encompasses scholarly and creative activities that are linked with a sustained focus on public interiority. She holds a master's and bachelor's degree in architecture from the ET-SAM and is a registered architect in Spain and the United Kingdom. Feliz's projects and writing have been featured in publications including *Ground Up, Architectural Histories, Interiority, Interiors: Design/Architecture/Culture Journal, The Architect's Newspaper* and *urbanNext.* Her work has been exhibited nationally and internationally at a range of venues such as The Bentway, Space p11, SxSW Eco, Matadero Madrid, and multiple academic institutions.

Fredie Floré, Ph.D. | Professor in History and Theory of Interior Architecture and Design | KU Leuven
Fredie Floré is a professor in history and theory of interior architecture at KU Leuven, Faculty of Architecture. Her research focuses on the representational role of architecture, interiors, and furniture design in the second half of the twentieth century. She is a founding member of the research group Architecture Interiority Inhabitation (https://architectuur.kuleuven. be/a2i). This group studies architecture and interior architecture as contemporary practices and as fields of historical and theoretical reflection. Floré is co-editor of several books and special issues, including *The Politics of Furniture: Identity, Diplomacy and Persuasion in Post-war Interiors* (2017, co-editor Cammie McAtee) and *Architecture and Bureaucracy* (special collection of *Architectural History* 2022, co-editors Ricardo Costa Agarez and Rika Devos).

Alex Goldberg, MS | Adjunct Assistant Professor | Pratt Institute
Alex is a Brooklyn-based artist, educator, and healing arts practitioner. Her practice and pedagogy are rooted in the development and exploration of methods that facilitate awareness of patterns in relation to self, other, and environment. Alex has studied both SourcePoint Therapy®

and BreakThrough and is a visiting adjunct professor of Interior Design and Interdisciplinary Studies at the Pratt Institute. She has also taught at The Metropolitan Museum of Art, Parsons School of Design, and Village Community School. In 2021, she was awarded the State of the Disciplines Fellowship grant at Pratt to further develop her research on utilizing creativity to dissolve mental constructs in the pursuit of living a more present existence. Alex has had the opportunity to participate in numerous residencies across the world. Programs such as Textile Arts Center, Harvestworks, Slow Research Lab, Succurro, and The Swimming Hole have given her the opportunity to further explore processes for utilizing embodied knowledge as a method for processing human experience and connecting with the natural world.

Selma Ćatović Hughes, M.Arch. | Adjunct Faculty | American University of Sharjah

Born and raised in Sarajevo, Bosnia-Herzegovina, Selma Ćatović Hughes left her war-torn country on the brink of culmination of three years of conflicts. After completing a Master in Architecture, her research about memory began as a subconscious form of therapy, influenced by the extraordinary circumstances while growing up during the war, creating a collection of individual and collective voices. Selma has experimented on a number of mixed media projects of different scales, materials and functionality. Selma teaches Design Foundations at American University of Sharjah.

Marie Saldaña, M.Arch., Ph.D. | Assistant Professor | University of Tennessee, Knoxville

Marie Saldaña is a multidisciplinary scholar and designer working at the intersections of architecture, history, and new media. She has taught design and digital humanities at Stanford University, Rice University, and the University of North Carolina, Chapel Hill, and is currently an assistant professor of Interior Architecture at the University of Tennessee, Knoxville.

Virginia San Fratello, M.Arch. | Chair and Professor in the Department of Design | San José State University | RAEL SAN FRATELLO and Emerging Objects

Virginia San Fratello is an architect, interior designer, and educator. She is Chair of both The Department of Design and the Department of Art & Art History at San José State University in Silicon Valley. San Fratello recently won the International Interior Design Educator of the Year Award and is also a *Metropolis Magazine* Next Gen Design Competition winner. Her creative practice was named an Emerging Voice by The Architectural

League of New York. In 2021 she was awarded the Beazley Design of the Year for her Pink Teeter Totter installation. Her work is included in the permanent collection of The Museum of Modern Art in New York, The Cooper Hewitt Smithsonian Design Museum, The San Francisco Museum of Modern Art, LACMA, and the Design Museum in London.

Liz Teston, M.Arch. | Associate Professor | University of Tennessee, Knoxville
Liz Teston is an associate professor of interior architecture at the University of Tennessee, Knoxville. She has previously been named the Dudley Faculty Scholar (UTK 2017-19) and a Fulbright Scholar (Romania, 2018). Teston's work explores public interiority, design politics, cultural identity, and the atmospheric qualities of space. She has published in *Interiority*, *MONU*, *Int/AR*, *ii-journal*, *Interior Futures* (Crucible, 2019), and *Interior Architecture Theory Reader* (Routledge, 2018). Teston was a 2023 recipient of the AIA NY | Center for Architecture Arnold W. Brunner Grant and hosted the Public Interiority Symposium + Exhibition at the University of Tennessee in 2023.

Loukia Tsafoulia, MSAAD | Assistant Professor | Thomas Jefferson University
Loukia Tsafoulia is an assistant professor, at the College of Architecture and the Built Environment, Thomas Jefferson University, where she co-directs the *Synesthetic Research and Design Lab*, a platform in which inclusive design, interactive art, digital culture, and emergent health sciences meet. Exhibited work includes venues such as the ECC 2021 Venice Biennial, the Trajan Market Museum in Rome, the Municipal Theater of Piraeus in Greece, the IE Creativity Center in Segovia, Spain, the London 3D print show, and the ICFF in New York. Loukia is the editor of the books *Transient Spaces* and *KatOikia, Housing Explorations at the Intersection of Pedagogy and Practice*. She holds an MSAAD from Columbia University, NYC, and is a Ph.D. candidate at the National Polytechnic School of Athens. Her research explores relationships between performative environments, cognitive sciences, and cybernetic experiments.

Sam Vanhee, Ph.D. candidate Interior Architecture | University of Antwerp
Sam Vanhee is a PhD candidate at the Faculty of Design Sciences of the University of Antwerp, where he is a member of the interdisciplinary Henry van de Velde research group. Holding an MSc in Engineering-Architecture at Ghent University and a M.A.S. in Human Settlements at the KU Leuven, his expertise extends through different scales of the built environment. Vanhee is currently working on an FWO-funded research project

on the emergence of interior architecture in Belgium between 1945 and 1999, investigating education's role in forming a disciplinary identity. In that framework, he has worked on several publications, among others *Beyond Distinction-Based Narratives* (Journal of Interior Design, December 2021), and the upcoming *Opleidingen en Gendertoekenning* (Tijdschrift voor Interieurgeschiedenis en Design).

Gretchen Von Koenig, Ph.D. candidate, University of Delaware | University Lecturer Design History and Theory, New Jersey Institute of Technology (NJIT)
Gretchen Von Koenig is a Ph.D. candidate in the Hagley Program for the History of Capitalism, Technology and Culture. She is a designer and design historian who teaches at Parsons School of Design, Michael Graves School of Design and NJIT. Her research investigates the design and use of home security systems, studying how surveillance technologies materialized new understandings of domestic safety in the United States from 1960 to 1980. Her past research investigated US capitalism's influence on industrial design education and has written for *Metropolis Magazine*, the *Winterthur Portfolio* and is an editor of *Dense Magazine*, an unlikely design magazine about New Jersey.

Yang Yang, Ph.D. | Associate Director, cityLAB-UCLA | University of California, Los Angeles
Yang Yang is an architectural historian and associate director at city- LAB, a think tank at UCLA Architectural Department. Her research focuses on housing and transnational urbanism from a media/cultural perspective to rethink the politics of form. She was a visiting assistant professor of Architectural History and Theory at UNM and has lectured at UCLA, UCSD, and Otis College of Art and Design. Her academic work is complemented by curatorial and artistic practice. She was the assistant curator of the 2015 Shanghai West Bund Biennale and has exhibited interactive installations at the 2019 Bi-City Biennale of Urbanism\Architecture in Shenzhen.

ACKNOWLEDGMENTS

This volume has been inspired by our students and colleagues at Pratt Institute, who challenge the boundaries and push critical discourse for Interior Design—its history, theory, and praxis—on a daily basis. Our work has been especially energized by our contributing authors and we thank them for their time and dedication. Sincere thanks also go to Lydia Kessell at Routledge for her interest and support of this project and for continuing to publish the work of Interior Provocations. This volume would not have come together without the careful work of our research assistant Nour Bannout; we are so appreciative of her role in this publication. We would like to express deepest gratitude to our colleagues for their insight, dedication, and collaborative spirit, to Anita Cooney, Dean of the School of Design, Helio Takai, Dean of the School of Liberal Arts and Sciences, John Decker, Chair of History of Art and Design, and David Foley, Chair of Interior Design for their support of design research and this project in particular, and to our families for their unceasing support and encouragement. They know who they are.

INTRODUCTION

Erica Morawski

This volume represents work produced during that strange period just after the worst of the isolation and suffering of the COVID-19 pandemic and the initial urgent responses of movements such as Black Lives Matter, but only after a short time to reflect in a more sustained way upon the larger arc of the past few years. When crafting the symposium's call for content in fall of 2021, we had an altered awareness of how one's present affects thinking about the conceptual and the practical. The call opened by acknowledging that every year, current events affect the directions of research and culture, but the influence of the events of 2020–2021 could not be overstated. Who could say that the past almost two years had not left them "on edge" in some way?

The theme "on edge" offered an invitation to explore ways that interiors upset or institute our edges, whether physical, conceptual, or psychological, imagined, implied, necessary, or discriminatory. We invited contributions that explored these questions in history, theory, and praxis, across time, culture, and place. In seeking to reconsider the shift, need, and power for such edges as boundaries, thresholds, and screens, we solicited work that looked both to the past and future about how to accommodate fluidity, accessibility, and security. We intentionally outlined the theme broadly in order to elicit wide-ranging interpretation, encourage provocative and boundary-expanding proposals, challenge traditional assumptions, and bring to light overlooked parameters or influences.

Hence, the contributions in this volume consider edges not just in the content or perspective of the work examined in each project, but also in theory and method. Since we view history writing as a form of praxis, we embraced

DOI: 10.4324/9781003457749-1

the way many of these contributions challenge, redefine, or fabricate afresh the edges of the creative practice of writing history. Likewise, many of the contributions that engage with contemporary praxis do not simply think about physical edges, but explore how the edges of praxis are defined. In thinking about edges that do or make, all contributions—historical, theoretical, and practical—point to the way edges both connect and divide interiors, whether physically, politically, socially, environmentally, or emotionally.

Section I: Liminal Edges

Our volume's opening section addresses the material and immaterial nature of edges that connect, disconnect, and/or transition phases or spaces. The contributions in this section explore the way that edges resist, challenge, impose, or pose questions of permeability—whether social, political, historical, or psychological.

In her study of the marketization of housing in Shanghai, Yang Yang looks at state ideology and practices across the 1970s and 1980s in conjunction with publications illustrating state and market apartment designs. In Yang's work, the domestic space, in this case the Shanghai apartment, becomes the liminal space between public and private, nuanced by her detailed accounting of how the amount of space and configurations of apartments changed over time. These shifts, sometimes welcomed and sometimes not by those ultimately inhabiting these spaces, were met with varying responses, and Yang draws us in to the increasing engagement with DIY interior design as a means for negotiating the tensions of the liminal space of these apartments, at once individual and representative of the state and its hold on a new market economy for apartments.

Selma Ćatović Hughes's visual essay asks us to consider the edges of the Siege of Sarajevo both as it altered the urban palimpsest and memory. Hughes examines the makeshift construction of edges both permeable and impermeable, of danger and safety, in response to a war zone's c sniper pathways. *[Re]Tracing the Veil*, a series of installations, questions the lingering power of these edges in the cityscape and citizens' everyday lives. As cultural and communicative memory, these veils acknowledge a history of gaps, while enabling the reparation of connections.

In "Province of Interiors: Strategies and Tactics on the Frontier of Northern New Spain" Marie Saldaaña also looks at the way violence and safety influence notions of the interior, in particular as constructed in relation to the eighteenth-century frontier in the region that now includes South Texas. Locating this liminal edge between the void of a boundary and the human impulse to close that void, Saldaña considers the Spanish Crown's shifting thoughts on the territory, based on the alternative

notions and tactics of mestizos, criollos, and indigenous groups and how these undermined the Crown's attempt to control the landscape. Using techniques such as kinship and range, these groups negotiated colonial impulses and Saldaña expertly indicates how they exerted agency.

Turning that liminal edge to psychological drama, Eric Anderson looks to the reciprocal relationship between individual and interior through a close analysis of J. G. Ballard's 1962 short story "The Thousand Dreams of Stellavista." Anderson analyzes Ballard's use of the fantastical but riveting plastex walls to critique the "good life" promised by modernist design. Drawing on the persistent popularity of mid-century West Coast design, domestic horror fiction and disaster film, Freud's office, and Neutra's architecture, Anderson gives sensitive context to Ballard's edges and edgy dystopian suburb Vermilion Sands in ways that continue to resonate with today's expectations of the interior.

In the final contribution to this section, Severino Alfonso and Loukia Tsafoulia focus on the conscious and unconscious negotiation of the human-machine-environment. As they note, the edges between the components of what comprises an interdependent landscape raise questions about how neurodiverse people negotiate space and in turn, illuminate unseen or neglected edges. Striving for accessibility, their *Synesthetic Research and Design Lab* creates installations and experimental prototypes that offer practical and awe-inspiring solutions.

Section II: Material Edges

While all of the essays in Section II consider the material as it pertains to personal or domestic interiors, they also expand that consideration to address how they connect to larger social, economic, and cultural forces. Clay, microbes, and even publications become a means through which explorations on a personal level can allow for inquiry into societal practices or shared concerns.

Through a dramatic magnification of the smallest organisms in our domestic interiors, Nerea Feliz's project *Interior Landscapes*, presented in "Interior Landscapes: A Look at the Interior at the Microscale," raises questions about the falsity of many of our perceptions about hygiene and sanitation in our interiors. Prompted by the way COVID-19 caused a heightened awareness of microbes and germs in the home, coupled by recent research and publications on domestic and corporeal biomes, Feliz explores new ways of knowing and engaging with what we already live with on a daily basis through a manipulation of scale. By magnifying these microscopic organisms, Feliz invites us to see them as actors in our space that need a different kind of environmental attention.

Annie Coggan's visual essay, centered on Robert Manwaring's chair designs, uses the materiality of the published catalogue of these designs as the source material for her own practice of exploring history through the practice of drawing and etching. Works on paper turn attention to the two-dimensional material of three-dimensional form that leads Coggan to raise compelling questions about what we use to write history and how we use it. Dialogue with the forms of Manwaring's drawings provides an opportunity for a spatial exploration of domestic props and for the proposal of hypotheses regarding Manwaring as entrepreneur.

Elliot Camarra's "Earth-Eaters: Women and Búcaros in 17th-Century Spain" offers further examination of the materials of domestic interiors with an analysis of the subversive, yet surprisingly widespread practice among seventeenth-century Spanish women of consuming pieces of ceramic búcaros, which were used as decorative and cooling devices in Spanish homes. Camarra highlights how these vessels, imported from Spain's colonies in the Americas, played a vital role in allowing women to both conform to social strictures and expectations by presenting fashionable interiors and providing a more pleasant interior experience for inhabitants and visitors as well as resist social conventions imposed upon women. Largely relegated to domestic spaces and limited in public movement, women took part in búcaro consumption as both a shared social activity as well as a private act to exert agency over one's own body. Camarra's contribution calls attention to how domestic objects can be used to push social and behavioral boundaries.

Continuing an engagement with ceramics, Virginia San Fratello's visual essay presents her personal journey through her production of ceramic objects. As San Fratello moved across diverse geographies during the global COVID-19 pandemic, she explored different clays and their capacity to provide a better understanding of self and place in uncertain times. The work invites contemplation of what and how we hold materials precious as she investigates the interaction of natural materials, such as clay, with contemporary technology, in this case her 3D printer.

Section III: Mediating Edges

The contributions in the final section of the volume all address different ways in which edges are negotiated. The works here range in scale from the highly personal and individual to broader social scale of state. These essays highlight the ways in which edges are never a priori and constantly open to the possibility (or threat, depending on your position) of being shifted, erased, or manipulated in some way. Indeed, these works point to the ways that edges can serve as a means to enact or institute agendas and philosophies, in some cases quite politicized.

Gretchen Von Koenig posits that the largely unstudied rest stop design is a valuable site for better understanding post-World War II practices of building infrastructure and the impact this had on the traveling U.S. public. By focusing attention on the way these projects were ambiguously situated on newly created edges between public authority and private enterprises, Von Koenig opens up much larger questions about the "municipal enterprise" that emerged in the postwar period. She considers the way constant remodeling both in styling and to elicit greater consumption offers a "geneology of neoliberalism." Notably, Von Koenig pushes interior design scholarship to important considerations of race and who the traveling public was imagined to be, underscoring how rest stop interior design was meant for specific publics and mandated specific rest stop behavior.

Alex Goldberg's visual essay introduces her work in creating processes that can access embodied knowledge; what happens to the mediating edge, or dissolution of one, between mind and body? Goldberg's work also calls attention to the edges of disciplines, as she works in dance, design, and healing practices, among others. Calling on many fields allows her to address disconnects we often find between self and other or humans and nature, which she invites us to rethink as networked and connected.

Liz Teston explores the concept of polyatmospheric urban interiors. Based on the supposition that the Pandemicene still has at least a decade more to play out, Teston takes a long-durée approach, which allows her to explore how urban interior spaces are changing and will continue to change. Examination of the factors that shape these urban interiors allows Teston to argue for the necessity of these experiential communal places.

Contemplation of the COVID-19 pandemic's impact on the way we conceptualize interior edges also motivates Amy Campos' study of the intersection of the COVID-19 pandemic and toxic air caused by West Coast wildfires in 2020. Her work explores the way air—invisible and seemingly amorphous—soberly determines edges. This inquiry leads to consideration of Western perspectives on air movement in the past, either as something to be celebrated as salubrious or feared as a harbinger of sickness and disease. In the end, it is in her turn to indigenous practices that she locates hope for a future characterized by environmental crisis.

This section's final essay turns to the spaces of education for interior design. In their essay on the interior architecture program in higher education in Hasselt, Belgium, Sam Vanhee, Els De Vos, and Fredie Floré trace the interwoven histories of university spaces and the philosophy and pedagogy of interior design education. Utilizing analysis of the built environment and oral histories, the authors locate and discuss three different kinds of edges that were renegotiated through the relocation of the program from the city center to a peripheral campus. While they demarcate these

three types of edges—between school and city (physical edge), between education and society (educational edge), and between architecture and interior architecture (disciplinary edge)—their essay lays bare how intertwined these categories were in the example of Hasselt, effectively serving as a case study that could be employed elsewhere to consider the history of other interior architecture programs.

The Edge of the 1959 Cuban Revolution

Not surprisingly, working on this volume made me consider edges more carefully in my own work on the intersection of design, politics, and the state in the Hispanic Caribbean. One edge that remains a sticking point is Cuba 1959.[1] One of the practices of the revolution was to draw a sharp line demarcating the Cuba of before and the new revolutionary Cuba that seemingly appeared *ex novo* in 1959; and for most working on Cuban studies the notion that there is a sharp distinction, or even incomparable nature, between what happened in the island nation before and after Fidel Castro arrived with his troops in Havana, claiming victory in January 1959 and ushering in a revolutionary period, has been a defining feature. This is not to say that the state's imagery is a completely false representation of history. Indeed, many Cubans experienced radical changes in their lives after the revolutionary government came to power, especially in housing, education, and health care. However, complicating this edge—as more scholars are currently doing as they question this impossible narrative—makes possible not only new investigations and definitions but understandings of temporal edges.

Blurring the demarcation of 1959 opens pathways to illuminate how that overdetermined edge pushed aside many continuities, resulting in violence or damage against certain groups or histories. One type of continuity is the persistence of cultural and social practices and values. Sara Desvernine Reed's "Women, Work, and Revolution: A Do-It-Yourself Practice," looks at the intersection of labor, revolutionary ideology, and design as presented in the women's magazine *Mujeres*.[2] Reed's focus is the ways in which *Mujeres* sought to "propagate images of the women participating in revolutionary life to engender collective support for the Castro regime," which "simultaneously reinforced and subverted existing gender stereotypes."[3] The magazine employs the rhetoric of the collective for both the role of women in the workforce and the revolution (figured as inextricably linked), but Reed also points to how the magazine, the official mouthpiece of the revolutionary *Federación de Mujeres Cubanas* (FMA, Federation of Cuban Women), acknowledges the "double burden" of women. Reed underscores that pre-revolution expectations of women in the domestic

sphere persisted and points to the way that the FMC did not engage in critical debate about the double burden, but instead looked at women's multidimensional roles through rose-colored glasses. However, she fruitfully brings to light the way that, for example, articles that outlined DIY projects were not just responding to scarcity of goods and celebrating frugality, but also speaking to the fact that women were still expected to do the decorating and needed tips on how to do this while short on time.

Edges do not always mean a rupture. One need only look at any contemporary domestic interior in Cuba to find a veritable timeline of furniture from the late-nineteenth century to the present. More dated cane and mahogany armchairs and settees sit comfortably with mid-century buffets. Art Deco bedroom sets, solid and smooth, can be found mixed with flimsy, cheap functionalist desks, the product of the revolutionary government's more recent furniture importation practices. And in many you can find one of the trademarks of a Cuban interior, a *sillón*, or rocking armchair. These vary in material and form, from heavy cast iron, often painted white, to light tubular aluminum frames with green plastic cording used for the seat and back.

Offering an idiosyncratic timeline of Cuban furniture, these interiors do not align with the revolutionary government's intentions when it sought to create a new social order. In its efforts to clearly define edges, the Castro regime looked to upset housing practices and structures in order to provide more affordable housing for all. During its first years, the government radically reduced rents, deeded properties to owners, and created programs, such as the *Instituto Nacional de Ahorro y Vivienda* (INAV, National Institute of Savings and Housing), which, led by Pastorita Nuñez, was charged with the construction of large multifamily apartment buildings and complexes.[4] Though short lived, INAV (1959–1962) was not the only project aimed at providing large amounts of housing to the island's population. On July 27, 1967, Fidel Castro gave a speech to mark the opening of Grantierra housing project, in which he called for the construction of 100,000 housing units per year starting in 1970, to be funded by the profit from the 1970 *Zafra de los Diez Millones* (Ten-Million Ton Sugar Harvest). At this point the revolutionary government had already backtracked on their original proclamations to abandon an agricultural monoculture, instead looking to repurpose its profits for the benefit of the main social pillars of the revolution, of which housing was one.

These massive amounts of revolutionary housing would be visually marked by their employment of prefabricated systems of architecture, many of which were imported from other second world countries.[5] The government saw the opportunity in baking revolutionary rhetoric into the interior of these structures as well and to do so created a branch of

the *Ministerio de Industria Ligera* (MINIL, Ministry of Light Industry) to explore and develop a series of furniture for these housing units that could be produced on the island. While the project was shut down with the failure of the 1970 sugar harvest, the government allowed the small group to create some prototypes and organize some exhibitions.

What the group envisioned was a series of furniture pieces made democratically accessible through flat pack distribution and comprised of cane bagasse particle board. Their exhibition *Mueblepared*, which translates to "furniture-wall" advanced a new revolutionary way of living in which interiors were defined by furniture, not by immovable partitions. Not surprisingly, one of the pieces of this series was a large moveable wall, complete with adjustable shelves, cabinets, and desk/table space. Its customizable nature was presented as advantageous to the revolutionary project; by being able to adjust interior configurations, individuals would more easily and efficiently be able to contribute to the collective revolutionary project, though details of how, exactly, this operated were never articulated. Swedish architect Eva Björklund described her work on this design team and their approach to thinking about function and social issues in the Swedish magazine *Form*.[6] According to Björklund, the team attempted to maximize the functional possibilities of each piece and avoid the negative attributes of tradition. To that end, they focused on identifying bourgeois habits in order to create furniture. However, all accounts from the team are vague when it comes to defining bourgeois/capitalist habits versus collective/communist ones, leaving this question about the edge between communist and capitalist interiors very much unanswered.

The story of this design team and the government's commitment to housing and furniture production remains largely unrecognized. Far too often, people say that there was no real architecture or design profession after the revolution. This sort of statement is born out of the practice of embracing a sharp edge between pre- and post-1959 that is viewed only through the lens of disconnect, rather than continuity, and does violence to the architects and designers in Cuba that, whether educated before or after 1959, are still designing and practicing, though not according to the dominant capitalist definition of an architect. This edge reifies a narrow definition of the architect and designer as artist-genius—this more romantic notion of an unfettered creative—who works within a capitalist system and does a disservice of closing off a more expansive definition that could encourage more diverse and creative inquiry. In the case of Cuba, it is not that the design profession does not exist, but that its edges have shifted. There architects and designers continued to work, but the role was reconceptualized as one that supported society as a whole, not just the monied

class. As architecture and design was placed under the aegis of the state and materials became harder to come by, practices shifted to those rendered ideologically and economically sound, for example, movement away from idiosyncratic or expressive form and use of local materials, such as cement and cane bagasse. Thinking across the edge of 1959 in terms of byways as well as detours, better informs inquiry into local production, national sovereignty, and conceptualization of the design profession.

This glimpse of an application inspired by the myriad approaches presented here can be seen to illuminate the arbitrary nature of edges: how humans name, institute and resist edges whether to gain control or to expand horizons. In inviting us to question the edges of practice in history writing and designing they reveal the profound impact of how we use interior edges, whether liminal, material, or mediating. Deborah Schneiderman further reflects on this in an afterward that closes the volume.

Notes

1 The Cuban revolution is not figured as something that happened in the past—a discrete event, for example, the way the American Revolution is discussed, but rather is constructed as something that has been continuing to happen since its starting point in 1959. On how the Cuban revolution has been imagined in a temporal sense and the ideological ramifications of this, see Louis A. Pérez, Jr., *The Structure of Cuban History: Meanings and Purpose of the Past* (Chapel Hill: The University of North Carolina Press, 2013).
2 Sara Desvernine Reed, "Women, Work, and Revolution: A Do-It-Yourself Practice," *Design and Culture* 8, no. 1 (2016), 27–54.
3 Ibid, 28.
4 INAV was designed to finance the construction of housing with the funds from the National Lottery, based on the transformation of its tickets into savings bonds, an unprecedented practice in the country. See Ruslan Muñoz Hernández and María Victoria Zardoya Loureda, "Las 'casa de Pastorita' en La Habana"/ "'Pastorita houses' in Havana," *Arquitectura y Urbanismo* 37, no. 1 (2016), 37–50.
5 Systems from present-day Russia, Czech Republic, and Yugoslavia are some of the better known examples. In addition to the importation of these systems, thousands of Cubans traveled to Eastern Bloc countries to study engineering and other relevant fields, which impacted their work in the building and manufacturing fields in Cuba upon their return.
6 Eva Björklund, "Furniture for Cubans," *Form*, no. 9 (1969), 424–5.

Bibliography

Björklund, Eva. "Furniture for Cubans." *Form*, no. 9 (1969): 424–5.
de Carvahlo Braga, Patrick Calmon. "Arquitectura Cuba and the Early Revolutionary Project." *International Journal of Cuban Studies* 9, no. 2 (2017): 235–59.
Deupi, Victor, and Jean-François Lejeune. *Cuban Modernism: Mid-Century Architecture, 1940–1970*. Basel: Birkhauser, 2021.

Guerra, Lillian. *Visions of Power in Cuba: Revolution, Redemption, and Resistance, 1959–1971*. Chapel Hill, NC: University of North Carolina Press, 2012.

Kapcia, Antoni. *Havana: The Making of Cuban Culture*. New York, NY: Berg, 2005.

Mesa-Lago, Carmelo. *Cuba in the 1970s: Pragmatism and Institutionalization*. Rev. ed. Albuquerque, NM: University of New Mexico Press, 1978.

Muñoz Hernández, Ruslan, and Gabriela González González. "Labor desarrollada por el Instituto Nacional de Ahorro y Vivienda (INAV) en La Habana (1959–1962)"/"The Work of the National Institute of Savings and Housing (INAV) in Havana (1959–1962)." *Revista INVI* 30, no. 84 (2015): 89–120.

Muñoz Hernández, Ruslan, and María Victoria Zardoya Loureda. "Las 'casa de Pastorita' en La Habana"/"'Pastorita houses' in Havana." *Arquitectura y Urbanismo* 37, no. 1 (2016): 37–50.

Pérez, Louis A. Jr. *Cuba: Between Reform and Revolution*. 4th ed. New York, NY: Oxford University Press, 2011.

————. *The Structure of Cuban History: Meanings and Purpose of the Past*. Chapel Hill, NC: The University of North Carolina Press, 2013.

Reed, Sara Desvernine. "Women, Work, and Revolution: A Do-It-Yourself Practice." *Design and Culture* 8, no. 1 (2016): 27–54.

Thomas, Hugh. *Cuba: or the Pursuit of Freedom*. Rev. ed. New York, NY: Da Capo Press, 1998.

Zardoya Loureda, María Victoria. "La arquitectura educacional de los sesenta en Cuba"/"The Architecture of Education in the 1960s in Cuba." *Arquitectura y Urbanismo* 36, no. 3 (2015): 5–19.

SECTION I
Liminal Edges

1

FROM THE INSIDE OUT

China's Post-Socialist Housing Reform

Yang Yang

> *Architecture can be a profit-making industry. It is an important indus-*
> *trial sector that increases revenues and capital accumulation for the*
> *state. It is necessary to reconsider a series of policies on urban housing*
> *construction and allocation. Urban residents can buy a house or build*
> *one by themselves.*
> —Deng Xiaoping, "Speech at the Nationwide General
> Construction Conference," April 1980[1]

In 1980, shortly after initiating China's economic reform in 1978, Deng Xiaoping, leader of the Central Committee of the Chinese Communist Party (CCP), proposed another radical reform that would abolish the socialist welfare housing allocation system, reinstate a nationwide real estate market, and monetize housing consumption. The first step toward housing commodification involved redesigning dwelling units to develop an industrialized residential building system that also promoted individual home-ownership. The approach to domestic interior design shifted from simply allocating size quotas to creating customized functional subdivisions that accommodate everyday life and give some agency to the owner. The design's evolution was accompanied by the breakdown of a unified portrait of the working class, the recognition of families as the fundamental unit of society, and the reshaping of physical needs and wants in a consumer-driven culture. At the forefront of a market-driven reform, housing transformation in Shanghai, particularly the interior design of dwelling units, illuminates the post-socialist ideology's recognition of an individual's domestic physical

DOI: 10.4324/9781003457749-3

and psychological edges, including hierarchized living spaces linked to one's political or social identities and marked by private property boundaries where one can freely express their preferences and needs.

The Quota and the Type

Deng's reforms aimed to dismantle the national government's existing approach to centrally planned housing. In socialist China under Mao's rule, the housing sector served as a low-rent non-profit welfare system that only benefited bureaucrats who obtained more seniority in their work units (*danwei*) and a limited number of "model workers (*laodong mofan*)" who made outstanding technical contributions.[2] The management of housing was previously subject to state-regulated guidelines known as the "six uniform operations" that prioritized uniformity in planning, investment, design, construction, allocation, and management.[3] The focus was on reducing the square meters of public spaces, such as stairs, corridors, and elevators, to allow as much domestic interior space as possible. A pivotal index to evaluate the efficiency of housing design was the "K value" borrowed from the Soviet Union (USSR), whose model of industrialization was a significant influence on China's approach to socialist modernization—including housing standardization—during the 1950s.[4] The "K value" was the ratio of the living area—excluding kitchens and bathrooms—divided by the gross floor area. The higher the K value, the higher population density per square meter, meaning more efficient space utilization.

As early as 1956, the National Construction Committee established a special organization, the National Standard Design Institute, to draw up residential and public building design standards.[5] A Unified Architectural Modular System (Standard 104-55), specifying 100 mm (3.9 in.) as the basic scale unit, in accordance with USSR specifications, was adopted in the same year.[6] Uniform design facilitated uniform allocation. Unit size regulations established the average floor area per person based on the seniority and employment position of each inhabitant. For example, in the late 1970s, the municipal government of Shanghai developed the "mandarin duck building (*yuan yang lou*)," a typical type of standardized housing, composed of uniform single-room studios—each 3.3 m in width (Figure 1.1). It was designed to temporarily meet the urgent demands of newlyweds who, in principle, would shortly move out after a promotion led to access to a larger unit.[7] The homogeneity produced by this standardization of size and type received harsh criticism from Chinese architectural academics. Despite construction systems evolving from concrete and brick to large panel systems and mid-rise buildings replacing low ones, for two decades (1950–1970), the most common design for multi-family dwellings

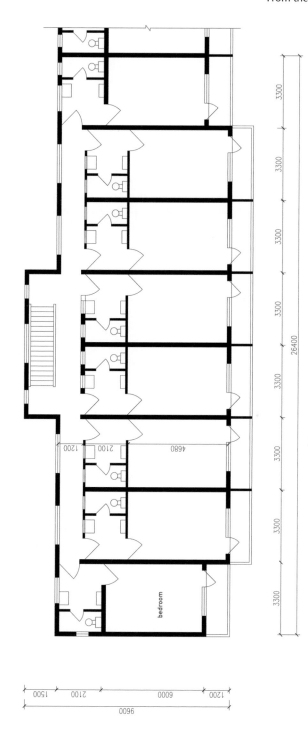

FIGURE 1.1 Standard floor plan of a "mandarin duck building (*yuan yang lou*)" for newlyweds, 1979.

was a modernist building slab with a long side corridor, widely denounced as "barrack-like."

In 1981, the National Construction Committee and the Architectural Society of China held a seminar on the "Standardization and Diversification of Residential Building Design" that reflected on the lack of flexibility and humanity in the first generation of industrialized housing systems based upon the Soviet model. After turning to contemporary housing techniques from Japan, Germany, the Netherlands, France, and Poland, the seminar participants proposed abandoning the K value since it failed to consider the household needs arising from differences in demographics, income, and lifestyle among families. For instance, researchers would need a private study space in their homes, while children over twelve years old might require their own bedrooms. The seminar participants further suggested that housing design be based upon "dwelling unit" (*tao xing*, literally "set type," referring to dwelling unit types based on available area per household) to develop a second generation of industrialized building system that focused more on household needs than on space efficiency.[8] The emphasis on a quantifier—"a set of" dwelling units—also reflected consideration of private kitchens and bathrooms as part of a necessary sanitary package for each residential unit that distinguished them from the shared-use units found in the workers' housing of the 1950s.

Despite the academics' advocacy for change, the central government's policies continued to enforce hierarchical standards for work unit-subsidized housing that hindered innovative design responsive to a variety of lifestyles. In the early stages of real estate market recovery, work units served as mediators between the state and salaried workers by engaging in housing consumption. This was particularly evident prior to the wage reform of 1985, where work units would purchase commodity housing in the market, and then sell to their employees at a lower price with subsidies, thereby sustaining a semi-welfare system.[9] To avoid corruption and individual manipulation, the state council enacted Strict Control on Urban Housing Standards in 1983 that stipulated four dwelling sizes that corresponded to four employment positions or ranks: general staff received units in rank one (42–45 m^2 per unit or 452–484 ft^2) and rank two (45–50 m^2 or 484–538 ft^2); county-level cadres (*gan bu*) and intellectuals (*zhishi fenzi*) lived in rank three units (60–70 m^2, or 646–753 ft^2), and province-level cadres and senior intellectuals enjoyed the larger spaces of rank four (80–90 m^2, or 861–969 ft^2).[10] These regulations reflected not only post-socialist China's compromise in promoting marketization but also the legitimization of social stratification. "Cadres" and "intellectuals" were differentiated from the unified working class in the Mao era and became newly empowered groups who now had the "right to purchase."[11]

As the early beneficiaries of China's economic reform gained more purchasing power, the state eventually abolished the upper limit of housing sizes, thus leaving the decision to the market.[12]

In 1986, the National Planning Commission issued a new set of Residential Design Specifications, outlining the minimum sizes of three scale units—18 m² (194 ft²) for a small unit, 30 m² (323 ft²) for a mid-sized unit, and 45 m² (484 ft²) for a large unit, along with the minimum sizes of bedrooms, living rooms, kitchens, and bathrooms.[13] Cities, such as Shanghai, asked to pilot housing reform, further applied a ratio of the number of family members to the number of rooms: a one-bedroom unit for a family of four or less, a two-bedroom unit for a family of six, and a three-bedroom unit for a family of seven or more. Moreover, after the implementation of the one-child policy in 1980, the proportion of small-scale families, particularly two-generational nuclear families consisting of a married couple and one or two children, began to rise significantly, with new policies initiated to encourage the development of more small-sized dwellings. The Shanghai Future Research Institute, a think tank for the government's policy-making, ambitiously envisioned a city whose housing development by 2000 would emulate Hong Kong. The institute suggested that Hong Kong's approach of constructing high-rise apartments with compact units could serve as a useful model for Shanghai, as both cities faced comparable issues of high population density, limited land resources, and inadequate housing.[14] These revised reforms brought about a new design concept, *hu xing*, or household type, which represented a changing perception of a dwelling unit. Unlike the previous *tao xing* (set type), *hu xing* focused on accommodating diverse inhabitants rather than construction components. The emphasis on the household allowed for innovative interior layouts that could adapt to the changing trends in family populations, age structures, and lifestyles, and push the edges of past approaches, physically and conceptually. Architects now needed to prioritize flexibility, along with economy and functionality, to meet the variety of market demands.

Small but Flexible

Housing standardization in China served a dual purpose: it enabled the mass production of housing and allowed the state to regulate the degree of housing marketization. Before a mature real estate market was developed, architects from state-run or city-owned design institutes played a crucial role in helping policymakers project market demand and supply. Similar to the path of economic reform described by Deng, housing reform in China was akin to "crossing a river by feeling one's way over the stones." Architects found their stepping stones by connecting interior space with

the rationale of home-centered consumptions, which they tested in a series of architectural design competitions in the 1980s.

In June 1982, in collaboration with Shanghai's Construction Committee, the Shanghai Urban Planning Bureau hosted the first architectural competition held in Shanghai since 1949. The competition called for innovative housing designs that could break existing norms—such as the barrack-like building layout—while still adhering to the general building codes.[15] The goal was to create practical yet unconventional solutions. Only four state-run design institutions were invited to the competition.[16] The winning entry by the Shanghai Civil Architecture Design Institute outlined the development of seven basic units that could be stacked into an assemblage of various building types—from terraced houses to multistory blocks and towers—that in turn could be grouped into nine building clusters surrounding a community center.[17] The plans' highlighting of modern necessities such as closets, bathtubs, washing machines, and refrigerators represented a conscious revision of the previous design's lack of clear functional divisions (Figure 1.2). The alteration was made to adapt to the changing domestic patterns and habits resulting from the growing demand for household appliances in major cities like Shanghai. Each unit now had a small foyer, around 4–10 m² (43–107 ft²) large. The foyer, traditionally a narrow entryway, became a "living room" that served as a reception or family social space as well as a place for valued household appliances—such as televisions and refrigerators—that were still uncommon in most households and indicated a modern domestic life.[18] Besides the small foyer, the winning 1982 competition unit design also featured south-facing bedrooms with attached balconies, ensuring ample natural light and ventilation in every room; seemingly extravagant at first, these became mandatory national housing standards a decade later.

Based on the prototypes from the 1982 competition, the Shanghai Construction Committee approved a "Dwelling Type #5" in 1984, including three standard unit plans, which were expanded to five in 1987 (Figure 1.3).[19] All of the units adopted a 3.6-m (11.8 ft) width module, wider than that used in the 1970s. Each room was a standardized prefabricated component that readied them for mass production. The north-south fenestration design allowed these units to be interconnected and extended in the east-west direction, yielding multiple combinations to form varied building plans in dots, strips, or zigzag patterns. These modifications sought to offer various interior configurations that provided an alternative to the rigid parallel layout of earlier socialist workers' housing.

In April of 1989, a decade after Deng put forward his housing reform ideas, the Chinese Ministry of Construction organized a national housing

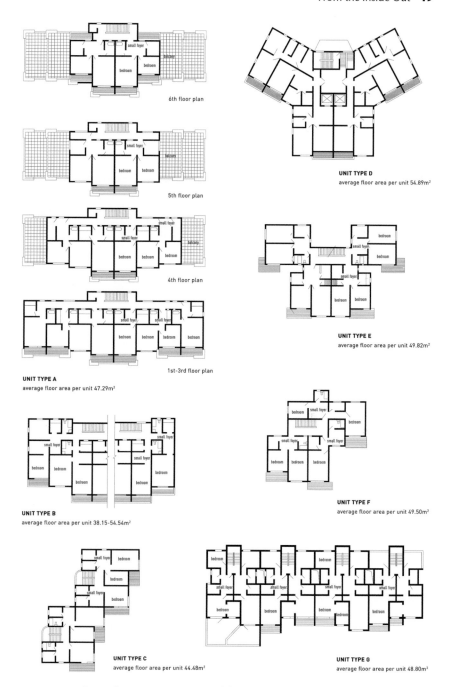

6th floor plan

5th floor plan

4th floor plan

1st-3rd floor plan

UNIT TYPE A
average floor area per unit 47.29m²

UNIT TYPE B
average floor area per unit 38.15-54.54m²

UNIT TYPE C
average floor area per unit 44.48m²

UNIT TYPE D
average floor area per unit 54.89m²

UNIT TYPE E
average floor area per unit 49.82m²

UNIT TYPE F
average floor area per unit 49.50m²

UNIT TYPE G
average floor area per unit 48.80m²

FIGURE 1.2 Seven basic units proposed for the Kangjian New Village, 1982.

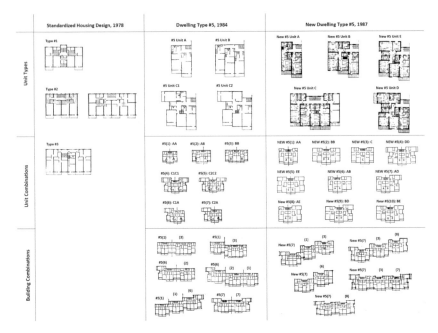

FIGURE 1.3 "Dwelling Types #5" approved by the Shanghai Construction Committee, 1984.

design competition, "Home in My Mind," to promote individual housing purchases that would boost the real estate industry. The competition called for new designs—"practical, promotional, experimental, yet also academic"—that would conceptualize housing as a commodity and provide reference housing types for local practices.[20] The jury panel was comprised of experts from the Chinese Institute of Building Standard Design and National Urban Housing Design and Research Network members.[21] Considering the needs of potential homebuyers and their economic situation, the primary criteria for selection addressed the flexibility of dwelling units that—regardless of their sizes—should be able to accommodate families of all sizes and demographics, thereby making the units more marketable. In over half of the thirty-nine winning entries, the only fixed elements were kitchens, bathrooms, staircases, and the load-bearing walls separating two units. Light partition walls could be positioned according to the residents' wishes (Figure 1.4).

The competition generated design methods that intentionally divided private interiors and common building shells both architecturally and institutionally, which required the state, the local government, and individuals to have a role in the design. In his speech at the competition

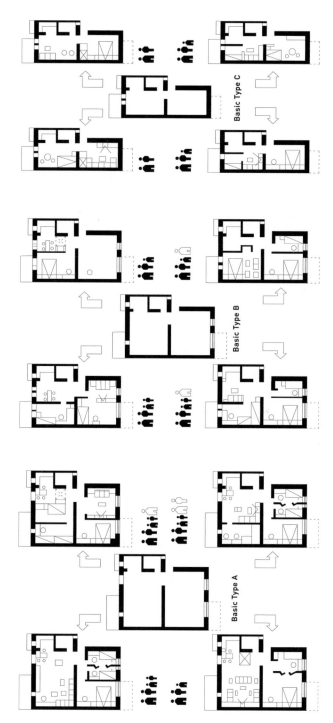

FIGURE 1.4 Standard unit-type design by first-prize winners, 1989 National Commodity Housing Design Competition.

review conference, the deputy minister of the Chinese Ministry of Construction stated:

> Housing studies at this stage should focus on realizing the commodification step by step, part by part, such as the recent "support-infill study." That is, the state and local governments are responsible for the investment and decision-making on the development of urban tissues; work units take responsibility for housing design and construction [including the main body of the structure, exterior walls, staircases, and shared facilities]—the support; and the individuals take care of the interior [including partition walls, furnishing, and household equipment]—the infill, who can arrange their homes according to their purchasing powers, lifestyles, and hobbies.[22]

Zhou's speech acknowledged the state's withdrawal from commodity housing construction and the rights of individuals to customize their own interior spaces. Housing design became the apparatus for reinstituting individuals decoupled from the socialist welfare system, who, instead of being limited by quota-based allotments, were granted greater freedom in their consumer and design choices.

In 1990, following the national competition, many local governments, including Shanghai's, held city-level competitions under the same title; Shanghai's Municipal Construction Committee began to draft new housing design standards simultaneously. Based on the market conditions of the past two years that were gathered from leading real estate developers, the competition called for designs for medium- and small-sized units for individual homebuyers and specified the floor areas per consumer type: a maximum of 45–50 m² (484–538 ft²) for local buyers and an average of 60–80 m² (646–861 ft²) for foreign buyers.[23] The distinction between types of homebuyers reflected the so-called "dual-track system (*shuang gui zhi*)," a price-setting policy implemented in the transitional stage of China's economic reform.[24] Shanghai began to carry out the dual-track housing system—a domestic market and an overseas one—in 1988. With a price ceiling established, the domestic market was only open to local residents—who also had the right to buy high-grade housing if they could afford it—but excluded foreign buyers. In contrast, the freedom of price negotiation was given to the other track.[25] The differential pricing systems allowed the overseas market to perform as a paradigm for the domestic market, including its spatial designs, development models, and sales strategies. At the testing stage of the dual tracks, the 1990 competition asked entries to freely determine the proportion of different-sized units based on their estimation of demands in both markets.

The winning design had only one basic plan: the typical set of 3.0-, 3.3-, and 3.6-m modules that could be developed into four unit types using lightweight partition walls to add more bedrooms. No matter the size and configuration, all types of units upheld the principle of "large living rooms and small bedrooms." According to the winning architects, their design departure responded to the developers' needs for a flexible and highly marketable product. They also pointed out that the form of housing was determined by different forms of government and economic ideology:

> The welfare system had shaped the idea throughout the entire process, from decision-making and investment to construction. To control costs and optimize distributions, the state had to regulate unified housing standards, which then rigidified the living patterns of the users. In this way, welfare housing appeared as a *static* form ... Housing commodification was founded on private ownership. The demands of the buyers and sellers in the market should serve as a basis for new design conceptions.[26]

The winning architects continued to propose the minimum living standards for different family structures to enable a certain amount of affordable commodity housing as a form of "respect for human rights and the state's humanistic care." The appeal for humanistic care shows that architects from state-run design institutes, who were summoned to design competitions to stimulate the marketization of housing via innovative designs, also utilized these competitions to impact policy. By introducing flexible interiors, architects offered an alternative to the previous design that restricted inhabitants to passively adapting to rigidly defined spaces. The result of Shanghai's 1990 competition in turn affected the revision of the city's housing codes. In October 1994, the Shanghai Construction Committee issued its updated Design Standards for Residential Buildings (DBJ08-20-94) to set up minimum housing standards by adding an average of 8 m² floor area per household, reaching up to 52 m² per dwelling unit to enhance the general living standards of the city.[27]

DIY "Home Infrastructure"

The evolution of housing design that balanced standardization—from quotas to minimum areas—and variation is not only the result of the state's attempt to alleviate housing shortages through market means but also indicates individual desires awakened by economic reforms and their ability to afford more than socialist welfare housing. The new focus on designing large living rooms also better allowed for home entertainment and

consumption of new electronics for this purpose.[28] An increasing number of families began to want and own televisions and VCRs, for example, and whether related or not, it correlated to greater consumer interest in clothing and other domestic products advertised through media. Chinese political scientist Wang Shaoguang pointed out, as state control over the private lives of urban residents loosened during the 1980s, patterns of leisure shifted under the "pragmatic Deng regime."[29] Wang argued that the increase of and increased flexibility in leisure activities produced (and reflected) an enlarged private sphere intentionally unleashed by the state, or in his term, the state's "indifference zone." According to Wang, this deliberate turn was partly due to the recognition that the state's monopolization of personal time in the 1960s and 1970s was not conducive to economic progress and social stability, and partly due to the devaluation of collectivism. However, he emphasized, the state "intended to *loosen* rather than *lose* its control." Although the private realm expanded, the state did not retreat completely from its control of consumption patterns because "[o]nce allowed to be expressed through 'cultural markets,' individual preferences for leisure become a powerful force [for profit-driven activities that could potentially transcend administrative boundaries and risk the state's guidance role], so powerful that it is able to 'chip away' the state's domination over people's private time."[30] Book publications and television programs were prominent examples of the emerging forces of cultural markets. As less-political state agents, they played a significant role in the shaping of people's home-centered leisure patterns while inadvertently illuminating an autonomous space for individuals to express emotions and desires that were previously suppressed.

In 1987, responding to the "International Year of Shelter for the Homeless (IYSH)" advocated by the United Nations, a Shanghai TV program, *Friends of Life*, produced a segment on modern home furnishing entitled "An Elegant Home Need Not Be a Big House (*Shi Ya Wu Xu Da*)." The show solicited home design strategies from its broad audience—the "amateur designers." Eighteen out of 900 submissions were awarded under five categories—single-room units, double-room units, bedrooms, kitchens, and bathrooms—and exhibited over three episodes. The show had an overwhelming response from the audience, achieving an audience rating of 35%, and was aired on twenty-nine other provincial TV channels throughout China. Shanghai TV received numerous audience requests for the design drawings. As a result, the program released a subsequent catalog titled *Master Arrangement of Houses*, which sold out all 150,000 copies immediately.[31] The show particularly propagated the concept of the "combined furniture (*zuhe jiaju*)" that flexibly grouped closets, TV stands, bookshelves, and cabinets on one wall to save room and subdivide smaller

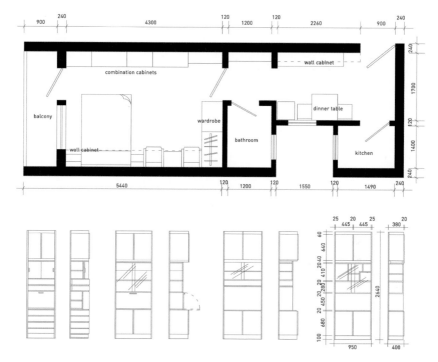

FIGURE 1.5 Four cabinets of uniform width to demarcate activity zones in a couple's bedroom, 1987.

spaces. For instance, using convertible furniture could resolve awkward situations, such as when adult children often had to share a single-room apartment with their parents. In a couple's bedroom, four cabinets of uniform width—containing a dressing table, a foldable writing desk, a TV stand, and a glass display case—were used to demarcate activity zones and allow at least some semblance of privacy between couples (Figure 1.5). The program director celebrated these clever furnishing designs:

> Our wisdom has magic potential. Small rooms became spacious through the hands of amateur designers (no, they are indeed skillful craftsmen). The multi-functional furniture, both artistic and practical, takes less space and cleverly solves the conflict between the current housing difficulties and the house owners' pursuit of modern lives.[32]

The "pursuit of modern lives" was most evident in the glass case that appeared in many home furnishing guidebooks and advertisements. It became a must-have piece for almost every Shanghai family during the 1980s for displaying dolls, imported wines, coffee kits, and other commodities

that were not for daily use but showcased the owners' hobbies, tastes, or personalities. By making accessible efficient interior design options in mainstream television programs, inadequate living space was now seen as a difficulty that could be ameliorated. Furnishing design softened the psychological edges of the standardized residential shells mandated by the state, allowing a threshold for one to release individuality within the sanctuary of their own homes.

Home furnishing became a popular topic, not only on television but also in print publications, where it was non-existent during the socialist period. In 1979, *Culture and Life* magazine started a DIY (Do-it-Yourself) furniture column to provide readers with personalized solutions for adapting to housing standardization and spatial quotas.[33] How to make full use of every square meter to create privacy while efficiently managing domestic life was considered essential knowledge. In the preface of *Home Economics,* a mid-1980s bestselling book series on household management launched by the Shanghai Culture Press, the editor eloquently stated:

> The family is the fundamental cell of society. Home is where people live and the primary social production and consumption unit, cultivating the younger generation and supporting the elderly. The new socialist families should stress the scientific management of domestic life and the enhancement of citizens' cultural life; both are necessary for our period.[34]

The "scientific management" was reflected in the practicality and beauty of home furnishing. Since private life and guest hosting were squeezed into one room, the furniture nearly every family owned—wardrobes, chests of drawers, and dining tables—were used as spatial dividers to demarcate zones for sleep, work, and recreation. As for aesthetic considerations, these guides recommended adding a set of open shelves on top of a dresser or in the corner of a writing desk for displaying ornaments—a plant pot, a glass vase, or a globe, which need not necessarily be expensive but offered aesthetic pleasure, or "the finishing touch." The "science of furnishing" promoted by the official-endorsed mass media empowered the inhabitants to expand their private spheres while giving tacit consent to the state's quota restrictions on everyday living spaces.

Perhaps unsurprisingly, DIY furniture was promoted as the "modernization of home infrastructure."[35] Before 1989, the state-owned Municipal Furniture Corporation monopolized the furniture industry of Shanghai and offered only a voucher-based system for acquisition of furniture. In response, the Shanghai Furniture Research Institute published manual books to help popularize the concept of "DIY furnishings" that made a

customized interior possible by putting together standardized panels and joints in new ways using the same logic as the standard unit design.[36] These DIY manuals showed simple sketches in plans and elevations that suggested the least amount of effort required by readers or users. Customized furnishing altered traditional furniture layouts and reconciled housing standards with individual tastes—vibrant colors, glossy finishes, and the layering of interior spaces. As a valuable family necessity, the TV—the instrument for, and powerful symbol of, emerging consumer desires—was commonly the focal point in the publications' renderings. The expression of individual creativity under constrained living conditions coincided with the official promotion of consumerism, which diverted public attention away from criticizing the state's failure to fulfill its promise of welfare housing and its reluctance to release its grip on the real estate industry. The quota-based standardized unit design allowed for differences between households but only within a manageable range, implying the lingering total control of a socialist society over the construction of housing and families. In this process, DIY furnishing eased the tension between state intervention and market construction, offering a loosening boundary for the inhabitants to fulfill individual desires, albeit disciplined.

Notes

1 Translated by author. Deng's speech was published as "Deng Xiaoping guanyu jianzhuye he zhuzhai wenti de tanhua" 邓小平关于建筑业和住宅问题的谈话 [Deng Xiaoping's Speech on Architecture and Housing Problems], *People's Daily*, May 15, 1984.

2 Work unit, or *danwei*, a term generated in the mid-1950s, was the primary social agent in urban China that aimed to bring all individuals together in a communal life of production and allocation. The work-unit system was an organizational instrument of the state to monopolize social resources. The function of a work unit was to distribute political propaganda and exert social control over its members. This involved allocating wages, benefits, and political rights based on employment status. For more on the work-unit system, see Kenneth Lieberthal and David M. Lampton, Susan Shirk, and Yanjie Bian.

3 In the early 1950s, following the CCP's socialist transformation campaign, which involved transferring ownership of means of production (including private real properties) from private to public hands, the state took over housing construction in a centralized manner to exclude any market forces. See Lu Wenda and Xu Baorun ed., *Shanghai fangdichan zhi* [Shanghai Real Estate Chronicles], 201–2.

4 In February 1953, Mao urged China to learn from the Soviet Union, resulting in the First Five-Year Plan for Economic and Social Development (1953–1957), which aimed to establish more industrial bases to aid in postwar economic recovery and accelerate China's transformation into an industrialized country. See "Zhengxie diyi jie quanguo weiyuanhui disi ci huiyi bimu: Mao Zedong sandian zhishi" 政协第一届全国委员会第四次会议闭幕: 毛泽东三点指示 [The Fourth Session of the First National Committee of the Chinese People's Political

Consultative Conference Concludes: Mao Zedong's Three Instructions], The Central People's Government of the PRC, accessed November 16, 2022, http://www.gov.cn/test/2008-02/20/content_894595.htm.

5 The National Standard Design Institute was the predecessor of the Chinese Institute of Building Standard Design and Research.

6 National Construction Committee, Jianzhu tongyi moshu biaozhun-104-55 建筑统一模数制标准-104-55 (1956) [Unified Architectural Modular System-104-55], 1956.

7 The rental cost for a *mandarin duck* unit was on a per square meter basis, with an average monthly rate of 1.14 RMB. The lease agreement usually lasted between one to two years, with an added 50% rental fee for any period beyond that. Due to the chronic housing shortage in Shanghai, residents of *mandarin duck* buildings were not typically assigned another apartment by their work units and often stayed for prolonged periods. Without a sustainable housing cycle, this type of housing eventually vanished from the market. "Shangpin zhuzhai jianshe" 商品住宅建设 [Commodity Housing Construction] in *Shanghai Housing Construction Chronicles* Vol. 4, Shanghai Local Chronicle Office 上海地方志办公室, accessed November 30, 2023, https://www.shtong.gov.cn/difangzhi-front/book/detailNew?oneId=1&bookId=75091&parentNodeId=75153&nodeId=90909&type=-1.

8 Zhao Guanqian 赵冠谦, "Lun woguo zhuzhai jianzhu de biaozhunhua yu duoyanghua" 论我国住宅建筑的标准化与多样化 [Standardization and Diversification of Residential Architecture in China], *Zhuzhai keji* 住宅科技 [Housing Science] Issue 1 (1985), 10.

9 Before the wage reform, most people who earned a fixed salary could not afford to purchase residential property on their own. In 1984, the Shanghai government issued Measures for the Sale of Commodity Housing, which set the base price for unified housing at 360 RMB per square meter in both high-rise and multistory buildings, with a coefficient variable depending on each unit's location, floor, and orientation. Meanwhile, the Shanghai Statistic Yearbook reported that in the same year, the average annual income of state-owned enterprise and public institution employees in Shanghai was 1,110 RMB. This meant that for a dual income family looking to purchase a 50 m² unit, the housing price-to-income ratio exceeded 8. Shanghai Municipal Government, Shanghaishi chushou shangpin zhuzhai guanli banfa 上海市出售商品住宅管理办法 [Measures for the Sale of Commodity Housing in Shanghai], May 28, 1984.

10 State Council of the PRC, Guowuyuan guanyu yange kongzhi chengzhen zhuzhai biaozhun de guiding 国务院关于严格控制城镇住宅标准的规定 [Strict Control on Urban Housing Standards], December 15, 1983.

11 The notion of the "working class" was introduced through Marxist class theory and became a crucial component of CCP's ideological framework. After the establishment of the CCP government, the communist party-state integrated traditional geopolitical identities and replaced them with the working class, whose interests were represented by the party.

12 In 1985, Deng Xiaoping coined the political dictum "Allow some people to become rich first" to justify China's move away from socialist egalitarianism and to encourage its shift toward market-oriented economic reform. Those who "became rich first" were groups outside or exempt from the work-unit system due to their distinctive political or financial status, including self-employed business owners, high-ranking officials, and renowned intellectuals.

13 National Planning Commission, Zhuzhai jianzhu sheji guifan 住宅建筑设计规范 [Residential Design Specification (GBJ 96-86)], September 22, 1986, 2.

14 Yu Songnian 俞松年, "2000 nian hou de Shanghai zhuzhai he jiating" 2000 年后的上海住宅和家庭 [Shanghai Housing and Family after 2000], *Weilai yanjiu* 未来研究 [Future Research] Issue 6 (1983), 4–5. The Shanghai Future Research Institute, established in 1982, was affiliated with the Shanghai Scientific and Technical Committee. It functioned as a think tank for the government to study economic reforms and social sciences problems.

15 A 217-acre site in the southwest suburb of Shanghai, with a floor area ratio (FAR) of 1, was used for the first phase of the long-term development of 528 acres for the future Kangjian New Village. "Shanghai shi Kangjian xincun guihua sheji yaoqing jingsai gaikuang" 上海市康建新村规划设计邀请竞赛概况 [Overview of Shanghai Kangjian New Village Planning and Design Invitational Competition], *Jianzhu xuebao* 建筑学报 [Architectural Journal] No. 6 (1983), 6.

16 The four design institutions were the Shanghai Civil Architecture Design Institute, the East China Industry Bureau Architectural Design Company, the Shanghai Urban Planning and Design Institute, and the Tongji University Architectural Design and Research Institute.

17 Li Yingqi and Chen Qingzhuang 李应圻 陈庆桩, "Juzhuqu guihua de xin shexiang" 居住区规划的新设想（7号方案）[New Conceptions in Residential District Planning (Plan No. 7)], *Jianzhu xuebao* 建筑学报 [Architectural Journal] Issue 06 (1983), 10–13.

18 This prototype appeared in many of the proposals from the 1979 National Urban Housing Design Competition held by the Construction Ministry of China. The original idea then was to use passage spaces—spaces that did not count as the unit floor area—for dining activities and to separate the sleeping areas of adult children from their parents in case a multi-generation family had to share a one-room unit.

19 Shanghai was the city with the tightest control of the average residential area per household in the country since the 1950s, and the standardized design of dwelling types was an effective control measure.

20 "1989 nian quanguo chengzhen shangpin zhuzhai sheji jingsai fangan pingxuan zongshu" 1989 年全国城镇商品住宅设计竞赛方案评选综述 [Jury Review of the '89 National Commodity Housing Design Competition], *Jianzhu xuebao* 建筑学报 [Architectural Journal] Issue 5 (1990), 19.

21 Founded in 1956, the China Institute of Building Standard Design was a public institution directly under the Ministry of Construction responsible for researching, compiling, and managing the national building standard design. The National Urban Housing Design and Research Network was established in 1982 as an organization initiated by the Ministry of Construction to promote communication within the urban housing design field.

22 "Jianshebu fubuzhang Zhou Ganshi tongzhi zai quanguo chengzhen shangpin zhuzhai sheji jingsai huibaohui shang de jianghua," 建设部副部长周干峙同志在全国城镇商品住宅设计竞赛汇报会上的讲话 [Speech by the Vice Minister of Construction Gansi Zhou at the Review Conference of the National Urban Commodity Housing Design Competition (Summary)], *Zhuzhai keji* 住宅科技 [Housing science] Issue 4 (1990), 4–5. The support-infill theory Zhou mentioned was a theory initiated by Stitching Architecten Research (SAR, or Foundation for Architects Research) and introduced to China by Bao Jiasheng, a professor of architecture at Nanjing Institute of Technology, who had been a visiting scholar at MIT in 1981. In his book *Support Housing*, Bao criticized welfare housing as a unified, closed, and static model of housing development that excluded the residents from the construction process. The "support theory" he proposed divides housing, or even the urban district, into two

parts—the support and the infill, which would be invested in and decided by the state, the work unit, and the individual to develop urban housing collaboratively. For more on the support theory, see Bao Jiasheng 鲍家声, *Zhichengti zhuzhai* 支撑体住宅 [Support Housing] (Jiangsu Science and Technology Press, 1988).

23 Peng Shengqin 彭圣钦, "Shanghai wo xinzhong de jia sheji jingsai jiexiao" 上海《我心中的家》设计竞赛揭晓 [Shanghai 'Home in My Mind' Design Competition], Jianzhu xuebao 建筑学报 [Architectural Journal], Issue 02 (1990), 35.

24 The two tracks—a planned track and a market track—allowed selected products to be sold at a market price while continuing a uniform pricing principle in the state monopoly sectors where goods were still produced and sold according to planned quotas. In this way, the state had dominant control over the national economy and the extent of the "reform and opening-up."

25 Under the price ceiling, each developer could freely decide the base price according to their costs and the market situation in the domestic market. The differential pricing strategy was also carried out by charging higher land use fees for developing "high-grade housing." Purchasing on this track was processed only in foreign currencies. See Mei Li 梅理, "Shangpin zhuzhai jiage guanli xingshi" 上海住宅价格管理形式 [Price Management of Commodity Housing], in *Shanghai fangdichan zhinan* 上海房地产指南 [Shanghai Real Estate Manual], ed. Yang Xiaolin 杨小林 (Shanghai: People's Press, 1993), p. 96.

26 Translated by author. Ouyang Kang and Guo Weigong 欧阳康 郭为公, "Shangpinhua zhufang sheji de sikao" 商品化住房设计的思考 [Thoughts on Commodity Housing Design], *New Architecture* 新建筑 Issue 3 (1992), p. 20.

27 The new Standards stipulated the minimum net floor area per household on three levels, respectively, 33, 40, and 52 m^2; and the minimum size for the main bedroom, the living room, the bathroom, and the kitchen, respectively 12, 12, 3.5, and 4 m^2. It also specified that each dwelling unit should have its living room, or at least one bedroom, facing 35 degree east and west of due south. The ideology behind the minimum standard was distinct from the European modernists' housing experiment, such as the concept of *Existenzminimum* (minimal existence) and the behavioral analyses for the Frankfurt Kitchen design. The latter ones attempted to introduce the logic of industrialization and Taylorist management into the field of household economics. Shanghai Construction Committee, *Zhuzhai jianzhu sheji biaozhun* 住宅建筑设计标准 [Design Standards for Residential Buildings (DBJ08-20-94)], October 1, 1994.

28 Tao Ye, et al. 陶冶. "Shanghai chengshi jiating wenhua xiaofei de jingji zhichu xianzhuang he yuce" 上海城市家庭文化消费的经济支出现状和预测 [Current State and Prospect Prediction on Household Cultural Consumptions in Urban Shanghai], in *Shanghai chengshi wenhua fazhan zhanlue yanjiu diaocha baogaoji* 上海城市文化发展战略研究调查报告集 [Shanghai Cultural Development Strategies Research] (Propaganda Department of the CCP Shanghai Municipal Committee, 1986), 374–81.

29 Shaoguang Wang, "The Politics of Private Time: Changing Leisure Patterns in Urban China," in *Urban Spaces in Contemporary China: The Potential for Autonomy and Community in Post-Mao China*, ed. Deborah Davis (Washington, D.C.: Woodrow Wilson Center Press, 1995), 149–72.

30 Ibid., 170.

31 *Shanghai guangbo dianshi zhi* 上海广播电视志 [Shanghai Broadcasting and Television Chronicles (2002)], Vol. 4 Television Programs, Chapter 1 Cable Television, Section 3 Social Education Program, Shanghai Local Chronicle Office 上海地方志办公室, accessed May 2, 2023, https://www.shtong.gov.cn/

difangzhi-front/book/detailNew?oneId=1&bookId=4510&parentNodeId=63
818&nodeId=12588&type=-1.

32 The 150,000 copies of the collection were sold out at once. Yan Zhenxin and
Lin Qiyin 闫振新 林启茵, "Preface," in *Jushi qiao anpai* 居室巧安排 [Master
Arrangement of Houses] (Shanghai Science & Technology Press, 1987), 2.

33 Themed on clothing and domestic life, *Culture and Life* (*Wenhua yu Sheng-
huo*) was also the first magazine that ran advertisements after the economic
reform in mainland China.

34 Sun Chengyuan 孙承元, *Jiating Buzhi* 家庭布置 [House Economics: Interior
Furnishing] (Shanghai Culture Press, 1984), 1.

35 You Qijun 尤齐钧, "xinying zuhe jiaju" 新颖组合家具 [Novel Combined Fur-
niture], *Shanghai huabao* 上海画报 [Shanghai Pictorial] Issue 5 (September
1986). *Shanghai Pictorial*, a journal initiated in 1982, was edited and pub-
lished by the Shanghai Pictorial Publishing House under the direct leadership
of the Propaganda Department of the Shanghai Municipal Commission and
the Municipal Press and Publication Bureau. Combining pictures with texts
in both Chinese and English, it recorded novel changes to the social life of
the Shanghai people since the reform and opening up, becoming an important
window for Shanghai's external publicity.

36 During the high tide of the socialist transformation in 1956, privately owned
businesses in the furniture handicraft industry had been transformed into a
cooperative business model. Four hundred twenty-eight private-owned fur-
niture stores and twenty-four privately owned workshops were converted to
joint state-private ownership, headed by Shanghai First Municipal Bureau of
Commerce affiliated Household Appliances Corporation. The corporation was
renamed Shanghai Bamboo and Timber Appliances Industry in 1962, focusing
on furniture manufacture, which later established the Shanghai Furniture Re-
search Institute. The marketization of the furniture industry in Shanghai began
after October 1989.

Bibliography

"Deng Xiaoping guanyu jianzhuye he zhuzhai wenti de tanhua" 邓小平关于建筑
业和住宅问题的谈话 [Deng Xiaoping's Speech on Architecture and Housing
Problems]. *People's Daily*. May 15, 1984.

"Jianshebu fubuzhang Zhou Ganshi tongzhi zai quanguo chengzhen shangpin
zhuzhai sheji jingsai huibaohui shang de jianghua" 建设部副部长周干峙同志
在全国城镇商品住宅设计竞赛汇报会上的讲话 [Speech by the Vice Minister of
Construction Gansi Zhou at the Review Conference of the National Urban
Commodity Housing Design Competition (Summary)]. *Zhuzhai keji* 住宅科技
[Housing Science] Issue 4, 1990, pp. 4–5.

Li, Mei 梅理. "Shangpin zhuzhai jiage guanli xingshi" 上海住宅价格管理形式
[Price Management of Commodity Housing]." In *Shanghai fangdichan zhinan*,
edited by Yang Xiaolin 杨小林, 上海房地产指南 [Shanghai Real Estate Man-
ual]. 96. Shanghai: People's Press, 1993.

Li, Yingqi, and Chen Qingzhuang 李应圻 陈庆桩. "Juzhuqu guihua de xin shexi-
ang" 居住区规划的新设想（7 号方案）[New Conceptions in Residential Dis-
trict Planning (Plan No. 7)]. *Jianzhu xuebao* 建筑学报 [Architectural Journal]
Issue 6, 1983, pp. 10–13.

National Construction Committee. Jianzhu tongyi moshu biaozhun-104-55 建筑统一模数制标准-104-55 (1956) [Unified Architectural Modular System-104-55]. 1956.

National Planning Commission. Zhuzhai jianzhu sheji guifan 住宅建筑设计规范 [Residential Design Specification (GBJ 96-86)]. September 22, 1986.

"1989 nian quanguo chengzhen shangpin zhuzhai sheji jingsai fangan pingxuan zongshu" 1989 年全国城镇商品住宅设计竞赛方案评选综述 [Jury Review of the '89 National Commodity Housing Design Competition]. Jianzhu xuebao 建筑学报 [Architectural Journal] Issue 5, 1990, pp. 19–24.

Ouyang, Kang, and Guo Weigong 欧阳康 郭为公. "Shangpinhua zhufang sheji de sikao" 商品化住房设计的思考 [Thoughts on Commodity Housing Design]. Xin Jianzhu 新建筑 [New Architecture] Issue 3, 1992, pp. 20–22.

Shanghai guangbo dianshi zhi 上海广播电视志 [Shanghai Broadcasting and Television Chronicles (2002)]. Shanghai difangzhi bangongshi 上海地方志办公室 [Shanghai Local Chronicle Office]. Accessed May 2, 2023. https://www.shtong.gov.cn/difangzhi-front/book/detailNew?oneId=1&bookId=4510&parentNodeId=63818&nodeId=12588&type=-1.

"Shanghai shi Kangjian xincun guihua sheji yaoqing jingsai gaikuang" 上海市康建新村规划设计邀请竞赛概况 [Overview of Shanghai Kangjian New Village Planning and Design Invitational Competition]. Jianzhu xuebao 建筑学报 [Architectural Journal] No. 6, 1983, pp. 6–7.

"Shangpin zhuzhai jianshe" 商品住宅建设 [Commodity Housing Construction]. Shanghai Housing Construction Chronicles Vol. 4. Shanghai difangzhi bangongshi 上海地方志办公室 [Shanghai Local Chronicle Office]. Accessed November 30, 2023. https://www.shtong.gov.cn/difangzhi-front/book/detailNew?oneId=1&bookId=75091&parentNodeId=75153&nodeId=90909&type=-1.

Shengqin, Peng 彭圣钦. "Shanghai wo xinzhong de jia sheji jingsai jiexiao" 上海《我心中的家》设计竞赛揭晓 [Shanghai 'Home in My Mind' Design Competition]. Jianzhu xuebao 建筑学报 [Architectural Journal], Issue 2, 1990, p. 35.

State Council of the People's Republic of China. Guowuyuan guanyu yange kongzhi chengzhen zhuzhai biaozhun de guiding 国务院关于严格控制城镇住宅标准的规定 [Strict Control on Urban Housing Standards]. December 15, 1983.

Sun, Chengyuan 孙承元. Jiating Buzhi 家庭布置 [House Economics: Interior Furnishing]. Shanghai Culture Press, 1984.

Tao, Ye, Sun Huimin, Zhang Youming, and Hu Min 陶冶 孙慧敏 张酉鸣 胡敏. "Shanghai chengshi jiating wenhua xiaofei de jingji zhichu xianzhuang he yuce" 上海城市家庭文化消费的经济支出现状和预测 [Current State and Prospect Prediction on Household Cultural Consumptions in Urban Shanghai]. In Shanghai chengshi wenhua fazhan zhanlue yanjiu diaocha baogaoji 上海城市文化发展战略研究调查报告集 [Shanghai Cultural Development Strategies Research]. Propaganda Department of the CCP Shanghai Municipal Committee, 1986, pp. 374–81.

Wang, Shaoguang. "The Politics of Private Time: Changing Leisure Patterns in Urban China." In Urban Spaces in Contemporary China: The Potential for Autonomy and Community in Post-Mao China, edited by Deborah Davis, 149–172. Washington, D.C.: Woodrow Wilson Center Press, 1995.

Yan, Zhenxin, and Lin Qiyin eds. 闫振新 林启茵. Jushi qiao anpai 居室巧安排 [Master Arrangement of Houses]. Shanghai Science & Technology Press, 1987.

You, Qijun 尤齐钧. "Xinying zuhe jiaju" 新颖组合家具 [Novel Combined Furniture]. *Shanghai huabao* 上海画报 [Shanghai Pictorial] Issue 5, 1986.

Yu, Songnian 俞松年. "2000 nian hou de Shanghai zhuzhai he jiating" 2000 年后的上海住宅和家庭 [Shanghai Housing and Family after 2000]. *Weilai yanjiu* 未来研究 [Future Research] Issue 6, 1983, pp. 4–5.

Zhao, Guanqian 赵冠谦. "Lun woguo zhuzhai jianzhu de biaozhunhua yu duoyanghua" 论我国住宅建筑的标准化与多样化 [Standardization and Diversification of Residential Architecture in China]. *Zhuzhai keji* 住宅科技 [Housing Science] Issue 1, 1985, pp. 6–12, 22.

"Zhengxie diyi jie quanguo weiyuanhui disi ci huiyi bimu: Mao Zedong sandian zhishi" 政协第一届全国委员会第四次会议闭幕: 毛泽东三点指示 [The Fourth Session of the First National Committee of the Chinese People's Political Consultative Conference Concludes: Mao Zedong's Three Instructions]. The Central People's Government of the PRC. Accessed November 16, 2022, http://www.gov.cn/test/2008-02/20/content_894595.htm.

2

[RE]TRACING THE VEIL

Implied Boundary and Invisible Wall

Selma Ćatović Hughes

The city is constantly (un)veiling throughout history, overlapping political, social, and religious influences on its people. During the Siege of Sarajevo, the natural contours of the river and invisible screens of the snipers served as impermeable walls. The implied boundary [of danger] was more powerful than any massive concrete barricades. In response, simple sheets of fabric were placed at strategic locations throughout the city, mainly at street crossings, to create a make-shift barrier that could provide some cover to citizens from unavoidable sniper fire. Today, this once uninhabitable threshold between the two sides appears to be just another public space along the river: a linear park and pedestrian riverwalk. The traces of warfare, survival, and implied boundary—however threatening—are absent, as is any evidence of history or memory.

How can we [re]trace a series of events that forever changed the boundary, flow, and fabric of a city? Is it possible to recondition something [a building, space, soul] to be the same or feel the same, when it was wounded, destroyed, and deeply scarred on the interior? *[re]Tracing the Veil* is a proposed series of installations threaded through the urban memoryscape, narrating part of the city's most recent history and creating new urban interiors. No longer is the veil creating a physical barrier to the other side; rather, it outlines the implied boundary of danger that once existed. The new veil is perpendicular to the river and major crossings, and it reveals to its viewer the layers of our past. Juxtaposed with the existing urban condition, *[re]Tracing the Veil* dissolves two timelines simultaneously.

While cultural memory is institutionalized, disembodied, and systematically stored in museums, archives, and libraries, communicative memory

DOI: 10.4324/9781003457749-4

is living, embodied storytelling that is (re)interpreted with new meaning for current socio-political contexts—a reminder that collective memory and dispersion of historical facts have impact on second-hand witnesses and future generations. Together, cultural and communicative memory present both the connections and gaps between actual and potential re-membrance—"communicative memory characterized by its proximity to the everyday, and cultural memory characterized by its distance from the everyday."[1] How can these two offer potential non-spatial but place-related collective remembrance for a post-conflict society to draw connec-tions rather than deepen gaps both in memory and in the urban landscape?

For four years, Sarajevo (Figure 2.1), the capital city of a small country in Europe where historically the East and the West were seen to meet, was divided into two parts—one occupied by the oppressor and the other by the captive. Nestled in the valley with the Miljacka River as the natural divider of urban settlements, Sarajevo's main circulation conduit stretches along the east-west axis, with the secondary roads and bridges connecting the north and south sides of the city. The physical borders of the Siege of Sarajevo—in place from 1992 until early 1996 by the Army of Republika Srpska and their extensive artillery—followed the highest points of the nearby mountains and hills that offered an advantageous position to re-lentlessly shoot at the civilians below. Additionally, a strategic section of the river in the middle of Sarajevo, that offered the potential to encroach on the inner-city neighborhoods and thus further divide the city, was a critical part of the siege boundary (Figure 2.2).

The bare exposure of Sarajevo's street intersections, residential neigh-borhoods, playgrounds, bridges, and water collection areas to constant sniper fire created an urban landscape of fear.[2] Today, designated as a linear park and pedestrian riverwalk, the traces of warfare, survival, and implied boundary are absent, and the opportunity to usher history to con-temporary life is foregone.

To avoid sniper fire, people would use the aforementioned sheets of fabric as protection (Figures 2.3 and 2.4) before running across streets as fast as they could, whether on their way to work, the hospital, or to gather food supplies, often clenching their children in their arms (Figure 2.5). Some would wait seemingly for an eternity, to convince themselves that it was the perfect time to make that leap of faith. Others casually walked across these semi-shielded paths, defying the snipers and all odds. A col-lection of woven threads suspended in the air between the existing urban fabric became a symbol of resilience in spite of unrelenting life-threatening circumstances.

The proposed installation, *[re]Tracing the Veil* narrates part of the city's most recent history and creates new urban interiors. Permeating

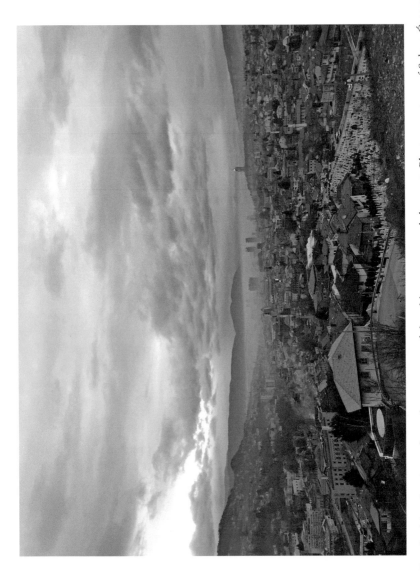

FIGURE 2.1 Overlooking Sarajevo, from the east part of the old town toward the west. Photo courtesy of Selma Ćatović Hughes.

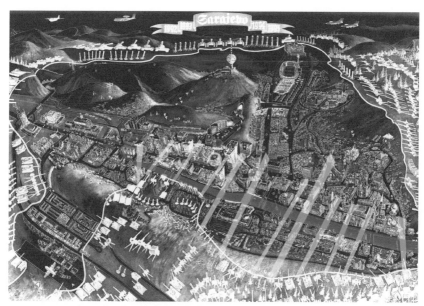

implied boundary [of danger]: sniper zones
{underlay map by fama international-www.famainternational.com}

FIGURE 2.2 Implied boundary of danger with sniper fire across the river and major street intersections. Underlay map by FAMA Collection, modified and illustrated by Selma Ćatović Hughes. Source: https://www.famacollection.org/projects/10/index.html

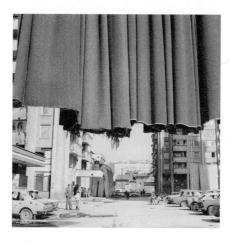

FIGURE 2.3 Sheets of fabric used as an improvised sniper barrier. Photo courtesy of Paul Lowe. Source: https://radiosarajevo.ba/metromahala/kultura/uskoro-pocinje-modul-memorije-festival-u-skladu-s-mjerama-izolacije/372371#

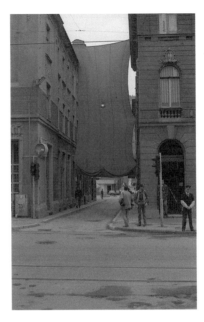

FIGURE 2.4 Sheets of fabric used as an improvised sniper barrier downtown Sarajevo. Photo courtesy of Zoran Kanlić. Source: https://twitter. com/SniperAlleyPhot/status/1510915482412593156/photo/1

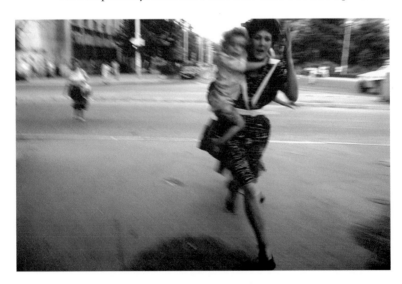

FIGURE 2.5 Citizens of Sarajevo running across the major street intersection to avoid sniper fire. Photo courtesy of Paul Lowe. Source: https://vii-insider.org/resource/reporting-the-siege-of-sarajevo/ paul-lowe-sarajevo/

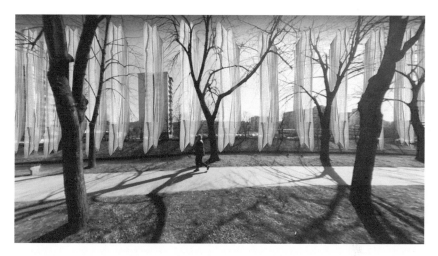

FIGURE 2.6 Conceptual proposal *[re]Tracing the Veil* is conceived as a series of installations threaded around the urban memoryscape. Photo by Selma Ćatović Hughes.

current urban fabric, the framework embraces the inhabitants' flow along the river, choreographing screens of retrieved information to (re) digest the past and (re)constructing memories into experiential episodes. Capturing everyday moments of life under siege, these visual diaries encapsulate emotions and textures together with chronology and progression of a time period within a constricted urban setting (Figure 2.6). Presence of numerous foreign journalists and photographers and their portrayal of daily life during the siege was personal and life-altering[3] (simultaneously for them as well as for the citizens of Sarajevo) but it also created an instrumental layer of history, intricately weaving both our cultural and communicative memory. *[re]Tracing the Veil* aims to integrate—and unveil—archival data gathered via local and international reporting agencies from the period of the siege as well as the post-war documentation process together with personal accounts (storytelling, war diaries, witness reports).

> I haven't been writing for a while. For the last 3-4 days, we got nothing – no water, electricity, or gas. Pretty soon there will be no air either! Bullshit. There was a big party at Jasna's on Friday, about 16 people … it was awesome. There was no electricity, but we entertained ourselves somehow – a couple of acoustic guitars, singing, dancing … and because we still have the overnight police hour in effect, everyone stayed until 7 in the morning.[4]

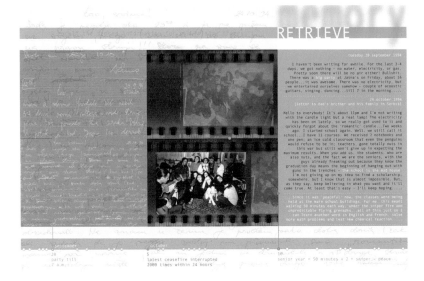

FIGURE 2.7 Excerpt from a personal war diary. Photo, text and illustration by Selma Ćatović Hughes.

This collective approach in reconceptualizing remembrance of time and space allows us to cultivate our culture of memory and develop new frameworks of dialogue (Figure 2.7). Retracing an elusive boundary transforms: the new screen no longer creates a physical barrier to the other side of the river; rather, it reprises the implied boundary that once existed and divided the city, activating a palpable spatial framework of the past and ensuing practices of its remembrance (Figure 2.8). The sequence of parallel veils, perpendicular to the river and major crossings, reveals to its viewer

FIGURE 2.8 Conceptual section drawing at the river site for *[re]Tracing the Veil*. Photo and illustration by Selma Ćatović Hughes.

FIGURE 2.9 Conceptual proposal *[re]Tracing the Veil* as a tactile depository of cultural memory. Photo by Selma Ćatović Hughes.

palimpsests of embodied experiences and traces of war, expanses of individual encounters of life under the siege, as well as the physical division of the city; it is a social invitation for critical discussion and reflection of personal and collective stories to further build a multigenerational depository for cultural memory (Figure 2.9).

Memory is often more directly fused to time, but retrieval and reconstruction of elusive episodes consistently entangle details of spatial and tactile qualities. Reflecting on the effort to render memory visible, Hamel points out that "in their accumulation of everyday detail, autobiographical accounts represent a twofold transformation of lived life: first, the figuration into memory of experiences and sensations, and then the transmutation of that memory into a coherent narrative."[5] The quest to manifest both individual and collective memory as something 'visible' and tangible (from cultural and political platforms to spatially experiential and tactile environments) is still an ongoing, if not, impossible task in Sarajevo. Complex peace resolutions furthered a significant gap within the society between conflicting views and fragmented memories that keep people at veiled edges rather than woven together into a collective remembrance. Thirty-two years since the beginning of the siege, the wartime urban memoryscape continues to dissolve in the pool of complicated politics, leaving an indistinct vestige of difficult histories. *[re]Tracing the Veil* enfolds generational responsibility to facilitate a mechanism to preserve tangible and elusive borders of the past. It is a trace, a relic, a collection of remains that outline the narrative of each of our stories, weaving together four threads—time, scale, site, and narrative—into a spatial storytelling.

Notes

1 Jan Assmann and John Czaplicka. "Collective Memory and Cultural Identity," *New German Critique*, no. 65, Cultural History/Cultural Studies (Spring-Summer, 1995), 128–9.
2 Visual representation and city maps by Mirjana Ristic outline the exposure of various areas of Sarajevo to sniper's view and fire, creating an urban landscape of fear. Mirjana Ristic, "'Sniper Alley': The Politics of Urban Violence in the Besieged Sarajevo," *Built Environment (1978–)* 40, no. 3 (2014), 342–56.
3 Kenneth Morrison and Paul Lowe, *Reporting the Siege of Sarajevo* (London: Bloomsbury Academic, 2021).
4 Selma, Ćatović Hughes. Excerpt from a personal war diary, 1994.
5 Catherine Hamel. "Beirut, Exile, and the Scars of Reconstruction." In *Memory and Architecture*, ed. Bastéa, E., 213–34 (Albuquerque, NM: University of New Mexico Press, 2004).

Bibliography

Assmann, Jan, and John Czaplicka. "Collective Memory and Cultural Identity." *New German Critique*, no. 65, Cultural History/Cultural Studies (Spring-Summer, 1995), 125–33.

Hamel, Catherine. "Beirut, Exile, and the Scars of Reconstruction." In *Memory and Architecture*, edited by E. Bastéa, 213–34. Albuquerque, NM: University of New Mexico Press, 2004.

Morrison, Kenneth, and Paul Lowe. *Reporting the Siege of Sarajevo*. London: Bloomsbury Academic, 2021.

Ristic, Mirjana. "'Sniper Alley': The Politics of Urban Violence in the Besieged Sarajevo." *Built Environment (1978–)* 40, no. 3 (2014), 342–56. http://www.jstor.org/stable/43296901.

3

PROVINCE OF INTERIORS

Strategies and Tactics on the Frontier of Northern New Spain

Marie Saldaña

If interiors can be defined by their edges and borders, then it makes sense to ask how notions of interiority are defined by processes of identity formation in which the "self" draws boundaries against the "other." In turn, we might ask how such notions of identity are conditioned by historically specific representational strategies that were used to delimit interior space through words, acts, and signs. This essay considers some of the descriptive modes used to demarcate interiority in 18th-century Northern New Spain, a region that today includes South Texas (Figure 3.1), and how the early modern "self" was defined as a subject through its differentiation from the "other" on the frontier. Drawing on Michel de Certeau's ideas relating to the differentiation of the "proper place," the essay articulates several ways in which interiors were operative in the negotiation of power.[1] The strategic mapping of defensive lines failed to create interiority and thus provide the foundation for a stable presence in the borderlands. In contrast, tactical placemaking through flexible, entangled social networks linked families in otherwise isolated outposts and succeeded in enabling long-term habitation on the edges of Spain's empire.

According to de Certeau, "there is no spatiality that is not organized by the determination of frontiers."[2] As a typology, the frontier is a paradox: it is a space of differentiation between bodies whose contacts also become their common points. It is a buffer zone, a "space in-between" that is simultaneously shared and contested. The frontier belongs to no one: "it is a void, a narrative symbol of exchanges and encounters."[3] Within this dynamic, the interior becomes representative of the human impulse to close the void, to create a reserve of the self to withdraw into a protected

DOI: 10.4324/9781003457749-5

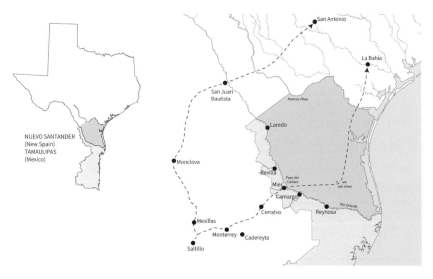

FIGURE 3.1 Map showing the extent of Nuevo Santander (Tamaulipas) and major routes in relation to Texas. Drawing by author.

identity. This aspect of interiority can be identified with Certeau's "proper place" which "can be delimited into its *own* and serve as the base from which relations with an exteriority composed of targets or threats ... can be managed."[4] In de Certeau's distinction between *space* and *place*, space is a condition of coexistence and possibility, and place "excludes the possibility of two things being in the same location ... [each is] situated in its own 'proper' and distinct location, a location it defines."[5] An interior emerges when a place is differentiated from space; it is an indication of stability and ownership, a stronghold of identity. Places are associated with power: those who are unable to demarcate an interior (a "proper" place) are unprotected in enemy territory.

In order to speak of the interiority of the frontier, then, it is necessary to grapple with complex and overlapping layers that constituted the dialogue of "inside-outside" in the colonial imagination, in native worldviews, and in modern historiography. Representational strategies and practical tactics that were deployed in interior-making on the northern frontier of New Spain in the mid-18th century can provide insight into a critical period in the process of settler colonialism that led to the formation of what is today South Texas. The two case studies that follow demonstrate how strategies and tactics are fundamentally different ways of actualizing space and place for the purposes of colonization. For de Certeau, strategies are related to the panoptic gaze that relies on *place* in order to calculate and manipulate power relationships; they are by nature atemporal.[6] Tactics, however,

make clever use of time, as well as *space*, exploiting the "intersections of mobile elements" that undermine power structures.[7] The political cartography that tracked the founding and destruction of the Mission of Santa Cruz de San Saba in Texas shows that mapmaking, the strategy of the Spanish Crown, struggled to accomplish its intended purpose of demarcating territory in order to aid the security of the frontier against indigenous and European incursion. An alternative example can be found in the town of Mier, one of the civilian settlements along the Rio Grande in the province of Nuevo Santander. The social history of Mier illustrates how tactics deployed by indigenous people and criollo-mestizo civilians operationalized the discursive modes of narrative and itinerary as a more successful way of occupying the "in-between space" of the frontier. These tactics can be located in networks of entanglement based on kinship relationships, which elucidate the dynamics at play in the 18th-century borderlands, and the function of interiority as a spatial tactic in the creation of identity.

San Saba and the Strategic Interior

A frontier is a borderland without a stable border. One hundred years before an international boundary was drawn at the Rio Grande, Texas was a remote and isolated province, created to exist as a buffer zone between British and French colonial interests in what is now Canada and the United States and the rich silver mines in Mexico. It lays at the edge of the vast interior of an unknowable, scarcely controllable continent, full of recalcitrant indigenous groups known to the Spanish as *Norteños* or Nations of the North. The moniker referred to Plains tribes, including the Comanche, Wichita, and Hasinai Caddo, who controlled the land to the north of Spain's most outlying settlements. The placemaking strategies of Norteños were defined by mobility and speed, defying attempts by the Spanish to "reduce" them to sedentary life as productive vassals of the Crown. Norteños entered the Spanish consciousness in 1758, introducing themselves with the sudden and overwhelming destruction of the mission of Santa Cruz de San Saba. The incident shook Spanish complacency to the core and had wide-ranging implications for colonial placemaking across the continent, contributing to Spain's decision to withdraw its settled areas southward, toward the interior of Mexico.

The attack came one year after the mission's founding in 1757 at an isolated spot 145 miles northwest of the town of San Antonio de Bexar. The mission had been built at the request of the Lipan Apache. For the first thirty years of Bexar's existence, Spanish settlers were locked with the Apache in a cycle of raids and reprisals. At stake in these violent exchanges were key resources for indigenous placemaking—not land or territory per

se, but horses (the primary means of mobility, hunting, and security for Plains tribes) and kinship networks, which were threatened by the Spanish practice of taking Apache women and children as captives and "raising" (i.e., enslaving) them in their households. While captive-taking was a familiar part of the raiding economy among indigenous groups, the Spanish failed to recognize the importance of kinship in political and economic exchanges. Indigenous alliances were cemented through the creation of fictive kinship bonds, and the *rescate* (ransom) of captive family members was an important way to negotiate and resolve conflicts. The Spanish, however, viewed captives simply as prisoners of war (though slavery was technically illegal in New Spain, there was a loophole when it came to enemy combatants) and sold them to distant locations, refusing to trade them to desperate Apache men who came with horses, hides, truces, or whatever else they could offer in exchange for the restoration their wives and children.[8]

Meanwhile, the Lipan Apache were being forced out of their lands by a new presence in the southern plains, the Comanche, who were encroaching on Apache territory from the north, even as Spain was increasingly occupying the area to the south. Thus encircled, the Apache took advantage of Spanish readiness to congregate them in a military-protected mission on the San Saba River. The existence of this mission was a strategic Apache effort to leverage alliance with the Spaniards in order to reinforce their position against their Comanche enemies, and to delimit what de Certeau designates as *un lieu propre*, "one's own place." For de Certeau, a strategic practice "seeks first of all to distinguish its 'proper' place, that is, the place of its own power and will, from an 'environment' ... it is an effort to delimit one's one place in a world bewitched by the invisible powers of the Other."[9] In other words, because it has edges, it becomes an interior. Interiors allow the delimitation of the self as separate from the other. From this strategic interior, the territory can be safely viewed and surveyed. Thus, the Lipan Apache initially sought to manipulate Spanish placemaking for their own purposes.

Yet when one spring morning in 1758, around 2,000 Norteños obliterated the mission, there were no Lipans present. The Apache had recognized the miscalculation in their plan: the impossibility of establishing a stable place in the "in-between" zone of the frontier. They declined to settle at the mission, knowing that the Comanche had a fundamentally different concept of space, one that created a condition where the strategic interior could not hold. The Norteños' raiding tactics demonstrate that the concept of *range* defined their defensible interior—delimited by time and distance, rather than by walls and fortifications. They would descend unexpectedly and, before they could be pursued, ride for days and nights

without stopping until they reached their own interior, deep within the Southern Plains.[10] In this vast area, among the buffalo and horses that sustained their nomadic lifestyle, they could regroup, undisturbed, until their next attack. In this manner the Comanche dominated the vast area that came to be known as *Comanchería*, without the need to resort to stable "place"-making through forts and maps.[11] Their use of transversal spatial tactics of movement and temporality challenged the European idea of the statically delimited interior as a source of power. Using speed, agility, and the element of surprise, Comanche tactics imposed a fluid space "caught in the ambiguity of an actualization": even in times of peace, the mere possibility or expectation of Comanche raids ensured that residents of the frontier could not delimit their own place under such circumstances.[12] With the arrival of the Comanches, Apache and Spanish alike were now fully in the territory of the other—they had lost the interior that is the reserve of strategic power.

With a death toll of nine, the intention behind the destruction of San Saba seems to have been less an outright massacre than to give a shock to the Spanish system. The Norteños did not attack the nearby presidio, an under-manned and easy target, and seemed intent on humiliating instead of killing their enemies, not even taking the trophies that would have indicated they considered the Spanish as worthy opponents.[13] The attack did indeed unnerve the Spaniards, in no small part because the Norteños wielded firearms obtained from the French. Partly because of this incident, the Crown ordered a wholescale inspection and reassessment of its frontier strategy. In 1766, the Marques de Rubí and engineers Nicolas de Lafora and José de Urrutia were dispatched to the frontier to inspect military installations. One result of their visit was the creation of a beautifully rendered series of maps that manifested the Enlightenment spirit of the Bourbon Reforms, then re-shaping life in Spain's empire (Figure 3.2).[14] Although the citizens of the frontier likely never saw the maps, made by Urrutia after his return to Europe, they were crucial to Spain's colonial rationale. Maps can be identified with de Certeau's Foucauldian reading of the type of spatial practice he calls "strategic": with totalizing, panoptic vision, cartographers observe and measure in order to control.[15] Maps normalize undifferentiated space into discrete, bounded, and named places, creating the field of possibility for the strategic interior. The relationship is reciprocal: maps also depend on such an interior for their very existence. The frontier itself, with its conditions of long travel distances on horseback across harsh terrain into potentially hostile territory, did not afford the stable "place" in which to draw a map. It was only after Urrutia and La Fora had returned to Spain, after they retreated to the "interior" of Europe, that the map could be drawn, reports could be safely studied,

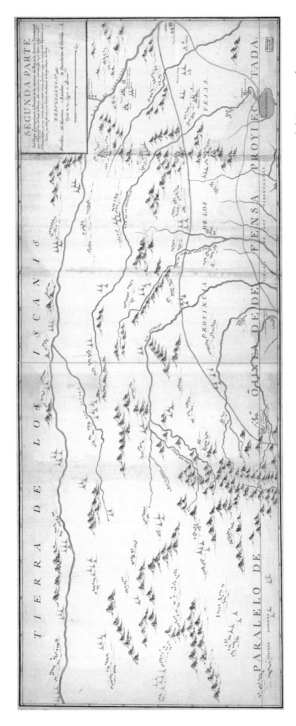

FIGURE 3.2 José de Urrutia and Nicolas de la Fora. *Mapa, que comprende la Frontera, de los Dominios del Rey, en la America Septentrional* (detail). 1769. Library of Congress.

and decisions rationally made. From this strategic position, Rubí drew a straight line across the continent from the Pacific coast to the Gulf of Mexico, following the 30th parallel of latitude, attempting to normalize space into an enforceable boundary.[16] This, he determined, would consolidate Spanish control against foreign (European) and indigenous incursion. Presidio garrisons were relocated to equidistant nodes along the line, which they had to patrol laterally for miles in each direction, regardless of terrain or conditions. In 1772, most settlements above the line were ordered to evacuate, including those in northeast Texas that until then had served as the capital of the province. Residents were forced to abandon their homes, deprived of their sheltered interiority through a line drawn on a map on the other side of the world.

If Urrutia's 1769 map of Texas exemplifies the strategic gaze, an earlier map, made in 1747, contains elements that suggest a different kind of spatial representation: one that operates through tactical narrative. This map shows figures of Indians in movement, gleefully cavorting across the landscape in dance-like postures, in the midst of shooting arrows or lounging on rocks, untethered to fixed dwelling places.[17] Though colorful tents or teepees are shown, it is unclear whether they represent encampments of Spanish expeditions or Indian rancherías, an ambiguity that exemplifies the shared/contested space of the frontier. Figurations such as these suggest sequential movement through a landscape as described in narrative itineraries, which served as the primary means of navigation prior to the Enlightenment. For de Certeau, they are not mere illustrations, but "like fragments of stories, mark on the map the historical operations from which it resulted."[18] Narrative figures such as the dancing Indians undermine and problematize the panoptic space of the gridded map by inserting human agents and their chaotic movements into cartographic space. The figuration of the Indian as a "proper" or improper subject on the frontier is linked to their role in the delimitation of boundaries, the formation of interiors, and their participation in—or thwarting of—the strategies and tactics of inhabiting the space in-between. As one scholar has argued, Indians are "plotted" in the landscape as coordinates for future Spanish settlement: "the Indian was the condition of possibility for Spanish settlement of New Spain ... the landscape was necessarily full of Indians who were either potential converts, malingering infidels, or both."[19] The rhetoric of this map, made to accompany José de Escandón's report on the initial explorations of his projected colonization of the province of Nuevo Santander, depicts the landscape as inhabited.[20] By contrast, Urrutia's 1769 map de-emphasized negotiation and co-dependence, sequestering the human figures of Indians inside neat clusters of teepees scattered across a huge area labeled *Tierra de los Cumanches,* located above the *línea de*

defensa proyiectada. The rhetoric of Urrutia's map, created in a post-San Saba world, underscored the ability of cartographic space to contain the Norteño threat.

The San Saba incident has attained almost mythological status in the early history of Texas. It draws in sharp relief a time when the colonial image of a hegemonic European power imposing its spatial order on the North American continent had not yet been accomplished, even to the extent that it could be resisted or reversed by indigenous agency.[21] Instead, in the mid-18th century, the frontier was in a state of spatial fluidity where contacts and exchanges and the network of entanglements between people—their fleeting alliances, affective ties, suspicions, and aspirations—constituted the only real form of space.

Networks and Tactics at Mier

Networks of entanglement belong to the arsenal of tactics that enabled both *vecinos* (Spanish citizens) and Indians to live in the in-between zone. According to de Certeau, tactics are a practice of the weak. Those who must resort to tactics are those who lack a "proper" interior, and thus lack autonomy. He states that "the space of the tactic is the space of the other. Thus it must play on and with a terrain imposed on it and organized by the law of a foreign power. It does not have the means to *keep to itself*, at a distance, in a position of withdrawal, foresight, and self-collection: it is a maneuver 'within the enemy's field of vision'."[22] Yet tactics are not only a mode of resistance, they can be a deliberate choice: to undermine the strategic control of space is effectively to appropriate that control. Tactics of speed, agility, and mobility were used by the Comanche to dominate the frontier. Instead of a border, the result was a void: a gaping wound that could not close as long as its edges kept moving. The line Spaniards tried to draw at the 30th parallel did little to stabilize those edges.

The residents of the frontier responded with tactics of their own, creating networks of entanglement that knitted the in-between zone into a whole or "proper" place. A network is flexible: if one link fails, there are many others that preserve the relationship among elements. Kinship networks, an important common characteristic of criollo, mestizo, and indigenous society in the colonial era, formed trajectories for the circulation of stories about spaces ("the ranch of my mother-in-law," "my brother's home," "the spring where we camp on the way to our summer pastures") that create what de Certeau calls a field of engagement: the precondition or legitimized theater that must precede all political or military action.[23] Just as the figures of Indians on Escandón's map indexed narratives that created the possibility of colonization, the repetitious recitation of events

and ties "re-present" the stories that frame "dangerous and contingent so-
cial actions." The danger arises because "the mixing together of so many
micro-stories gives them functions that change according to the groups
in which they circulate," and thus the ability to either facilitate or under-
mine the establishment of stable, strategic places.[24] Over time, the repre-
sentations that emerge from these fluid, polyvalent spaces are expressed
through movement and narrative: "what the map cuts up, the story cuts
across."[25] An example of the creation of such a field of engagement can be
found in the establishment of the town of Mier and its network of families
that extended across both sides of the Rio Grande.

Movement through the region north of the Rio Grande and below the
Nueces River had long presented a problem for the Spanish government.
Due to its lack of streams and thick chaparral the area was known as the
"Wild Horse Desert," or *despoblado*—a dry, unpopulated wilderness, the
void on Escandón's map filled with the figures of "unreduced" Indians.[26]
It was a void that the Crown was eager to occupy before a rival European
power could do so. José de Escandón, a savvy administrator, was selected
to form the new province of Nuevo Santander. Escandón recruited fami-
lies from nearby Nuevo León and Coahuila who had already lived on the
northern frontier for four to five generations.[27] These settlers brought to
the new colony a range of proven frontier tactics, including their own
social structures and economic practices. Some of them had already be-
gun to inhabit the *despoblado* before Escandón's arrival, commuting from
towns like Cerralvo, Cadereyta, and Saltillo to ranches along the Rio
Grande, intermarrying with each other and forming kinship bonds.[28] As
they and their families moved northward, they knitted together the new
colony with older places they had inhabited for around 150 years. It was
these *pobladores*, rather than Escandón and his officials, who completed
the rituals of possession necessary to establish boundaries and occupy the
despoblado. According to de Certeau, "founding is the primary role of the
story. It opens a legitimate *theater* for practical *actions*."[29] In other words,
the interior precedes the delimitation of its exteriority.

Eventually residents of Nuevo Santander established their homes and
ranches on both sides of the Rio Grande, extending a network of fam-
ily ranches throughout the *despoblado*. After independence from Spain
in 1821, the region became part of the Mexican state of Tamaulipas, and
it remained separate from Texas until the Treaty of Guadalupe Hidalgo
set the southern border of the United States at the Rio Grande in 1848.
Due to the cross-border family networks that exist to this day, the South
Texas borderland retains a distinct cultural identity that links it closely
to Mexico.[30] Mier, the midpoint and smallest of five towns established
by Escandón on the Rio Grande, was located at a natural ford on the

Rio Grande called Paso del Cántaro.[31] The ranchers who had been living at the site prior to the organization of the colony petitioned Escandón to form the town with their own resources, at no cost to the Royal treasury. When an official visitor arrived in Mier in 1757, he found the residents to be of "good quality," but still living on their ranches in dispersed settlements on the outskirts of a town that had not yet been built.[32] This concerned the Spanish authorities, because it evoked the manner in which Indians lived in dispersed kinship-based informal settlements called *rancherías*, and ran counter to the colonization practices prescribed in the Laws of the Indies. These precepts were based on a long tradition of occupying the frontier that had its roots in Spain's reconquest of Iberia from the Moors.[33] The Laws of Indies required settlers to build formal towns around a plaza surrounded by a church and government buildings and to reside within orderly streets oriented to the cardinal directions. However, as elsewhere on the northern frontier in New Spain, and much to the consternation of colonial bureaucrats, settlers found it more expedient to live in small family clusters closer to their rangelands. The tendency to disperse was one reason that Escandón delayed the distribution of individual land grants that had been promised to the settlers as part of the incentive to settle on the frontier, but this ongoing situation was unacceptable both to the colonists and to Escandón's superiors.[34] The officials wanted organized settlements of armed colonists that would form a distinct defensive line on a map, while the colonists wanted their own land where they could establish permanent *ranchos* and settle with close relatives far from, and undisturbed by, the oversight of Spain or Mexico City.

The terms *rancho* and *ranchería* derive from the same linguistic root, which loosely means a "camp" or informal, temporary dwelling place. By the 18th century, the Spanish usage had been racialized: *rancho* indicated a Spanish stock-raising settlement, while *ranchería* meant an encampment of Indians. Both were spatially organized around kinship structures, and existed in proximity to one another, often overlapping. Yet while *rancherías* were designed to be mobile and flexible, moving with the people as their needs changed, the architecture of some Spanish *ranchos* sought to emulate the presidio as an exercise in strategic placemaking. The homes built on the ranches near 18th-century Mier were like stone forts, with no openings except a heavy wooden door and one or two *troneras*, or loopholes.[35] The *rancho* presents a hybrid typology of strategy and tactics. The defensive interior could easily become a place of entrapment. Some houses included a *torreón*, a fortified, circular tower that ceased to be protective when raiders set fire to the house, turning into funeral pyres for those caught inside. To prevent this, all exterior surfaces of the home, except for the door, were treated with a thick coat of fire-resistant lime concrete.[36]

This created a further problem: the enveloped, windowless interior is deprived of vision, the most defining characteristic of the strategic locus of power, which provides "to be able to predict, to run ahead of time" and thus achieve "a mastery of places through sight."[37] The home can no longer function as a "proper" interior, becoming instead a space under siege. To counterbalance this, the home included a trap door in the ceiling that allowed access to a flat roof surrounded with a parapet, high enough to be out of reach of a rider on horseback, which afforded something of a lookout from which to view the surrounding terrain (Figure 3.3).[38]

The ability to enclose space was deeply significant in frontier culture, but enclosures were flexible and tactically adaptable to changing conditions. The built environment of a ranch consisted of an aggregation of spaces with overlapping and distinct ways of defining boundaries. In addition to the strategic fortified house, like the Indian *ranchería*, it was built

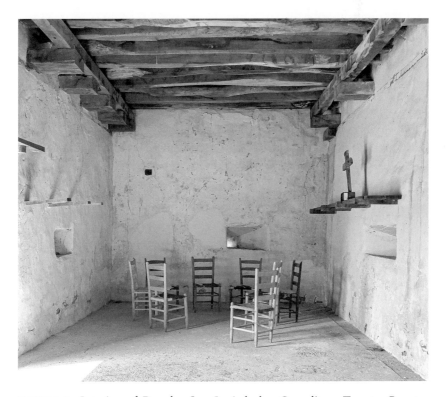

FIGURE 3.3 Interior of Rancho San José de los Corralitos, Zapata County, Texas. The trapdoor to the roof is in the right-had corner, and troneras (loopholes) are visible in each of the walls. Photo by the author, 2022.

on the idea of a non-fixed *range* defined through temporal movements and practices: the expanding/contracting zone of defensible space, the wanderings of livestock, the fickle presence of water, and the oral tradition of ownership and relationships. Outbuildings were constructed of ephemeral materials, such as adobe, or *jacales* made of mesquite branches and straw. The stone *casa grande* thus did not represent the total extent of livable space on a ranch, but provided a refuge when danger was present. Cooking took place outdoors, using beehive-shaped *horno* ovens, and animals roamed in the brushlands free of fencing. Water—its physical location, and its temporality—was also a means of delimiting space. When it was quantified for transactional purposes, land was often measured in units of time—the number of days or hours during which the owner enjoyed the rights to access to water from communal irrigation ditches. In such cases, deeds of sale did not record the area of a parcel of land, only the amount of water time associated with it.[39] Along the Rio Grande, where irrigation was difficult and the river was the main water source, the edges of land holdings were defined by surveys which typically only measured the river frontage and left the rest undefined.[40] The lack of survey coordinates did not perturb settlers whose family trees served as the diagram of land ownership: according to Spanish custom, undivided land was held in common by descendants of the original grantee, and owners of adjacent tracts were usually related by blood or marriage. Also, before the invention and adoption of barbed wire in the 1870s, practices such as livestock roundup and branding were more meaningful than land acreage or boundaries in terms of demonstrating ownership. Animals were allowed to roam freely and were periodically rounded up, separated by owner, and calves were branded with the owner's registered mark. These marks, more than any kind of built construction, served as spatial signifiers to the rancheros, as the value of rangeland was determined by the number of cattle, goats, sheep and other livestock it could support. The actual boundaries of the land came into play only during roundups when unbranded livestock and wild cattle called *mesteños*, could be claimed by the owner of the land on which they were captured.[41]

The drive toward enclosure is evident in the town of San Ygnacio, Texas, which grew up around a stone-house ranch headquarters.[42] The Treviño-Uribe house, the oldest part of which dates from 1830, is a rare existing example of a fortified frontier home (Figure 3.4).[43] It demonstrates the way in which such homes were clustered together until they became small towns, even incorporating a central plaza, in ad-hoc imitation of the towns mandated by the Laws of the Indies. The fact that settlers replicated the form of traditional Spanish town life, but defied authority by locating towns on private property, demonstrates the primacy of

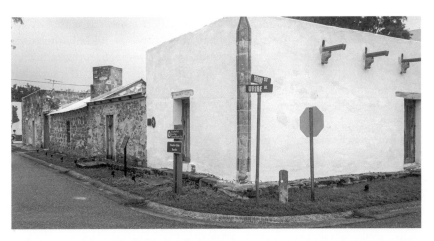

FIGURE 3.4 The Treviño-Uribe fortified house in San Ygnacio, Texas. Photo by the author, 2016.

interpersonal networks as the driver of spatial interiority. By 1871, the one-room Treviño-Uribe fortified stone house had been expanded to surround a central courtyard, showing that the rectangular fortified house was in essence the seed of a courtyard-style enclosure, of which it defines one side.[44] Few ranch houses ever grew into the full courtyard typology, but over time the principle of enclosure transcended its early associations with defense and remained so pervasive that it became a marker of cultural identity, leading cultural geographers to identify it as the single most common trait among the diverse housing typologies in the Texas-Mexico borderlands in the late 20th century.[45]

Affect and Entanglement as Interiority

A crucial facet of enclosure's tactical effectiveness lay in the fact that it was not only a spatial arrangement but also operated as a social process through the familial networks that bound together the edges of the frontier. Relational and spatial networks of entanglement were created by the ties of mutual interdependence that existed among the Spanish and Indian residents of Mier, and reinforced through practices that included intermarriage and the sharing of critical natural resources, such as water. María Josefina Saldaña-Portillo has observed "how extraordinarily dependent the Spaniards were on los indios in Texas. The Spaniard appears to the reader as a thwarted lover, bitter, vengeful, violent, but sustained in the gaze of the other nonetheless ... this imagined Indian is the Spaniard's intimate."[46] This "becoming intimate" creates stories, and thus sets the field of engagement from which spatial tactics emerge.

In 1757, thirty-nine families of Spanish settlers coexisted with fifty Indian families at Mier.[47] At stake in the relationship was not only the peace that existed between the two groups but also the protection their alliance provided both sides from the dangerous *norteño* tribes. Yet all knew that the delicate balance could be upset at any time. Trepidation and wariness can be sensed behind Captain Florencio Chapa's report that the residents of Mier "are in good communication without having any difficulty with the Indians whom they keep united with them."[48] In order to preserve the peace, Captain Chapa extended special courtesy to an indigenous woman named Margarita, "a polyglot widow who knows how to speak and pray in Spanish and is the one who rules the Indians of this tribe."[49] Many of the tribes that lived near Mier had migrated with the settlers from Nuevo León.[50] Nevertheless, when Comanche raids penetrated the Rio Grande Valley following the destruction of Mission San Saba, the Indians who had been friendly to the Spaniards at Mier relocated to the coast and out of the zone of the raids.[51] These tribes had re-drawn the boundaries around themselves, and in the process re-configured the boundaries of others.

Like the Indians, the *pobladores* of Mier redrew boundaries through their migrations. They moved northward with the frontier, and the frontier moved with them. By positioning themselves on the edge of New Spain, they defined the edge and came to be defined by it. Networks of entanglement linked them to both sides of the in-between zone, to both Spanish and indigenous ways of dwelling. *Entanglement* is a term borrowed from quantum physics that has come into usage in various fields as a way to describe the dependencies among humans, and between humans and things. Whereas network analysis is the mathematical study of the form produced by the links between multiple nodes, entanglement is concerned with the substantive nature of the links themselves.[52] In this way, entanglement recalls de Certeau's category of *trajectories*, "temporal movement through space ... a diachronic *succession* of points through which [the trajectory] passes, and not the figure that these points form on a space that is supposed to be synchronic or achronic."[53] The corresponding mode of representation cannot be located in the atemporal normalized space of a map, but must be described as a sequence, by using narrative or descriptive itineraries. Like stories, de Certeau considered itineraries or tours as a form of representation in opposition to maps, because they describe space through its practices, adding the element of time and of motion between, among, and across points whose location never remains fixed. By tracing itineraries, a network becomes implicit.

The implied networks of entanglement that existed in 18th-century Mier emerge from the itineraries of priests who performed annual *padrones* (censuses). Each year, the priest would ride through the town and

outlying areas, describing the route he took and enumerating the families he found clustered in ranches along the way. The resulting picture is of a temporal and spatial network of relationships. Families lived in kinship groups in town or in outlying areas on both sides of the Rio Grande. In addition to the *padrones*, the Church acted as the creator and repository of records that document the formation and evolution of networks over time through births, marriages, and deaths. A narrative emerges of space-making practices and events. The dangers of the frontier are told in death records that note a fall from a horse, a snake bite, or a settler killed by Indians. Ties of patronage are documented in birth and marriage records where individuals were asked to serve as a godparent or witness. Marriage records often note the owner of the home where the marriage was celebrated, and enumerate the names of the citizens in attendance. Intermarriage was common, out of sparsity of available partners, and also a concern for reinforcing the networks that knit together the flexible web of interiors that allowed settlers to inhabit the "space in-between." Marriages between cousins more closely related than the fourth degree required a dispensation from the church, and the resulting investigations provide valuable documentary evidence of the self-awareness of entanglement that the settlers practiced.

By placing these practices spatially and temporally in relation to one another, the study of networks of entanglement provides insight into the differentiation of identities that evolved on the northern frontier of New Spain in the second half the 18th century. While the Spanish imperial strategy of military occupation and cartography struggled to define and control the frontier, the spatial, social, and temporal world of colonial Nuevo Santander was one that understood the precarity of life in the in-between zone. Like the native groups with whom they were entangled, settlers could "make do" by creating a world of stories and affinities. Theirs was an interiority whose edges were constantly shifting and knitting together a fluid but stable place, even within a land increasingly defined by its borders.

Notes

1 Michel de Certeau, *The Practice of Everyday Life*, trans. Steven F. Rendall (Berkeley, CA: University of California Press, 1984); first published in French in 1980 as *L'Invention du Quotidien*. In this work, de Certeau is interested in critiquing the ways that "user" or "consumer" practices and behaviors undermine and transform for their own purposes the power structures that Foucault investigated in *Discipline and Punish* (1977).
2 Ibid., 123.
3 Ibid., 127.
4 Ibid., 36 (emphasis in original).
5 Ibid., 117–8, on the distinction between places and spaces.

6 Ibid., 36–39, on the distinction between strategies and tactics.

7 Ibid., 117.

8 Juliana Barr, *Peace Came in the Form of a Woman: Indians and Spaniards in the Texas borderlands* (Chapel Hill, NC: University of North Carolina Press, 2007), 159–80.

9 Certeau, *The Practice of Everyday Life*, 36.

10 Pekka Hämäläinen, *The Comanche Empire* (New Haven, CT: Yale University Press, 2008), 65.

11 Hämäläinen, *Comanche Empire*, 62–67.

12 Certeau, *The Practice of Everyday Life*, 117.

13 Barr, *Peace Came in the Form of a Woman*, 183–6. The modern Comanche tribe is known as the Comanche Nation or Nʉmʉnʉʉ, meaning "The People" (Comanche Nation website, accessed July 2, 2023, https://comanchenation. com/our-nation/about-us).

14 The Bourbon Reforms of the 18th century were designed to reinforce and streamline Spain's political and economic control of the colonies, and to weaken the power of the Catholic church.

15 Certeau, *The Practice of Everyday Life*, 36. J.B. Harley, in "Deconstructing the Map," *Cartographica* 26, no. 2, (1989): 13, sees the gridding and dividing of space in cartography as exemplary of the structures of what Foucault called "knowledge/power." Foucault's interpretation of Bentham's panopticon in *Discipline and Punish: The birth of the prison*, trans. Alan Sheridan (New York, NY: Vintage Books, 1977), 195–230, while not explicitly about mapmaking, was widely influential in critical cartography. See for example Deleuze, who proposed an analysis of *Discipline and Punish* under the title "A New Cartographer" (Gilles Deleuze, *Foucault*, trans. Sean Hand (Minneapolis, MN: University of Minnesota Press, 1988).

16 *Imaginary Kingdom: Texas as seen by the Rivera and Rubí military expeditions, 1727 and 1768*, ed. Jack Jackson (Austin, TX: Texas State Historical Association, 1995), 82–84. The so-called Interior Provinces or *Provincias Internas*, to which the title of my essay refers, were an administrative unit formed in 1776 partly as a result of Rubí's recommendations.

17 *Mapa de la Sierra Gorda y costa de el Seno Mexicano desde la Ciudad de Querétaro, que se halla situada cerca de los veinte y un grados, hasta los veinte y ocho y medio en que está la Bahía de el Espíritu Santo, sus Ríos, Ensenadas y Fronteras, hecho por Don Joseph de Escandón, Coronel de el Regimiento de Queretaro, Theniente de Capitan General de la Sierra Gorda, sus Misiones, Precidios y Fronteras y Lugarteniente de el Ex[celentísi]mo Señor Virrey de esta Nueva España para el reconocimiento, pacificacion y pueble de la Costa del Seno Mexicano y las suyas, que de orden de su Ex[celenci]a reconoció este año de 1747*. MP-MEXICO, 162, Archivo General de Indias, Seville, Spain. Here I use the term Indian to refer to the ethnic and racial type constructed by Europeans that was reinforced through its visual and textual representation.

18 Certeau, *The Practice of Everyday Life*, 121.

19 María-Josefina Saldaña-Portillo, *Indian Given: Racial geographies across Mexico and the United States* (Durham, NC: Duke University Press, 2016), 53.

20 Harley, "Deconstructing the Map," 7–11.

21 The inversion of the colonial power structure is a key aspect of revisionist historian Pekka Hämäläinen's argument in *Comanche Empire*. Saldaña-Portillo critiques this reading as a "Romantic mode of emplotment," in that it adheres to a Eurocentric spatiotemporal model (Saldaña-Portillo, *Indian Given*, 85).

22 Certeau, *The Practice of Everyday Life*, 37.

23 Ibid., 124–5.

24 Ibid., 125.

25 Ibid., 129.

26 Daniel Arreola, *Tejano South Texas: A Mexican-American cultural province* (Austin, TX: University of Texas Press, 2002).

27 The northeast of New Spain had been first explored and settled in colonization efforts led by Alberto del Canto (1577) and Luis Carvajal y de la Cueva (1580).

28 For example, Cristobal Ramírez Sánchez of Saltillo and Manuel Hinojosa of Cerralvo were ranching at the junction of the Alamo River and Rio Grande (the site of Mier) as early as 1734, when the area was the property of the wealthy Almandos family. Ramírez married a daughter of Manuel Hinojosa in 1740, which indicates that social networks in the region were in place at least 10 years before Escandón's arrival.

29 Certeau, *The Practice of Everyday Life*, 125. Emphasis in original.

30 Arreola, *Tejano South Texas*, passim. See also Jovita Gonzales, *Life Along the Border*, ed. Maria Eugenia Cotera (College Station, TX: Texas A&M Press, 2006); and Américo Paredes, *"With His Pistol in His Hand": A border ballad and its hero* (Austin, TX: University of Texas Press, 1958).

31 The five towns were Laredo, Revilla, Mier, Camargo, and Reynosa. All except Laredo were sited on the south bank of the river. See Patricia Osante, *Orígenes del Nuevo Santander, 1748–1772* (Mexico City: Universidad Autónima de México, 1997), 93–152; and Galen Greaser, *New Guide to Spanish and Mexican Land Grants in South Texas* (Austin, TX: Texas General Land Office, 2009), 5–7.

32 Jose Tienda de Cuervo, *Estado General de las Fundaciones Hechas por d. José de Escandón en la Colonia del Nuevo Santander, Costa del Seno Mexicano* (México, Secretaría de Gobernación, Publicaciones del Archivo General de la Nación, t. XIV, XV. The translation is by Edna Brown (unpublished, not paginated).

33 Greaser, *New Guide*, 7.

34 Greaser, *New Guide*, 17.

35 W. Eugene George, *Lost Architecture of the Rio Grande Borderlands* (College Station, TX: Texas A&M Press, 2008), 32.

36 George, *Lost Architecture*, 30.

37 Certeau, *The Practice of Everyday Life*, 36.

38 George, *Lost Architecture*, 3–4.

39 Leslie Offutt, *Saltillo, 1770–1810: Town and Region in the Mexican north* (Tucson, AZ: University of Arizona Press, 2001), 60.

40 Greaser, *New Guide*, 50.

41 This predictably led to a proliferation of lawsuits. See, for example, Jack Jackson, *Los Mesteños* (College Station, TX: Texas A&M Press, 1986), Ch. 5.

42 George, *Lost Architecture*, 5–7. San Ygnacio was located within the jurisdiction of Revilla and was settled by residents of that town. It is about 60 miles upriver from Mier.

43 Today the home is a registered historic landmark and has been thoughtfully restored. It serves as the headquarters of the River Pierce Foundation, an arts organization.

44 See Chris Wilson, *The Myth of Santa Fe: Creating a Modern Regional Tradition* (Albuquerque, NM: University of New Mexico Press), 36–39, on the *placita* or ideal courtyard house.

45 Daniel Arreola and James R. Curtis, *The Mexican Border Cities* (Tucson, AZ: University of Arizona Press, 1994), 166–71.

46 Saldaña-Portillo, *Indian Given*, 93.

47 Tienda de Cuervo, *Estado General*.
48 Ibid.
49 Ibid.
50 Martín Salinas, *Indians of the Rio Grande Delta* (Austin, TX: University of Texas Press, 1990), 96.
51 Ibid., 48.
52 Ian Hodder and Angus Mol, "Network Analysis and Entanglement," *Journal of Archaeological Method and Theory* 23, no. 4 (2006), 1069.
53 Certeau, *The Practice of Everyday Life*, 35.

Bibliography

Arreola, Daniel D. *Tejano South Texas: A Mexican American Cultural Province.* 1st ed. Jack and Doris Smothers Series in Texas History, Life, and Culture; No. 5. Austin, TX: University of Texas Press, 2002.

Arreola, Daniel D., and James R. Curtis. *The Mexican Border Cities: Landscape Anatomy and Place Personality.* Tucson, AZ: University of Arizona Press, 1994.

Certeau, Michel de. *The Practice of Everyday Life.* Berkeley, CA: University of California Press, 1984.

Deleuze, Gilles. *Foucault.* Translated by Sean Hand. 1st ed. Minneapolis, MN: University of Minnesota Press, 1988.

Foucault, Michel. *Discipline and Punish: The Birth of the Prison.* 1st American ed. New York, NY: Pantheon Books, 1977.

George, W. Eugene. *Lost Architecture of the Rio Grande Borderlands.* College Station, TX: Texas A&M University Press, 2008.

Gonzalez Mireles, Jovita. *Life along the Border: A Landmark Tejana Thesis.* 1st ed. Elma Dill Russell Spencer Series in the West and Southwest; No. 26. College Station, TX: Texas A&M University Press, 2006.

Greaser, Galen. *New Guide to Spanish and Mexican Land Grants in South Texas.* Austin, TX: Texas General Land Office, 2009.

Hämäläinen, Pekka. *The Comanche Empire.* Lamar Series in Western History. New Haven, CT: Yale University Press, 2008.

Harley, J B. "Deconstructing the Map." *Cartographica: The International Journal for Geographic Information and Geovisualization* 26, no. 2 (June 1989): 1–20.

Hodder, Ian, and Angus Mol. "Network Analysis and Entanglement." *Journal of Archaeological Method and Theory* 23, no. 4 (December 1, 2016): 1066–94.

Jackson, Jack. *Los Mesteños: Spanish Ranching in Texas, 1721–1821.* College Station, TX: Texas A&M University Press, 1986.

Jackson, Jack, ed. *Imaginary Kingdom: Texas as Seen by the Rivera and Rubí Military Expeditions, 1727 and 1767.* Austin, TX: Texas State Historical Association, 1995.

Offutt, Leslie Scott. *Saltillo, 1770–1810: Town and Region in the Mexican north.* Tucson, AZ: University of Arizona Press, 2001.

Osante, Patricia. *Orígenes Del Nuevo Santander, 1748–1772.* Instituto de Investigaciones Históricas Serie Historia Novohispana 59. Universidad Autónima de México: Mexico City, 1997.

Paredes, Américo. *With His Pistol in His Hand," A Border Ballad and Its Hero.* Austin, TX: University of Texas Press, 1958.

Saldaña-Portillo, María Joséfina. *Indian Given: Racial Geographies across Mexico and the United States. Indian Given*. Durham, NC: Duke University Press, 2016.

Salinas, Martín. *Indians of the Rio Grande Delta: Their Role in the History of Southern Texas and Northeastern Mexico*. Austin, TX: University of Texas Press, 1990.

Tienda de Cuervo, José. *Estado General de las Fundaciones Hechas por d. José de Escandón en la Colonía del Nuevo Santander, Costa del Seno Mexicano (1757)*. Translated by Edna Brown. México, Secretaría de Gobernación, Publicaciones del Archivo General de la Nación, t. XIV, XV.

Urrutia, José de, and Nicolas de La Fora. *Mapa, que comprende la Frontera, de los Dominios del Rey, en la America Septentrional*. 1769. Library of Congress. https://www.loc.gov/item/00556406/ (accessed June 18, 2023).

Wilson, Chris. *The Myth of Santa Fe: Creating a Modern Regional Tradition*. 1st ed. Albuquerque, NM: University of New Mexico Press, 1997.

4

THE PLASTEX WALL AND THE ANALYTIC COUCH

Surface, Subject, and the Psychotherapeutic Interior

Eric Anderson

COVID-19 amplified the anxieties and comforts of the architectural edge. Under lockdown, interior surfaces became sites of deadly contamination. Exterior walls provided barriers against the incursion of pathogens. Computer screens offered safe conduits to an otherwise threatening outside. Against the backdrop of pandemic domesticity, this chapter presents historical manifestations of the material edge as threat, therapy, and technology. The inquiry centers on British writer J. G. Ballard's 1962 short story "The Thousand Dreams of Stellavista" about a house with unusual technological and palliative capacities.[1] Channeling the existential anxieties of his own time, Ballard speculated on the possibilities and limitations of therapeutic design through the fantastical architectural motif of "plastex" walls embedded with computerized receptors. These empathic surfaces perceive, process, and reproduce inhabitants' moods in ways that promise emotional benefit but ultimately prove more destructive than curative. As suggested in illustrations by artist Virgil Finlay that accompanied the original publication, the animated walls physically threaten the story's protagonists, pushing them toward a psychological break (Figure 4.1). Combining futuristic promise with gothic horror, "Stellavista" presents an opportunity to consider the domestic interior and its designed surfaces in relation to edge conditions, material as well as emotional, both during the Cold War era and in the pandemic present.

Previous scholars have drawn attention to the richly rendered architectural settings that appear throughout Ballard's fiction. Several have located the author's fantastical designs in relation to postwar British artistic and

DOI: 10.4324/9781003457749-6

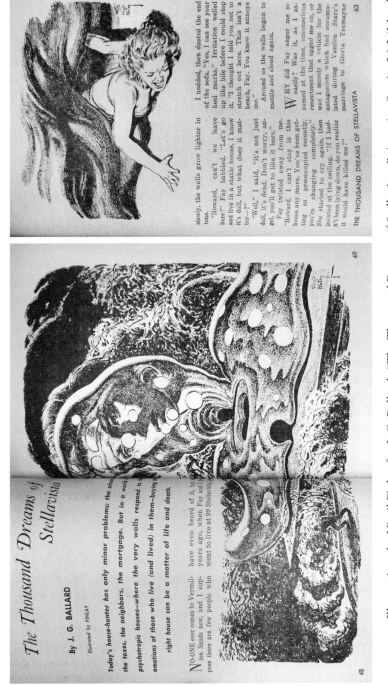

FIGURE 4.1 Illustrations by Virgil Finlay for J. G. Ballard, "The Thousand Dreams of Stellavista," *Amazing Stories* 36:3 (March, 1962), pp. 48–49, 63. Collection of the author.

social discourses. Laura Colombino linked the unsettled houses that appear in "Stellavista" and other early short stories to ideas of "existentialist" dwelling in the work of British architects including Alison and Peter Smithson and the Archigram group that Ballard encountered in 1950s and 1960s London.[2] Jonathan Davies portrayed the imposing concrete apartment tower at the center of the later novel *High-Rise* as a reflection of British class politics and architectural debates of the 1970s.[3] This chapter considers Ballard's melting plastex walls in other contexts, namely the domestic architecture of American suburbia and Freudian psychotherapy. As Sylvia Lavin has shown, midcentury U.S. architecture's engagement with "psychoanalytic culture" produced new ideas about therapeutic design.[4] Set in a modernist subdivision in Southern California, Ballard's tale of a sensitive yet sinister house offers a trenchant—and darkly entertaining—critique of this historical alliance of design practice and medical theory.

Architectural and psychological motifs intertwine in "Stellavista." Ballard's setting, a fictional suburb called Vermilion Sands, is a hothouse of progressive design and troubled lives. From a distance, Vermilion Sands projects futuristic promise, but on closer inspection reveals fissures in its architectural and social foundations. The "one-time playground of movie stars, delinquent heiresses, and eccentric cosmopolites" has recently become host to scandalous, sometimes unhinged behavior.[5] Its sculptural "abstract villas," built of novel materials like plastic and aluminum, have begun to crack and rust. The computer systems meant to control the walls and respond to inhabitants' personalities fail to operate as intended, producing trauma rather than pleasure. Worn facades, broken circuitry, and dysfunctional relationships cast shadows over the sunny landscape of midcentury California domesticity. Ballard's dystopia calls into question the era's popular "good life" image of elegant modern houses and happiness by design.

To better understand and contextualize the architectural and social critique of "Stellavista," this chapter presents a series of historical comparisons. Beginning with several works of midcentury Southern California design that Ballard might have drawn on as models, the chapter then connects the story's sensational plot to the Gothic literary tradition of domestic horror fiction and to the 1950s Hollywood disaster-film genre. Finally, the chapter turns to several prominent therapeutic environments with which Ballard would have been familiar: Sigmund Freud's Vienna consulting office, with its carpet-draped analytic couch and shimmering optics of color and pattern, and the houses of Richard Neutra, the Austrian emigree architect steeped in psychoanalytic theory, who believed deeply in the palliative capacity of the modernist glass wall. Both Freud and Neutra understood the materiality and visuality of the surface to play a role in the therapeutic process, but each held a different

understanding of the possibilities and limits of therapy by design. The chapter ultimately argues that Ballard's comic-horror story of psychotic walls both critiques the pretensions of the curative home embodied in Neutra's work and affirms Freud's understanding of the designed environment as adjacent and complementary to, rather than instrumental in, psychoanalytic therapy.

One local iteration of the midcentury modernism evoked by "Stellavista" is the Case Study House program, a collection of model dwellings erected around Los Angeles from the mid-1940s to mid-1960s. With their white walls, structural grids, and elegantly spare furnishings, the Case Study Houses articulated a seductive fantasy of a socially homogeneous, moderately affluent good life through good design (Figure 4.2).[6]

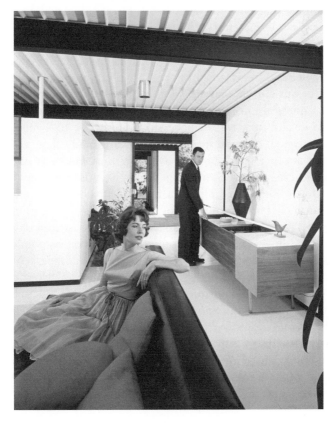

FIGURE 4.2 Photograph by Julius Shulman of Pierre Koenig, Case Study House 21 (Bailey House), Los Angeles, California, 1958. Copyright J. Paul Getty Trust. Getty Research Institute, Los Angeles (2004.R.10).

The protagonists of "Stellavista," Fay and Howard Talbot, a young, childless couple, covet the glamorous image promoted by the Case Study Houses, with its veneer of good taste, endless leisure, racial whiteness, and conventional gender roles. They also recognize its contradictions. The pair moved to Vermilion Sands to escape the "dust, smog, and inflationary real estate prices" of the city and assimilate into the "suburban norms" of "bridge tables and dinner parties."[7] At the same time, Howard Talbot readily casts doubt on the "bogus front of bourgeois respectability" that he and Fay seek to raise for themselves by acquiring a second-hand modernist trophy home.[8] While admiring the persona of "a prosperous bank president and his devoted spouse," Howard ultimately recognizes—and even seems to relish—a more unseemly social reality characterized by "ulcer-ridden, quadri-divorced TV executives."[9] Nor can he avoid seeing flaws in the "awful, beautiful" architecture of the subdivision's modernist houses.[10]

Appropriately, the architectural style of Vermillion Sands that attracts Howard Talbot is considerably more exuberant, even excessive, in comparison to the demure minimalism of the Case Study program. Rather than rigid steel beams and unadorned white walls, the houses of "Stellavista" consist of sculptural forms made possible by the aforementioned malleable plastex. In imagining a fancifully organic alternative to a more conventional, hard-edged, Miesian modernism, Ballard might have taken inspiration from another nearby model dwelling, the "House of the Future" shown from 1957 to 1967 at Disneyland, like the fictional Vermilion Sands, a site of Southern California fantasy (Figure 4.3). Sponsored by the Monsanto chemical company and designed in collaboration with architects at MIT, the Disneyland exhibit was meant to entice visitors with a technologically novel and formally sculptural variation on good-life modernism, made possible by recently developed plastic building materials and electronic automations.[11] The resemblance between the Disneyland house and Ballard's fictional architecture suggests that this was precisely the sort of design the author had in mind. The "House of the Future" consisted of a central concrete base from which four bulbous plastic volumes cantilevered into space. The petal-like forms suggest movement, as if the house might open and close, blossoming in response to the environment and the inhabitants. Compare the following description of the Talbots' house at 99 Stellavista Drive:

> Shaped like an enormous orchid, it was set back on a low concrete dais in the center of a blue gravel court. The white plastex wings, which carried the lounge on one side and the master bedroom on the other, spanned out across the magnolias on the far side of the drive. Between

FIGURE 4.3 Monsanto Chemical Company, "Monsanto House of the Future," Disneyland, Anaheim, California. Designed 1955, exhibited 1957–1967. Photograph by G. E. Kidder Smith. Copyright Massachusetts Institute of Technology.

the two wings, on the first floor, was an open terrace around a heart-shaped swimming pool. The terrace ran back to the central bulb, a three-story segment containing the chauffeur's apartment and a vast two-decker kitchen.[12]

That Ballard may have had the "House of the Future" in mind when writing "Stellavista" is especially likely given that the author spent the immediately preceding years, from 1958 to 1962, working as an editor at the British trade journal *Chemistry and Industry*, where he encountered and eagerly consumed news of the latest commercial technologies and design innovations.[13] Monsanto's plastic exhibition house is precisely the sort of ubiquitous advertising image of "better living through chemistry" (as the Dupont company phrased it) that Ballard regularly drew on during this period when formulating his critical satires of technological modernity.

The social conformity, technological optimism, and stylish design of the Case Study Houses and the Disneyland "Home of the Future" provided starting points for Ballard's architectural imagery. But as the narrative of "Stellavista" unfolds, the architecture reveals its underlying strangeness. The community of Vermilion Sands, the narrator explains, included some

"really weird" houses. The oddest element is the "psychotropic" technology. Computer-like "senso cells" implanted in the walls of the houses pick up the emotions and actions of the inhabitants, store them in a "memory drum," and play them back by causing the plastex to alter physically.[14] The expression of recorded emotions can be orchestrated from a control panel mounted on a wall like a high-fi set. The inhabitants toggle switches and levers to modulate, soften, or enhance the emotional feedback to suit and change the mood. In response to the input, the walls expand and contract like a balloon; they ooze, twist, and form themselves into new shapes; they change color. The effect is like some kind of enormous blob of computer-programmed, phosphorescent slime.

At the beginning of the story, the psychotropic architecture, while undoubtedly odd, seems benevolent. Fay and Howard believe it will enhance the pleasure and happiness of living at home. What fun, they think it will be, to inhabit a dwelling that responds to and enhances their moods. But, as accentuated in Virgil Finlay's ominous illustrations, the psychotropic function turns increasingly autonomous and aggressive, driven by an unseen internal agency. The problems stem from the system replaying not only the emotional lives of the present tenants but of past residents too. This predictably creates conflict. The narrative hinges on a confrontation between the current owners and the stored memories of the departed. The house is poised in the middle as an emotional go-between, but manages somehow to stoke rather than resolve the conflict. The plot, with its domestic tensions ratcheted up as the animate dwelling feeds the young couple's anxieties and resentments, turns increasingly melodramatic. At the climax, the house seems to come fully alive and physically attacks Howard, threatening to suffocate him with its seething walls.

In a subversion of modern domesticity's conventional gender schema of the rational male and emotional female, the cool-headed Fay quickly becomes wary of the house's seductions and outbursts, while Howard loses himself in its strange inner world. Fay's decidedly reasonable responses include first attempting to shut down the threatening technology and then, when her husband resists, simply moving out and getting on with her life. Howard, meanwhile, lets himself be pulled ever deeper into the technological-emotional vortex. Though in the end he hangs onto just enough sanity to hit an emergency cutoff switch as the house is about to crush him, he cannot fully extricate himself from its allure. In the story's final sentence Howard reveals the depth of his attachment. "Often I unlock the control console and examine the memory drum ... Nothing would be simpler than to erase it. But I can't. One day soon, I know that I shall have to switch the house on again."[15]

The motif of the house with animate walls that push the occupant to a state of extreme emotional distress places "Stellavista" in a Gothic literary tradition of architecturally induced madness.[16] There are plenty of precedents, among them Charlotte Perkins Gilman's "The Yellow Wallpaper," in which a woman is psychologically tortured by the eponymous decorative surface, a tattered, sickly hued, sinuously patterned textile that appears to entrap a ghostly being within.[17] Stories like "The Yellow Wallpaper" hinge on what Anthony Vidler has labeled, borrowing the terminology of Freud, "the architectural uncanny."[18] The horror of Gilman's uncanny walls, like the threat of Ballard's plastex, derives from the unsettling experience of an inorganic element coming alive through apparently sentient forces lurking just out of sight but tangibly and dreadfully present nonetheless.

The mobile, threatening architecture of "Stellavista" receives its uncanny charge from something other than ancient or ineffable monsters, however. Its hidden agency stems instead from modern technology, from a human invention that seems beneficial but proves otherwise.[19] In this sense Ballard draws not only on older Gothic motifs but also on more recent anxieties about the unknowability and uncontrollability of technologies like nuclear weapons, computers, and even synthetic materials like plastics.[20] In 1965, just a few years following "Stellavista," the American critic Susan Sontag published "The Imagination of Disaster," an essay on representations of technological horror in popular entertainment. Sontag's focus was science-fiction movies in which humanity is threatened with extermination by seemingly irresistible external forces, sometimes from outer space, in other cases from unanticipated scientific fallout. The terror of such "zombie-like," "mechanical," or "blobby" threats, according to Sontag, is amplified by their dispassionate, inexorable nature. These alien or technological intrusions represent "a regime of emotionlessness" that promises to negate human will.[21] Sontag understood such pop-cultural imagery to express collective fears about not only the threat of physical annihilation by technology but also of psychological breakdown caused by the oppressive impersonality of modern society. Building on Sontag's essay, Hannah Fenichel Pitkin identified the motif of "the blob" as a characteristic expression of midcentury fears of uncontrollable systems. Pitkin linked such disparate sources as political theorist Hannah Arendt's 1958 book *The Human Condition*, with its analysis of modern mass society as an insidious, all-consuming threat, and the Hollywood disaster film *The Blob* released the same year.[22]

The Blob resonates in particular with "Stellavista" and the oozy illustrations by Virgil Finlay. Following Sontag's and Pitkin's arguments, Ballard's attacking mass of computerized plastex might be understood

as an architectural variation on postwar disaster-story vernacular. The house's haywire circuitry and material fluidity take the inhabitants by surprise and quickly exceed their control, bearing down ever closer until the story's near fatal conclusion.

Yet although Ballard mimics the outward features of Hollywood horror, "Stellavista" is not so much concerned with merciless external forces evoked by *The Blob* as with the frailty of the individual psyche. The house may appear monstrously uncontrollable, but throughout the story it remains within the inhabitants' reach to shut it off if they would only so choose. The real threat and cause of breakdown are instead internal and human. Howard Talbot's own ego, and not the plastex, is what the flawed protagonist ultimately fails to control.

Ballard features the motif of modern architecture less to comment on the oppressive homogeneity of postwar society as manifest in suburban domesticity, or on the perils of new technology, but rather as a critique of the idea of design as individual therapy. The story asks: what does therapy by design promise and what does it deliver to the human subject? Can it be transformative in a positive, healthy way? Or is it merely entertainment, like a recreational drug, pleasantly distracting but potentially dangerous? "Stellavista" presents the modernist house as a social and technical invention that promises happiness through a form of architecturally enabled psychoanalysis, but fails to recognize both the limits of design and the vicissitudes of mental life.

The exploration in "Stellavista" of design as therapy can be understood as a specific component of Ballard's general interest in psychoanalysis and the work of Freud, which appears, as others have shown, throughout his writing. Samuel Francis has demonstrated how Ballard's early fiction explores "the relationship between psychological professional and patient" and presents a "detailed dramatization of the psychoanalytic process."[23] Roger Luckhurst understands the collection of short stories including "Stellavista" that Ballard published under the title *Vermilion Sands* as a set of "case histories," like those compiled by Freud, that document the self-destructive "repetition compulsion" of their characters.[24] Here Ballard's interest in Freudian theory and practice relates to architecture and design. The motif of the plastex wall invites comparison to Freud's own consulting office and its carpet draped analytic couch, another example of a psychotherapeutic setting with unstable material edges.

A photograph of Freud's office interior at Berggasse 19 in Vienna reveals the psychoanalyst's own interest in decoration (Figure 4.4).[25] Especially notable are the patterned, colorful carpets draped over and around the couch. Freud's taste for layered surfaces and saturated colors derived from an older Viennese decorative style popular in the 1870s and

FIGURE 4.4 Sigmund Freud's Consulting Room, Berggasse 19, Vienna. Photograph by Edmund Engelman, 1938. Copyright Sigmund Freud Museum, London.

1880s, exemplified by the iconic studio interior of artist Hans Makart (Figure 4.5).[26] The period appeal of Makart's enormously popular space, open daily to visitors and well-known to Freud, hinged on a distinctive interplay of light, color, and materials, and the resulting visual effect of surfaces appearing to dissolve in a deep red-gold glow.[27] The same density, eclecticism, and color of Makart's studio are all present in Freud's office decoration. Freud's carpets create a field of color and pattern that appears to spill and flow across the room, outward from the couch, down onto the floor, and up the wall. The visual effect, as in Makart's studio, is one of surfaces dissolving into colorful depths; materiality becomes visuality and hard edges melt into soft sensations.

The fashionable *Makartstil* would have interested Freud for several reasons, not only because it signified taste and status but also because it was closely associated with emotional comfort. For many of the era's writers and designers, the shimmering, dimly lit, and polychromatic décor of Makart's studio promised a passive form of therapy, a color cure that could regenerate the neurasthenic urban bourgeois male subject.[28] Freud would have been well aware of the *Makartstil's* palliative connotations.

FIGURE 4.5 Eduard Charlemont, Makart in His Studio, ca. 1880, oil on canvas, 139 × 84.5 cm. Wien Museum, Inv. 47.260. CC BY 4.0, Foto: Birgit und Peter Kainz, Wien Museum (https://sammlung. wienmuseum.at/objekt/1473/).

However, the psychoanalyst would not have seen the decorative environment of his office as directly instrumental in his patients' treatment. As Leslie Topp has observed, in a comparison to another Viennese model of therapeutic design, Josef Hoffmann's white-walled Purkersdorf Sanatorium, Freud would have disagreed with the idea that decorated surfaces could be directly curative.[29] Rather, the textiles on Freud's couch can be seen to create an environment merely conducive to therapy. By enabling a

sensory condition of dissolution, Freud's couch becomes suggestive. The optical experience of the blurred edge conveys to the patient the idea of penetrating outward appearances and passing from the physical realm of the outside world into the domain of the mind. Decoration visualized the process of psychoanalysis itself, of probing beneath the surface and discovering hidden layers of experience.

A generation later, the interplay of interior, surface, and psychology in Freud's carpet-draped office resonated in the steel-and-glass houses of Richard Neutra. While studying in Vienna around 1910, Neutra became personally acquainted with the Freud family and began a lifelong engagement with psychoanalytic theory.[30] In the 1920s, he relocated to Los Angeles and began designing houses based on ideas of curative design. By the 1950s and 1960s he developed an explicitly psychotherapeutic approach, influenced by his Viennese roots, in which spaces and surfaces were understood to ameliorate emotional disturbances caused by past traumas and the libido. Neutra's midcentury houses display plenty of the recognizable elements of period modernist design but, as Lavin has shown, include unusual features related to the architect's therapeutic aims (Figure 4.6). Especially distinctive in Neutra's work are the materiality and spatiality of the interior-exterior boundary. Outer walls meet at nearly invisible mitered glass corners. Deeply overhanging roofs are held up by dramatically projecting beams. Pools of water flow under the window walls, connecting inside and outside. Exterior lighting reduces reflections on the glass at night. All of these elements combine to render the architectural periphery visually complex, even deceptive. Lavin argues that Neutra intended the blurred edges of his domestic environments to create "perceptual confusion" and "intense spatial ambiguity."[31] Walls become "billowing membranes"; interiors are "viscous environments."[32] Neutra understood his permeable edges to affect the subject in directly therapeutic ways. The experience of seeing through ambiguous boundaries, the architect proposed, would stimulate the inhabitant's body with "throbbing intensity."[33] For Neutra the semi-permeable perimeter provided both an energy field and a buffer. By experiencing the house as simultaneously open and closed, freeing and protective, the subject could take pleasure in the experience of the outside world and nature, but avoid what Neutra understood in psychoanalytic terms as the "birth trauma" of passing from private to public space, of leaving the shelter of home for the anxiety of exposure and contact.[34]

How might Neutra's therapeutic houses and their billowing glass walls be compared to Freud's office with its softened textile-covered edges? There are similarities but also opposing ideas about the role of the designed environment in mental life. Both emphasized the sensation of permeability.

FIGURE 4.6 Photograph by Julius Shulman of Richard Neutra, Perkins House, Pasadena, California, 1952–1955. Copyright J. Paul Getty Trust. Getty Research Institute, Los Angeles (2004.R.10).

Both used surfaces to create ambiguity about inside and outside. This ambiguity is, for Neutra and Freud alike, a useful deception. The inhabitant loses sensory grasp of physical boundaries. Surfaces appear simultaneously fixed and fluid, both wall and opening, a protective barrier that keeps anxiety at bay, and a gateway through which the inhabitant may pass into an unprotected space beyond. For Freud, that exploratory space was internal, the patient's own mind. For Neutra, it was external, the world outside the house. By encouraging the subject to move between states of shelter and exposure, Freud as well as Neutra understood the interior and its surfaces to support the work of mitigating trauma.

Yet a clear difference remains between the way that Neutra treated architecture as a direct intervention in the inhabitant's mental life and the way that Freud understood decoration as complementary to the

therapeutic process. Neutra acknowledged as much when he recalled how, in his early encounters with Freud in Vienna, the doctor responded dismissively to the young architect's therapeutic ambitions. "To him the formative and moulding influences of a human mind were primarily human relations I, on the other hand, could not possibly study architecture if I were to subscribe to this view," Neutra later recalled.[35] The architect intended his permeable surfaces to be directly, passively transformative. He believed the inhabitant would feel better just by living in the house and experiencing the world through its special glass walls. Freud's surfaces, in contrast, supply a backdrop to a therapeutic process that must be carried out separately and actively by the patient. Freud's colorful carpets serve as a metaphor and an encouragement; but they provide nothing much on their own. Decoration can't do the work of talking and analyzing.

It seems likely that Ballard knew of Neutra's houses and approach, given their proximity to the Southern California setting of "Stellavista." In any case, Ballard's story can easily be read as a parody of the kind of architectural therapy that Neutra advocated. The fluid plastex of the psychotropic house gives absurdly literal form to Neutra's viscous surfaces and their throbbing energy.[36] Neutra believed his glass walls could stimulate and comfort anxious inhabitants. Ballard's edges seem at first to promise just such an effect. Yet they fail to soothe. Instead the computerized plastex shoves the inhabitants' emotional traumas right back at them; it prods, annoys, attacks, and ultimately terrorizes. Ballard points out the preposterousness of Neutra's conception of therapeutic design, and of a culture seduced by the promise of easy self-improvement and pleasure through technology and prepackaged, passive therapies. Technology and design in its popular "Home of the Future" guise was to Ballard a threat rather than a comfort. Therapeutic design for Ballard amounted to another of the many material and social monstrosities of postwar modernity caricatured in period disaster movies.

"Stellavista" reflects not only on Neutra's model of therapeutic design but also on Freud's analytic technique. The psychotropic house mimics the figure of the doctor.[37] As in psychoanalysis, the house listens and records the patient's experiences and emotions. But the house-as-therapist lacks the crucial capacity for restrained distance. Instead, it absorbs, responds, and becomes embroiled in the patient's emotional life, with unhealthy consequences. Ballard's house bungles the intervention and only heightens the patient's neurosis. Is this a critique of Freudian analysis? Ballard seems to question less the practice of psychoanalysis than the idea, as misconstrued by architects like Neutra, that design could achieve the same therapeutic goal. As the disastrous experience of living within plastex walls

demonstrates, the house cannot be taken like medicine or stand in for the doctor and the process of analysis. Naive belief in a passive cure through design worsens the symptoms it aims to alleviate.

In *Are We Human?*, a related critique of modernism's legacies, Beatriz Colomina and Mark Wigley write:

> Design is never quite what it claims to be. Fortunately. Its attempt to smooth over all the worries and minimize any friction always fails, in the same way that almost every minute of daily life is organized by the unsuccessful attempt to bury the unconscious. We need to put design on the couch. Design is filled by what it wants to hide. The simple question *are we human?* is just a way to say *what is design?* Until the confessions and the fantasies come out.[38]

Colomina and Wigley argue that design's overestimation of its own powers, like humans' distorted self-regard, obscures complexity behind a false veneer. Design is a fundamentally human endeavor in the way that it suppresses and pretends. To "put design on the couch" means to disturb modernism's deceptively smooth surfaces and reveal its shortcomings.

"Stellavista" offers a similar assessment. Like Colomina and Wigley, Ballard shared with Freud a sense of both the complexity of the psyche and the limitations of design. Ballard rejected the idea that the interior and its surfaces can make us emotionally healthier, at least in a passive sense. Neutra's proposition as satirized in the short story becomes a disaster, of therapeutic treatment as well as of design, in which the inhabitant and the house both fall apart. "Stellavista" is a cautionary tale of design exceeding its capacities and, in trying to heal, instead nearly killing the patient. The psychotropic house fails on its promise of well-being. For all its therapeutic pretensions, the dwelling instead pushes its inhabitants to the edge. By calling modernism's ambitions into question, Ballard put design on the couch.

Notes

1 Originally published in *Amazing Stories* 36:3 (March 1962): 48–68; reprinted in J. G. Ballard, *Vermilion Sands* (London: Berkeley Books, 1971); and in J. G. Ballard, *The Complete Stories of J. G. Ballard* (New York, NY: Norton, 2009), 305–20. Quotations cited here are from *The Complete Stories*.
2 Laura Colombino, "The House as Skin: J. G. Ballard, Existentialism and Archigram's Mini-Environments," *European Journal of English Studies* 16 (2012): 21–31. Colombino discusses Ballard's visit to the pop-art exhibition *This is Tomorrow* in 1956, where he encountered the installation "Patio and Pavilion," a collaboration among the Smithsons and others. In Colombino's description,

the installation depicted "a rickety shack reflecting uncertainty upon itself. . . . a primitive abode providing only a tenuous protection from the outer unknown and potentially hostile space." (22) Like "Patio and Pavilion," Ballard's dwellings "are often, either explicitly or implicitly, post-catastrophic and display a return to primordial conditions." (22). For another assessment of Ballard's engagement with *This is Tomorrow*, see Natalie Ferris, "J. G. Ballard: Visuality and the Novels of the Near Future," in K. Mitchell and N. Williams, eds., *British Avant-garde Fiction of the 1960s* (Edinburgh: Edinburgh University Press, 2019), 125–42.

3 Jonathan Davies, "Transition, abstraction and perverse concreteness in J.G. Ballard's High-Rise," *Textual Practice* 32 (2018): 1741–61. The Brutalist tower of *High-Rise* and the dystopian community that inhabits it are, for Davies, "poised at the intersection between the Keynesian consensus and neoliberalism, between 'high' modernist and post-modern planning and architectural paradigms, on the cusp of punk provocations and Thatcherite reassertions of class authority." For another analysis of Ballard's Brutalist apartment building as a framework for social organization and dissolution, "both as an epitome of the idealized subject codes of organized modernity and as a site for the articulation of alternative subject forms," see Nora Kuster, "Bringing Down the House: De/constructing 20th-Century Middle-Class Subjectivity in J. G. Ballard's *High-Rise*," in *Subject Cultures: The English Novel from the 18th to the 21st Century* (Tübingen: Gunter Narr, 2015), 193–208.

4 Sylvia Lavin, *Form Follows Libido: Architecture and Richard Neutra in a Psychoanalytic Culture* (Cambridge, MA: MIT Press, 2007).

5 Ballard, "Stellavista," 305.

6 On the racial dimensions of the era's good design, see Dianne Harris, *Little White Houses: How the Postwar Home Constructed Race in America* (Minneapolis, MN: University of Minnesota Press, 2013); Mabel O. Wilson, "White by Design," In D. English and C. Barat, eds., *Among Others: Blackness at MoMA* (New York, NY: Museum of Modern Art, 2019), 100–9; and Kristina Wilson, *Mid-Century Modernism and the American Body: Race, Gender, and the Politics of Power in Design* (Princeton, NJ: Princeton University Press, 2021).

7 Ballard, "Stellavista," 310, 308.

8 Ibid., 305.

9 Ibid., 308–9.

10 Ibid., 306.

11 On the Monsanto House in relation to postwar technology and domesticity, see Stephen Phillips, "Plastics," in B. Colomina, A. Brennan, and J. Kim., eds., *Cold War Hothouses: Inventing Postwar Culture, from Cockpit to Playboy* (New York, NY: Princeton Architectural Press, 2004), 91–123. Ballard visited another model "House of the Future" in London, designed by British architects Alison and Peter Smithson, which also featured fluid forms and embedded electronics. On the Smithsons' house, see Beatriz Colomina, *Domesticity at War*, 193–238. Ballard's encounter with the Smithsons' house is noted in Simon Sellars and Dan O'Hara, eds., *Extreme Metaphors: Interviews with J.G. Ballard, 1967–2008* (London: Fourth Estate, 2012), 36.

12 Ballard, "Stellavista," 309.

13 In his memoirs, Ballard described his fascination with the "conference reports, annual bulletins from leading research laboratories around the world and publications put out by UN scientific bodies and organizations such as Atoms for Peace [...] the accounts of psychoactive drugs, nuclear weapons research,

the applications of the latest-generation computers." Quoted in Natalie Ferris, "J. G. Ballard: Visuality and the Novels of the Near Future," in K. Mitchell and N. Williams, eds., *British Avant-garde Fiction of the 1960s* (Edinburgh: Edinburgh University Press, 2019), 128. Ferris deems Ballard's experience at the journal to have been "key to his development as a novelist, nurturing his scientific interests." The Monsanto House of the Future was widely publicized in both popular and trade publications. See, for example, "Monsanto's House of the Future: Plastics Used Boldly, Creatively as Building Materials," *Monsanto Magazine*, summer 1957, pp. 1–10.

14 Roger Luckhurst has noted that responsive technologies, including "sonic sculptures, psychotropic houses, photosensitive canvases and bio-fabrics, all of which respond to emotional surrounds," are a common motif across Ballard early stories. See Roger Luckhurst, "Repetition and Unreadability: J. G. Ballard's Vermilion Sands," *Extrapolation* 36 (1995): 297.

15 Ballard, "Stellavista," 320.

16 A list of fictional portrayals of haunted houses with animated walls includes (but is not limited to) Edgar Allen Poe, "The Fall of the House of Usher," *Burton's Gentleman's Magazine* 5 (1839): 145–52; Ray Bradbury, "The Veldt," originally published as "The World the Children Made," *The Saturday Evening Post*, September 23, 1950; Shirley Jackson, *The Haunting of Hill House* (New York, NY: Viking, 1959); and Silvia Moreno-Garcia, *Mexican Gothic* (New York, NY: Del Rey, 2020). Will Wiles has compared the "Stellavista" house to haunted dwellings in the stories of H. P. Lovecraft. Will Wiles, "The Corner of Lovecraft and Ballard," *Places Journal*, June 2017. Accessed November 1, 2022. https://doi.org/10.22269/170620.

17 Originally published as Charlotte Perkins Stetson, "The Yellow Wall-Paper. A Story," *The New England Magazine* 11 (1892): 647–56.

18 Anthony Vidler, *The Architectural Uncanny: Essays on the Modern Unhomely* (Cambridge, MA: MIT Press, 1992).

19 Laura Colombino has observed that Ballard's particular brand of "Gothic uncanny" replaces the ghost in the walls with an electronic "neural system." Colombino, "The House as Skin," 26. Another hybrid of Gothic dwelling, psychological terror, and futuristic technology appeared in Bradbury's "The Veldt," in which a "Happylife Home" outfitted with empathic virtual reality screens plagues the inhabitants with violent imagery. Architectural historian Alexandra Midal has noted other instances in which Gothic house fiction met science fiction, often in ways that reflected period fears of new, unseen domestic technologies. Alexandra Midal, "Dark Places: Design Between Horror and Science Fiction," *Rosa B*, "Fourth Issue: The Event Horizon." (n.d.) Accessed November 1, 2022. https://www.academia.edu/37228060/Dark_Design_Design_between_Horror_and_Science_Fiction. Midal, who may be the only other scholar to place "Stellavista" in a design history context, in another essay has cited Ballard's story and its psychotropic house as an example of an alternative legacy of sensory and emotional design that has long been obscured by a dominant functionalist narrative of design history. Alexandra Midal, "Design Wonder Stories: When Speech is Golden," in P. Antonelli, ed., *Talk to Me: Design and Communication Between People and Objects* (New York, NY: MoMA, 2011), 92–97.

20 See also Massimiliano Gioni, "Of Ghosts and Machines," in M. Gioni and G. Carrion-Murayari, eds., *Ghosts in the Machine* (New York, NY: Rizzoli, 2012), 8–12. Gioni calls Ballard "the bard of the more insidious, invasive postmodern technology" and of "the idea that contemporary image-society is an

external outgrowth of our nervous system, made possible by a kind of technology that slips under the skin." Gioni links Ballard's dystopian "prophecy" to the work of media theorist Marshall McLuhan, artist Richard Hamilton, and psychoanalyst Viktor Tausk, a Viennese disciple of Freud. On period anxieties about the computer, see John Harwood, "Imagining the Computer: Eliot Noyes, the Eames and the IBM Pavilion," in J. Pavitt and D. Crowley, eds., *Cold War Modern: Design, 1945–1970* (London: V&A, 2008), 192–7.

21 Susan Sontag, "The Imagination of Disaster," *Commentary* 40:4 (October, 1965): 47.

22 Hanna Fenichel Pitkin, *The Attack of the Blob: Hannah Arendt's Concept of the Social* (Chicago, IL: University of Chicago Press, 1998).

23 Francis specifies that "Stellavista" engages the Freudian concept of "the transference" in which the patient reenacts past experiences by projecting them into the relationship with the analyst. For Francis the "house qua patient" relives and releases its buried memories of past experiences in a destructive way, a "violent abreaction of repressed trauma." Samuel Francis, *The Psychological Fictions of J. G. Ballard* (London: Continuum Books, 2011), 40.

24 Roger Luckhurst observes that Ballard's narrators attempt futilely to correct their compulsions by performing psychoanalysis on themselves. The male narrators in particular seek to master their compulsions, which they understand as female, but fail in comic ways. Responsive objects, including the psychotropic house of "Stellavista," record and reproduce human experiences of trauma in ways that contribute to the repetition compulsion. "They become, in effect, externalizations of the psyche that bear the marks of trauma that will be repeated by the next owner." Luckhurst, "Repetition and Unreadability," 295, 297. In Luckhurst's reading, the "Stellavista" house is a patient. In contrast, the argument here identifies the house with the figure of the analyst.

25 Others have shown how Freud arranged furniture and collections to support his therapeutic work, for example, Mary Bergstein, *Mirrors of Memory: Freud, Photography, and the History of Art* (Ithaca: Cornell University Press, 2010); Diana Fuss and Joel Sanders, "Berggasse 19: Inside Freud's Office," in: J. Sanders (ed.), *Stud. Architectures of Masculinity*, New York, NY: Princeton Architectural Press, 1996), 112–39; and John Forrester, "Mille et tre: Freud and Collecting," in J. Elsner and R. Cardinal, eds., *The Cultures of Collecting* (London: Reaktion, 1994), 224–51.

26 On Freud's decorative tastes and inspirations, see Eric Anderson, "Dreams in Color: Sigmund Freud's Decorative Encounters," in E. Shapira, ed., *Design Dialogue: Jews, Culture and Viennese Modernism* (Vienna: Böhlau, 2018), 161–78.

27 On Makart's studio, see Eric Anderson, "Hans Makart's Technicolor Dreamhouse: Decoration and Subjectivity in Nineteenth-Century Vienna," *West 86th* 22 (2015): 3–22.

28 For a period example, see the popular decorative advice book Jakob von Falke, *Die Kunst im Hause* (Vienna: Gerold, 1871). On the history of neurasthenia and decoration, see Joyce Henri Robinson, "'Hi Honey, I'm Home': Weary (Neurasthenic) Businessmen and the Formulation of a Serenely Modern Aesthetic," in *Not at Home: The Suppression of Domesticity in Modern Art and Architecture*, C. Reed, ed. (London: Thames and Hudson, 1996), 98–112.

29 Leslie Topp, "An Architecture for Modern Nerves. Josef Hoffmann's Purkersdorf Sanatorium," in: *Journal of the Society of Architectural Historians* 56 (1997), pp. 414–37.

30 Lavin, *Form Follows Libido*, 25–32.

31 Ibid., 83.

32 Ibid.

33 Neutra quoted in ibid.

34 Ibid., 56.

35 Neutra quoted in ibid., 89.

36 Will Wiles, in one of the few analyses of Ballard's work focused primarily on architecture, noted the prevalence of curves and ambiguous corners in the writer's extensive use of architectural imagery, including the blobby house of "Stellavista." Wiles understands Ballard's malleable walls as a motif of passage between outer and inner worlds, a reading that resonates with Neutra's idea of the psychotherapeutic potential of the perceptually ambiguous surface. Wiles further emphasizes the ways that Ballard's architecture enacts psychological terror. Wiles, "The Corner of Lovecraft and Ballard."

37 Samuel Francis, like Roger Luckhurst (see n. 29 above), offers an alternative reading that identifies the Stellavista house with the patient rather than the doctor. While both angles are apparent in Ballard's text, the present analysis treats the house as doctor in order to consider Ballard's critique of design's pretensions to provide therapeutic benefit. Francis, *Psychological Fictions*, 40.

38 Mark Wigley and Beatriz Colomina, *Are We Human? Notes on an Archeology of Design* (Zurich: Lars Müller, 2016), 274–5.

5

EMBODIED IMAGINARIES OF INTERIOR SPACE

A Framework for Dynamic Environments and Sensory Inclusion

Severino Alfonso and Loukia Tsafoulia

Our daily interaction with our environments, particularly interiors, is mediated through a vast network of electronics, sensors, and control devices, such as thermostats, infrared touchless systems, "smart" lights, and security control systems, to name just a few. The global pandemic increased human-machine-environment entanglements at an unseen rate, significantly impacting our daily habits, as our experiences are increasingly funneled through constant negotiations with interconnected systems. These systems are not isolated media but constitute an interdependent landscape that shapes the material complex surrounding us. Unraveling this complex is a step toward embracing the critical issues of accessibility in interior environments that comprise edges and exclusions for various sensory perceptual abilities and differences.

Over 3.5 million people in the United States are diagnosed with autism, and roughly 1% of the global population is on the autism spectrum.[1] Conditions such as autism, ADHD, dyslexia, and dyspraxia can affect how people process sensory information, limiting accessibility to the built environment and obstructing—practically, intellectually, and emotionally—their participation in daily objectives as learners, workers, parents, or people moving through the world. Although many historical figures of the design disciplines may intuitively understand the connections between materiality, sensory experience, and generated affect, contemporary discourse on the affective parameters of space is limited.[2] This chapter examines the role dynamic, multisensory, and informational environments can play in redirecting our spatial interactions more equitably in consideration of overlooked issues of neurodivergence. How and where do we greet

DOI: 10.4324/9781003457749-7

differences and make neurodivergent individuals comfortable? Interior environments that support neurodiversity can help fully integrate everyone into our systems and promote quality of life and wellness. In that sense, interiors can be an agent of inclusive change and expansion beyond cognitive boundaries and contribute to "*a future that accommodates fluidity, accessibility, and security.*"[3]

The *Synesthetic Research and Design Lab*,[4] *SR&DL*, part of the College of Architecture and the Built Environment at Thomas Jefferson University in Philadelphia, develops research-driven interactive and experiential installations and experimental prototypes as a way to transgress the art, health, and design fields' boundaries. The lab investigates design systems that provide a layered understanding of *embodied spaces*—affective and performative—through the experimental meshing of the physical and digital realms.[5] Two such projects presented herein, the traveling installation *Synesthesia* and the prototype *Soft*, are rooted in theories of embodied cognition and explore dynamic, interactive environments that support neurodivergence. These projects offer a resource for the future of elastic and inclusive environments as they address accessibility through interaction with technology and sensory reciprocity.

The Overlaps of Embodied Cognition and Design

The *Embodied Turn* refers to the modern period when a renewed interest in the body became established among researchers of embodied cognition theories.[6] The theories of embodied cognition state that a "body intrinsically constrains, regulates, and shapes the nature of mental activity."[7] In other words, one's mind is shaped by the interactions of the body and its environment, privileging the role of sensorimotor experience in the development of knowledge rather than the dualism between brain and body. Knowledge, therefore, is grounded in the physical properties of the body and the surrounding world and is situated in a social and environmental context.[8] Seeing the body as a protagonist in our cognitive logic has had meaningful implications for the design fields, and given its intimate association with the human body, more so for the design of interiors.[9]

Considered together, the cognitive science theories from the early 1950s, the *enactivist theories* of the mind of the late 1960s,[10] and the parallel evolution of the *design methods movement* to the *design thinking* approach in the 1960s[11] (Figure 5.1) reveal a continuous evolution toward softening harsh conceptual dichotomies that qualify as a basis for studying complex systems. These dichotomies regard the formulation of conceptual edges at the beginning of the *design methods* movement in design and *computationalism* in cognitive sciences, such as reason versus subjectivity, sense

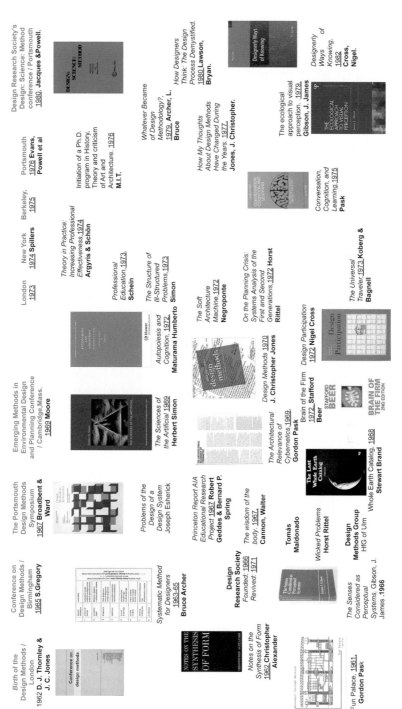

FIGURE 5.1 A lineage of the Design Methods movement conferences and associated publications and literature.

versus sensibility, representation versus action, abstracted versus embodied cognition, and the body-mind-environment split.[12]

Counter to these distinctions stand concepts of embodiment that recognize that space is determined by a set of complex bodily actions as much as space defines the actions of the body. McCulloch's 1965 anthology, *Embodiments of Mind*, articulated views of the mind as an embodied information processor. English psychiatrist and pioneer in cybernetics, Ross Ashby's adaptive systems, also important to the genesis of the embodied mind concept,[13] serve as a conceptual basis for the projects, *Synesthesia* and *Soft*, presented in the last section of the chapter. Our work references these experimental epistemologies and learns from biological and social sciences to address a holistic understanding of embodiment. Referencing Harry Francis Mallgrave:

> A holistic theory of embodiment is being revealed, one that views consciousness, thinking, and communication activities as intrinsic to our biological organisms or functioning bodies, responding to the characteristics of the physical, social, and cultural environments in which we dwell.[14]

The SR&DL's research recognizes and expands the *4EA: Embodied, Embedded, Enactive, Extended, and Affective* approach[15] by adding a technological dimension and prioritizing the importance of intrinsic knowledge and the lived experience in actively involving neurodivergent communities in the design and design evaluation processes.[16] It investigates the sensemaking processes in the individuation of humans, technologies, and their affective environments.

As in any cognitive process, design endeavors to act upon an environment to improve a situation or create something new and valuable.[17] Thus, its role in interactivity and participation calls for a better understanding of agency. In his *The Natural History of Agents*, computational scientist George Kampis suggests that agency is the ability of a human to act upon its environment by taking the initiative.[18] Kampis connects the properties of intentionality—the ability of an agent to affect an interaction by giving it purposes and desires—and that of autonomy or self-care, the ability to operate intentionally and interactively.[19]

Interactivity as a Discourse for Sensory Inclusion in the Design Field

During the past four decades, emergent theories of the mind—such as *enactivism*—paired with advances in the areas of computational design and

human-computer interaction have shed light on the potential of dynamic environments that have the capacity to adapt to personalized needs to be more inclusive. As Larry Busbea discusses in *The Responsive Environment: Design, Aesthetics, and the Human in the 1970s*, such environments can respond to various sensory and perceptual models, call for intuitive relations between human perception and the ways we experience spaces, and address multimodal and embodied interactions with the world.[20] Grounded in the potential of multisensory perception, dynamic environments explore the relationship between body awareness and spatial perception and its implication for design disciplines. The entanglements between humans, machines, and environments ultimately bring sensory decisions to the center of the design discipline while accommodating fluidity between sensory-driven boundaries.

While interactivity as a discourse for inclusion is not yet a distinct paradigm, it is emerging as a robust approach to cognition and social interaction research that, in turn, highlights the importance of social, cultural, and technological influences on everyday human activity. Sune Vork Stefensen defines interactivity as a "sense-saturated coordination that enables and contributes to human action(s)."[21] In their article "Interactivity and Enaction in Human Cognition," Matthew Isaac Harvey, Rasmus Gahrn-Andersen, and Sune Vork Stefensen discuss how coordination is experientially and emotionally rich and that both aspects are fundamental to how human activity is organized. Sense-saturation also reveals how human activity is constrained and sometimes constituted by social roles.[22] Interactivity, understood from an enactive perspective, is thus at the nexus of socially relevant and technologically radical human contributions to problem-solving. By exploring technologically conditioned spatial experiences, we embrace new scientific, symbolic, and aesthetic positions; and eventually produce new materialities, spatial experiences, and their assigned meanings. Emergent sensor-based adaptable systems help employ more embodied, participatory, and empowered ways of being.

STEM disciplines, including design and medicine, have played an important role in exploring the interplay of information, senses, and materiality and in advancing technologies that fuse data and matter. These include interactive surfaces and programmable materials.[23] XR experiences and adaptive environments also allow for new forms of bodily and virtual engagement with a space.[24] How does this search for spatial augmentation affect our daily experiences? And how can technology help reevaluate the relationship between the body's sensory complex and spatial experience? The answers can be found in the regulating patterns linking our environments and psychophysiological states. For example, flickering, buzzing

lights, and poor acoustics in an interior environment can contribute to low concentration and high-stress levels.

Consciously or passively, we constantly engage in sensorial environmental interactions, and as neuroimaging studies document, our sensory modalities are interconnected.[25] In his chapter "'Know Thyself': Or What Designers Can Learn from the Contemporary Biological Sciences," Harry Francis Mallgrave suggests that tactile areas of the somatosensory cortex are also called into play when one views an architectural material.

> In other words, in an act of simulation we at the same time simulate the touch of the surface with our hands, we inhale its odor, we pick up traces of its acoustic resonance or hardness.[26]

In embracing the embodied aspects of our spatial experiences, new methods and applications such as wearables and responsive pods can support a full-body experience. For example, vibration and tactile sensation can offer a "new way of hearing," and sound manipulation can provide "new ways of seeing" for neurodivergent individuals and people with hearing and vision impairment. Via meshing physical and informational matter, the dynamic, performative environments presented in this chapter aspire to expand design approaches and the links between human perception, somatosensory sensations, and physical space.

Synesthetic Research and Design Lab's Framework for Responsive Environments and Acceptance

In meshing scientific expertise with creative praxis, immersive technology, industry, and the community, the projects presented below explore *interaction* and *immersion* as a valuable creative praxis in softening established disciplinary borders. On the one hand, the work presented stems from the desire to make ungraspable affective qualities in the design discourse visible and tangible, and on the other hand, it stems from the desire to investigate sensory-based design solutions as a response to physical and psychological edges. Edges can be collisions between various and often opposing sensory needs. Design can help mitigate the contradicting forces that often emerge from attending to different human perception models simultaneously. Design can and should quantify, evaluate, and act upon these potentially disruptive forces that one comfort threshold could bring to a conflicting second one. For example, for some autistic individuals, the placement of interior transparent partitions stimulates perceptual nuances that are difficult to accommodate due to the flickering light patterns, the layering of reflections, and the lack of a sense of protection and

privacy, but hard-of-hearing individuals would benefit from such an approach since transparency helps expand their visual range to anticipate their actions in a given space better, and reflections can aid self-control of their blind visual scope. If one perceptual model contradicts another, the scientific question that the design pursues is put in disarray. Could adaptable technologies enhance variability and personalization while addressing these particular "wicked" problems, as described by Rittel and Melvin?[27] Technology can act upon a material to change it for different circumstances—such as a room light dimmer—and support individuals by augmenting their perceptive sensibilities. In examining data-driven metrics for both the space and the body to evaluate a design environment, the space can sense and respond to accommodate a set of comfort thresholds for the human body. Human body biometric data, in turn, can be used to evaluate an environment and thus inform design decisions.

The SR&DL employs two principal fields of inquiry. First, the lab engages in unconventional endeavors that challenge the *design thinking* scientific boundaries mentioned above. In that respect, the lab develops art installations, such as *Synesthesia* and *Apomonos*,[28] in search of unknown terrains rather than resolving predetermined questions. The second field of the investigation follows a set of strategic and practical procedures familiar with the *design thinking* agenda. This process closely relates to Nigel Cross's core design premises "such as the ability to resolve ill-defined or 'wicked' problems, adopt solution-focused strategies, use abductive and productive reasoning, and employ non-verbal, graphic/spatial modeling media."[29] Project *Soft*, presented at the end of the chapter, falls within this field of inquiry.

Synesthesia: A Multisensory, Interactive Installation

The multisensory, interactive, traveling installation *Synesthesia* evokes a sense of place by combining sight, sensation, movement, touch, memory, and perception.[30] Indirectly referencing the neurological condition, *Synesthesia* investigates the combined sensory and cognitive aspects that make up an experience through a choreographed collection of body-like elements, light and sound effects projected, layered, and superimposed on top of each other in a unifying mesh. Conceived as a deformed sphere—a central, internal node of multiple projections shaped like a blob and based on topological deformations—*Synesthesia* acts as a three-dimensional cinema (Figure 5.2).[31]

Synesthesia's complex, tensile physical skin constitutes both physical and virtual interfaces. Its large, blob-like volume—approximately 12' × 14' × 13'—is lifted by six aluminum poles that scissor-cross in pairs and

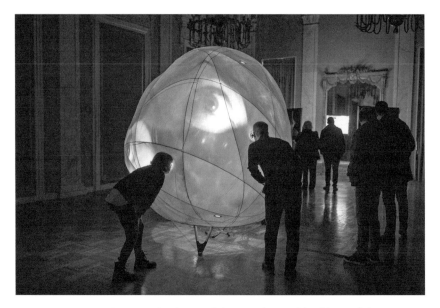

FIGURE 5.2 *Synesthesia* at the foyer of the neoclassical building of the Municipal Theater of Piraeus in Athens, Greece.

Photo by Thomas Daskalakis, *NDP Photo Agency* for the Municipal Theater of Piraeus.

connect at their top and bottom joints. The metal poles hold fifteen flexible fiberglass rods that bend into the blob's computed form. The rods are the skin's tensile frame—a neutral, light-gray, flexible, and slightly translucent membrane. Such a continuous surface wraps the blob except for twenty-four portals, referred to as "eyes," that hold black 3D-printed micro-telescopes. In blinking Morse signals, these "eyes" or peeping holes invite visitors to participate in a game of curiosity.[32] Selected portals possess a complex optics mechanism with an embedded sensor, a small LED, and a beam splitter at 45 degrees allowing a hidden camera to detect the human eye. This *eye* configuration is the "computing brain" of the installation—designed as a camera obscura that records the human eye when in proximity (Figure 5.3). The video recording of the participant's human eye is projected in real-time onto the skin from the interior of the blob. *Synesthesia* can be looked through but also looks outwards. The interactions are live streamed on the SR&DLab's webpage, creating an active exchange between the installation, the in situ participants, and the wider public, thus cutting across physical and virtual scales (Figure 5.4).

The blob also includes a series of light events that respond to the visitors' presence in various ways. It provides visual stimulation at low light levels with dynamic light and color projections as animated visuals in

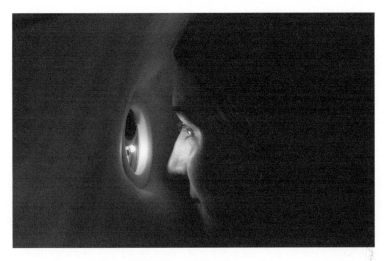

FIGURE 5.3 Close up view from the outside of one of the "eye portals" that act as the "computing brain" of the installation while exhibited at the IE Creativity Center, Segovia.

Photo by Kiko Misis, *más que imagen*, for the *Synesthetic Research and Design Lab*.

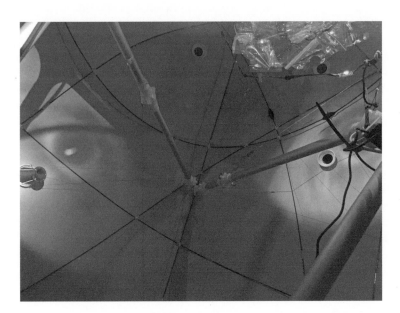

FIGURE 5.4 *Synesthesia*'s view from within capturing the participants' eyes while interacting with it, layered with the internal structure and the light patterns of the installation.

Photo by the *Synesthetic Research and Design Lab*.

Lumia formations.[33] Together with the live video projections of the eyes, these light events complete the visual effects projected on the blob's surface. Its interior includes a series of olfactory, sound, and vibrating events. The work engages in tactile, embodied interactions with its low-frequency vibration that one can feel but cannot hear. Whether the visitor actively engages in all sensory interactions within *Synesthesia*'s narrative or is unconsciously impacted by them, the environment created by the artwork stimulates the audience's psychophysiological states, emotions, and feelings. By engaging multi-sensory modalities, *Synesthesia* acquires new meanings and activates a holistic praxis of embodiment.[34]

Synesthesia operates via entangling senses, emotions, patterns, variations, and information in an enacted topological domain, triggering and responding to overlapping sensory input and output layers. In that sense, it provides a rational and emotional understanding of what it means to live among "conversational" machines and raises awareness of the design potential behind responsive environments. For the human enacting the predetermined possibilities the space affords, these fields of inquiry explore how the space provides opportunities for meaningful interaction while adapting to inclusive perceptual factors. The transition from a physical space of formal aspects to an informational environment operated by real-time data processing yields a meaningful alteration in human perception. *Synesthesia* hence activates a discourse on complex environmental systems embedded in cultural, aesthetic, technological, material, symbolic, and bodily discussions.[35]

Synesthesia promotes an idea of what it means to be human and to have agency via a collective space that shifts the narrative of an agreed syntax of form to a spatial construct of performing bodies. Body and scene, in that sense, enter a mutual agency, a constant state of becoming, and bring the installation to life through the participation of its viewers, thus symbolically dissolving the notion of authorship as it has been traditionally conceived in the artistic processes. *Synesthesia*'s interactive interfaces expand human agency through sensors, actuators, real-time responses, and a human-machine participatory constitution.[36]

Designed as a traveling experience, *Synesthesia* can reach various communities and places.[37] This inclusive aspect of the work amplifies the narratives and cultural interactions it triggers in developing methods for ethnographic impact and observational analysis.[38]

Soft: A Prototype for Responsive Environments and Neurodivergence

Individuals with autism frequently seek smaller, sensory-friendly spaces to help them self-regulate. Project *Soft* is a spatial wearable, an encapsulated,

safe space with an adaptive interior environment that meets this need while providing the flexibility necessary in various public and private spaces. *Soft* is currently under development by the *SR&DL* and combines science and design expertise with the lived experience of neurodivergent advocates.[39] The project aims to create a reactive environment to assess an individual's sympathetic nervous system activation and respond by intelligently modifying the sonic and light environmental aspects to soothe, calm, and self-regulate.[40]

Soft integrates two design strategies: a physical and a virtual/responsive one. *Soft*'s curvilinear, nature-inspired geometry and tectonic language create a smooth transition entry zone from a larger space to an intimate interior. The project is inclusive of various ergonomic factors; it provides flexibility and variability via various microzones, resting options, intimate nooks, and the individual's ability to organize interior space components, such as movable furniture pieces. It, therefore, provides multiple, nested scales within its larger, approximately 13′ curvilinear footprint that progressively narrows as it develops vertically (Figure 5.5). Its geometric composition, gender-neutral material finishes, color, light, texture, acoustics, and overall detailing follow evidence-based research to provide multiple options and space personalization (Figure 5.6).

Regarding the project's deployability, efficiency in the fabrication process can ensure an automated, cost-efficient construction and assembly process. Its fabrication relies on detachable pieces for easy placing, construction, and dismantling, making it viable for various environments. The structure relies on large-scale steam-bending wood techniques to achieve complex space curvatures in combination with textile and tensile interior moments to create a hybrid environment for various tactile needs.

Unlike other notable works in this field, *Soft* uses *distant-to-the-body* technology to adapt the sonic and light characteristics of the environment in real-time in response to personal biometrics. It examines how modifying sensory aspects of an interior environment—focusing on the effects of sound and light—can affect a body's spatial condition, posture, heart, respiratory rate and variability, and other physiological and psychological factors. Closed-loop biofeedback is a well-established concept in which an individual's biomedical data can modify external stimuli in real-time to achieve a desired outcome. Biofeedback-mediated relaxation techniques have also shown benefits for sufferers of migraines, ADHD, and anxiety. The project thus establishes a series of spatial parameters that serve as a scaffold for individualized customization with continuous, real-time adaptation taking place dynamically. It serves several contexts, such as sensory-loaded lobbies, educational facilities, concert halls' and theaters' foyers, and hospitals' calm-down rooms. The project's virtual deployment is also

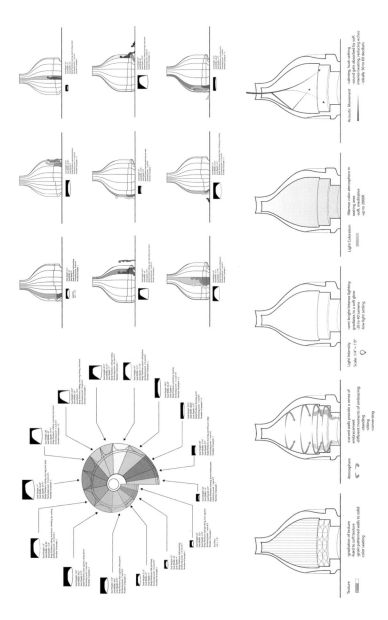

FIGURE 5.5 (Top) Project's Soft planar and elevational diagrams indicating provision of variability and flexibility aspects, via various micro zones, resting options, and intimate nooks inclusive to various ergonomic factors. (Bottom) Diagram of the environmental aspects dynamically adapting in real-time in response to body-based biometrics.

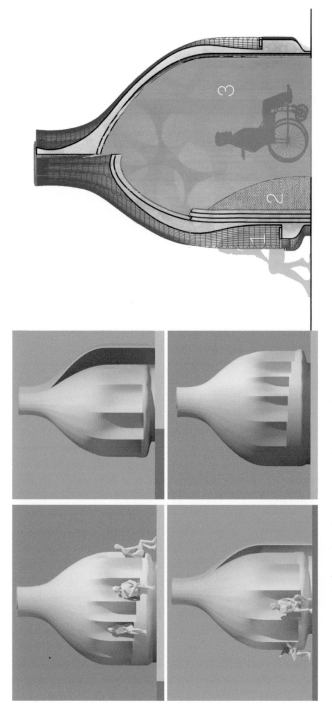

FIGURE 5.6 Project *Soft* rendered exterior and sectional views.

regarded as a networked technology applicable to various spaces, scales, and occupants.

In embracing the multimodal and embodied aspects of spatial experience, the working prototype incorporates body pressure pockets to modulate pressure intensity, frequency, and topography in relation to sound and light.[41] Emerging strategies that "visualize" relationships between the human body, mind states, and spatial aspects include interactive sonification based on joint movement analysis, the translation of respiratory rates or emotional states to dynamic light projections, and sound qualities to tactile wall surfaces.

Like other works of the *Synesthetic Research and Design Lab*, Project *Soft* delivers interdisciplinary recommendations and guidelines for various contextual typologies and overlooked experiences.[42] In following these tenets, the project has a more specific dual goal: to offer a spatial solution that responds to the needs of neurodivergent individuals and to act as a research framework on embodied and affective systems addressing design for inclusive environments. In testing experimental methodologies and technologies, the project's framework addresses the need for our spaces to leverage conditions of perceptual differences to catalyze change, challenge existing boundaries, and meet the needs of the neurodiverse population, with proven benefits for the neurotypical.[43]

Concluding Thoughts

Cognition is embodied. We perceive the world through our bodies and produce *meaning* through our interactions with the environment. Different bodies equal different affordances and different experiences. We are thus embedded, enacted, and extended within an environment. In interlacing the unknowns of perception with the body, the *embodied mind* offers a valuable resource for the future of the design discipline in addressing sensory equity. The nexus of science and creativity, of relevance and radicality, can place those at the edges to the center of shaping fluid, inclusive, and consequently empowering interiors. The work presented supports and demonstrates dialectical design thinking as a way for importing and exporting concepts and methods traditionally found on the design field's periphery. The theories of embodied cognition have a long history, yet they remain on the outskirts of the design realm.

How can practitioners and theorists of design disciplines advance the efficacy of our engagement in *accepting* spaces that can still reshape our environments and ultimately change how we work without resorting to an overtly codified set of practices?[44] In order to create dynamic and inclusive interior environments that upset edges, there is more to learn from the

senses and embodied, intrinsic, and lived experiences. How can we forge a new paradigm for inclusion through interaction? The growing support network[45] for addressing neurodivergence and inclusion, and the increasingly powerful voices of self-advocates[46] are vital partners in shaping our spatial visions. *Synesthesia* and *Soft* illustrate the potential for resilient design and operation of our daily "battlefields"[47] that could transform disabling spaces as well as attitudes toward how civic structures could celebrate and strengthen diverse perceptual models.

The "question of inclusion" has no one answer. The presented projects, and the ongoing work of SR&DL, address how the overlooked, critical questions of inclusive and equitable access, safety, and comfort—of everyone's spatial reality—do not have to constitute edges and exclusions for any sensory perceptual mode of experience.

Notes

1 "Data and Statistics on Autism Spectrum Disorder | CDC," Centers for Disease Control and Prevention, April 4, 2023, https://www.cdc.gov/ncbddd/autism/data.html.
2 The history of theories on the relationship between perception and space is long. Following the lead of Immanuel Kant, Arthur Schopenhauer argued that perception is not a passive process but one in which the brain actively constructs its world through a complex series of neurological operations. Richard Neutra, an early proponent of using neuroscience to inform architecture, argued in his 1954 book *Survival through Design* that designers should incorporate "current organic research" and "brain physiology" into their designs to explore multisensory interaction with the built world, as well as undertake research in areas of "sensory significance." See Richard Neutra. *Survival through Design* (New York, NY: Oxford University Press, 1954), pp. 111–244. More recently, Juhani Pallasmaa has offered several texts on architecture and embodied experience. For instance, see Juhani Pallasmaa, *The Eyes of the Skin: Architecture and the Senses*, 3rd edition (Chichester: Wiley, 2012).
3 Referencing the Interior Provocations OnEdge Call. See "OnEdge2022," Interior Provocations, accessed May 12th, 2023, https://www.interiorprovocations.org/2022-onegde.
4 The *Synesthetic Research and Design Lab, SR&DL*, directed by Severino Alfonso and Loukia Tsafoulia is a research-design platform that develops practical and theoretical methodologies that critically frame the interactions between humans, objects, and environments. The lab collaborates with the Jefferson Health Center for Autism and Neurodiversity, the Occupational Therapy and Neurology Departments at Thomas Jefferson University, and the University College Dublin Inclusive Design Research Centre of Ireland in partnership with SMARTlab teams in Dublin and Cahersiveen, Ireland, and Niagara Falls, Canada. It also partners with self-advocacy communities and industry experts to build collective knowledge that addresses all-inclusive ways of perceptually experiencing our spaces. Through international symposia, publications, and applied research, these collaborations stimulate international dialogue among artists, planners, designers, therapists, medical field experts, tech companies,

educational institutions, advocates, neurodivergent people, and their caregivers. See the "3rd International Neurodiversity & the Built Environment Symposium: PlaceMaking," Thomas Jefferson University, accessed December 1, 2022, Jefferson.edu/NeurodiversitySymposium.

5 Anthony Vidler refers to the intersection of media and genres as a "warping" in his preface to the book *Warped Space: Art, Architecture, and Anxiety in Modern Culture*: "The second kind of warping is that produced by the forced intersection of different media—film, photography, art, architecture—in a way that breaks the boundaries of genre and the separate arts in response to the need to depict space in new and unparalleled ways. Artists, rather than simply extending their terms of reference to the three-dimensional, take on the questions of architecture as an integral and critical part of their work in installations that seek to criticize the traditional terms of art. Architects, in a parallel way, are exploring the processes and forms of art, often on the terms set out by artists, in order to escape the rigid codes of functionalism and formalism. This intersection has engendered a kind of 'intermediary art,' comprised of objects that, while situated ostensibly in one practice, require the interpretive terms of another for their explication." See Anthony Vidler, *Warped Space: Art, Architecture, and Anxiety in Modern Culture* (Cambridge, MA: MIT Press, 2000).

6 An essential source of inspiration for embodied and embedded cognition, central to the embodied turn, can be found in the phenomenological tradition. Martin Heidegger, Edmund Husserl, and Maurice Merleau-Ponty emphasized the physical embodiment of our conscious, cognitive experiences. Cognition in their works is physically interactive, embedded in physical contexts, and manifested in physical bodies. Also central to the embodied turn are J.J. Gibson's novel theory on *ecological psychology* as an embodied and situated approach to cognition and *connectionist psychology* which sees perception as an extended process involving whole organisms in motion through their environments. See James J. Gibson, *The Ecological Approach to Visual Perception* (London: Psychology Press, 2014); Roger Garlock Barker, *Ecological Psychology: Concepts and Methods for Studying the Environment of Human Behavior* (Stanford, CA: Stanford University Press, 1978); V. Bruce, M.A. Georgeson, and P.R. Green, *Visual Perception: Physiology Psychology and Ecology* (London: Psychology Press, 2000); James J. Gibson, "The theory of affordances." *Hilldale, USA* 1, no. 2 (1977): 67–82.

Controversies regarding human cognition and perception in sciences, philosophy, and design converges with the overarching mind-body debate and thus have shaped the *embodied turn*. The tensions between *computationalism* and the *enactivism* theories of the mind have shaped this controversy. Common to computationally oriented research is the idea that cognitive activity occurs in the agent's nervous system and that cognition and consciousness are a form of computation. Since the late 1980s, though, embodied approaches have resurged, most significantly through embodied robotics and the various versions of *enactivism*.

7 Foglia, L. and R.A Wilson, "Embodied cognition," *Wiley Interdisciplinary Reviews Cognitive Science* 4 no. 3 (2013): 319–25.

8 Da Rold, F., "Defining embodied cognition: The problem of situatedness," *New Ideas in Psychology* 51 (2018): 9–14.

9 Evidence-based methods, scientifically driven design research with the use of simulations, case studies, ethnography, or grounded theory approaches are examples of such implications.

10 The terms "enaction" and "enactive" are attributed to Francisco Varela, Evan Thompson, and Eleanor Rosch in their 1991 *The Embodied Mind*. Varela et al.

develop an enactivist approach for describing and explaining human experience by employing cognitive science and neuroscience methods, philosophical phenomenology, and Buddhist meditation techniques. Enactivist theories of the mind are most relevant to this paper in describing cognition as a mental function that arises from the dynamic interaction of an organism with its environment. Discussed also by Evan Thompson and Mog Stapleton. "Making Sense of Sense-Making: Reflections on Enactive and Extended Mind Theories," *Topoi* 28, no. 1 (2008): 23–30.

11 Developing *"design methods"* in the 1960s led to the idea of "design thinking" as a particular approach to solving problems via creativity. From the early 1970s onwards, more works would see scientific methods as a specific form of design inquiry. The 1960s design methods movement emerged at the same time that computational theories of the mind dominated both scientific and philosophical conversations; it was not until the 1970s—or even 1980s—that the "dormant" body-mind dualism declared itself. See Lucy Kimbell, "Rethinking Design Thinking: Part I," *Design and Culture* 3, no. 3 (2011); Molly Wright Steenson, *Architectural Intelligence: How Designers and Architects Created the Digital Landscape* (Cambridge, MA: MIT Press, 2017); Arindam Dutta, ed. *A Second Modernism: MIT, Architecture, and the "Techno-Social" Moment* (Cambridge, MA: MIT Press, 2013). Also, Ingrid Halland discusses how cybernetics was related to design methods and the developments toward design thinking. See Ingrid Halland, "Error Earth: Displaying Deep Cybernetics in 'the Univeritas Project' and 'Italy: The New Domestic Landscape', 1972" (PhD, University of Oslo, 2018).

12 These harsh distinctions were founded during early rational approaches of the cognitive sciences (computationalism) and the design methods movement respectively. In both the sciences and design, the coupling between reasoning, perception, and embodiment enriched their original scope. See Severino Alfonso, and Loukia Tsafoulia. 2021. "Performance as Action. The embodied mind." In proceedings of the 2021 International Architectural Research Centers Consortium Performative Environments Conference, 2021, pages 329–336, Tucson, AZ: University of Arizona.

13 Ross Ashby's Homeostat, an adaptive system built in 1948, which seeks an ultra-stable state and is able to act reliably to maintain the stability of its essential variables against disturbances. The Homeostat is positioned along with other early cybernetic experiments from the 1940s and 1950s by scientists that were trying to demystify the wonders of the human brain by building sophisticated electromechanical "perception" devices that had the capacity to perform actions through adaptation. These were themselves adaptive and were used as perspicuous and suggestive models for understanding the brain. Ashby extended Walter Cannon's (1967) concept of homeostasis to give a general definition of adaptive systems and included all systems. What emerged was a new way of looking at systems, not just mechanical and electrical, but also biological and social: a unifying theory of systems and their relation to their environment. Discussed by Alfonso, Severino, and Tsafoulia, Loukia, 2021. "Performance as Action. The embodied mind." In proceedings of the 2021 International Architectural Research Centers Consortium Performative Environments Conference, 2021, pages 329–36, Tucson, AZ: University of Arizona. See also Andrew Pickering, The Cybernetic Brain, Sketches of Another Future (Chicago, IL: University of Chicago Press, 2011).

14 Harry Francis Mallgrave, "'Know Thyself': Or What Designers Can Learn from the Contemporary Biological Sciences," in *Mind in Architecture: Neuroscience,*

Embodiment, and the Future of Design, ed. Sarah Robinson and Juhani Pallasmaa (Cambridge, MA: The MIT Press), 13.

15 Embodied and situated approaches to philosophical cognitivism have collectively come to be known as "4EA": Embodied, Embedded, Enactive, Extended, and Affective. See Francisco J. Varela, Evan Thompson and Eleanor Rosch, *The Embodied Mind: Cognitive Science and Human Experience* (Cambridge, MA: MIT Press, 1991).

16 Ribeiro R., *"The role of experience in perception,"* *Human Studies* 37 no. 4 (2014): 559–81: "Two individuals with distinct sets or degrees of experience may actually perceive different things within the same perceptual scene. That is, their phenomenal fields have been shaped differently given the experiences they have had and may be altered accordingly. On the other hand, the context in which perception takes place may lead the same individual to sense different things within the same given scene. In sum, assuming a perceptual scene, the claim is that the phenomenal field appears differently according to individuals' experiences and circumstances."

17 Herbert Simon's 1969 book, *The Sciences of the Artificial*, articulated the idea of design as a way of thinking in the sciences.

18 George Kampis, "The natural history of agents," in Agents Everywhere, eds. Gulya's, L., Tatai, G. and Vancza, J. (Budapest: Springer, 2002): 24–48.

19 Argyris Arnellos, Thomas Spyrou, and John Darzentas, "Cybernetic embodiment and the role of autonomy in the design process." Kybernetes 36 (2007): 1207–24.

20 Larry Busbea, *The Responsive Environment: Design, Aesthetics, and the Human in the 1970s* (Minneapolis, MN: University of Minnesota Press, 2020).

21 Stefensen Sun Vork, "Human interactivity" in *Cognition Beyond the Brain: Computation, interactivity, and Human artifice*, eds. Cowley s. J. and Valle-Tourangeau F. (London: Springer, 2013): 195–223.

22 Harvey, Matthew, Gahrn-Andersen, Rasmus and Steffensen, Sune Vork. "Interactivity and enaction in human cognition." Constructivist Foundations, Vol. 11, no. 2 (2016): 234–264.

23 In the last few decades programmable materials—like electroactive polymers and pneumatics, self-transforming carbon fiber, printed wood grain, custom textile composites and other rubbers/plastics—have been used in many areas of engineering and design with benefits on customization and adaptability, at the medical fields as artificial muscles as well as at the field of Human Computer Interaction, offering embodied, and ubiquitous computing solutions. See Tibbits Skylar, *Active Matter* (Cambridge, MA: The MIT Press, 2017); Bar-Cohen Y., "Electroactive Polymers as Artificial Muscles: A Review," *Journal of Spacecraft and Rockets* 39 no. 6 (2002): 822–827; Ishii, H., Lakatos, D., Bonanni, L., and Labrune, J.B, "Radical atoms: beyond tangible bits, toward transformable materials" *Interact* 19 no. 1 (2012): 38–51.

24 Vittorio Gallese and Alessandro Gattara, "Embodied Simulation, Aesthetics, and Architecture: An Experimental Aesthetic Approach," in *Mind in Architecture: Neuroscience, Embodiment, and the Future of Design*, ed. Sarah Robinson and Juhani Pallasmaa (Cambridge, MA: The MIT Press), 174.: "Immersive VR and AR technologies offer ways to empirically test the relationship between bodily nature and spatial experience. Via recording the brain and bodily responses of volunteers perceptually experiencing and exploring virtual architectonic environments. Today, virtual caves can reproduce high-accuracy, three-dimensional and richly dimensioned digital versions of spaces."

25 For example, research on mirror neurons shows that vision encompasses the activation of motor, somatosensory, and emotion-related brain

networks. See Vittorio Gallese and Alessandro Gattara, "Embodied Simulation, Aesthetics, and Architecture: An Experimental Aesthetic Approach," in *Mind in Architecture: Neuroscience, Embodiment, and the Future of Design*, ed. Sarah Robinson and Juhani Pallasmaa (Cambridge, MA: The MIT Press), 165.: "More than twenty years of research on mirror neurons have demonstrated the existence of a mechanism directly mapping action, perception and execution in the human brain, here defined as the mirror mechanism (MM)." Mirror neurons—motor neurons activated during the execution of an action and its observation performed by someone else—map the action of others on the observer's motor representation of the same action.

See G. di Pellegrino, L. Fadiga, L. Fogassi, V. Gallese, and G. Rizzolatti, "Understanding Motor Events: A Neurophysiological Study," *Experimental Brain Research* 91 (1992): 176–180; G. Rizzolatti, L. Fadiga, V. Gallese, and L. Fogassi, "Premotor Cortex and the Recognition of Motor Actions," *Cognitive Brain Research* 3 (1996): 131–141; G. Rizzolatti, L. Fogassi, and V. Gallese, "Neurophysiological Mechanisms Underlying the Understanding and Imitation of Action," *Nature Reviews Neuroscience* 2 (2001): 661–670.

26 Harry Francis Mallgrave, "'Know Thyself': Or What Designers Can Learn from the Contemporary Biological Sciences," in *Mind in Architecture: Neuroscience, Embodiment, and the Future of Design*, ed. Sarah Robinson and Juhani Pallasmaa (Cambridge, MA: The MIT Press), 28.

27 Horst W. J. Rittel and Melvin M. Webber. *Dilemmas in a General Theory of Planning* (Berkeley, CA: Institute of Urban and Regional Development, University of California, 1973).

28 *Apomonos*, an interactive, traveling art installation currently under development, uncovers the complex layers behind human isolation and mental health in technologically mediated spaces. *Apomonos* derives from and extends the Eastern State Penitentiary—ESP—a historic building in Philadelphia. The installation communicates concepts behind the reform method implemented during the penitentiary's foundation: repentance via body-mind isolation. *Apomonos* delivers a commentary on human disembodiment situated in timely discussions on technology and culture. In one of ESP's cells, *Apomonos* engages visitors with personal narratives from current inmates. The cell space is reshaped into a soft wrapper that smoothens its infrastructure without erasing it. A formally inverted experience of *Synesthesia* with the surface becoming a body wrapper, the interstitial space between the new skin and the cell's walls hosts a series of effects that engage the visitor in a multi-sensorial conversation. The visitor's presence is recorded and collected, generating a symbolic virtual "panopticon." In a second, facing cell, the proposal presents a video art piece made of the participants' recorded presence, belonging thus to many entities as the boundaries of its ownership are intentionally blurred. The project serves as an empirical-driven testing ground that examines the relationships between our bodily nature and spatial experience through immersive XR technologies.

29 Nigel Cross, "The Nature and Nurture of Design Ability," *Design Studies* 11, no. 3 (1990): 127–140, https://doi.org/10.1016/0142-694x(90)90002-t

30 "Synesthesia," Synesthetic Research & Design Lab, https://www.synestheticdesignlab.com/synesthesia. We refer to the sense of place as it is discussed by Edward Relph, *Place and Placelessness* (London: Pion, 1976).

31 The project connects to the enactivist theories of the mind with enactive cinematic approaches and debates between embodiment and cinema. *Synesthesia* "bends" the traditional planarity of the cinematic surface. Referencing the

term enaction in the visual arts, *Synesthesia* embraces the shift from traditional cinematic spectacles to works probing the frontiers of interactive, performative, and networked media. Gene Youngblood described "expanded cinema" in his 1970 book Expanded Cinema as an explosion of the frame outward toward immersive, interactive, and interconnected forms of culture. Interestingly, Youngblood also wrote extensively about consciousness, cybernetic cinema, computer films, and synesthesia. See Severino Alfonso and Loukia Tsafoulia, "Synesthesia: An Experiment on Enacted Surfaces," *Metode* vol. 1 "Deep Surface" (2023).

32 *Synesthesia* makes a reference to the holes found in the often opaque enclosures covering construction sites or private spaces in every city. As city dwellers encounter these unattended openings, they are allowed to explore the "other side" and gain visual access to an unknown territory. The enclosure in *Synesthesia* simulates this thin urban layer that separates the public from the private. The openings in this enclosure then function as a short temporary fusion of the two realms. Such a concept draws on Gibson's ecological approach to perception. Tim Ingold in his essay The Earth, the Sky and the Ground Between, refers to the notion of surface as "perforated by holes or keys that allow information, and sometimes materials, to pass from one side to the other." See Tim Ingold, "The Earth, the Sky and the Ground Between," Metode vol. 1 "Deep Surface" (2023).

33 Reference to the work of Thomas Wilfred.

34 See participants' transcribed quotes and their interpretations in the various locations where the installation has been exhibited: Severino Alfonso and Loukia Tsafoulia, "Synesthesia: An Experiment on Enacted Surfaces," Metode, vol. 1 "Deep Surface" (2023); "Synesthesia: An Experiment on Enacted Surfaces," Metode, accessed May 10, 2023, https://metode.r-o-m.no/artikler/essay/synesthesia-an-experiment-on-enacted-surfaces.

"The contrast of *Synesthesia*'s form and softness to the theater's neoclassical architectural features, its geometric ceiling ornamentation, and its hard marble resembling patinas creates a juxtaposition that forces contextual awareness." Participant comment: Municipal Theater of Piraeus Exhibition.

"The context is striking. *Synesthesia* with its multimodal sensoriality, effectual character, and lightness, next to the rich ancient material and symbolic layers of the Fora and in dialogue with the weight of the Roman caryatid that faces it. It made me think of wormholes, a transtemporal trip." Participant comment (archeologist): Trajan's Market Museum of the Imperial Fora, Rome Exhibition.

"The ways the dynamic light effects are occurring is a mystery. I feel as if it is an experience of the cosmos. A very meditative environment that puts me *in the zone*." Participant comment: Municipal Theater of Piraeus Exhibition.

"Such an electric atmosphere; it alters the ordinary conditions of sensation." Participant comment (curator): Trajan's Market Museum of the Imperial Fora, Rome Exhibition.

35 The work also points to the need to acknowledge how the aesthetics and politics of algorithms, information, and digital technologies impact our capacities to assign meanings to surfaces, objects, and environments. With *Synesthesia*, we ask: What is our agency as mediators between the instrumentality of algorithmic protocols, human perception, and the environments that manifest them? Also discussed by Luciana Parisi, *Contagious Architecture: Computation, Aesthetics, and Space*, Technologies of Lived Abstraction (Cambridge, MA: MIT Press, 2013).

36 Collectively, the installation equates environment to experience and mediates our bodies' agency via interlacing action and perception. Ross Ashby's theory of the *Embodied Mind* and the electromechanical inventions by Ashby, Gray Walter, and Gordon Pask known as "perception devices" offer a conceptual framework for this work.

37 *Synesthesia* has been exhibited at the European Cultural Center, as part of the 17th Venice Architecture Biennale (May–November 2021), at the Municipal Theater of Piraeus in Athens (December 2021–January 2022), at the great hall of Trajan's Market Museum of the Imperial Fora in Rome (April–May 2022), and at the IE Creativity Center in Segovia (February-March 2023). Before traveling to Europe, the project launched MICRO • GALLERY, an experimental space of the HOT • BED art gallery in Philadelphia (February–March 2021). See news links for more information and press on each exhibited venue:

SynestheticRDL. 2022. "Synesthesia at Mercati Di Traiano, Museo Dei Fori Imperiali in Rome." SR&DL. https://www.synestheticdesignlab.com/post/synesthesia-at-mercati-di-traiano-museo-dei-fori-imperiali-in-rome.

SynestheticRDL. 2022. "Synesthesia at the Municipal Theatre of Piraeus, Athens." SR&DL. https://www.synestheticdesignlab.com/post/synesthesia-in-greece.

SynestheticRDL. 2021. "Synesthesia at the ECC Architecture Venice Biennial 2021, Palazzo Bembo." SR&DL. https://www.synestheticdesignlab.com/post/interview-during-the-ecc-architecture-venice-biennial-2021-opening-events.

SynestheticRDL. 2023. "Synesthesia at the IE Creativity Center | IE University in Segovia, Spain," SR&DL, https://www.synestheticdesignlab.com/post/synesthesia-in-segovia-spain.

Given, Molly. 2021. "New Interactive Art Display Hits Philly before Going to Italy – Metro Philadelphia." Metrophiladelphia.com. https://metrophiladelphia.com/new-interactive-art-display-hits-philly-before-going-to-italy/.

38 The results of observational analyses, transcribed discussions with participants and documentation of interactions via motion capture technology serve the development of our Lab's ongoing projects on neurodivergence and dynamic environments. Also, the Lab's research on role technology can potentially play in redirecting our built environment relationships around neurodivergence.

39 The development of project *Soft*, to date, is being supported by a neurologist, co-director of the *Center for Neurorestoration*, and a lead Research and Development engineer involved in a Brain-Computer Interface for Stroke Clinical Trial from within our academic institution, Thomas Jefferson University in Philadelphia. An electrical and computer engineer from Temple University in Philadelphia specializing in bioengineering is involved in integrating the sensor and biometrics recording systems. From within our academic institution, a pediatric nurse practitioner, associate director of Nursing Research at the *Jefferson Center for Injury Research and Prevention*, and a developmental and behavioral pediatrician, director of the *Jefferson Health Center For Autism and Neurodiversity*, together with an occupational therapist from the *Department of Occupational Therapy*, College of Rehabilitation Sciences, are also collaborators to the project in supporting the creation of a diverse focus group of neurodivergent individuals. Additionally, in communicating post-occupancy surveys to the focus group of non-verbal, autistic individuals with the use of reading board technologies, their team is developing. Our current focus group for feedback and assessment consists of a nonverbal young man with AS, a verbal young man with AS and medical conditions, a verbal young woman with AS, an adult woman, an architect with AS and OCD, an autistic adult who uses

they/them or he/him pronouns. The selection is based on various differences, abilities, ages, medical conditions, and gender/sexuality. Our aim is to expand this list to eight individuals as a beginning point.

40 The project's conceptual development phase during 2021–2022 has been supported by a research completion grant and a seed grant from the Center for Smart and Healthy Cities at Thomas Jefferson University. During 2023–2024 the project will be developed as part of our awarded residency at the S+T+ARTS ReSilence call. "Resilience Project," May 9, 2023, https://resilence.eu/. This residency will expand our collaborators to include the software development company up2metric and a number of the reSilence partners, such as UM's (Maastricht University) Brain&Emotion lab, the Max Planck Institute for Empirical Aesthetics in the aesthetic perception and experience of sound, CERTH's (Centre for research and technology) expertise in "translating" sound to tactility and haptic experiences, and UNIGE's (University of Genoa) technologies of body movement analysis.

41 The positive aspects of compression and deep pressure on autistic individuals have been studied by Temple Grandin, "Calming effects of deep touch pressure in patients with autistic disorder, college students, and animals," *Journal of child and adolescent psychopharmacology* 2 no. 1 (1992): 63–72.

42 The detailed methodologies developed for project *Soft* will be discussed in the upcoming presentation at the Design For Inclusivity track of the UIA 2023 CPH World Congress, "Sustainable Futures – Leave No One Behind" and forthcoming paper at the Sustainable Development Goals Series published by Springer.

43 Similarly to how a ramp accommodates not only people on wheelchairs but also serves an array of needs such as parents with strollers, environments that support neurodivergence are also important for everyone's cognitive well-being.

44 Architects and designers, still appear largely disengaged from means of activism that would allow us to interact with more potency, and contribute more effectively to the cultivation, preservation, and claim to dignified space; By actively expanding our ideological and critical role in the making of multivalent environments that embrace diversity in meaningful ways.

45 Examples include: "Autism Speaks," Autism Speaks, accessed May 10, 2023, https://www.autismspeaks.org/, "Home," AsIAm, May 10, 2023, https://asiam.ie/, "Neurodiversity Network | Learn. Connect. Work. Achieve.," Neurodiversity Network, accessed May 10, 2023, https://www.neurodiversitynetwork.net, "The Neu Project: An Event Professionals Guide to Neuroinclusive Events," accessed May 10, 2023, https://www.theneuproject.com/.

Also refer to presenters from neurodivergence networks at the yearly international symposia organized by the *SR&DL*: "3rd International Neurodiversity & the Built Environment Symposium: PlaceMaking," Thomas Jefferson University, accessed December 1, 2022, Jefferson.edu/NeurodiversitySymposium.

46 "Architecture teaches us that context is everything, so we must look at the whole picture. Autism has context, too. However, as autistics we live in a world not made for us and our wonderful feedback, whether it be not knowing the social norms, missing social cues, or having to navigate spaces without autonomy. It is hard to get by in a world where we are not perceived as typical, because all we can really know best is our own selves. But by simply including us at the capacity we are able to, we can make spaces that are not only accessible, but inclusive to all human differences. After all, there is only one you, and there is only one me." In conversation with Rachel Updegrove, Self-Advocate, Autistic Woman.

47 A visit to a hospital and the experience of a waiting room for example can be a very challenging task for any person under psychological pressure. When considering an autistic person this is incrementally troubling. An adequate design strategy for these environments can be meaningful in such situations.

Bibliography

Alfonso, Severino, and Loukia Tsafoulia. "A Vision of Complexity. From Meaning and Form to Pattern and Code." In *Narrating the City – Mediated Representations of Architecture, Urban Forms, and Social Life*, edited by A.A. Kavakoğlu, T.N. Hacıömeroğlu and L. Landrum, 74–92. Bristol: Intellect Books, 2020.
Alfonso, Severino, and Loukia Tsafoulia. "Performance as Action. The embodied mind." In *Proceedings of the 2021 International Architectural Research Centers Consortium Performative Environments Conference*, 329–336, Tucson, AZ: University of Arizona, 2021.
Alfonso, Severino, and Loukia Tsafoulia, "Synesthesia: An Experiment on Enacted Surfaces," *Metode* (2023), vol. 1 "Deep Surface."
Ammaniti, Massimo, and Vittorio Gallese. *The Birth of Intersubjectivity: Psychodynamics, Neurobiology, and the Self*. New York, NY: W. W. Norton, 2014.
Arnellos, Argyris, Thomas Spyrou, and John Darzentas. "Cybernetic Embodiment and the Role of Autonomy in the Design Process." *Kybernetes*, 36 (2007): 1207–1224. https://doi.org/10.1108/03684920710827247.
Ashby, W. Ross. *An Introduction to Cybernetics*. New York, NY: Wiley, 1956.
Ashby, W. Ross. *Design for a Brain: The Origin of Adaptive Behavior*. London: Chapman & Hall, 1960.
Bar-Cohen, Yoseph. "Electroactive Polymers as Artificial Muscles: a Review." *Journal of Spacecraft and Rockets* 39, no. 6 (2002): 822–827. https://doi.org/10.2514/2.3902
Barker, Roger Garlock. *Ecological Psychology: Concepts and Methods for Studying the Environment of Human Behavior*. Stanford, CA: Stanford University Press, 1978.
Bruce, Vicki, Georgeson Mark, and R. Green Patrick. *Visual Perception: Physiology Psychology and Ecology*. London: Psychology Press, 2003.
Busbea, Larry D. *The Responsive Environment: Design, Aesthetics, and the Human in the 1970s*. Minneapolis, MN: University of Minnesota Press, 2020.
Cannon, Walter B. *The Wisdom of the Body*. New York, NY: Norton, 1967.
Centers for Disease Control and Prevention. "Data & Statistics on Autism Spectrum Disorder." CDC. Accessed January 5, 2023. https://www.cdc.gov/ncbddd/autism/data.html
Cross, Nigel. "The Nature and Nurture of Design Ability." *Design Studies* 11, no. 3 (1990): 127–140. https://doi.org/10.1016/0142-694x(90)90002-t.
Cross, Nigel. *Designerly Ways of Knowing*. London: Springer, 2010.
Da Rold, Federico. "Defining Embodied Cognition: The Problem of Situatedness." *New Ideas in Psychology* 51 (2018): 9–14. https://doi.org/10.1016/j.newideapsych.2018.04.001
Damasio, Antonio R. *The Feeling of What Happens: Body and Emotion in the Making of Consciousness*. San Diego, CA: Harcourt Inc, 1999.

Di Pellegrino, Giuseppe, Luciano Fadiga, Leonardo Fogassi, Vittorio Gallese, and Giacomo Rizzolatti. "Understanding motor Events: A Neurophysiological Study." *Experimental Brain Research* 91, no. 1 (1992): 176–180. https://doi.org/10.1007/BF00230027

Dutta, Arindam, Stephanie Tuerk, Michael Kubo, Jennifer Yeesue Chuong, and Irina Chernyakova. *A Second Modernism: MIT, Architecture, and the "Techno-Social" Moment.* Cambridge, MA: MIT Press, 2013.

Foglia, L., and R.A Wilson, "Embodied Cognition," *Wiley Interdisciplinary Reviews Cognitive Science* 4, no. 3 (2013). https://doi.org/10.1002/wcs.1226

Fogassi, Leonardo, Vittorio Gallese, Luciano Fadiga, Giuseppe Luppino, Massimo Matelli, and Giacomo Rizzolatti. "Coding of Peripersonal Space in Inferior Premotor Cortex (Area F4)." *Journal of Neurophysiology* 76, no. 1 (1996): 141–157. https://doi.org/10.1152/jn.1996.76.1.141

Gibson, James Jerome. *The Senses Are Considered as Perceptual Systems.* London: Bloomsbury Academic, 1966.

Gibson, James Jerome. *The Ecological Approach to Visual Perception.* Boston, MA: Houghton Mifflin, 1979.

Grandin, Temple. "Calming Effects of Deep Touch Pressure in Patients with Autistic Disorder, College Students, and Animals." *Journal of Child and Adolescent Psychopharmacology* 2, no. 1 (1992): 63–72. https://doi.org/10.1089/cap.1992.2.63

Halland, Ingrid. "Error Earth: Displaying Deep Cybernetics in 'the Univeritas Project' and 'Italy: The New Domestic Landscape', 1972." Ph.D. diss, University of Oslo, 2018.

Harvey, Matthew Isaac, Rasmus Gahrn-Andersen, and Sune Vork Steffensen. "Interactivity and Enaction in Human Cognition." *Constructivist Foundations* 11, no. 2 (2016): 234–245. http://constructivist.info/11/2/234

Ingold, Tim. *Imagining for Real: Essays on Creation, Attention, and Correspondence.* London: Routledge, 2021.

Ingold, Tim. "The Earth, the Sky and the Ground Between." *Metode*, vol. 1 "Deep Surface" (2023). https://metode.r-o-m.no/media/files/articles/tim-ingold.pdf

Ishii, Hiroshi, Dávid Lakatos, Leonardo Bonanni, and Jean-Baptiste Labrune. "Radical Atoms: Beyond Tangible Bits, Toward Transformable Materials." *Interactions* 19, no. 1 (2012): 38–51.

Kampis, George. "The Natural History of Agents." In *Agents Everywhere*, edited by L. Gulya's and G. Tatai, 24–48. Budapest: Springer, 1999.

Kimbell, Lucy. "Rethinking Design Thinking: Part I." *Design and Culture* 3, no. 3 (2011): 285–306.

Martin, Reinhold. "The Organizational Complex: Cybernetics, Space, Discourse." *Assemblage* no. 37 (1998): 103–127. https://doi.org/10.2307/3171358.

Martin, Reinhold. "Organicism's Other." *Grey Room* no. 4 (2001): 34–51. https://doi.org/10.1162/152638101750420799

McCulloch, Warren S. *Embodiments of Mind.* Cambridge, MA: MIT Press, 2016.

Moholy-Nagy, László. *Vision in Motion.* Chicago, IL: P. Theobald, 1947.

Moholy-Nagy, László. *The New Vision: Fundamentals of Bauhaus Design, Painting, Sculpture, and Architecture.* Translated by Daphne M. Hoffmann. Mineola, NY: Dover, 2012.

Neutra, Richard Joseph. *Survival Through Design*. New York, NY: Oxford University Press, 1954, 111–244. https://doi.org/10.2307/425926

Pallasmaa, Juhani. *The Embodied Image: Imagination and Imagery in Architecture*. Hoboken, NJ: Wiley, 2011.

Pallasmaa, Juhani. *The Eyes of the Skin: Architecture and the Senses*. Hoboken, NJ: Wiley, 2012.

Parisi, Luciana. *Contagious Architecture: Computation, Aesthetics, and Space*. Cambridge, CA: MIT Press, 2013.

Pickering, Andrew. *The Cybernetic Brain: Sketches of Another Future*. Chicago, IL: University of Chicago Press, 2010.

Relph, Edward. *Place and Placelessness (Research in Planning and Design)*. New York, NY: Sage Publishing Ltd, 2022.

Ribeiro, Rodrigo. "The Role of Experience in Perception." *Human Studies* 37, no. 4 (2014): 559–581. https://doi.org/10.1007/s10746-014-9318-0

Rittel Horst, J., and Melvin M. Webber. *Dilemmas in a General Theory of Planning*. Berkeley, CA: Institute of Urban and Regional Development, University of California, 1973.

Rizzolatti, Giacomo, Leonardo Fogassi, and Vittorio Gallese. "Neurophysiological Mechanisms Underlying the Understanding and Imitation of Action." *Nature Reviews Neuroscience* 2, no. 9 (2001): 661–670. https://doi.org/10.1038/35090060

Rizzolatti, Giacomo, Luciano Fadiga, Vittorio Gallese, and Leonardo Fogassi. "Premotor Cortex and the Recognition of Motor Actions." *Cognitive Brain Research* 3, no. 2 (1996): 131–141. https://doi.org/10.1016/0926-6410(95)00038-0

Robinson, Sarah, and Juhani Pallasmaa. *Mind in Architecture: Neuroscience, Embodiment, and the Future of Design*. Cambridge, CA: MIT Press, 2015.

Simon, Herbert A. *The Sciences of the Artificial*. Cambridge, CA: MIT Press, 1969.

Simon, Herbert A. "The Science of Design: Creating the Artificial." *Design Issues* 4, no. 1/2 (1988): 67–82. https://www.jstor.org/stable/1511391.

Steenson, Molly Wright. *Architectural Intelligence: How Designers and Architects Created the Digital Landscape*. Cambridge, CA: MIT Press, 2017.

Steffensen, Sun Vork. "Human Interactivity." In *Cognition Beyond the Brain: Computation, Interactivity, and Human Artifice*, edited by Stephen J. Cowley and Frédéric Vallée-Tourangeau, 195–223. London: Springer, 2013.

Synesthetic Research and Design Lab. "Synesthesia." Accessed December 3, 2022, https://www.synestheticdesignlab.com/synesthesia.

Thomas Jefferson University. "3rd International Neurodiversity & the Built Environment Symposium: PlaceMaking." accessed December 1, 2022. Jefferson.edu/NeurodiversitySymposium.

Thompson, Evan. *Mind in Life: Biology, Phenomenology, and the Sciences of Mind*. Cambridge, MA: Harvard University Press, 2010.

Thompson, Evan, and Mog Stapleton. "Making Sense of Sense-Making: Reflections on Enactive and Extended Mind Theories," *Topoi* 28, no. 1 (2009): 23–30. https://doi.org/10.1007/s11245-008-9043-2

Tibbits, Skylar, ed. *Active Matter*. Cambridge, MA: MIT Press, 2017.

Varela, Francisco J., Evan Thompson, and Eleanor Rosch. *The Embodied Mind: Cognitive Science and Human Experience*. Cambridge, MA: MIT Press, 1991.

Vidler, Anthony. *Warped Space: Art, Architecture, and Anxiety in Modern Culture*. Cambridge, MA: MIT Press, 2000.

Vischer, Robert. "On the Optical Sense of Form." In *Empathy, Form, and Space: Problems in German Aesthetics, 1873–1893*, translated by Harry F. Mallgrave and Eleftherios Ikonomou. Oxford: Oxford University Press, 1993.

Wölfflin, Heinrich. "Prolegomena Toward a Psychology of Architecture." In *Empathy, Form, and Space: Problems in German Aesthetics, 1873–1893*, translated by Harry F. Mallgrave and Eleftherios Ikonomou. Oxford: Oxford University Press, 1993.

Youngblood, Gene. *Expanded Cinema: Fiftieth Anniversary Edition*. New York, NY: Fordham University Press, 2020.

SECTION II
Material Edges

6

INTERIOR LANDSCAPES

A Look at the Interior at the Microscale

Nerea Feliz

Introduction

During the peak of the SARS-CoV-2 pandemic, we were largely house-bound and on edge. Intense confinement, marked by a new heightened and germophobic awareness of the spaces we inhabit and the objects we touch, forever altered our experience of domestic space. Meanwhile an entire invisible ecosystem of species exists on the edges of our domestic environment. While we primarily think of domestic space as occupied by humans, interiors are in fact home to an astonishing multiplicity of life forms—one study revealed twelve types of mammals, 1,000 insects, and 51,965 fungi species.[1] Additionally, scientists estimate indoor environments might hold up to 97,800 different bacteria types hiding in plain sight.[2] Rob Dunn, Professor of Applied Ecology in North Carolina State University and director of The Public Science Lab, leads the "Wild Life of Our Homes" project, "the first comprehensive analysis of the microbial communities found in the home."[3] Using cotton swabs as sampling devices to collect dust and the application of genetic methods to detect microbial life, these researchers found over 200,000 species.[4] More specifically, they tracked 40,000 species of fungi, which is more than the amount of cataloged fungal species in North America, and more than 80,000 kinds of bacteria.[5] After sampling a 1,000 houses, they had found about ten times the species than there are types of birds and mammal on the planet.[6] The scientific study's comprehensive data collection of the microbial life found in homes across the United States inspired *Interior Landscapes*, a conceptual project that, through a series of drawings and casts, seeks to bring attention to

DOI: 10.4324/9781003457749-9

the bio-geological nature of the spaces we inhabit and the challenges and untapped potentials of designing at the microscale while trying to expand our reductive anthropocentric views of the built environment.[7] The intention of this chapter is to situate *Interior Landscapes* within a topical constellation of multidisciplinary explorations ranging from research by scientists to artists' works in order to offer an expanded perspective of the domestic interior.

Interior Biome

The average American spends 90% of their time indoors, in a building, or a car.[8] In his book about non-human species in the domestic environment, Dunn refers to us as *"homo indoorus."*[9] He points out how, in very dense urban environments, such as Manhattan, the total indoor area is three times the size of its outdoor surface.[10] The interiorization of the environment carries with it disturbing spatial and biological implications regarding selective inclusion and exclusion of species. Exhaustive urbanization drastically decreases biodiversity in cities by eliminating the habitats of most native species. Farming and agriculture likewise support a small selection of species to the detriment of all others, but the environmental damage of urbanization takes a significantly longer time to recover from than that of agriculture. The Anthropocene has dramatically made apparent the position of dominance that humans take toward other species. A recent study estimates that 96% of all mammals currently on the planet are either humans or livestock, and 70% of all birds on Earth are chickens and other poultry raised for human consumption.[11] Parallel to climate change, experts foresee a "sixth mass extinction," an incipient biodiversity crisis marking the beginning of a huge loss of species on Earth. If we want to avoid this, we may need to start by interrogating systemic exclusion of species from urban environments, including the indoors.

Urbanization is proliferating around the world at an unprecedented speed, with the number of urban dwellers having increased from 751 million in 1950 to 4.2 billion in 2018.[12] The UN Department of Economic and Social Affairs predicts that, by 2068, 70% of the world population will live in cities; today that percentage is 55%. Simultaneously, as urbanization expands, so do the number of species that thrive in human-made interior environments. Seemingly inanimate, the indoors and the objects within them are far from sterile at the microscale. Scientific studies such as the "Wild Life of our Homes" show how the apparent erasure of biodiversity of the indoors is only a visual illusion. While we try to seal our homes from wildlife and pests to completely exclude most visible non-human

species, except pets, from the domestic interior, indoor biomes are very fertile living environments. The microscopic species living with us, and on us, are among the most rapidly evolving species on the planet, both because they reproduce quickly and because their ecosystem of the human household continues to expand at high speed.[13] The impact of these evolving ecosystems—on humans and on the planet at large—is something that we are not yet equipped to measure. But we know that the species that are able to prosper in the indoors' particular medium will continue to multiply and thrive.

The study of the domestic biome is important because it is the natural habitat of the species that we are most closely in contact with.[14] The lack, or excess, of some of these microscopic organisms may determine either a healthy or toxic interior atmosphere.[15] Dunn explains how every time we breathe, we draw in hundreds of thousands of microscopic species and particles, some of which benefit our immune systems and some of which can be threatening to our bodies.[16] Emissions from interior material finishes, furnaces, fireplaces, equipment such as printers, and from certain activities, like cooking or cleaning, contaminate the interior environment and harm our health. For example, volatile organic compounds such as benzene, toluene, or formaldehyde can be found in building materials, combustion emissions, and some consumer products.[17] The effects from exposure to these pollutants can range from headaches to minor respiratory irritation, major respiratory diseases, and cancer.[18] Jeffrey A. Siegel, Professor of Civil Engineering at the University of Toronto and expert in indoor air quality, explains that compared with the way we control the quality of drinking water, there are hardly any mechanisms in place to control the quality of indoor air and the amount of indoor air pollution. He attributes this to two facts: first, the tools and technologies required are still evolving; and second, indoor air is privately owned, which presents numerous regulation challenges.[19] And while traditionally we have been mostly concerned with preventing indoor pollution by blocking outdoor contaminants, the reverse is also a problem. The effects of polluted indoor air are far reaching on the environment at large, not just on humans but also across species and territories globally. Flame retardants, for example, such as the ones found in textiles and electronic devices as well as other persistent organic compounds, have been found in polar bears in Arctic Canada, eastern Greenland, Svalbard, and northwestern Alaska.[20] Constant exchanges between indoor and outdoor air make air composition and the flow of pollutants very complex problems that require a better understanding of the multifaceted interconnections among indoor and outdoor biomes.[21]

Worlds within Worlds

Inspired by Dunn Lab's "Wild Life of Our Homes" research project, *Interior Landscapes*, offers a form of visualization to reveal the microscopic ecologies inhabiting the surfaces of the domestic interior. The bacteria communities found in the dust sampled by this project can only be measured in microns (one micron equals one millionth of a meter). In her book *The Secret Life of Dust: From the Cosmos to the Kitchen Counter, the Big Consequences of Little Things*, Hannah Holmes provides a collection of examples that are helpful to understand this unit as a measure of our immediate environment:

> One inch: 25000 microns. Human hair: 100 microns. Dust: 63 microns and smaller. Pollen: 10-100 microns. Cement dust: 3-100 microns. Fungal spores: 1-5 microns. Bacteria: 0.2-15 microns. Fresh startdust: 0.1 microns. Various smokes: 0.01-1 microns. Tobacco smoke: 0.01-0.5 microns.[22]

The microorganisms populating dust range so much in scale that they belong to radically different orders of magnitude. Microbial organisms and particles, such as pollen grains, fungi, viruses, bacteria, tardigrades, face mites, ant legs, human hair, and skin flakes, blend together in an outer layer covering the surfaces of the interior. Minute fragments of the environment, such as brick shards, sweater thread, rotting leaves, tire rubber, etc., might also be present. Face mites, for example, range in size between 100 and 300 μm from early life to adulthood, which is 1,000 times larger than a bacteria (0.2–15 μm). While both are equally invisible to us and inhabit the same space, they occupy de facto parallel universes. We are talking about worlds within worlds that are impossible to perceive simultaneously.

The scalar disparity between these life forms poses an important challenge when it comes to representation. In response to this problem, the 1977 film *Powers of Ten: A Film Dealing with the Relative Size of Things in the Universe and the Effect of Adding Another Zero*, written and directed by Ray and Charles Eames, takes the viewer into a cross-scalar journey of space through progressive zooms. At a one power of ten per ten seconds speed, the film first zooms out into the galaxy and later zooms in—from a hand, to a skin cell, to a carbon atom—following negative powers of ten: 10^{-1} m, and so forth, until reaching 10^{-16} m. *Interior Landscapes'* exploration of the representation of the domestic interior at the microscale benefited from the digital space of modeling software that, by simply zooming in and out, enables movement across scales. The project started with a series of preliminary tests regarding the perception of these microorganisms at different scales and settled on scenes at twenty-five thousandths of an inch, where edges

blur between us and our objects in a state of disintegration to minuscule fragments. At this scale, the traditional semiotics of the domestic become unfamiliar yet bountiful *Interior Landscapes*.

"Wild Life of Our Homes" examines the types of bacterial communities found in nine locations in the domestic environment: cutting board, kitchen counter, refrigerator, toilet seat, pillowcase, door handle, television screen, and interior and exterior door trim.[23] *Interior Landscapes* is an interpretation of the conversations with Dunn, his team, and the data they collected. The project encompasses five bio-based epoxy casts of the edges of a selection from Dunn Lab's study of common household elements: a doorknob, a door frame, a pillow, a toilet seat, and a television screen. *Interior Landscapes* also includes illustrations of these same items at the microscale. To enable the visibility of bacteria, which range in size between 0.2 and 15 μm in size, *Interior Landscapes'* representations are drawn at $1{:}10^{-6}$. Each location was represented in two different scales and mediums: at their actual size, through the casts, and in a magnified perspective drawing. Inspired by the narrative structure of "Powers of Ten," *Interior Landscapes'* dialectic representation of selected interior features at full scale (casts) and in microns (drawings) enables an augmented and cinematic reading of domesticity and allows the viewer to simultaneously look at a familiar representation of the interior (cast) and its graphic and unfamiliar expression at $1{:}10^{-6}$ (Figure 6.1).

FIGURE 6.1 *Interior Landscapes* casts and drawings in Space P11, Chicago. On the Inside with You exhibition (12/06/21 to 02/28/22) curated by Jonathan Solomon and David L. Hays. Project completed by Nerea Feliz with Alex Gagle and Samantha Panger.

Casts and the Collection of Dust

The storytellers have not realized that the Sleeping Beauty would have awoken covered in a thick layer of dust; nor have they envisaged the sinister spiders' webs that would have been torn apart at the first movement of her red tresses. Meanwhile dismal sheets of dust constantly invade earthly habitations and uniformly defile them: as if it were a matter of making ready attics and old rooms for the imminent occupation of the obsessions, phantoms, spectres that the decayed odour of old dust nourishes and intoxicates.[24]

Georges Bataille

Dust can be found everywhere at all times; it is constantly being generated as we, and the built environment, slowly decompose into minute flakes and rubble. *Interior Landscape's* five bio-epoxy casts of a doorknob, a small section of a door frame, the corner of a pillow, a toilet seat and lid, and the corner of a television screen were designed to naturally collect a visible layer of dust that visually delineates the missing object (Figure 6.2). The casts were made directly over a series of found objects, which were coated with wax, sunk in resin molds, and released after the completion of the curing process. The recognition of these very generic objects in the resulting three-dimensional "voids" produces an uncanny sensation and contradictory feelings of tangibility and intangibility.

Dust also feels both tangible and intangible, ubiquitous but elusive, difficult to catch. There is an important legacy of artworks collecting dust starting with Man Ray's photograph from 1920, *Dust Breeding (Duchamp's Large Glass with Dust Motes)*. The photograph was taken with a two-hour-long exposure, revealing dust that had slowly deposited over the surface of *The Large Glass* for a full year.[25] After the photograph was taken, Duchamp applied diluted cement to affix the dust particles of a small portion of the surface to permanently incorporate them into the piece. Today, one of the objectives of renowned artist and preservationist Otero-Pailos' ongoing project, *The Ethics of Dust*, is to produce a historic archive of the microscopic pollutants of a particular place and time, using latex to collect the pollution that accumulates on monuments across the world. In contrast, *Interior Landscapes* aims to illustrate the already existing archive produced by the Dunn Lab.

Dunn Labs four main hypotheses regarding the nature of the species inhabiting domestic dust speak to the extreme specificity of this compound:

- Your home's physical characteristics influence the microbial communities found inside it.

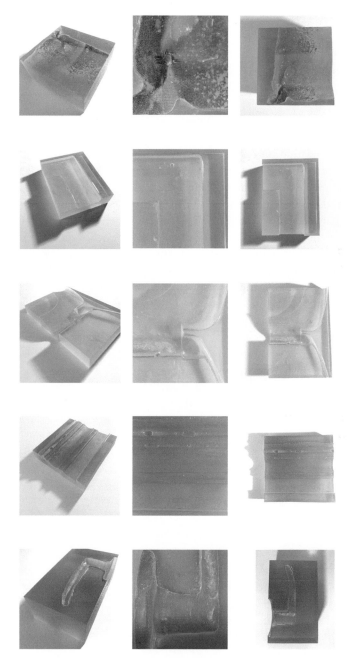

FIGURE 6.2 *Interior Landscapes.* Casts by Nerea Feliz Studio with Samantha Panger. From top to bottom: toilet, door knob, TV screen corner, pillowcase.

- The macro-species with whom you share your home influence the microbial species found within it.
- Geography, climate and landscape features influence the microbial composition inside and outside of houses.
- The microbes you live with influence your health and well-being.[26]

Exterior environmental conditions, pets, as well as the physical characteristics of a home—particularly the building materials, interior finishes, ventilation, heating and cooling systems—will influence a home's dust, or microbial landscape of human, vegetation, animal, and mineral debris.[27] By looking at the bacterial presence found in the dust collected in a home, scientists from the lab were able to determine the presence of pets, the gender of the occupants, indoor materials, and climatic location, among many other things. In other words, according to Dunn: "*Each bit of dust is a microhistory of your life.*"[28] Dust, and the life within it, is a highly specific material derivative of a unique and complex network of natural forces, cultural patterns, relations, inhabitation practices, and technological byproducts.

Based on these findings, *Interior Landscapes* sought to challenge our understanding of the relationship between us and our built environment. In her book *The Secret Life of Dust*, Holmes describes how "each of us is constantly enveloped in a haze of our own skin flakes and disintegrating clothing."[29] Organic debris from our bodies and non-human particles from our environment mix up in dust. "For you are dust, and to dust you shall return."[30] Dust is everything, and everything turns into dust, its combination of both organic and inorganic sources defies traditional distinctions between the natural and artificial. As we breathe dust, our environment permeates our bodies. *Interior Landscapes*' representations at the microscale aims to illustrate the inter-scalar exchanges between us and the objects and the spaces we occupy, transforming both the matter that surrounds us and our own bodies.

Still Life Drawings

There's something epic about the slow but relentless disintegration of particles of our bodies and the built environment taking place on the surfaces of the domestic space. In this regard, *Interior Landscapes*' illustrations can be connected to a long tradition of still life representation of the interior and everyday objects, particularly the vanitas genre that consolidated in the Netherlands in the early seventeenth century.[31] Featuring a range of often luxurious consumer goods, including food and objects, the opulence of these scenes illustrated through exotic imported fruits, lavish meals and precious objects, reflected the vanity of fleeting earthly accomplishments and temporary pleasures, as well as the transience of all things. These paintings

were also allegories of the ephemerality of our lives. The presence of flowers, fruits, and other perishable goods served as symbols of the inevitability of change and the cycles of nature. The depiction of decay served as a reminder of the inescapability of death. In these figurative compositions full of symbolism, inanimate objects can be perceived as individual characters, with distinct personalities, that establish relationships with each other and the space around them. Similarly, *Interior Landscapes*' close representation of the microscopic inhabitants of the interior can produce a sense of both intimacy and curiosity between us and other life forms.

Vanitas paintings were also testament to a flourishing commerce of local and global trade. They made important statements about the movement and exchange of goods between our intimate interior spaces and the outdoors, including foreign and distant locations. *Interior Landscapes*' depiction of surfaces at the microscale in five interior scenes also tries to challenge conventional divides between interior and exterior, human and non-human, natural and artificial, and by revealing the entanglements of these elements at twenty-five thousandths of an inch, as described in the next paragraphs.

Pillowcase (Figure 6.3). A field of textile fibers is populated with dead skin cells and hairs that appear as monumental structures. A face mite

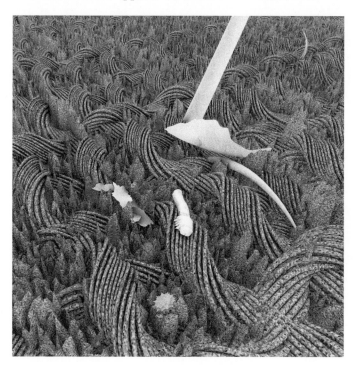

FIGURE 6.3 *Interior Landscapes.* Pillowcase drawing by Nerea Feliz studio with Alex Gagle.

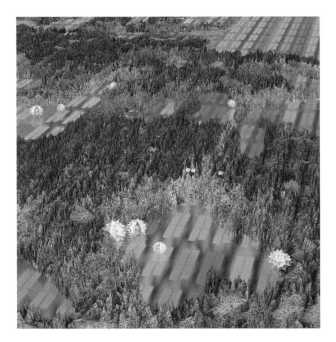

FIGURE 6.4 *Interior Landscapes.* TV screen drawing by Nerea Feliz studio with Alex Gagle.

crawls out from within the field. These species live in the skin pores of every adult's face and are related to ticks and, more distantly, to spiders.[32] Their corpses can often be found on the surfaces that surround us.

Television (Figure 6.4). A tv screen aerial perspective shows a fertile ecology of microbes reproducing in a rapid state of adaptation to a new and expanding material medium. Microorganisms of different origins, such as wildlife, human, soil, vegetation, and synthetic sources, are shown evolving in real time, interacting and reacting to each other to produce emergent configurations of ever-shifting biomes that occupy the spaces we inhabit.

Toilet (Figure 6.5). A toilet bowl perspective looks across the accumulation of bacterial biofilm, the macro structure of bacteria colonies, or "bacterial housing." This drawing represents the kind of high density "urban environment" of bacterial colonies collecting on the toilet surface in an interpretative colored pattern.

Door Trim (Figure 6.6). The drawing of the door trim makes apparent the porosity of the wood's cellular structure and the progressive decomposition of its outer layer that is home to bacteria, pollen, and fungi.

Door Handle (Figure 6.7). The portrayal of a steel door handle with the bacterial fingerprint of a hand left on its surface illustrates a hybrid combination of a man-made material and human residuum.

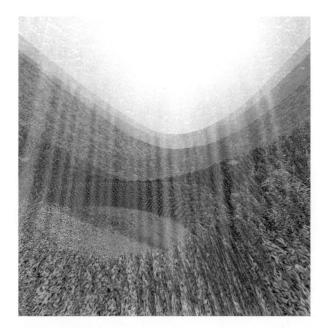

FIGURE 6.5 *Interior Landscapes.* Toilet drawing by Nerea Feliz studio with Alex Gagle.

FIGURE 6.6 *Interior Landscapes.* Door sill drawing by Nerea Feliz studio with Alex Gagle.

FIGURE 6.7 *Interior Landscapes.* Door handle drawing by Nerea Feliz studio with Alex Gagle.

Manufactured Biomes and Design at the Microscale

Interior Landscapes also aims to bring attention to the risks of engaging in selective manipulation of interior biomes with our limited understanding of its complex ecology. Our cultural preoccupation with hygiene has fueled efforts to control interior biomes in order to expel a wide range of real and perceived contaminants in the form of germs, viruses, pests, and toxic emissions and substances. This widespread social anxiety has only spiked since the onset of the pandemic. According to the Center for Disease Control (CDC), obsessive cleaning in the early phases of the pandemic resulted in one in three adults using chemicals unsafely while trying to keep a virus out of their homes.[33] While we are aware that the exchanges between us, the objects, and the spaces we occupy transform both our surroundings and our bodies, the implications of those complex material and biological reverberations are largely unknown. On one hand, experts warn us about both the dangers of living with certain indoor pollutants which, according to EPA, can reach concentrations two to five times higher inside than in the outdoors.[34] On the other hand, scientists also alert us to how attempts to eradicate some microbial organisms and control indoors

complex ecosystems can sometimes do more damage than good. The case of cockroaches is a good example. Since chlordane was first used as a pesticide in 1948, German cockroaches have grown resistant not only to chlordane (1951) but also to Malathion, Diazinon, fenthion (1966), and even DDT.[35] Rob Dunn thinks that we are far from understanding the intricate interdependence between species, particularly at a bacterial level, and that we should be cautious in our efforts to control bacterial populations in indoor biomes and ecologies beyond. Instead, he advocates for biodiversity, even in the interior, not only because of its contribution to the environment at large but also because he argues that it can help keep pathogens in check and strengthen our immune systems.[36]

But besides the cleaning and pesticide industries, interior manufacturers and designers are also attempting to control indoor biomes through the manipulation of interior surfaces at the microscale. An experimental rug, *Fervent Carpet*, by Studio Siem & Pabon heats up to kill dust mites living in its textile. The Eindhoven-based designers envision that their design would help mitigate the presence of indoor air pollutants that may be contributing to an increase in the number of people with asthmatic conditions.[37] But while we might think that asthma is the result of indoor dust presence, new research suggests that perhaps it is the lack of dust that may have induced the asthma epidemic.[38]

Teknos, a global company specialized in painting and interior finishes coatings, has launched a new decorative paint under their Hygienic Paints Collection called Biora Air. Teknos' presentation of this new product claims that Biora Air's technology exterminates indoor pollutants:

> The amount of air pollutants in our indoor air may surprise you. The impurities such as aldehydes originate from everyday household items such as cleaning products or personal care products, building materials and furnishings. Most people don't experience symptoms from exposure to small amount of aldehydes. As levels increase, aldehydes, and especially formaldehyde can cause irritation of the skin, eyes, nose and throat. High levels and long term of exposure may cause health problems. BIORA AIR's extraordinary technology helps to clean the air by binding the harmful aldehydes, such as formaldehyde, and neutralizing them. The result is a cleaner and fresher indoor air.[39]

Similarly, the AYRSORB line of products from Framergy, a Texas-based company founded in 2011, uses a series of microscale structures called Metal Organic Frameworks (MOFs) and Porous Organic Polymers (POPs) to trap selective pollutants from the air. They have worked on numerous applications of this technology. Most recently, they are testing the

insertion of their micro-structures as a coating inside the porous structure of clay. "Azulejos Pasivos" is an experimental tile made by Clay Imports, that incorporates this technology in order to collect air impurities and serve as a filter to purify air from "harmful toxin particles."[40] In Spain, another tile company, Vives, manufactured a series of ceramic tile products, ABIC (Anti-Bacterial Ceramics), that, by releasing silver ions, "reduces the chances of bacteria reproducing and eliminates the presence of viruses on surfaces."[41] These are just a few examples of the increasing proliferation of incipient technologies applied to interior finishes.

Product and lighting designers are also experimenting with sanitation technologies. The transportation industry sometimes uses short-wavelength UV light (UV-C), ultraviolet germicidal irradiation, to clean planes and buses. Recently, classic Italian design company, Artemide, has launched a new collection of lamps, Integralis, that incorporate a new technology which switches light fixtures from emitting standard light into ultraviolet light when rooms are not occupied by humans. In people's absence, UV light is used to sanitize the room by killing pathogens, disinfecting surfaces and air. Artemide's app helps program the light as desired by the user. "Through Artemide App, Integralis follows the rhythm of life working on the concept of 'dose'. A 'dose' is the measure of the density of energy to be applied to the environment surface."[42] The increasing use of medical jargon used by high-end commercial designers reveals the way interiors are now conceptualized in pathological terms.

Given the current anxiety exacerbated by the pandemic to increase sanitation measures, along with the pace of technological change, it is fair to assume that engineers, designers, and manufactures will continue to attempt to "clean" indoor biomes from actual and perceived pollutants. Others will most likely continue to question the efficacy and rationality behind some of these attempts. Until we fully understand the complex network of biological exchanges between us and our surroundings, and until new tools and technologies are mastered, the objective of a germ-free indoor environment will most likely continue to fuel the evolution of interior finishes and products, often at the expense of eradicating beneficial lifeforms. As our knowledge grows, the technologies operating today will change, and even disappear, in favor of new ones.

Conclusion

Current technologies such as pesticides, insulation, air conditioning, heating, electricity, and more have enabled our current understanding of the domestic interior as a pristine, engineered, benign, and comfortable version of the "natural" outdoor world. At the same time, in part due to

those same technologies and expanding urbanization, the outdoors are being increasingly altered by intentional and unintentional human intervention, to the point that, in a maybe not-so-distant future the outdoors might be as manufactured as the indoors. In the context of the Anthropocene, distinctions between indoor and outdoor, natural and manmade have started to blur. An indoor pollutant like ozone can derive from outdoor air, but also from ion generating air cleaners, some photocopy machines and laser printers. Despite our increased awareness about these issues, they can sometimes feel like global problems that occasionally manifest in climatic disasters but that are mostly alien to our daily lives. By putting a $1:10^{-6}$ magnifying lens on some of the most intimate domestic locations such as the toilet, a door handle, or a pillowcase, the illustrations of *Interior Landscapes* urge us to think about the implications of these complex exchanges between natural and manmade entities taking place right next to us.

Notes

1 "Species Diversity in Houses," The Public Science Lab, North Carolina State University, accessed December 20, 2022, http://robdunnlab.com/science-portfolio/species-diversity-in-houses/?portfolioCats=120.
2 "Species Diversity in Houses," The Public Science Lab.
3 "Wild Life of Our Homes," The Public Science Lab, North Carolina State University, accessed December 20, 2022, http://robdunnlab.com/projects/wild-life-of-our-homes/.
4 Rob Dunn, *Never Home Alone: From Microbes to Millipedes, Camel Crickets, and Honeybees, the Natural History of Where We Live* (New York, NY: Basic Books, 2018), Prologue, 2, Kindle.
5 Rob Dunn, "The First National Inventory of All Household Life (on a swab)", accessed December 20, 2022, http://yourwildlife.org/2015/08/the-first-national-inventory-of-all-household-life-on-a-swab.
6 Dunn, "The First National Inventory of All Household Life (on a swab)."
7 *Interior Landscapes* is a creative project that was initiated thanks to an invitation from Jonathan Solomon to take part in an exhibition in Space P11, a gallery located in the Chicago Pedway, directed by Jonathan Solomon and David L. Hays. The exhibition, titled "On the Inside with You," included works from Nerea Feliz, and Zherui Wang. *Interior Landscapes* was on view from December 2021 to the end of February 2022 and was completed with the assistance of Samantha Panger, who built a series of casts, and Alex Gagle, who worked on the drawings.
8 "Indoor Air Quality. What are the trends in indoor air quality and their effects on human health?" U.S. Environmental Protection Agency, accessed December 20, 2022, https://www.epa.gov/report-environment/indoor-air-quality.
9 Dunn, *Never Home Alone*, Prologue, 1.
10 Ibid, Prologue, 4.
11 Yinon M. Bar-On, Rob Phillips, and Ron Milo, "The Biomass Distribution on Earth," *Proceedings of the National Academy of Sciences* 115, no. 25 (May, 2018): 6506–11, https://doi.org/10.1073/pnas.1711842115.

12 "68% of the world population projected to live in urban areas by 2050, says UN," United Nations, last modified May 16, 2018, https://www.un.org/development/desa/en/news/population/2018-revision-of-world-urbanization-prospects.html#:~:text=Today%2C%2055%25%20of%20the%20world's, increase%20to%2068%25%20by%202050.

13 "Sampling your Home's Microbes," The Public Science Lab, North Carolina State University, accessed December 20, 2022, http://robdunnlab.com/projects/wild-life-of-our-homes/project-description/.

14 North Carolina State University, "Sampling your Home's Microbes."

15 North Carolina State University, "Sampling your Home's Microbes."

16 Dunn, *Never Home Alone*, Prologue, 2.

17 Jeffery Siegel, "Engineering the Indoor Environment," in *Toward a New Interior, An Anthology of Interior Design Theory*, ed. Lois Weinthal (New York, NY: Princeton Architectural Press, 2011), 351.

18 Siegel, "Engineering the Indoor Environment," 351.

19 Siegel, "Engineering the Indoor Environment," 350.

20 Derek C.G. Muir, Sean Backus, Andrew E. Derocher, Rune Dietz, Thomas J. Evans, Geir W. Gabrielsen, John Nagy, Ross J. Norstrom, Christian Sonne, Ian Stirling, Mitch K. Taylor, and Robert J. Letcher, "Brominated flame retardants in polar bears (*Ursus maritimus*) from Alaska, the Canadian Arctic, East Greenland, and Svalbard," *Environmental Science & Technology* 40(2) (January 2006): 449–55, https://doi.org/10.1021/es051707u. PMID: 16468388.

21 Siegel, "Engineering the Indoor Environment," 353.

22 Hannah Holmes, *The Secret Life of Dust: From the Cosmos to the Kitchen Counter, the Big Consequences of Little Things* (New York, NY: Wiley, 2001), Introduction, 4, Kindle.

23 Robert R. Dunn, Noah Fierer, Jessica B. Henley, Jonathan W. Leff, Holly L. Menninger, "Home Life: Factors Structuring the Bacterial Diversity Found within and between Homes," *PLoS ONE* 8–5 (May 22, 2013): e6413, https://doi.org/10.1371/journal.pone.0064133.

24 Georges Bataille, "Dust," in *Encyclopaedia Acephalica*, ed. Alastair Brotchie, trans. Iain White (London: Atlas Press, 1995), 42–43.

25 *The Bride Stripped Bare by Her Bachelors* by Marcel Duchamp, commonly referred to as *The Large Glass*, 1915–23.

26 "Sampling your Home's Microbes," The Public Science Lab, North Carolina State University, accessed December 20, 2022, http://robdunnlab.com/projects/wild-life-of-our-homes/project-description/.

27 North Carolina State University, "Sampling your Home's Microbes."

28 Emily Anthens, "Our Dust, Ourselves," *The New Yorker*, November 4, 2015, https://www.newyorker.com/tech/annals-of-technology/what-your-dust-says-about-you.

29 Holmes, *The Secret Life of Dust*, Introduction, 2.

30 New American Standard Bible – NASB 1995, Genesis 3:19, accessed December 20, 2022, https://www.bible.com/bible/100/GEN.3.19.NASB1995.

31 This Latin term translates to vanity in English.

32 Brandon Spector, "'Face Mites' Live in Your Pores, Eat Your Grease and Mate on Your Face While You Sleep," *Life Science*, May 22, 2019. https://www.livescience.com/65533-your-face-mites-never-poop.html.

33 Radhika Gharpure, DVM, Candis M. Hunter, Amy H. Schnall, Catherine E. Barrett, Amy E. Kirby, Jasen Kunz, Kirsten Berling, Jeffrey W. Mercante, Jennifer L. Murphy and Amanda G. Garcia-Williams "Knowledge and Practices Regarding Safe Household Cleaning and Disinfection for COVID-19 Prevention, United States, May 2020," Centers for Disease Control and

Prevention, *MMWR Morbidity and Mortality Weekly Report* 69: 705–9, last modified June 12, 2020, https://doi.org/10.15585/mmwr.mm6923e2.

34 U.S. Environmental Protection Agency, "Indoor Air Quality."

35 Dunn, *Never Home Alone*, Chapter 9, 161.

36 Dunn, *Never Home Alone*, Chapter 11, 229.

37 Jessica Mairs, "Studio Siem & Pabon's Fervent Carpet kills dust mites to relieve asthma sufferers," *Dezeen*, 16 October, 2014, https://www.dezeen.com/2014/10/16/fervent-carpet-studio-siem-pabon-heat-asthma-sufferers/.

38 Holmes, *The Secret Life of Dust*, Introduction, 2.

39 "Paints to Enhance Wellbeing at Home," Teknos, accessed December 20, 2022, https://www.teknos.com/decorative-paints/products/biora-hygienic-interior-paints/.

40 "Farmergy × Clay Imports: Azulejos Pasivos, Breakthrough Innovation in Science and Design," Clay Imports, https://clayimports.com/blogs/blog/azulejos-pasivos-press-release.

41 "ABIC (Anti-Bacterial Ceramics) by Vives," *Dezeen*, October 20, 2021, https://www.dezeen.com/2021/10/20/abic-anti-bacterial-ceramics-vives-dezeen-showroom/.

42 "Integralis, A universal light to stay safe together," Artemide, accessed December 20, 2022, https://www.artemide.com/en/journal/28/integralis%C2%AE.

Bibliography

Anthens, Emily. "Our Dust, Ourselves." *The New Yorker*. November 4, 2015, https://www.newyorker.com/tech/annals-of-technology/what-your-dust-says-about-you.

Artemide. "Integralis, A universal light to stay safe together." Accessed December 20, 2022. https://www.artemide.com/en/journal/28/integralis%C2%AE.

Bar-On, Yinon M., Rob Phillips, and Ron Milo. "The Biomass Distribution on Earth." *Proceedings of the National Academy of Sciences* 115, no. 25 (May, 2018): 6506–11. https://doi.org/10.1073/pnas.1711842115.

Bataille, Georges. "Dust." In *Encyclopaedia Acephalica*, edited by Alastair Brotchie, 42–43. London: Atlas Press, 1995.

Clay Imports. "Farmergy × Clay Imports: Azulejos Pasivos, Breakthrough Innovation in Science and Design." Accessed December 20, 2022. https://clayimports.com/blogs/blog/azulejos-pasivos-press-release.

Dezeen staff. "ABIC (Anti-Bacterial Ceramics) by Vives," Dezeen, 20 October, 2021. https://www.dezeen.com/2021/10/20/abic-anti-bacterial-ceramics-vives-dezeen-showroom/.

Dunn, Rob. *Never Home Alone, from Microbes to Millipedes, Camel Crickets and Honeybees, the Natural History of Where We Live.* New York, NY: Basic Books, 2018.

Dunn, Rob. "The First National Inventory of All Household Life (on a swab)." Your Wild Life. Accessed December 20, 2022. http://yourwildlife.org/2015/08/the-first-national-inventory-of-all-household-life-on-a-swab/.

Dunn, RR, N Fierer, JB Henley, JW Leff, and HL Menninger. "Home Life: Factors Structuring the Bacterial Diversity Found within and between Homes." *PLoS ONE* 8-5 (May 22, 2013): e6413. https://doi.org/10.1371/journal.pone.0064133.

Gharpure, R, CM Hunter, and AH Schnall, et al. "Knowledge and Practices Regarding Safe Household Cleaning and Disinfection for COVID-19 Prevention—United States, May 2020." *Centers for Disease Control and Prevention, MMWR Morbidity and Mortality Weekly Report* 69: 705–9. Last modified June 12, 2020, https://doi.org/10.15585/mmwr.mm6923e2.

Holmes, Hannah. *The Secret Life of Dust, From the Cosmos to the Kitchen Counter, the Big Consequences of Little Things.* New York, NY: Wiley, 2001.

Mairs, Jessica. "Studio Siem & Pabon's Fervent Carpet kills dust mites to relieve asthma sufferers." *Dezeen*, 16 October, 2014. https://www.dezeen.com/2014/10/16/fervent-carpet-studio-siem-pabon-heat-asthma-sufferers/.

Muir, DC, S Backus, AE Derocher, R Dietz, TJ Evans, GW Gabrielsen, J Nagy, RJ Norstrom, C Sonne, I Stirling, MK Taylor, and RJ Letcher. "Brominated Flame Retardants in Polar Bears (*Ursus maritimus*) from Alaska, the Canadian Arctic, East Greenland, and Svalbard." *Environ Sci Technol* 40, no. 2 (2006): 449–55. https://doi.org/10.1021/es051707u. PMID: 16468388.

New American Standard Bible – NASB 1995. Genesis 3:19. Accessed December 20, 2022. https://www.bible.com/bible/100/GEN.3.19.NASB1995.

North Carolina State University, The Public Science Lab. "Species Diversity in Houses." Accessed December 20, 2022. http://robdunnlab.com/science-portfolio/species-diversity-in-houses/?portfolioCats=120.

North Carolina State University, The Public Science Lab. "Wild Life of Our Homes." Accessed December 20, 2022. http://robdunnlab.com/projects/wild-life-of-our-homes/.

North Carolina State University, The Public Science Lab. "Sampling your Home's Microbes." Accessed December 20, 2022. http://robdunnlab.com/projects/wild-life-of-our-homes/project-description/.

Siegel, Jefferey. "Engineering the Indoor Environment." In *Toward a New Interior, An Anthology of Interior Design Theory*, edited by Lois Weinthal, 348–57. New York, NY: Princeton Architectural Press, 2011.

Spector, Brandon. "'Face Mites' Live in Your Pores, Eat Your Grease and Mate on Your Face While You Sleep." *Life Science*, May 22, 2019. https://www.livescience.com/65533-your-face-mites-never-poop.html.

Teknos. "Paints to Enhance Wellbeing at Home." Accessed December 20, 2022. https://www.teknos.com/decorative-paints/products/biora-hygienic-interior-paints/.

U.S. Environmental Protection Agency. "Indoor Air Quality. What are the trends in indoor air quality and their effects on human health?" Accessed December 20, 2022. https://www.epa.gov/report-environment/indoor-air-quality.

7

BEING MANWARING

Crafting Embodied History

Annie Coggan

In my practice as an artist and designer, I put forward alternative methods for understanding historical archival objects found in a series of library collections. I have examined books, artifacts, and ephemera and have created handmade projects that aim to extend scholarly conversations. Hand drawing is my primary medium in understanding historical visual culture. Drawing as a method of research is a way of bringing history into being. I am an advocate for haptic historic research that advances stories that are unseen in the academic realm. Drawings can propel and extend facts. They can amplify details and can create a historic atmosphere.

My current muse for this practice is eighteenth-century cabinet maker Robert Manwaring. In 1765, Manwaring published the not-so-humbly titled *The Cabinet and Chair-Maker's Real Friend and Companion* or *The Whole System of Chair: Making Made Plain and Easy*. Manwaring had previously published a guide to railing designs, and he spearheaded the publication of *One Hundred New and Genteel Designs, Being the Most Approved by Present Taste* by the Upholstery Society. Considered a lesser, peripheral member of the great London cabinet makers of the late eighteenth century, Manwaring forged an interesting pre-manufacturing entrepreneurship that can be seen conceptually as a bridge to the hyper-consumption of the late eighteenth century that continued into the nineteenth century and beyond (Figure 7.1).

To date, I have hand drawn sixty-seven chairs that are featured in Manwaring's *Cabinet-Maker's Companion* and, with master printmaker Janis Stemmermann, have developed a series of copper plate etchings based on these drawings. Both acts of drawing are efforts to embody the builderly knowledge

DOI: 10.4324/9781003457749-10

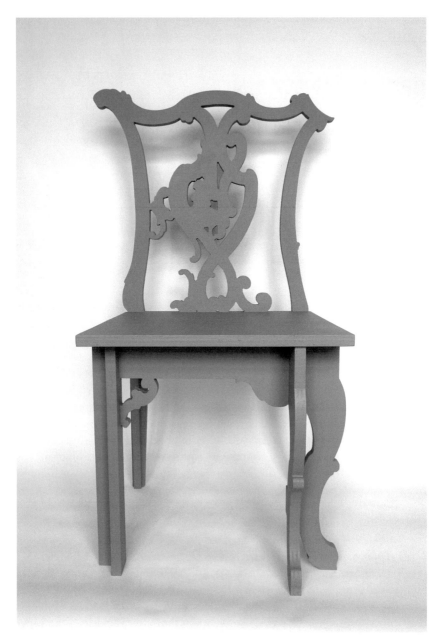

FIGURE 7.1 Annie Coggan, Being Manwaring prototype 2023, CNC cut plywood, fabricated by Caleb Crawford, Christian Adamik, and Annie Coggan.

of Manwaring's work. Antiquarian and scholar R.S. Clouston looks down on the drawings attributed to Manwaring, dismissing them as poorly proportioned and drawn without proper knowledge of perspective and depth of field. Instead, I propose they are regarded as process drawings for actual built constructions and the publication regarded as an example of the energy and exuberance of the printing culture of eighteenth-century London.

I initiated the practice of copying the chair drawings in order to answer questions about Manwaring's intent and a primary question that arose in my examination of his work: is Manwaring a carpenter or an engraver caught up in eighteenth-century print culture? Drawing, or more blatantly copying, is a definitive method of understanding the proportional system of the chairs. The majority of the chairs that I drew are based on the chair's seat back, as the area from the top of the seat to floor are essentially just squares. Manwaring created a box frame for the seat and simple coplanar legs that can be embellished with an intricate system of brackets and filigree to adorn the surface of the front-facing leg. Aside from his forensic essay on wood glues in the introduction of *The Cabinet and Chair-Maker's Real Friend and Companion*, these drawing proportions point to a desire on Manwaring's part to make the construction more straightforward and possibly more economical for his friend, the cabinet maker.

It was viewing the folio of *One Hundred New and Genteel Designs, Being the Most Approved by Present Taste* in the Victoria and Albert Museum that pushed me to engage with the actual manner in which the books were made. The special collections hold a 1760 folio volume with a library plate from the great aesthete Horace Walpole. This collection is aptly described in the article "Smith, Manwaring, Sayer and a Newly Discovered Set of Designs" by Christopher Gilbert. Gilbert frames the improvisational and ad hoc quality of these portfolios. Robert Sayer, a Fleet Street print and map seller, encouraged Manwaring to collect a variety of strike offs and lesser designs from greats like Ince and Mayhew, and possibly Thomas Chippendale, to capitalize on the furniture pattern book craze initiated in the 1750s. The drawings in these volumes are not formatted consistently, are of differing paper stock, and are in a variety of embossed framing formats. The improvisational quality of the volume illuminates the eighteenth-century urgency to publish quickly in order to compete; the printer had to use the materials on hand to win the race for the next great furniture pattern book.

There is this certain urgency of London's eighteenth century that I wanted to explore in a traditional drawing technique of copper plate printing. My original Manwaring drawings are literally "built" from a series of cross hairs, center lines and alignment marks, and construction guidelines to build the drawing. These construction lines don't translate well on the copper plate; the drawing in the printed medium must be a

precise translation of the chair without the querying lines of my experiential sketches. With a soft ground coating on top of the copper plate, the pencil mark can only go in one direction. Therefore, the drawing process on the plate is shockingly swift; a drawing can be put down in fifteen minutes once the maker knows the desired effects. This is illuminating considering the vast number of iterations of chairs that Manwaring or any designer was able to produce and get out into a pattern book volume. This expediency suits the energy of the *One Hundred New and Genteel Designs* volume, where quick, concise images were drawn to go with the strike offs already at hand in the print shop. Understanding and experiencing the process of copper plate printing also gives credence to the awkwardness and mistakes found in Manwaring's series of designs. If the printer is standing over you to get the plate printed, you might just forget a back leg or skew a perspective too tightly. It was the idea of the chair that was important, not the image in the book. The image was to generate a conversation between maker and client, not to be understood as a product.

The next aspect of the project of embodying Manwaring's work was to recreate two full-scale chairs. Manwaring's drawing style was direct and efficient. His peers, Thomas Chippendale, William Ince, and John Mayhew wanted to illustrate multiple styles on one page; they left a discreet space between two styles. Manwaring very directly placed the two styles side by side in his design books, creating a delightful chair monster for the audience's consumption. Now, our twenty-first century eyes are accustomed to such a mash up both visually and technologically. A CNC router can easily take on the rococo vocabulary, as well as the asymmetry and kinetics that Manwaring's drawings provide. Since there is no record of any physical Robert Manwaring chair, this chair joins the legions of designs "attributed" to Manwaring, all built manifestations of Manwaring's print output and vivid imagination.

With this printing project and ultimately building of full-scale chairs, I have become a practitioner of the past, someone who wants to experience material culture through action and endeavor. Little is known of Robert Manwaring the designer—his four volumes of furniture and railing design books are all we have. But mimicking Manwaring's chairs via a drawing, printing techniques, and building has enabled my understanding of his priorities of the chair design—simple in construction, made for the cabinet maker's ease. My practice has also led to my evaluation of Manwaring as more of a character of London and eighteenth-century print culture, a hustler if you will. His output of only the four minimal texts published between 1763 and 1765 illustrates his desire to mimic the fame and fortune of Chippendale. Manwaring sidestepped the need for a physical output of furniture and cabinetry and achieved greatness through his quirky and naive, but deeply expressive, drawings and engravings (Figures 7.2–7.4).

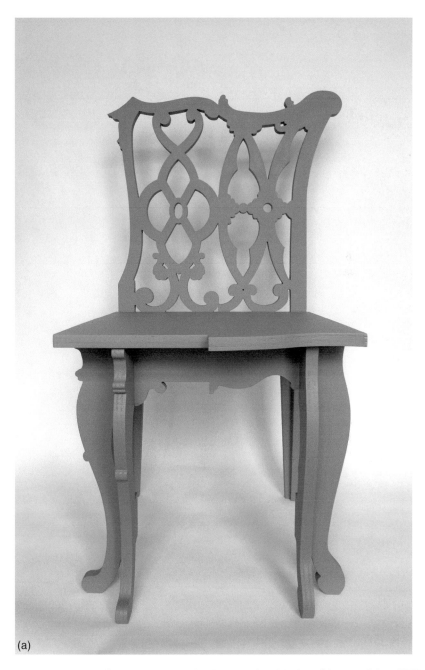

(a)

FIGURE 7.2 (a)–(g) Annie Coggan, Being Manwaring 2023, etchings on Rives BFK paper printed in an edition of 15, printed by Janis Stemmermann, published by Russell Janis Projects, Brooklyn, NY. *(Continued)*

(b)

FIGURE 7.2 *(Continued)*

(c)

FIGURE 7.2 *(Continued)*

(d)

FIGURE 7.2 *(Continued)*

(e)

FIGURE 7.2 *(Continued)*

(f)

FIGURE 7.2 *(Continued)*

(g)

FIGURE 7.2 *(Continued)*

FIGURE 7.3 Annie Coggan, Being Manwaring prototype 1 2023, CNC cut plywood, fabricated by Caleb Crawford, Christian Adamik, and Annie Coggan.

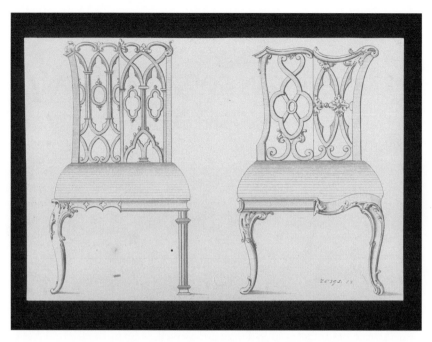

FIGURE 7.4 Annie Coggan, Being Manwaring prototype 2 2023, CNC cut plywood, fabricated by Caleb Crawford, Christian Adamik and Annie Coggan.

Bibliography

Clouston, R. S., Minor English Furniture Makers of the Eighteenth Century. Article II-Robert Manwaring, *The Burlington Magazine for Connoisseurs*, May, 1904, Vol. 5, No. 14 (May, 1904), pp. 173–8. Burlington Magazine Publications Ltd.

Gilbert, Christopher, and Manwaring Smith, Sayer and a Newly Discovered Set of Designs, *Furniture History*, Vol. 29 (1993), pp. 129–33. London: The Furniture History Society.

Manwaring, Robert, and Robert Pranker. *The Cabinet and Chair-maker's Real Friend and Companion, or, The Whole System of Chair-Making Made Plain and Easy*. London: Printed for Henry Webley, 1765.

Society of Upholsterers and Cabinet Makers, London, Robert Manwaring, Thomas Chippendale, William Ince, Thos Johnson (Thomas), John Mayhew, *The IId edition of Genteel Household Furniture in the Present Taste*. London: [publisher not identified], 1762.

8

EARTH-EATING IN GOLDEN AGE SPAIN

On the Pleasure of Clay and the Secrets of Women

Elliot Camarra

In seventeenth-century Madrid, imported red clay vessels known as *búcaros* fed a notorious infatuation among aristocratic women. These vessels were manufactured in Portugal, as well as Spanish-colonial Mexico, Panama, and Chile, each with distinguishing regional characteristics. When arranged in Spanish interiors, the porous earthenware was used to store water, which evaporated through its unglazed walls, cooling, humidifying, and scenting the hot, dry air. This evaporative process simultaneously chilled water for drinking, imbuing the remaining liquid with a desirable earthy flavor. Period descriptions of the fashionable pottery portray it as luxurious, mysterious, and highly sensual. For many of the women enamored with *búcaros*, sensual engagement culminated not only in feeling their burnished smoothness or sipping the cooled and flavored water they contained, but in eating the prized vessels themselves. This unusual relationship with a domestic object unsettled many onlookers, who often framed the phenomenon in the language of vice, insatiability, and transgression. The compulsion did carry physical risk. When María Luisa de Orléans, Queen of Spain (known to frequently indulge in the habit) died of poisoning, her autopsy suggestively records that she had been eating *búcaros* from Chile.[1] Yet consuming this pottery also promised numerous rumored benefits, including improved complexion, as well as hallucinations and even contraception—seemingly worth the risk. While it is difficult to know which, if any, of these infamous effects were sought by the women who consumed *búcaros*, their notoriety alone suggests the vases offered Golden Age women an opportunity for mental and physical expansion beyond the borders of social and cultural

DOI: 10.4324/9781003457749-11

expectation. Attitudes toward and beliefs surrounding *búcaros* illuminate the strictures under which this class of women lived, as well as a vital female culture within those strictures. Stimulating uncanny encounters within the household interior, búcaros offered women experiential opportunities that defined and transgressed the boundaries of acceptability in seventeenth-century Spain.

Porous, polished, red clay *búcaros* were considered to be roughly sortable by aesthetic markers (the high polish and dimpling on Mexican versions differed from the matte and punctured surfaces of the Portuguese or the occasionally gilded and painted bodies of Chilean vessels). As Guadalajara became the center of production, *búcaros* manufactured there came to be known to smell and taste best[2] (Figure 8.1).

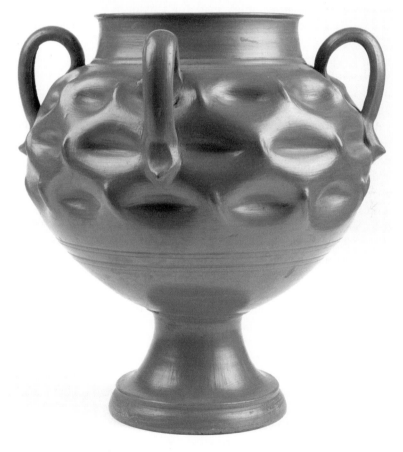

FIGURE 8.1 Unpainted earthenware dimpled ceramic Bucaro vase, Tonalá, Mexico (1600–1700). © Victoria and Albert Museum, London.

Traditional western Mexican ceramics, such as those of the Capacha (Colima) and Opeño (Michoacán), feature similarly burnished mono-chromatic forms stretching back millennia.[3] In the characteristic gloss of Guadelajaran *búcaros*, one might trace an ancient, pre-Hispanic tech-nique of once-fired burnished earthenware.

While larger vessels were used to store water, smaller beakers and cups—often punched, stamped, or incised—could be put to personal use. The pleasure of consuming water cooled by these fine and fragrant vessels escalated, for many women, into the notorious habit of ingesting them— a type of geophagia, or earth-eating. Early-twentieth-century German anthropologist and historical geographer Berthold Laufer cataloged in-ternational instances of geophagy, most often in the form of raw earth, but occasionally as formed and fired vessels as well. Laufer describes the "craving for the *búcaro* pottery made of a reddish, odoriferous clay on the part of Peruvian and Portuguese women alike," emphasizing the great distances over which diverse groups of people concurred that "certain clays have an agreeable and spicy flavor and that they are attracted to them irresistibly."[4] While a Portuguese-influenced habit of eating clay and drinking clay-flavored water was already present on the Iberian Peninsula by the fourteenth century, well before the arrival of American *búcaros*, an influx of coveted Guadalajaran vessels magnified the habit and its no-toriety, giving rise to the seventeenth-century phenomenon referred to as bucarophagy.

Thin walls and low firing temperatures rendered *búcaros* fragile and liable to break in transport between the Americas and Spain, yet their unique sensory qualities sustained their value and marketability even as shards. Most *búcaros* exported from the Americas were sent to Spain and Portugal, but many others went to Italy and elsewhere in Europe.[5] These fervently collected objects of wonder were displayed in aristocratic homes alongside other symbols of taste, like porcelain and Venetian glass, earn-ing a place "if not in the dining room or in the kitchen—as a showpiece among the boudoirs of women."[6] In a letter from the seventeenth-century Florentine philosopher and scholar of *búcaros* Lorenzo Magalotti to Mar-quise Ottavia Strozzi (who owned around 300 of these vessels), Magalotti reports, "everywhere the curious, the erudite, the philosopher, observes them, studies them, reasons about them. The courtier, the soldier, the prince, once they come to know them, they prize them ... the princesses adorn themselves with them ... the ladies crave them ... and Lady Mar-quise Strozzi falls in love with them."[7] As Magalotti's chronicle reveals, of all its admirers, women were most associated with this pottery, and considered its most avid enthusiasts.

In seventeenth-century Spain, rigidly conceptualized femininity demarcated social expectations of women, as expressed in period texts like Luis de Léon's *La perfecta casada* (*The Perfect Wife*, 1583). Léon's late-sixteenth-century manual for recently married women charted the ideal wife: silent, obedient, and out of public as much as possible. She should birth, breastfeed, and educate her children, using her own body to do so. On average, women married in their early twenties—varying minorly by region—and men married only slightly later.[8] A woman's presumed fundamental disobedience necessitated her protection from both herself and the predatory world outside.[9] As in most Mediterranean countries at the time, women's seclusion mediated this perceived risk—a technique applied not just to noblewomen, but to lower class women as well. In Fray Miquel Agustín's 1617 handbook for peasant households, he details exemplary comportment of unmarried daughters—eyes to the ground, keeping close to their mothers when outside the house, faces partially obscured by a shawl.[10] While this ideal of sheltered and out-of-sight women was not always possible for widows or those working to support their families, noblewomen were more easily sequestered in the home. Male family members could provide protection for obedient daughters and wives, while the church did the same for women who chose religious life instead.[11]

Búcaros made their way into female spaces in domestic and religious contexts alike, passing from the expansive space of the New World to scent the protected interior. Many paintings of *búcaros* exhibit this crossing, displaying material sensuousness and evoking distant locales. Royal portraits such as Alonso Sánchez Coello's *Doña Juana de Mendoza, duquesa de Béjar, con un enano* (1585) and Diego Velázquez's *Las Meninas* (1656) picture young women receiving *búcaros*. The Spanish royal interior of Velasquez's *Las Meninas* is rife with colonial imports of Mexican red dye, silver, and clay (Figure 8.2). Vanitas still lifes reinforced the place of *búcaros* among other luxurious household objects. In Juan Bautista De Espinosa's 1624 *Still Life of Silver Gilt Salvers, a Fluted Cup, Red Clay Bowls, Salt Cellars, Flasks of Water and Wine and Other Objects*, *búcaros* sit prominently among elaborate tableware on a crisply starched tablecloth (Figure 8.3). The roughly symmetrical composition comprises sparkling metal serving dishes and cutlery punctuated intermittently by shapely Venetian glass, with dark red *búcaros* set at each corner. Water droplets visibly bud like sweat on the clay vessels. Across the table's edge, three oranges are evenly spaced. Two whole fruits nearly touch the painting's border, and a third, cut in half, faces up at the center—rendered visually parallel to the circular rims of the sweating *búcaros* filled with water, drawing a connection between clay vessels and

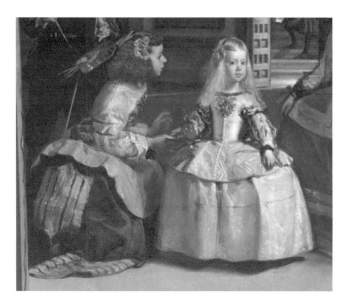

FIGURE 8.2 Detail of Diego Velázquez, *Las Meninas*, 1656. Oil on canvas. Museo del Prado, Madrid. © Photographic Archive Museo Nacional del Prado.

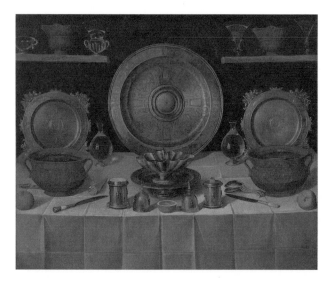

FIGURE 8.3 Juan Bautista De Espanosa, *Still Life of Silver Gilt Salvers, a Fluted Cup, Red Clay Bowls, Salt Cellars, Flasks of Water and Wine and Other Objects*, 1624. Oil on canvas. Masaveu Collection, Madrid. © Of the reproduction: Fundación María Cristina Masaveu Peterson, 2013.

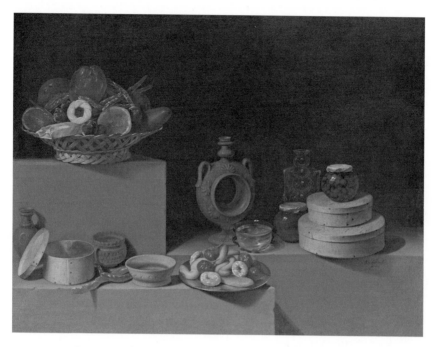

FIGURE 8.4 Juan van der Hamen y León, *Still Life with Sweets and Pottery*, 1627. Oil on canvas. National Gallery of Art, Washington DC. Samuel H. Kress Collection

juicy citrus. In Juan van der Hamen y León's 1627 *Still Life with Sweets and Pottery,* confections sprawl across multi-leveled stone plinths, comprising sweets typically served by the upper classes of Madrid on special occasions (Figure 8.4). On the upper left plinth, a basket contains a carefully arranged assortment of dried fruits. At the center, pastries and dried figs top a silver platter, amid circular boxes of marzipan. Glistening, clear glass jars hold preserved quinces, beside which a small glass cup filled with water conveys luxurious material delicacy. Among these sweets are four pieces of unglazed red pottery, three of which, of a deeper red, appear to be *búcaros.* The tallest, a spouted vessel with two handles, features a ring-shaped body with a central void through which the painting's black background is visible. The other two *búcaros* are smaller, perhaps for personal use, one in the form of a handled mug and the other a miniature vase. Such paintings record the residence of *búcaros* in European interiors in shimmering detail.

In his 1853 travelog *Wanderings in Spain,* nineteenth-century writer Théophile Gautier offers a helpful explanation of the way in which *búcaros* were enjoyed. Although written well after their introduction to

the country, Gautier's lengthy account demonstrates an enduring fascination with the vessels, attentively setting the scene of their domestic use:

> Six or eight [*búcaros*] are placed upon small marble tables or the projecting ledges round the room and filled with water. You then retire to a sofa, in order to wait until they produce the customary effect and to enjoy it with the proper degree of calm. The clay soon assumes a deeper tint, the water penetrates through its pores, and the *búcaros* begin to perspire, and emit a kind of perfume which is very like the odor of wet mortar, or of a damp cellar that has not been opened for some time. This perspiration of the *búcaros* is so profuse, that at the expiration of an hour half the water has evaporated. That which is left has got a nauseous, earthy, cisterny taste, which is, however, pronounced delicious by the *aficionados*. Half-a-dozen *búcaros* are sufficient to charge the air of a drawing-room with such an amount of humidity that it immediately chills anyone entering the apartment and may be considered as a kind of cold vapor-bath. Not content with merely enjoying the perfume and drinking the water, some persons chew small pieces of the *búcaros*, which they swallow after having reduced them to powder.[12]

Gautier reveals the sensuality of the *búcaro*—evoking its perspiration and earthy scent, air "charged" with cold vapor, sipping cool water, chewing clay. Natacha Seseña has noted the absence of writing on *búcaros* from Early Modern Spanish historians (a point observed by Hispanist Alfred Morel-Fatio in the nineteenth century as well), attributing the omission to modesty.[13] Outside observers, however—frequently Italian or French— more often recorded the presence and use of *búcaros* in domestic female spaces. French countess and writer Marie-Catherine D'Aulnoy, for example, lived in Spain between 1679 and 1680 and recorded her travels in a series of letters published as *Relation du voyage d'Espagne* (1691). In her eighth letter, she recounts a visit with the countess Monteleón and a group of other aristocratic women, in which, after snacking on dry jam, chocolate in porcelain cups, and biscuits, several women moved on to eating *búcaros*. She remarks on their "great passion for this earth, which usually causes them oppilations; their stomachs and bellies swell and become hard as a stone, and they are yellow as quinces."[14] In his 1677 inventory of the extensive cabinet of curiosities belonging to Bolognese nobleman Fernando Cospi (a collection which included numerous *búcaros*), Lorenzo Legati recounts a friend's visit to Naples. While there, this friend "observed a Princess who used to eat [*búcaros*] as others would eat pastas from Genoa. Offering some to him, she even invited him to taste them.

Showing him various cabinets full of similar vases, she said that she was planning to eat them all in a few months."[15] Both D'Aulnoy and Legati describe *búcaro*-eating women with beguiled curiosity, hinting at the habit's waywardness. D'Aulnoy depicts destructive bodily effects which do nothing to deter the ladies with whom she dined from the practice, while Legati's earth-eating princess offers a taste of her private *búcaro* collection to a curious male visitor in an unusual encounter between man, woman, mouth, and domestic object.

One does not often hear of a highly prized vase destroyed by the mouth of a lady. Sofia Navarro Hernandez has framed this habit as an addictive, contagious ritual, amplified by the difficulty of the pottery's acquisition and the anticipation and uncertainty as to its physical effects.[16] The earthenware could be consumed in various ways—some combined it with frozen water in a kind of sorbet, while others preferred sucking on broken fragments.[17] An equivalence between *búcaros* and tempting desserts is implied in paintings such as León's *Still Life with Sweets and Pottery*, which features *búcaros* among elaborately staged confections, as if equally irresistible. Peter Stallybrass has described the mouth as a surveilled location on the bodies of Early Modern women, "the threshold of the enclosed body."[18] The "correct" female mouth was closed to the world. Yet bucarophagy implicated a mouth wide open.

Descriptions of these vessels consistently allude to the ways they seduced the senses; their burnished smoothness, aroma, and flavor had a strong enough impact that someone might be compelled to "nibble" a vase. D'Aulnoy described the *búcaro* almost as if living: "It seems to boil when [water] is in it, at least one sees it restless and trembling (I don't know if this can be said), but when one leaves it there a little while, the cup empties itself completely, so porous is this earth; it smells very good."[19] Lorenzo Magalotti, seventeenth-century scholar of *búcaros*, recorded women's growing "passion" and "frenzy" for the vases, "amidst curiosity, luxury, and imagination."[20] This domestic object is rendered irresistible, "a thing-ly seducer," a phrase recently applied by Anna Grasskamp to sixteenth-century Nuremberg vessels incorporating spiral-shaped shells alluding to the female breast.[21] Pointing to visual and tactile associations between porcelain and shells or shells and breasts, Grasskamp considers the way these vessels "explicitly address the erotic implications of engaging with surfaces."[22] In this way, the Nuremberg vessels offered their male collectors an encounter with the fantasy of female bodies. The smooth, earthy burnish of *búcaros* attracted touch as well. Yet unlike the sensual encounter between a man and his collection described by Grasskamp, *búcaros* were experienced by and among women experimenting privately. And while the Nuremberg vessels seduced with sexually suggestive shapes,

búcaros were pharmacologically provocative, with risky physical side effects pertaining to female sexuality, namely that of contraception.

Scholars of Early Modern medicine, such as Alisha Rankin and Katherine Park, have discussed manuscripts produced by women as part of a genre of medicinal books of secrets. Park's double definition for the medical category known as "secrets of women" comprises both knowledge of the female reproductive system and experiential, bodily knowledge transmitted by word of mouth, all of which contribute to what Rankin calls "the hidden nature of female culture."[23] Often occurring in female-gendered spaces within the home, the practice of bucarophagy seems to have inspired a similarly anxious fascination, charged by the inaccessibility of female boudoirs, the communities that existed within them, and the bodies that consumed the clay. Reproductive implications of the "secrets of women" are rooted in the importance placed on experiential ways of gaining bodily knowledge and the choice to communicate that knowledge or not.[24] While information and advice shared between seventeenth-century women about sexual practices is largely unrecorded, Inquisition records affirm that this sharing took place.[25] Popular ideas about búcaros convey that bodily knowledge communicated through networks of women inspired anxiety for those outside. The vessels were associated with deceitful women who subverted male authority by regulating their bodies in unseen ways, such as using the internal "blockages" allegedly caused by their consumption to delay menstruation and work as a form of contraceptive. Park describes Early Modern writing on women's health as "haunted" by the "enigma of the interiority of the female body," or a certain fixation on the invisibility of what is contained inside.[26]

Concerns about visibility, secrecy, and female reproduction were similarly entangled in seventeenth-century conversations about women's dress, as demonstrated by Amanda Wunder's work on the Spanish *guardainfante*, an exceedingly wide hoop support worn under skirts[27] (Figure 8.5). In 1639, King Philip IV of Spain publicly banned the *guardainfante* for all women other than prostitutes. Powerful men imagined the garment as a tool for concealing pregnancies, despite a lack of evidence or logic. The *guardainfante* was considered dangerous, corrupting, subversive, and acquired a reputation not just for hiding secret pregnancies, but for obstructing legitimate ones as well.[28] Visual obstruction of female bodies beneath the *guardainfante* emphasized what men perceived as the dangerous inaccessibility of female culture—the secrets of women.

Issues of visibility also challenged attempts to understand bodily effects of consuming *búcaros*. Negative physical symptoms were often diagnosed broadly as what D'Aulnoy and others called "oppilations." To cure these oppilations, or obstructions, doctors recommended women drink steel

FIGURE 8.5 Workshop of Diego Rodríguez de Silva y Velázquez, *Infanta Maria Theresa*, 1653. Oil on canvas. Museum of Fine Arts, Boston. Photograph © 2024 Museum of Fine Arts, Boston.

water (water in which a hot iron rod was drenched).[29] The steel water remedy was also used to "re-awaken" women who had feigned fainting in the popular ruse to avoid unwanted suitors. Golden Age playwright Lope de Vega centers the fainting ploy in his *Steel of Madrid* (1608), in which a wealthy young noblewoman named Belisa—whose beautiful complexion is owed to a habit of chewing *búcaros*—affects faux illness to facilitate her sexual transgression.[30] Belisa contrives a plan to fake oppilations after consuming clay in order to interact with Lisardo, a young man of lower rank to whom the constantly chaperoned young woman is out of reach. A visit from the young man's servant in the guise of a doctor who advises the steel water cure and long walks enables otherwise impossible meetings with Lisardo. When Belisa's father arranges a more suitable match for her, Belisa "faints," avoiding the suitor. To wake her, the doctor fetches steel water in a small *búcaro* found up her sleeve.[31]

Belisa's hygienic walks—considered intrinsic to the effectiveness of the steel water cure—enable her secret meetings, ultimately culminating in pregnancy. In an essay on the representation of illness in Golden Age theater, Maríaluz López-Terrada underscores the double entendre de Vega employs with the concept of oppilation—simultaneously communicating both illness and pregnancy. Physician Nicolás Monardes writes on the usefulness of steel water for women in his 1574 *Dialogue on Iron and Its Great Qualities*, describing how the steel water cure resumed menstrual cycles stalled by oppilations, emphasizing the sexual implications of the cure itself.[32] While amenorrhea, or lack of menstruation, caused by oppilations could signify pregnancy, as in de Vega's play, consuming clay that causes these obstructions was also perceived as a contraceptive. This duality is not unlike that of the anxiety surrounding the *guardainfante*—imposing onto the garment the capacity to subvert male authority by the contradictory abilities to both hide illicit pregnancies and hinder those that were legitimate.[33]

While it is difficult to understand and problematic to generalize seventeenth-century women's perceptions of their own sexuality, hints of varying attitudes come through period literature written by women, often focused on female relationships. In the collection of stories published by Spanish feminist author María de Zayas in 1647 as *Desengaños Amorosos* (*The Disenchantments of Love*), a series of women narrate true stories to Lisis, an aristocratic bride-to-be before her wedding, intending to "disenchant" her by revealing the deceptiveness and danger of men. Throughout these stories, sexual attraction is repeatedly described as "appetite," particularly that of easily bored men: "they're attracted to beauty or dominated by their appetites or they crave satisfaction."[34] This appetite for beauty, often characterized as violent, conjures images of earth-eating

women, possessed by boredom, craving the satisfaction of consuming a vase against all logic. Lorenzo Magalotti described witnessing the way women placed their lips on pottery, a sip becoming a kiss:

> a certain pretty little joke that this moistened earth makes to the lips, gently sticking to them, without them noticing it before they break away. But whoever is used to it, to multiply these playful kisses, during a same drink detaches the mouth more than once from the rim of the *búcaro*; the newer it is, the more sticky and tenacious; and the hand that wants to detach it from the mouth, before letting it go, pulls the lip more than a little, and in leaving it, it produces a smack that sounds like a farewell kiss.[35]

In some ways, the scene sounds whimsical, childlike, yet hints of a dangerous, fundamentally sexual female nature are close at hand. For many, bucarophagy was considered sinful and strange. A 1698 letter from the Marquis d'Harcourt in Madrid regarding the delivery of numerous *búcaros* to Madame de Torcy notes the contraceptive potential of these vessels, explaining that "it is forbidden for priests to give women absolution if they eat them, because it is contrary to creation." Yet in the case of his own wife, he will "let her eat as many as she wants, and thus she will not ruin me in the end by being too fertile."[36] Meanwhile, D'Aulnoy observed in a letter, "Women have such great passion for this earth ... If one wants to please them, he should give them these *búcaros*, which they call *barros*; and often their confessors do not impose on them any other penitence than to spend one day without eating them."[37] In 1596, Father Torrejón, the very first Spanish author to write of this earth-eating craze, similarly described women's bucarophagic pleasure, and noted the difficulty of the job faced by confessors attempting to put a stop to the vice.[38]

Yet despite taboo and priestly discomfort, búcaros had a place in convents as well. In Mexico, Spanish priests set up workshops where *búcaros* were manufactured for export, becoming the most important center of production.[39] In Chile, nuns undertook the manufacture of scented pottery. The Poor Clares, an order of Franciscan nuns, knew of *búcaros* as early as 1584 and became famous for their production, particularly in Spain.[40] Nuns not only constructed these vessels but lived with them as well. Copious Guadalajaran and Chilean *búcaros* were shipped from patrons or relatives to convents in Madrid, such as the Descalzas Reales.[41] Encounters between nuns and their pottery are evinced by chewed vases and texts penned by sisters themselves.[42] Sister Estefanía de la Encarnación from Madrid, for example, recounted being twelve years old in 1609 when the devil inclined her to eat a vase: "it seemed good to me and

I wanted to taste it, I did it and I was so taken by that earthy smell that, with the craving that a vice must engender for what it is inclined to, I gave in to eat it."[43] Not even nuns could resist the debaucherous pleasure of consuming this clay.

Seventeenth-century Mexican scholar and nun Sor Juana Inés de la Cruz moved from her role as a lady-in-waiting to devote herself to her studies in the protected space of the convent. When búcaros appear in the writing she produced there, they maintain their popular romantic implications. In her poem, Romance #48 or *In Reply to a Gentleman from Peru, Who Sent Her Clay Vessels While Suggesting She Would Better Be a Man*, de la Cruz responds to a man who has delivered búcararos as gifts. The poem sends a reply out across the threshold. She writes, "From such lowly matter/ forms emerge that put to shame/the brimming Goblets made of gold/from which Gods their nectar drained./Kiss, I beg, the hands that made them,/ though judging by the Vessel's charm/—such grace can surely leave no doubt—/yours were the hands that gave them form." Elane Granger Carrasco highlights the innuendo in de la Cruz's use of the word *filis*, referencing the pottery's carved designs and the sharp tool used to incise them, its meaning encompassing grace, dexterity and, in Greek, a lover.[44] Although meant as a ploy before launching an offense at the man's desire to abstract her body, the insinuation reinforces a correlation between *búcaros* and sexuality, even from within a convent's walls.

Despite its sinful connotations, nuns may have employed bucarophagia as a means of reaching a meditative state, visions, or hallucinations— colluding with vice to get closer to God. Sister Estefanía de la Encarnación described her experimentation with eating *búcaros* this way, saying that the effect for her was a feeling of love and Godly connection.[45] When the habit became addictive, however, she blamed the devil for distracting her from better deeds.[46] In Inquisition records, Lisa Vollendorf has located a subversion of the concept of women's sexuality as both barred and intrinsic by the many religious women who embraced "the physical in the name of spiritual fulfillment," not unlike Sister Estefanía's bucarophagy.[47] The drug-like, possibly hallucinogenic effect described by some, facilitating religious visions and meditation, suggests another opportunity to subvert confined space from inside. Perhaps the women who found freedom from patriarchal society within the confines of the convent's walls further surmounted female social confinement with yet another form of interiority— that of a wide open mind.

The physical decorum of civility, or the "'correct' techniques" of the sixteenth- and seventeenth-century European body, were theoretically rooted in the significance of "closed" versus "open," such as the ideal of the closed female mouth.[48] Protected by clear boundaries, the exemplary female body

was a "locked house."[49] A locked house promises chastity, vigilance, loyalty, and shelter for women perceived to be threatened by their own natures. Yet *búcaros* crossed this threshold from the outside in—entering female boudoirs and convents. In *The Poetics of Space* (1958), Gaston Bachelard theorizes the demarcation of the door: "At times, it is closed, bolted, padlocked. At others, it is open, that is to say, wide open."[50] Doors reflect difference—a cultural technique, as termed by Bernhard Siegert—operating "the primordial difference of architecture": inside versus outside.[51] Yet for aristocratic women, so often imagined as opaquely confined behind definitively closed doors, the entrance was occasionally left ajar. For Bachelard, the doorway is an expansive place of daydreams, desires, and temptations, "an entire cosmos of the Half-open."[52] And just as *búcaros* crossed the thresholds of protected homes, they crossed the threshold of bodies, too, by way of desirous mouths.

Through observations of women's intimate interactions with *búcaros*, one sees domesticity experienced with the utmost sensuality, and formality unraveled to the extent that one might break, dissolve, and consume an element of the highly designed interior, as if the clay elicited a certain unavoidable response. Even Lorenzo Legati, in creating his scientific inventory of *búcaros*, employed what Davide Domenici calls a "tongue testing" method to distinguish between places of origin, noting, for example, whether and how the vessels stuck to his tongue.[53] Yet descriptions of bucarophagy often express vice, bad habits, and addiction. Illicitness derived from escalation, as in Gautier's description of those women "*not content* with inhaling the perfume and drinking the water," moving on to chew and swallow pieces of pottery.[54] A customary pleasure accelerated into one more disconcerting: half-open door, wide-open mouth. To quote Anne Carson in a poem on eros, "It is the edge separating my tongue from the taste for which it longs that teaches me what an edge is."[55] Placing the mouth at the rim of a new *búcaro*, one approaches this edge and sticks to it. In a culture that valued a woman's steadfast heart, personal discretion, and devotion to the domestic interior, women transgressed bodily borders and limits, to taste and consume it—de Zaya's appetite, unleashed on the interior.

Bucarophagy rendered the mouth the mediator between an interior, hidden world and one that was exterior, physical, and expansive, manipulating space through the surreal act of eating treasured pottery. Yet what truly demarcates public versus private space is up for debate, whether delineated by earshot, visibility, or a locked door.[56] The nature of bucarophagy—taking place inside and among women curious about its physical effects—allowed for the by-passing of male gatekeepers. Invisible or obscured bodily experience, easily feigned for the sake of transgressive

acts, as done by Belisa, allowed for the transcendence of secluded space by way of the objects that embellished it. In *Women and Space: Ground Rules and Social Maps* (1981), Shirley Ardener states that "once space has been bounded and shaped" by social organization, "it is no longer merely a neutral background: it exerts its own influence." By their presence within it, *búcaros* seem to have transformed the domestic space into a place in which female delight and risky physical experimentation could transpire, contrary to social ideals defining the home as safe, internal, and sealed. Through its powerful influence, this pottery enabled sheltered women to explore both the close and the remote through body and mind. What is the distance to near? To far? To God? For many seventeenth-century women, bucarophagy closed the gap. In the words of Sister Sor Juana Ines de la Cruz, "art lifts a toast to appetite/in lovely Vessels of fragrant clay."[57]

Notes

1 Natacha Seseña, *El Vicio Del Barro* (Madrid: El Viso, 2009) 45.
2 Davide Domenici, "Tasting Clay, Testing Clay. Medicinal Earths, Bucarophagy and Experiential Knowledge in Lorenzo Legati's Museo Cospiano (1677)," *Cromohs* 22 (2019): 3.
3 Alberto Ruy Sánchez Lacy et al. "Ceramics from Tonalá." *Artes de México*, no. 14 (1998): 83.
4 Berthold Laufer, *Geophagy* (Chicago, IL: Field Museum of Natural History, 1930), 108.
5 María Concepción Garcia Saíz, "Mexican Ceramics in Spain," in *Cerámica Y Cultura: The Story of Spanish and Mexican Mayólica*, ed. Robin Farwell Gavin, Donna Pierce, and Alfonso Pleguezuelo (Albuquerque, NM: University of New Mexico Press, 2003), 189.
6 Lacy, 92.
7 Lorenzo Magalotti, "Lettera ottava," in *Varie operette del Conte Lorenzo Magalotti, con giunta di otto lettere sulle terre odorose d'Europa e d'America volgarmente dette buccheri e ora pubblicate per la prima volta* (Milano: Giovanni Silvestrini, 1825), 412.
8 James Casey, *Early Modern Spain: A Social History* (New York, NY: Routledge, 1999), 27–28.
9 Lisa Vollendorf, "Good Sex, Bad Sex: Women and Intimacy in Early Modern Spain." *Hispania* 87, no. 1 (2004): 3–4.
10 Casey, 204. Many lower class women worked in public spaces, such as fields or markets, and Mary Elizabeth Perry has demonstrated that in Seville, the shops, tools, and guild memberships of deceased husbands could be passed to their widows (as long as they did not remarry). See, Elizabeth Perry, *Gender and Disorder in Early Modern Seville* (Princeton, NJ: Princeton University Press, 1990), 15–17.
11 Vollendorf, 3–4.
12 Théophile Gautier, *Wanderings in Spain: With Numerous Engravings* (United Kingdom: Ingram, Cooke and Company, 1853), 89.
13 Seseña, 26.

14 Marie-Catherine D'Aulnoy, "Huitième Lettre," in *Relation du voyage d'Espagne* (Paris: E. Plon et cie, 1874).

15 Lorenzo Legati, *Museo Cospiano annesso a quello del famoso Ulisse Aldrovandi e donato alla sua patria dall'illustrissimo signor Ferdinando Cospi* (Bologna: Giacomo Monti, 1677), 272. Translated in Domenici, 10.

16 Sofia Navarro Hernandez, "Consumption: Addiction to Geophagy during the Golden Age of the Spanish Empire," in *Cultures of Contagion*, ed. Beatrice Delaurenti and Thomas Le Roux (Cambridge, MA: MIT Press, 2021), 170.

17 Domenici, 6.

18 Peter Stallybrass, "Patriarchal Territories: The Body Enclosed," in *Rewriting the Renaissance: The Discourses of Sexual Difference in Early Modern Europe*, ed. Margaret W. Ferguson, Maureen Quilligan, and Nancy J. Vickers (Chicago, IL and London: University of Chicago Press, 1986), 124, 138.

19 D'Aulnoy, "Huitième Lettre."

20 Lorenzo Magalotti, "Lettera ottava," in *Varie operette del Conte Lorenzo Magalotti, con giunta di otto lettere sulle terre odorose d'Europa e d'America volgarmente dette buccheri e ora pubblicate per la prima volta* (Milano: Giovanni Silvestrini, 1825), 455–6.

21 Anna Grasskamp, "Spirals and Shells: Breasted Vessels in Sixteenth-Century Nuremberg." *Res: Anthropology and Aesthetics* 67–68 (2017): 157.

22 Grasskamp, 147.

23 Alisha Michelle Rankin, *Secrets and Knowledge in Medicine and Science, 1500–1800*, ed. Alisha Michelle Rankin and Elaine Leong (Farnham and Burlington: Ashgate Publishing, 2011), 18. Alisha Michelle Rankin, *Panaceia's Daughters: Noblewomen As Healers In Early Modern Germany* (Chicago, IL and London: University of Chicago Press, 2013), 194 and John M. Riddle and J. Worth Estes, "Oral Contraceptives in Ancient and Medieval Times," *American Scientist* 80, no. 3 (1992): 226.

24 Katherine Park, "Secrets of Women" in *Secrets of Women: Gender, Generation, and the Origins of Human Dissection* (Cambridge, MA and London: MIT Press, 2006), 91.

25 Vollendorf, 11.

26 Park 95, 104.

27 Amanda Wunder, "Women's Fashions and Politics in Seventeenth-Century Spain: The Rise and Fall of the Guardainfante," *Renaissance Quarterly* 68, no. 1 (2015): 133–86.

28 Wunder, 145.

29 Maríaluz López-Terrada, "'Sallow-Faced Girl, Either It's Love or You've Been Eating Clay': The Representation of Illness in Golden Age Theater," in *Medical Cultures of the Early Modern Spanish Empire*, ed. John Slater, Maríaluz López-Terrada, and José Farnham Pardo-Tomás (Taylor & Francis Group, 2014), 172. Hernandez, 168.

30 López-Terrada, 173. Jorge Cañizares-Esguerra, "Clay Vessels," in *New World Objects of Knowledge: A Cabinet of Curiosities*, edited by Mark Thurner and Juan Pimentel (London: University of London Press, 2021), 93.

31 S. Griswold Morley, "El Acero De Madrid." *Hispanic Review* 13, no. 2 (1945): 166.

32 López-Terrada, 174, 176.

33 Wunder, 145.

34 María de Zayas y Sotomayor, *The Disenchantments of Love*, translated by Harriet Boyer (Albany, NY: State University of New York Press, 1997), 273.

35 Lorenzo Magalotti, "Lettera quinta," in *Varie operette del Conte Lorenzo Magalotti, con giunta di otto lettere sulle terre odorose d'Europa e d'America volgarmente dette buccheri e ora pubblicate per la prima volta* (Milano: Giovanni Silvestrini, 1825), 330, translated in Domenici, 12.
36 Seseña, 26.
37 D'Aulnoy, "Huitième Lettre."
38 Seseña, 17.
39 Saiz, 188.
40 Seseña, 20.
41 Saiz, 193.
42 Seseña, 18.
43 Seseña, 18. Translation mine.
44 Elane Granger Carrasco, "Sor Juana's Gaze in *Romance 48*," *Mester* 20: 21 (1991), 21 and Pamela H. Long, "*Bucarofagia: Una Lectura Alternativa Del Romance 48 de Sor Juana Inés de la Cruz*," in *Tempus Fugit: Décimo Aiversario de Destiempos*, 31.
45 "*Como era tan poco lo que comía, pues no llegó a ser de un real de a ocho, me parecía que no ofendía a Dios ... estas ten taciones causan tedio con el mismo Dios y a mi me engen draban amor, en toda mi niñez se me acuerda de haber esta do más recogida, más llegada a Dios.*" Seseña, 18.
46 Hernandez, 137.
47 Vollendorf, 9.
48 Stallybrass, 123–41.
49 Stallybrass, 127.
50 Gaston Bachelard, "The Dialectics of Outside and Inside," in *The Poetics of Space* (Boston, MA: Beacon Press), 222.
51 Bernhard Siegert, "Door Logic, or, the Materiality of the Symbolic: From Cultural Techniques to Cybernetic Machines," *Cultural Techniques: Grids, Filters, Doors, and Other Articulations of the Real* (Fordham University Press, 2015), 193.
52 Bachelard, 222.
53 Domenici, 12.
54 Gautier, 89.
55 Anne Carson, *Eros the Bittersweet* (Champaign, IL: Dalkey Archive Press, 1998), 52.
56 Shirley Ardener, *Women and Space: Ground Rules and Social Maps* (New York, NY: St. Martin's Press, 1981), 20, proposes gaze as a measure, along with Aida Hawile's suggestion of boundaries measured by earshot.
57 Sor Juana Inés de la Cruz, *Romance #48* or *In Reply to a Gentleman from Peru, Who Sent Her Clay Vessels While Suggesting She Would Better Be a Man.*

Bibliography

Ardener, Shirley. *Women and Space: Ground Rules and Social Maps*. New York, NY: St. Martin's Press, 1981.
Bachelard, Gaston. *The Poetics of Space*. Boston, MA: Beacon Press, 1994.
Cañizares-Esguerra, Jorge. "Clay Vessels." In *New World Objects of Knowledge: A Cabinet of Curiosities*. Edited by Mark Thurner and Juan Pimentel. London: University of London Press, 2021.

Carrasco, Elane Granger. "Sor Juana's Gaze in Romance 48." *Mester* 20, no. 21 (1991): 19–26.

Carson, Anne. *Eros the Bittersweet*. Champaign, IL: Dalkey Archive Press, 1998.

Casey, James. *Early Modern Spain: A Social History*. New York, NY: Routledge, 1999.

D'Aulnoy, Marie-Catherine. *Relation du voyage d'Espagne*. Paris: E. Plon et cie, 1874.

de la Cruz, Sor Juana Inés. *Romance #48 or In Reply to a Gentleman from Peru, Who Sent Her Clay Vessels While Suggesting She Would Better Be a Man.*

de Zayas y Sotomayor, María, and Harriet Boyer. *The Disenchantments of Love*. Albany, NY: State University of New York Press, 1997.

Domenici, Davide. "Tasting Clay, Testing Clay. Medicinal Earths, Bucarophagy and Experiential Knowledge in Lorenzo Legati's Museo Cospiano (1677)." *Cromohs* 22 (2019): 1–16.

Gautier, Théophile. *Wanderings in Spain: With Numerous Engravings*. Ingram, London: Cooke and Company, 1853.

Grasskamp, Anna. "Spirals and Shells: Breasted Vessels in Sixteenth-Century Nuremberg." *Res: Anthropology and Aesthetics* 67–68 (2017).

Hernandez, Sofia Navarro. "Consumption: Addiction to Geophagy during the Golden Age of the Spanish Empire." In *Cultures of Contagion*. Edited by Beatrice Delaurenti and Thomas Le Roux. Cambridge, MA: MIT Press, 2021.

Lacy, Alberto Ruy Sánchez, Charlotte Broad, Otto Schöndube, María Concepción García Saíz, María Angeles Albert, Kurt Hollander, Gutierre Aceves Piña, Karen Cordero Reiman, and Rubén Páez Kano. "Ceramics From Tonala." *Artes de México*, no. 14 (1998): 82–88.

Laufer, Berthold. *Geophagy*. Chicago, IL: Field Museum of Natural History, 1930.

Levitsky, Rachel. *Neighbor*. Brooklyn, NY: Ugly Duckling Press, 2020.

Long, Pamela H. "Bucarofagia: Una Lectura Alternativa del Romance 48 de Sor Juana Inés de la Cruz." In *Tempus Fugit: Décimo Aiversario de destiempos*. Mariel Reinoso Ingliso y Lillian von der Walde Moheno Mexico City, 2016.

López-Terrada, Maríaluz. 'Sallow-Faced Girl, Either It's Love or You've Been Eating Clay': The Representation of Illness in Golden Age Theater." In *Medical Cultures of the Early Modern Spanish Empire*. Edited by John Slater, Maríaluz López-Terrada and José Farnham Pardo-Tomás. Burlington, Farnham: Taylor & Francis Group, 2014.

Magalotti, Lorenzo. *Varie operette del conte Lorenzo Magalotti, con giunta di otto lettere sulle terre odorose d'Europa e d'America volgarmente dette buccheri e ora pubblicate per la prima volta*. Milano: Giovanni Silvestrini, 1825.

Morley, S. Griswold. "El Acero De Madrid." *Hispanic Review* 13, no. 2 (1945): 166–9.

Park, Katherine. *Secrets of Women: Gender, Generation, and the Origins of Human Dissection*. Cambridge, MA and London: MIT Press, 2006.

Rankin, Alisha Michelle. *Secrets and Knowledge in Medicine and Science, 1500–1800*. Edited by Alisha Michelle Rankin and Elaine Leong. Farnham and Burlington: Ashgate Publishing, 2011.

Rankin, Alisha Michelle. *Panaceia's Daughters: Noblewomen As Healers In Early Modern Germany*. Chicago, IL: University of Chicago Press, 2013.

Riddle, John M., and J. Worth Estes. "Oral Contraceptives in Ancient and Medieval Times." *American Scientist* 80, no. 3 (1992): 226–33.

Saíz, María Concepción Garcia. "Mexican Ceramics in Spain." In *Cerámica Y Cultura: The Story of Spanish and Mexican Mayólica*. Edited by Robin Farwell Gavin, Donna Pierce, and Alfonso Pleguezuelo. Albuquerque, NM: University of New Mexico Press, 2003.

Seseña, Natacha. *El Vicio Del Barro*. Madrid: El Viso, 2009.

Siegert, Bernhard. "Door Logic, or, the Materiality of the Symbolic: From Cultural Techniques to Cybernetic Machines." *Cultural Techniques: Grids, Filters, Doors, and Other Articulations of the Real*. New York, NY: Fordham University Press, 2014.

Stallybrass, Peter. "Patriarchal Territories: The Body Enclosed." *Rewriting the Renaissance: The Discourses of Sexual Difference in Early Modern Europe*. Edited by Margaret W. Ferguson, Maureen Quilligan, and Nancy J. Vickers. Chicago, IL: University of Chicago Press, 1986.

Vollendorf, Lisa. "Good Sex, Bad Sex: Women and Intimacy in Early Modern Spain." *Hispania* 87, no. 1 (2004): 1–12.

Wunder, Amanda. "Women's Fashions and Politics in Seventeenth-Century Spain: The Rise and Fall of the Guardainfante." *Renaissance Quarterly* 68, no. 1 (2015): 133–86.

9

AT THE EDGE OF THE EARTH

Virginia San Fratello

Familial Clay

Sometimes you have to examine the edge of the earth in the place where you are to find what you are looking for. Sometimes you don't even know what you are looking for, but you intuitively know it's buried just below the surface.

This is a story about a journey to discover my family's wild and ancestral clays. I started this journey in March 2020 when the University closed due to the pandemic. I decided to pack up my clay 3D printers, desktop printers, and robot arm, remove them from my laboratory and bring them home where I could have continuous access to them. My family and I subsequently decided to pack up all of this equipment in a U-Haul rental truck and drove it halfway across the country, from the coast of California to the high alpine desert of Colorado, and for the first time my partner, Ronald Rael, and I took all of our experiments out of the laboratory and into the landscape.

We set up our robot arm and 3D printers in the San Luis Valley where it meets the Taos Plateau, a place where adobe—a combination of sand, silt, clay, water, and straw—is dried in the sun, and is the traditional building material of the region. Adobe has been used in the construction of buildings for over a thousand years in this region, and we decided to literally build on this tradition of fabricating with mud using our robotic setups. We dug from a site where we knew the earth we harvested would have the right mixture of clay, silt, and sand based on the tacit knowledge of the locals. The earth we dug was free, and we did not have to dig deep—the right mix was directly located below the surface. All of the

DOI: 10.4324/9781003457749-12

earth we excavated is from alluvial soil deposits in a field adjacent to the site (within 500 m) and processed by hand through a 1/4″ (1 cm) screen to remove any large gravel from the mix. Chopped wheat and barley straw from a local farmer (14 miles, 26 km away) was combined with water and local soil in a portable cement mixer before being loaded into a hopper that would feed the adobe mixture through our robotic setup.

We decided to make a small building which we call the *Casa Covida*, a house for co-habitation built during the time of COVID-19. It is an experiment in combining 3D printing with indigenous and traditional building materials and methods that would employ both new and ancient ways of living. Throughout the design and fabrication of the *Casa Covida*, we were looking for opportunities to take the knowledge we had acquired in previous years with 3D printed clay and earth, and apply it to a house that would be occupiable and livable even if only in a short term context. We were also looking for ways to print quickly, to bring the process closer to a timeline that would be on par with the timeline required to build a stick-built house or masonry house (Figure 9.1).

The house is comprised of three interior spaces, each where two people can quarantine. There is a space for sleeping, bathing, and gathering around fire and food, and the spaces have openings to the sky, the horizon, and the ground. The central space contains a hearth surrounded by two *tarima*, or earthen benches, covered with woven textiles (Figure 9.2).

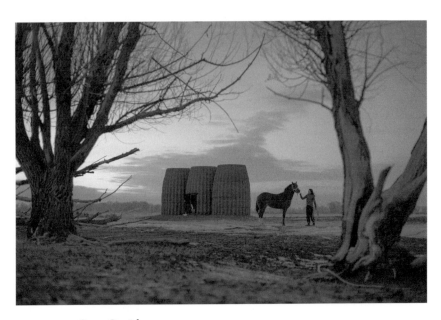

FIGURE 9.1 *Casa Covida.*

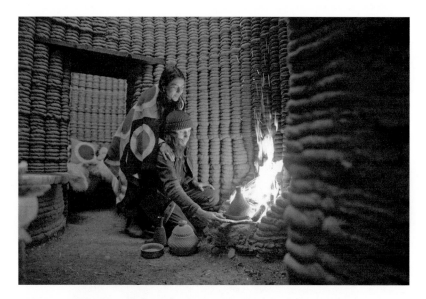

FIGURE 9.2 *Casa Covida* hearth.

The sleeping space is built of a platform constructed of locally harvested beetle kill pine covered with sheep skins and woven churro wool blankets and cushions designed in collaboration with Josh Tafoya, a local weaver (Figure 9.3).

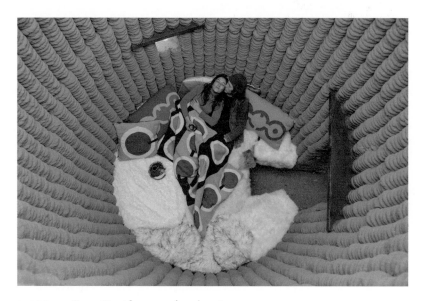

FIGURE 9.3 *Casa Covida* room for sleeping.

FIGURE 9.4 *Casa Covida* room for bathing.

Views of the landscape and the sky are framed by the adobe oculus. A lightweight, pneumatic roof—an ephemeral and synthetic addition to the structure that appears like a blooming cactus—can shelter the oculus from the occasional rain or snow in a landscape with an annual precipitation of only nine inches and also keep in heat from the hearth. The bathing space is filled with ancient waters from the deep aquifer below this mountain desert landscape, and the retention of heat is provided by the ground. Tumbled river stones surround the bath, and bathers can view the sky (Figure 9.4).

The door handles to *Casa Covida* were fabricated use the lost PLA process, which is the same as the lost wax process. We start by 3D printing a bio-plastic master that was then cast in the same adobe mixture used to fabricate the building, and when dry, the master was burnt out by pouring molten aluminum into the adobe mold. The aluminum came from cans collected from along the desert roadside by my son. Doors and lintels are also locally harvested beetle-kill pine, treated by flame-charring the exterior.

The interior space for gathering includes 3D printed cookware crafted using regional micaceous clay reminiscent of traditional New Mexico

Pueblo pottery, which can withstand the heat shock of the hearth, to cook locally grown beans, corn, and chiles. During the summer of 2020 the clay for the cookware was painstakingly gathered deep in the mountains of the Carson National Forest of northern New Mexico on an excursion led by Johnny Ortiz, a local potter and chef who graciously invited us to harvest clay from one of his family's primary ancestral clay deposits. We piled into two four-wheel-drive vehicles that could withstand the rough terrain of the forest and drove across the red earth until we arrived at a place where the ground glittered. There was a layer of mica covering the earth. We pulled over and moved in a single file into the forest with our shovels and buckets and began to lightly excavate the glistening micaceous clay from the edge of the earth. We did not dig too deep, we were asked to not wound the earth, to only take what we needed, no more, and no one would be allowed to return for a calendar year, which would give the scar time to heal (Figure 9.5).

FIGURE 9.5 Micaceous clay beanpot.

Processing the micaceous clay was laborious. The rocks and roots that we had collected as part of the harvesting needed to be sifted out, clay chunks had to be crushed and resifted, and the entire mixture wetted and dried and rewetted until a 3D printable mixture could be derived. We harvested enough clay to fabricate a bean pot, a tagine, a carafe, and several cups. Not many things give me more pleasure than sipping mezcal out of one of these cups today. I can taste the journey that I made that day when I dug my own wild clay from the edge of the earth.

Ancestral Clay

In 2021 my search for ancestral clay led me to Sicily. My grandfather immigrated as a child to the United States in the early 1900s through Ellis Island. Like many immigrants, his parents did not speak English, and when asked their surname, they said San Fratello, which is a small town on a hilltop in the Nebrodi Mountains of Messina, a province in northeast Sicily. I think it's natural sometimes to confuse who you are with where you come from. We consume the terroir of the places we live and it becomes a part of our genetic makeup, which is then passed on from one generation to another. My genes were telling me there was clay in or nearby San Fratello, and so I decided a visit was in order. I flew to Palermo, the capital of Sicily, and restlessly scoured the city searching for information from local potters about where clays could be found and had the good fortune to come across a collective called MUD lab. The owner of the laboratory pointed me to Stefano di Camastra, a small town known as "ceramic heaven" in Sicily for its traditional architectural ceramic production of bricks, mosaics, tiles, water pipes, and shingles. Clay was used to create almost the entire town in the seventeenth century, and it was located about thirty minutes from San Fratello. I drove to Stefano di Camastra, where I was generously gifted twenty-five kilos of the local earthenware clay.

I used this clay to fabricate the *Uphoria Amphora* vessels. They are objects that look both back and forward simultaneously. They are crafted of my ancestral clay, and they are representations of the journey to my homeland to discover the geology of my ancestors. Each vessel is an investigation into a traditional form that can be found in ancient Mediterranean amphorae and is reinterpreted by exploiting the opportunities and limitations that occur when 3D printing with clay. The wavy texture on the surface of the vessels is created through a collaboration with the robot. The robot extrudes a long line of clay which I then pinch and twist into a curl. These curls and the color of the clay are similar to that of my own hair so I knew this clay was in my DNA (Figure 9.6).

FIGURE 9.6 *Uphoria Amphora.*

Collaborating with my clay 3D printer has allowed me to edge away from complete reliance on a 3D printer itself to fabricate my designs. Since the journey to Sicily, and upon my return to California, I have started working co-botically with the hardware and the earthenware to make vases and dishes that are more original and impossible to replicate and to step outside of the boundaries and constraints that 3D printers and robots bring to the creative process. The *Sexy Beasts* are vessels that are 3D printed out of a clay body called Red Velvet native to Northern California, where I live and work. It's combined with white earthenware that is dyed either rose, blush, red, or salmon using mason stains. Each vessel is a balayage of color and shades from the organic and earthy red at the bottom to the more synthetically colored pink at the top. The robot 3D prints the digital design of the vase while I interact with each piece by cutting the strands of clay into a sexy shag and then blow dry them after they are

FIGURE 9.7 *Sexy Beasts.*

printed to modify the outcome. In this way, each beast receives a unique cut, color, and blow-out, designed by both robot and woman, working together with the local clay (Figure 9.7).

Present Day Clay

Legendary North Bay potter Edith Heath pioneered the use of the local Red Velvet clay that is excavated from clay pits in Lincoln, California; she called the premixed, commercial white clay that was ubiquitously available "gutless."[1] Starting in the 1940s, she made dishes out of the Red Velvet earthenware partly in reaction to the traditional old China that she found fussy, impractical, and unaffordable, and which only came out on special occasions. She dedicated her life to creating ceramics for real family

life. From her home in San Francisco, she would drive to the clay pits, take samples, and bring them back to her makeshift kitchen studio for tests and study. "I was looking for a clay that nobody knew anything about, that had unique properties that I could utilize and develop, that would be expressive of the region," said Heath.[2] And she found it in Lincoln. Since then she designed her own clay bodies, glazes, and tools which she used to open her own factory in Sausalito, CA, which is still operating today, manufacturing the legendary Heath ceramic designs. She not only designed tableware but also tiles which can be found in many California interiors. Her signature clay bodies, glaze colors and designs bring a unique modernist earthiness and warmth to the spaces they adorn.

Edith was not only passionate about using local clay to make dinnerware and tiles for a California lifestyle, but she was also experimenting with extruded clay bricks in response to the firestorms that are so prevalent as part of the California lifestyle. In 1991 she collaborated with Nader Khalili, founder of Cal Earth, or the California Institute of Earth Art and Architecture, to develop ceramic masonry prototypes that would deflect heat and be fireproof and could be used to build homes in the community.[3] My research into and love for all things Heath ceramics inspired me to think about how to make functional tableware and extruded bricks using local clays combined with the emerging technology of 3D printing which I set out to do in a 2022 summer artist residency in Faenza, Italy, a medieval town in Northern Italy renowned for its ceramic traditions.

Traveling with my 3D printer is normal now. Working in new landscapes and not in the laboratory is part of my contemporary practice. Since taking that first journey in 2020, I have since modified my printer so that it will fit in a hard shell golf case. The case protects the hardware, the delicate sensors, and the exposed electrical wiring. It also has wheels on it so I can roll it into the airport and take it on the airplane with me. It makes sense to have a mobile fabrication setup that is lightweight and agile; I can go to the earth and the clay, instead of bringing it to me, because the clay is very heavy and immobile. In the summer of 2022 I boarded a flight to Faenza with my 3D printer in tow.

In Faenza, even the street signs are made of ceramics. Faenza has been Italy's city of ceramics since 1100. Literally every building in Faenza is made of beautiful local clay that ranges from a soft blush red to a burnt orange sienna. All over the world the Fayence, Faience, or Faenza, however it is spelled, means red clay pottery covered in white glaze. The process of using a white tin glaze to cover the inexpensive local clay for interior use was invented here. The Faience glazed dishware was an inexpensive and more accessible hygienic alternative to porcelain, which is what made the style so popular and pervasive throughout Italy and most of Europe in the

middle ages. However, I found myself enraptured by the simple unglazed bricks that could be found everywhere throughout the city.

One of my favorite buildings in Faenza is the palazzo built by the Mazzolani counts in the seventh century.[4] It is located right next to my studio in Faenza, and I walked by it at least four times a day. The façade was never finished, and it is possible to see three different types of brick patterns along the surface of the palazzo. It is a beautiful building and it would have been a tragedy to cover the brickwork with stucco, to hide the labor and the richness of the materiality of this building and the region. In the spirit of Edith Heath, I decided to set up a woman-led and run 3D printing brick factory in Faenza as part of my artist residency at the Faenza Center for Ceramic Art (FACC). We devised a plan to design and create a 3D printed brick that would take advantage of the beautiful soft red clay of the region. The brick would have a feminine, lacy texture to it, reminiscent of a basket, and we would print hundreds of them to stack into a curvaceous form. In industrial brick production, a brick can be made in less than a second. In my brick factory, we engineered the brick to be made in five minutes, and we could make five bricks with exactly one tube of clay; not efficient compared to modern industrialized standards, but optimized for the circumstances. This is why our brick is an oval and not a rectangle. The printer has to slow down to make a tight 90-degree turn and we did not have time to do that. This is also why this brick is hollow; printing infill is time-consuming and uses a lot of material. The final design is a hollow, oval, lacy brick that is very lightweight and strong (Figure 9.8).

At my artist residency, I did not have a pugmill to deair the clay when filling the tubes of clay for the 3D printer. This meant that I had some air bubbles and inconsistencies in the clay body as it was printing. Because of this, loops sometimes broke during printing due to the presence of air bubbles. It was also scorchingly hot every day, 110 degrees Fahrenheit, which meant that the clay dried quickly and sometimes unevenly. When I printed quickly in the morning, the loops might be long and skinny, and when my assistants, Marta Potenza and Frederica Cinquepalmi, printed in the hot afternoons, the loops would be short and fat. I quickly learned to embrace the idea that each brick did not need to be the same or even perfect, that in fact all of the bricks would come together to create something perfectly imperfect, a philosophy shared by Edith Heath, because of the variation in the bricks. In the past, all of this variation might have seemed like failure to me, but under these circumstances, I was learning about the difference between failure, or the omission of what I might normally expect, and catastrophic failure, which would be a complete lack of success, or in this case a complete collapse of the 3D print. In this instance when you look at

FIGURE 9.8 3D-printed brick.

one brick, the material failure is discernible—some loops might be missing, or the layers uneven—but when you look at all of the bricks stacked together, to create an interior wall, all of these small failures add up to create something beautiful that feels almost handmade because of the variability across the crafted surface.

As part of a twentieth-century redevelopment project of the Palazzo Mazzolani, an archaeological exhibit was installed inside the grand hall of the entrance. We printed hundreds of bricks and installed them in the interior of the archeology exhibit in the Palazzo Mazzolani. In one scenario, the bricks were placed among the ancient first-century column fragments and stacked to create columns of the same proportion and dimension (Figure 9.9).

In another scenario, the bricks were stacked into a sinuous wall that plays on the pinks of the handmade traditional bricks of the seventeenth-century palazzo and the whites of the column capitals. The 3D printed bricks are made using cutting edge technology but are also curiously at home here in this 400-year-old building, both in harmony and in dialogue with the existing traditional architecture of brick columns and vaults in

FIGURE 9.9 Column assembly.

the palazzo and its centuries-old architectural elements. They are at home here, but also strangely foreign with their new shape and texture. This new 3D printed brick assembly is a kind of future archaeology or ruin, already a part of something historic but new at the same time (Figure 9.10).

Parallel to printing the bricks, I started making functional, everyday 3D printed tabletop ceramics with the goal of having a dinner celebration with friends and family that only uses 3D printed ceramics for serving and cooking. Taking inspiration from traditional Italian cookware, I created a *stufarola*, a ceramic cooking pot with lid which would be a center piece for this 3D printed table setting of the future (Figure 9.11).

FIGURE 9.10 Wall assembly.

I printed a water pitcher that has a handle and spout in a low woven texture, which makes it easy to clean and hold with matching cups. There is also a biscotti jar loosely based on the ceramic apothecary jars, which can be seen at the International Museum of Ceramics in Faenza, that were quite prevalent between 1150 and 1850 until glass jars replaced the ceramic versions (Figure 9.12).

This collection of 3D-printed ceramicware is inspired by forms that I found in Faenza but also by the material culture of "basket pottery." It is presumed that the first clay vessels were formed by women carrying water, pressing mud into a grass or reed basket in order to make them watertight.

FIGURE 9.11 *Stufarola.*

Eventually, these baskets were fired in earthen kilns, burning away the grasses, and leaving the ceramic vessel with the impression of woven baskets embedded into the surface. Later, the use of woven textiles, such as baskets, became commonplace as a method for making ceramic vessels. Over time, potters pressed textiles into the surface of their clay vessels in order to decorate them, sometimes using cords, notched wheels, or other implements to make markings that mechanically replicated the appearance of a textile. This cookware collection is a continuation of this practical material and cultural history. The woven texture is easily created and derived from my exploration into designing with G-code, the programming language for the numerical control of automated machinery.

I decided to place the cookware among the archeological fragments at Palazzo Mazzolani as well and to call this installation *Future Archeologies*

FIGURE 9.12 Biscotti jar.

because it is a project that ultimately explores the transformation of earthen materials and construction techniques at the edges of time. Time has a way of forcing one to cross new boundaries, of taking us to the outskirts, and into new spaces. When we examine and learn from our own histories, and then build upon them, it liberates us to create new destinies for ourselves.

The invention of new technologies does make it easier for us to make and do things that would otherwise be difficult or time-consuming, but it can also make things ubiquitous and impersonal. This journey has reminded me that when we bring our personal histories and narratives to our designs, they are more unique and meaningful, and when we bring local materials, such as the literal earth beneath our feet, and engage with new technologies, the designs we create can't help but be contextual. Building with the earth will not only help us save our earth, but it also might just help us find ourselves.

Project Credits

Casa Covida

Project Date: 2020.

Project Team: Emerging Objects: Ronald Rael, Virginia San Fratello, Mattias Rael, Sandy Curth, Logman Arja. 3D Potter: Danny Defelici. Textiles by Joshua Tafoya.

Special thanks to Christine Rael, Johnny Ortiz (Shed Project) and Maida Branch (Maida Goods). Photography by Elliot Ross and Emerging Objects.

Uphoria Amphora

Project Date: 2020.

Artist: Virginia San Fratello.

Special thanks to Paolo Pirelli and Lori Ann Brown at C.R.E.T.A. Rome.

Sexy Beasts

Project Date: 2021.

Artist: Virginia San Fratello.

Future Archeologies

Project Date: 2022.

Project Team: Virginia San Fratello, Marta Potenza, Frederica Cinquepalmi.

Special thanks to Davide Merendi and Mirco Denicolo at the Faenza Center for Ceramic Art (FACC) and to Mattias Rael the best mud technician.

Notes

1 See https://sfarts.org/story/edith-heath-a-life-in-clay-5rjcZlw93ES6nRUSxW-mvc4
2 See https://museumca.org/blog/edith-heath-distinctly-californian-artist-who-continues-inspire/
3 See https://www.calearth.org/our-founder
4 See http://faenza.amacitta.it/index.php/it/collezione/poi/palazzi20170920205429/palazzo-mazzolani20190321171505/palazzo-mazzolani-detail

SECTION III
Mediating

10

THE PRODUCTION OF THE TRAVELING PUBLIC

Rest Stop Interior Design, 1950–1970

Gretchen Von Koenig

Introduction

On September 23, 2021, I was southbound on the New Jersey Turnpike and stopped at the Molly Pitcher rest stop on the last day it was open before it closed for renovations. Molly Pitcher was a favorite rest stop of mine, frozen in time as an interior design of food courts from the 1990s—soft pink pastel tiles, black metal fan-backed chairs, and postmodern faux metal arches that surrounded eateries like Burger King and Nathans Hot Dogs. In 2017, Governor Chris Christie announced that all Turnpike rest stops were to become the "safest, cleanest, modern highway rest stops" through facelifts over the next several years that would feature trendy factory-aesthetics of exposed HVAC systems, hanging Edison bulbs, and white-and-black paint color schemes for restaurants like Pret-a-Manger and Honeygrow.[1] I stood in Molly Pitcher as the page was turning from yesterday's *everyday* to make way for the new *everyday*. But whose everyday is this? The new interiors have close ties to widely critiqued gentrification aesthetics—what user was in mind when this space was conceived? Whose experiences with food and travel do these spaces reflect? Consciously or not, the turnpike decided its user is someone who wants avocado toast from Pret-A-Manger, not someone who craves a Nathan's hot dog. I began to wonder, why do rest stops get remodeled? Who decides when they get remodeled and why?

Liminal spaces that host transitory interactions, rest stops have eluded critical attention but are ubiquitous forms of vernacular architecture, lining state and federal roadways throughout the United States. However,

DOI: 10.4324/9781003457749-14

they were much less common in midcentury, only emerging in the wake of postwar highway development and the mass consumption of automobiles. As Gabrielle Esperdy has explained, automobiles and highways had profound implications for architectures of roadside consumption, where restaurants and gas stations, formerly in cities and towns, were reconstituted along emerging typologies of mega highways.[2] The New Jersey Turnpike was one such road: a critical piece of state infrastructure, opened in 1951, that relieved the extreme congestion caused by New York and Philadelphia (the first and third largest US cities at the time) and was at the heart of Jean Gottman's Megalopolis.[3] While planning the limited access toll-road, the New Jersey Turnpike Authority became one of the earliest state agencies to design and produce rest stops. Their archives reveal an evolving practice of rest stop interior design where public government and for-profit business converged to produce concession stands, gas stations, and tourist information centers. A conduit to understand how highways share an unexpected edge with interiors in the United States, particularly the relationship between public government and private enterprise, rest stops are illuminative interiors to interrogate US history.

While interior designers and architects are common actors in design histories, the Turnpike rest stops reveal the porous edges of professional practice and prompt us to ask: *how do public authorities produce built environments?* A form of statecraft popularized in the New Deal era, public authorities are quasi-public, autonomous entities that are affiliated with the city, state, or federal governments but operate privately. They are usually tasked with financing, building, and maintaining public service infrastructure—such as New York City's Metro Transit Authority (MTA) and the Federal Housing Authority (FHA).[4] In the New Deal era, authority financing was secured tax-back bonds (also known as general obligation bonds), where repayment was made through tax legislation levied by elected officials. This meant that the public would have a say in how infrastructure was financed through elected officials and public review processes related to tax policies and civic budgets. However, in the 1940s and 1950s, authorities increasingly opted to use a new financial instrument: the revenue bond, where state entities borrowed against future earnings, in most cases the profits that were garnered through the project that the bonds funded.[5] This meant that private investors had to be convinced of the profitability of a project before investing in bonds. Thus, the Turnpike was expected to serve the public's traveling needs as well as exhibit a profitable business plan to attract bond investors.

Historians have noted that revenue bonds shifted "the institutional character of public economic activity" wherein midcentury authorities reimagined the practice of democracy by expanding responsibilities of the

state while simultaneously relegating them to private business practices.[6] Since authorities are "guided by the logic of the market," rather than "pursuing goals determined by democratically elected legislatures," practices of the free market make their way into how the Turnpike Authority conceives of what the rest stops *do*.[7] Authorities represent a unique, and still debated, border in US capitalism between public government and private enterprise. How do authorities design public space that aims to produce a profit? To that end, how does a "municipal enterprise" approach interior design?

The history of rest stop interiors, what the Authority calls service areas, compliment and complicate economic histories that articulate the profound shift from the New Deal order of the 1930s and 1940s, marked by government funded social services, to the New Federalist order of the 1960s and 1970s, where privatization of social services was seen as a "superior alternative to the state and state-based services" and laid the groundwork for neoliberalism in the late twentieth century.[8] The prominent economic historian Gary Gerstle has urged historians to look beyond the election cycle to identify the underlying cultural shifts from the New Deal political order to the neoliberal political order—I argue that analyzing the design-decisions of commercialized government spaces sheds new light on the "genealogy of neoliberalism".[9] While private businesses levied to privatize services such as insurance and housing, promising better service to the American people than government, scholars like Keeanga-Yamahtta Taylor have documented that US public-private partnerships had particularly detrimental effects for Black Americans seeking housing where racial discrimination was good business—and government supported.[10] Similarly, Mia Bay has documented Black mobilities in twentieth century travel histories and argues that as "transportation and accommodations developed, new forms of segregation followed."[11]

While the turnpike was not fully privatized, the archival records of the Turnpike Authority reveal an approach to interior design and spatial policy that was guided by an obsession with service design in order to produce a profit, resulting in a desire to keep the rest stops "new" and "updated" which led to frequent remodelings. Indeed, the constant evolutions of restaurant design and information centers reveals how the Authority came to adopt free market practices into their "lexicon of public policy" and reveal moments where racial and class segregation proliferate inside government-operated interiors.[12]

The history of rest stop design shows how structural inequalities are normalized into one of their most hidden forms—in everyday environments, a "commonplace of the given."[13] As Diane Harris has written, everyday spaces are "so pervasive and seemingly ordinary as to become

critically unobserved" warning that the ubiquitous can become the ideological.[14] Rest stops illuminate the complicated tensions of the political economy that endure today, asking whether private business or public government is better equipped to serve (or design for) society? Negotiating the edges between citizen and consumer, rest stops reveal how interiors inform evolving statecraft and democracy itself—providing lessons for how public and private interests can, or should, co-shape public space for the future of roadway travel in the United States.

The Turnpikes Origins and the Profit Motive

After winning the 1947 state gubernatorial race, Republican Alfred Driscoll went to work to fulfill his biggest campaign promise: alleviating New Jersey's crowded roadways by building a megahighway.[15] Driscoll would have to make a number of decisions before he broke ground on this new, state-wide infrastructure, the first of which was deciding between a toll road or state funded, and thus toll-free, roadway. While groups such as the American Automobile Association opposed toll roads as a form of "double taxing," Driscoll decided to build a toll-road after the financial success of the Pennsylvania Turnpike.[16] While the toll road solved operating costs for a megahighway, he still had to figure out how to finance the initial construction costs. In order to avoid raising taxes, Driscoll opted for the use of revenue bonds, which would be paid back with profits made from the highway project.[17] Driscoll's decision recalls a significant shift in the motivations of statecraft in midcentury America that soon commercialized the public sector and were a part of what historian Lizabeth Cohen has dubbed the "consumerization of the republic"—where the meanings of "citizen" and "consumer" grew closer.[18] American studies scholars Angus K. Gillespie and Michael Aaron Rockland argued this meant the turnpike would have to be operated not as a state-project, but a "straightforward, business-like enterprise" because "the bond market had to be convinced" that they would see a return on their investment.[19] Therefore, the use of revenue bonds resulted in motivations that secured profit first, and satisfied public needs second.

Most importantly, Driscoll had to decide if the Turnpike would be managed through existing state departments or if yet-to-be established public authority would take on the task. In order to build a road that was "needed yesterday," Driscoll decided that the time-consuming bureaucracy of the State Highway Department could not build expeditiously enough and also "lacked the philosophical approach needed" needed to effectively manage revenue-bond infrastructure and thus advocated for the establishing an authority, arguing that their autonomous and entrepreneurial nature avoided

bureaucratic stasis and would best satisfy the bond market.[20] Republican state senator Robert Meyer vocally opposed the establishment of an Authority, believing that the Authority was a "shadow" department that had no democratic oversight and transgressed the state constitution (which only outlined twenty-one departments). Driscoll's own State Highway Department fiercely resisted the establishment of an authority, arguing that critical state infrastructure should be operated by public offices and subject to public review.[21] They further argued that the enabling act was unconstitutional as it gave the Authority the power "to take state-owned lands in acquiring property for its super-highway."[22]

Local municipalities also vocalized opposition for similar reasons: many towns and counties were worried that the Authority would take taxable lands away, causing a deficit of taxes accrued to local governments. Local governments specifically argued that the service areas would cause a loss of "ratables" (taxable goods or services) to local businesses such as diners and gas stations, impacting not only taxes collected for city budgets, but also individual livelihoods—an issue that the City of Elizabeth sued the Authority over.[23] Even at the federal level this was a major consideration: under policy advisement from the American Association of State Highway Officials' Committee on Planning and Design Policies, President Eisenhower's Interstate Highway system stipulated that rest stops were to be "noncommercial spaces," designed exclusively as safety areas for fatigued drivers, so as to not compete with local businesses offering gas and food.[24] Despite these concerns, Driscoll's 1948 Turnpike Authority legislation won fifteen-to-one in the state senate.[25] Before the Turnpike construction even began, patterns of consumption were being reconstituted through legal means. As Driscoll's administration authorized for-profit businesses inside rest stops along a government-sponsored roadway, the edges of the public and private sphere began to blur even further.

In 1949, Driscoll appointed three men from the private sector to the board of directors: construction management entrepreneur Paul Troast as Chairman, President of Johnson and Johnson George Smith as Vice-Chairman, and financial analyst Maxwell Lester as Treasurer.[26] As the directors prepared financial and business proposals for the bond market, they began early imaginings about how the rest stops, in addition to tolls, could be "revenue producers" and "crowning amenities" that would attract drivers to use the toll road. While tolls made up the dominant revenue for the Turnpike, the Authority speculated that the service areas, where "concession revenue, obtained as a percentage of gasoline, oil, restaurant and miscellaneous merchandise sales," could potentially produce "substantial" profit and are "expected to prove a very important factor in

the satisfactory and successful operation of the Turnpike."[27] Early financial evaluations made the service areas activities essential to the financial operations of the Turnpike, making the service area spaces and interiors essential to infrastructure.

Profit Centers: Designing the Rest Stops

While other scholars of the Turnpike have asserted that its designs were dominated by an austere vision of "American pragmatism" with "virtually no attention to aesthetics," a close reading of rest stop design tells a more nuanced story.[28] The first visualization of a Turnpike service area, seen in the 1949 annual report, reflects stylistic and operative choices that the Authority deemed "more complete and convenient" than any other such facilities on US tolls roads (Figure 10.1). The service areas combined facilities such as gas pumps, restrooms, food services, convenience shopping, and lounge areas—from which "substantial revenue" could be earned.[29] Designed by Arthur Gorman Lorimer (a friend and former architect for Robert Moses, a known supporter of the authority model whose infrastructure legacy is tied to discrimination against low-income neighborhoods),

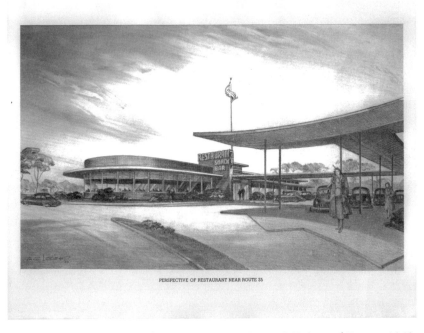

PERSPECTIVE OF RESTAURANT NEAR ROUTE 35

FIGURE 10.1 "Perspective of Restaurant Near Route 36" Annual Report 1949, p. 40. The New Jersey Turnpike Authority. New Jersey State Library.

the initial exterior designs of the service areas were in a streamlining style, characterized by tear drop and aerodynamic forms that were detailed with "horizontal lines in keeping with a high-speed highway."[30] Streamlining was a popular style for automotive habitats—such as Norman Bel Geddes and Raymond Lowey's designs for trains, cars, drive-in restaurants, and gas stations—and was also a style closely linked to consumerism. Streamlining designers employed methods such as the annual model change, or planned stylistic obsolescence, to encourage sales, a technique emerging from the consumer engineering ethos.[31]

Lorimer's rest stop design stylistically and literally connected itself to streamlining and consumption. The design features a large restaurant mixed with the covered roofs of drive-ins, with the words "Restaurant" and "Snack Bar" occupying the focal point of the image and there is a notable lack of reference to public services such as restrooms or picnic tables where one could eat without purchasing something. This imagined rest stop is driven by private consumption of goods and services, rather than public spaces for sitting or resting, suggesting that public services were not a priority for the Authority.

Lorimer's streamline designs were abandoned, however, in 1950 after the Authority received feedback on design proposals from the State Highway Department, public safety officials and gas and electric utility providers.[32] In 1950, the final rest stop schemes were designed by Modernist architect Roland Wank of Felliheimer and Wagner, famous for his work in co-op housing and for his work as the Chief Architect for the Tennessee Valley Authority, as well as serving as an architectural consultant to the United Nations Headquarters from 1947 to 1951.[33] Wank designed new service areas in a "restrained contemporary style" that aimed to "harmonize with the countryside" and, according to chief engineer Charles Noble, "provide a quiet atmosphere for the traveling public" (Figure 10.2).[34]

While Modernism had a wide variety of interpretations and applications in the United States, European and state-side Modernists shared a broad belief in the "machine as the vehicle for social change," which could "express a new and democratic society."[35] Wank espoused Modernist beliefs such as a rejection of historic ornamentation in favor of functionally legible architectural forms, and the embrace of mass production and modern materials such as aluminum and prefabricated concrete. Wank also, like many other modernists in the post-war era, believed prefabrication and modular building components were cost-effective solutions to post-war housing needs—espousing the Modernist belief in the promise of technology to provide single family housing for all, a belief intricate tied to suburbia in the United States.[36] Wank's "restrained modern" rest stop design for the Turnpike Authority utilizes visual associations with

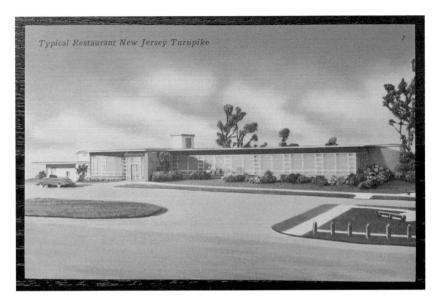

Typical Restaurant New Jersey Turnpike

FIGURE 10.2 "Typical Restaurant New Jersey Turnpike," Annual Report 1950, p. 31. The New Jersey Turnpike Authority, New Jersey State Library.

suburbia: manicured lawns, brightly colored shrubbery, and grass-lined walkways that transport the traveler off the asphalt mega-highway and into the "countryside" (Figure 10.2).

This rest stop design caters to the inhabitants of suburbia, who in the 1950s were predominantly white, middle-class citizens—the type of person who could afford the aspirational pink convertible car, the only car present in the rendering. As Diane Harris has argued, popular representations of the postwar house and garden contributed to an "iconography of racially based spatial exclusion" where prefabricated housing projects such as Levittown were highly discriminatory toward Black homeowners—falling short of a "housing for all" ideal.[37] By utilizing such coded elements as gardens and suburban architecture, this design extended suggestions of racial spatial exclusion into government-service structures. These sites that signified racial segregation became the sites of segregation performed when contracted food concessionaire, Howard Johnson's, refused service to Black travelers on the Turnpike.

Inside of the rest stops, however, is where the Authority focused its efforts in designing for maximum profitability. To accommodate future desires of the motoring public, the Authority decided that the service areas should be designed with flexibility in mind, what I call a profit driven flexibility.[38]

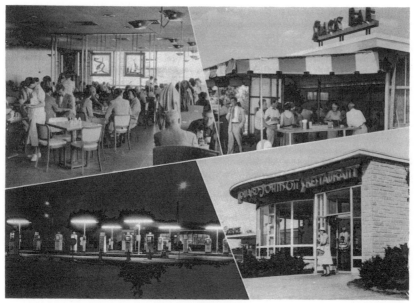

Typical service area

FIGURE 10.3 "Typical Service Area," Annual Report 1954, p. 31. The New Jersey Turnpike Authority. New Jersey State Library.

Service areas expanded from a central lounge from which pathways radiated to a variety of services—like "bathrooms, candy cashiers, tobacco counters, restaurants, and telephone booths" and any other services as "future use and demand dictated"—a plan that could incorporate any future amenities desired by the motoring economy into one-stop shops along state owned roadways[39] (Figure 10.3). The early designs were dominated by flexibility in dining, in particular. All thirteen of the service areas were designed so that they could be "readily enlarged to major restaurants if service to the public requires such expansion."[40]

With financial and spatial goals articulated, the Authority began to bid out contracts for the operations of food services and gas concessions, which also included automotive repair and information services. For the contract to operate all the food concessions, the Authority selected Howard Johnson's, a midcentury chain diner. For the exclusive automotive and information services contract, the Authority selected Cities Services (now known as Citgo). Howard Johnson's and Citgo fit their own corporate architectural and design schemes into authority designed and owned buildings, where private enterprise and public space became one and the same. Howard Johnson's food services had to abandon their iconic orange-roofed colonial revival design and fit

their services into the two different versions of Turnpike's thirteen rest stops: a lunchroom type, with seating for up to 60, and restaurant type, which could expand, as future use dictated, for seating up to 200. Howard Johnson's had to abandon their own interior schemes for Wank's restaurant designs—a dining room with iron partitions, walnut wall paneling, terrazzo flooring, and floating biomorphic artwork that was echoed in abstract lighting fixtures.[41] However, Howard Johnson's was charged with outfitting the snack bars, which they dressed with standing tables and awnings (Figure 10.3). Between sit down restaurants and stand-up snack tables, the built environment of the rest stops catered to multiple temporalities: an option for the less rushed driver who preferred a sit-down meal, and an option for the hurried traveler who wished only to eat briefly at standing-height tables.[42] The multitemporal scheme was produced under the flexibility imperative, and would soon be put to the profitability test when the Turnpike opened its toll gates in 1951.

While the service areas lagged slightly and opened in 1952, they would soon show that the "crowning amenities" most certainly did generate a profit for Turnpike operations. The Turnpike reached record numbers across all expected flows of revenue. The ridership in 1952 was at the level that highway consultants estimated for 1967, achieving annual toll revenue goals fifteen years ahead of schedule.[43] This included prolific use of the service areas: while tolls collected 127% more revenue than projected in 1952, the concession facilities made 183% more and 198% more the following year, generating 2.3 million dollars in revenue in a single operational year.[44] This fiscal success proved the flexibility approach a wise one, and the Authority paid more attention to these facilities in order to continue to capture profits.

The intense explosion of riders put a strain on the service areas, and they were quickly slated to be remodeled to hold a higher capacity of travelers. The Authority drew up more financial plans, with more revenue bonds, to finance "winterizing" the snack bars so they could operate year-round, expanding operations for 24-hour operating eateries and create a "takeout service" for "consumption while traveling," enabling a third temporality that were happening at the same time as the "perfection" of the fast food system, another automotive habitat responding to autopia.[45] The remodels created interiors that mixed the typologies of lunchrooms and restaurants. The Authority honed their understanding of dining habits and leveraged the built-in flexibility to offer dining temporalities that stretched across day and night and across the seasons, further increasing temporal participation in rest stop services. Because of this increase in food services, the service areas became more technologically complex with new refrigeration, food storage facilities, and garbage management systems as well as new mechanic facilities that were planned and paid for by the Turnpike, financed through additional revenue bonds.[46]

Seeking a continuous return on their facilities investments, the Turnpike spent the next several years enlarging many of the interiors to accommodate higher lunchroom capacity and introducing new styles to satisfy the evolving taste of the motoring public. In 1960, just three years after the latest remodel, the Authority decided the rest stops were "no longer new" and planned a "complete program of rehabilitation of restaurant interior decor, making them more attractive to the traveling public"—reflecting some of their initial impulses to the streamlining ethos which included the annual model change.[47] This "complete rehabilitation" debuted two new interior schemes: one that catered to the projected desires of a car-driving public and another that catered to bus riders. The upscale restaurant design was to feature "new color schemes, furniture design, draperies, lighting … and wall-to-wall carpeting"[48] (Figure 10.4). This scheme included abstract metal wall art, more detailed table settings and decorative wrought iron

FIGURE 10.4 "Newly furnished interior of restaurant on Mercer County," Annual Report 1961, p. 20. The New Jersey Turnpike Authority. New Jersey State Library.

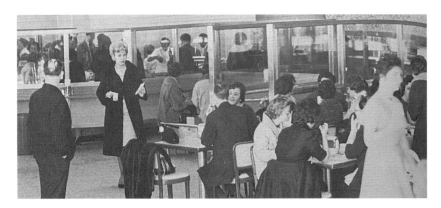

FIGURE 10.5 "Interior of bus stop at Cranbury," Annual Report 1961, p. 20. The New Jersey Turnpike Authority. New Jersey State Library.

room dividers. As Katharine Grier argues rooms are forms of rhetorical statements by displaying "agreed-upon sets of associations," this interior design is a departure from the more blue-collar diner interiors and deploys associations with white-collar fine dining.[49]

Also debuted that same year was a charter bus facility at the Cranbury service area. This was the only rest stop that would allow buses, a "specially designed haven" to ease the congestion that bus riders caused, or as the Authority characterized it: relieving the "swarm" of bus riders that caused "near riots" at other service facilities (Figure 10.5).[50] As explained by Manager of Patron Services Ernst Buchner, whose department oversaw the operations of the service areas, everything in the $2.6 million charter bus service station "was designed to save time" and would introduce a takeaway food service from Howard Johnson's and an integrated intercom system to announce bus departures. Reorienting their typical sit down service to a new function once again, Howard Johnson's charter bus-station cafeteria was a highly controlled space where turnstiles led to cafeteria-style lanes and then to temperature-controlled cabinets with individually wrapped food, a development that the Authority labeled a takeaway service—a contribution to the evolution of fast food systems.[51] Despite the efficiency-oriented design that this facility offered to a bussing public, it produced more sinister effects as well: keeping bus riders, typically of lower-economic status and more frequently people of color, out of the other service areas that catered to private-car owners, typically of higher economic status and who were usually white. While car drivers were offered a variety of eating experiences, the charter bus stop users were given a singular experience that centered around getting bus riders out of the service areas as soon as possible while still

capturing concession revenue. This design effectively kept bus patrons out of the other twelve service areas designed for higher-paying Turnpike customers.

As bus riders were relegated to one rest stop service, Black US citizens were offered no service at all, as Howard Johnson's was a known pro-segregation business. Variety in dining experiences became an imperative for the Authority's rest stop design but were produced in an age when Black travelers had little access to Turnpike service, let alone the multiple varieties of it, and had to consult texts like *The Negro Motorist Green Book* in order to know what roadside businesses allowed black patrons.[52] While there is scant evidence recorded in the Authority's archive, itself a telling point, white historian Herbert Aptheker recounts that when he and Black activist William Patterson were traveling on the New Jersey Turnpike in the early 1950s, Patterson knew that they would be denied service at a Turnpike-operated Howard Johnson's—and to Aptheker's shock, they were.[53] The same year Governor Driscoll proposed the Authority in 1948, he also proposed his civil rights legislation, the Freeman Bill, which prohibited discrimination based on race in any place of public accommodation.[54] Despite passing in 1949, Driscoll's so-called commitment to civil rights was obscured through the practices of racial segregation underneath his own nose, inside the interiors of the state infrastructure on which he prided himself. His hypocrisy could be reasoned away: that private enterprise made those decisions, not the Authority. Ironically, the Authority boasted in its 1963 Annual report that the bus service station successfully handled the influx of travelers for the March on Washington protest in 1963, while some of its very service area segregationist practices were what citizens marched against.

Driscoll's own political beliefs were guided by anti-federal sentiments that emerged in protest of a New Deal order. Calling his approach "working federalism," Driscoll argued for less government oversight and more individual freedom, political stances that led him to choose the authority model in the first place. Driscoll's "working federalism" shares contours with Richard Nixon's "New federalism," wherein federal granting policies shifted away from federally determined categories of spending, such as municipal health services or road improvement, and instead was given to states as lump sums for governors and mayors to use at their own discretion, which, as Jane Berger argues, turned mayors into entrepreneurs instead of civic stewards.[55]

Howard Johnson's segregationist policies were validated by Driscoll's "working federalism," that sought less governmental oversight which enabled private sector discrimination to flourish inside government-sponsored structures. Howard Johnson's would exclusively operate the service areas

until 1973, while regularly making national news throughout the 1960s for their segregationist policies. In 1962, 500 Black citizens protested a Durham, North Carolina, location; in 1963 Black activists lodged a civil suit against a location in Washington DC; and most famously, Howard Johnson's made national headlines when a Maryland location refused service to William Fitzjohnson, a visiting Sierra Leonean diplomat—an incident for which President Kennedy personally apologized.[56] The Authority continuously worked with Howard Johnson's for twenty-three years, inscribing the "traveling public" and the "motoring economy" as white.

While the Authority, and the New Jersey legislature more broadly, ignored Howard Johnson's segregationist practices, they closely monitored consumer pricing for the white motoring economy. According to its contract, Howard Johnson's was not allowed to raise prices in service areas unless it was cleared by the Authority first.[57] When the Authority denied a request for a price increase in 1964, Howard Johnson countered with the assertion that they had successfully managed food "services for the public" and even won "public esteem for the operators, its service and products, and for the Turnpike as a whole."[58] The Authority compromised that in light of their excellent service (to the white traveling public)—Howard Johnson's could raise prices of certain foods but would have to offer free coffee refills for Turnpike riders at all thirteen service areas. Through this compromise, the Authority acted as a consumer advocate by leveraging its statewide network of interiors. Service for the white motoring economy remained the pinnacle of design and policy decisions, outweighing concerns, or even acknowledgment, over discrimination against Black members of the traveling public. When the Authority eventually did end Howard Johnson's contract in 1973, it was on the basis of the company's poor service, not on its segregation policies. Howard Johnson's pushed back against the poor service allegations, stating that the Authority's unending search for glamorous "new eating concepts" were impossible to satisfy.[59]

The "Tourist Information Centers" are another site where the Authority's focus on service blurred the distinction between public and private practices. The Authority had explicitly contracted out the tourist information centers to avoid governmental critiques of favoritism. Cities Services were contracted to manage the information centers, as well as supply gas services. Their approach to information services were interactive and customer service oriented: they hired Pikettes, women in Turnpike-branded suits who would provide travelers with "the latest information on hotels, motor courts and the best routes" (Figure 10.6).[60] Marketed as the concierges of the Turnpike, the Pikettes were a popular service that added "experience of pleasurable driving" but soon fell to bribery and corruption.[61] According to a saga outlined by Max Weiner, Cities Services came under

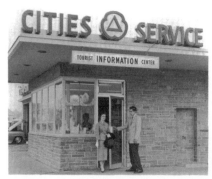

Entrance to tourist center.

Pikettes supplying information to motorists.

FIGURE 10.6 "Entrance to tourist center," and "Pikettes supplying informa-
tion to motorists," Annual Report 1958, p. 17. The New Jersey
Turnpike Authority. New Jersey State Library.

fire for taking bribes from New York hotels to recommend their businesses
to Turnpike travelers.[62] To curb this illegal practice, the Authority and Cit-
ies Services entered a formal agreement with New York City hotels where
the hotels would reserve a block of rooms exclusively for Turnpike travel-
ers in exchange for the Pikettes recommending them over any other hotels.
In this agreement, the Authority would receive a commission for every
hotel stay booked and paid for—essentially averting the flow of money as
bribes to Cities Services to the Authority as commissions.

As the Pikettes began to roll out this policy, the New Jersey Hotel As-
sociation raised a complaint that a state entity was encouraging patrons
to do business in another state. Further, they argued, it was unethical
to coerce hotels to reserve rooms for Turnpike users in order to be rec-
ommended to travelers, a practice they believed was too discriminatory
for proper statecraft. The Association suggested that interested travelers
should be given a list of hotels and provided free phones to call the New
Jersey hotels themselves, which the Authority rebuked since it "did not
provide much of a service."[63] The Authority also stated that because most
patrons were destined for New York, recommending New Jersey hotels
was not an appropriate service. As the Authority defended Cities Services'
hotel recommendations as a matter of business policy to attract customers
to the Turnpike, the Association escalated their demands, requesting that
Cities Services should be removed entirely from the tourist information
function and should be staffed and financed through the Authority. The
Association finally won and the Authority required Cities Services to end
the practice of the Pikettes recommending hotels and replaced them with a
more "objective" machine called a Directomat (Figure 10.7).[64]

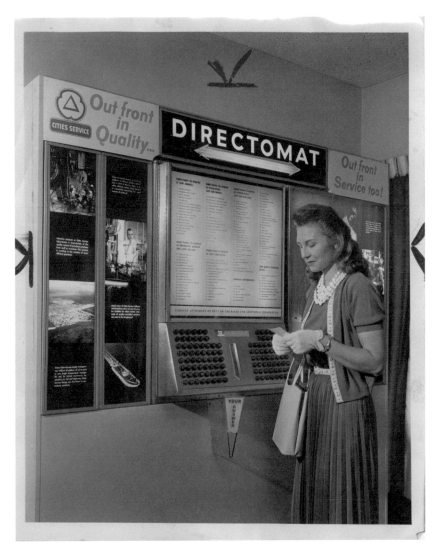

FIGURE 10.7 "New Directomat", July 1961, NYJA000709, B092, Cities Service Buildings, New York Journal-American photo morgue, Harry Ransom Center, The University of Texas at Austin, Austin, Texas. https://norman.hrc.utexas.edu/nyjadc/ItemDetails.cfm?id=709.

The Directomat was a "new automated device that … printed cards, answers questions about hotels, motels, churches, sports and many other subjects." In August 1961, the Turnpike employee newspaper *Pike Exchange* featured an article titled "Electronic Brain Aids Patrons" that explained how "the robot" had 120 buttons from which to select information. In

seconds, the "electronic brain" printed "trip slips," that gave recommendations to hotels and small businesses—reproducing bias toward more service-oriented suggestions but under the guise of technological objectivity.[65] While initiatives like the free coffee refills constitute aspects of consumer advocacy that speak to the public edge of the Authority, negotiations with the New Jersey Hotel association reveals how the Authority behaved like a private enterprise in competition with the state it is supposed to serve. As the hospitality-driven designs of the Pikette's information centers, mirroring the dress and arrangement of up-scale hotel concierge desks, gave way to the technologically modern machine aesthetic of the Directomats— the interior experiences of these facilities was guided by evolving service policy inside of statecraft, where edges became blurred, contested and reimagined.

Conclusion

Whereas Turnpike users were initially understood as the "traveling public," they came to be the "motoring economy" through the Turnpike's crowning amenity: its rest stops. The interiors show that public needs slowly gave way to private enterprise values and free market ideals. In the grand opening ceremonies of the Turnpike in 1952, the ceremony program stated that, "when revenue bonds are paid off, the Turnpike will become property of the State for free use by the people" which signaled the Authority's early hope for entrepreneurial methods to be leveraged for long-term public benefit.[66] However, the first twenty years of the Turnpike Authority reports discuss did not discuss the service areas in terms of public benefit, public bathrooms or public access to green space or picnic tables, but mostly in terms of profitability remodeling. Along with the constant maintenance of the roadway itself, the remodeling was always funded through new bond-issuances, trapping the Authority into a cycle of debt and profit-driven schemes to pay back investors—to this day the Turnpike has never been free to use by the people. As the private-enterprise values penetrated deeply into the built fabric, they not only essentialized the profit-motive in public spaces, but also naturalized racism and classism in roadside America.

The Turnpike rest stops show that "design decision-making is itself a study in the persuasive representation of ideas" and tell a bigger story about how capitalist values can deeply penetrate culture and inform how democracy is materialized in the built environment.[67] This public-private partnership served the values of private enterprise more than public-oriented amenities, leading the Authority to conceptualize itself in terms of potential profit rather than public service. Defining and naming the practices

of private-public relationships matter because they have real implications for how public space is imagined, designed and used. It can enfranchise and disenfranchise, reifying social boundaries along racial and class lines. Government-owned interiors offer a point of view that complicates and complements narratives about the relationship between government and business, aesthetics in roadside America, race in the US landscape, and mobility restrictions in class politics. While service areas are not overtly political, they have the power to distribute assumptions about people and places—and since they fall under the guise of the everyday, they hold extra power to remain hidden.

Notes

1 "Governor Announces Service Area Contracts: NJTA," New Jersey Turnpike Authority, August 30, 2017, https://www.njta.com/newsroom/2017/august/ governor-announces-service-area-contracts; An earlier version of this introduction was written for *Dense Magazine*, G. Von Koenig, "5049 Miles on the Turnpike, *Dense Magazine: Booth Please*, January 2022. https://www. densemagazine.org/post/5049-miles-on-the-turnpike.

2 Gabrielle Esperdy, *American Autopia: An Intellectual History of the American Roadside at Midcentury* (Charlottesville, VA: University of Virginia Press, 2019).

3 The French geographer famously labeled the region between Boston, MA and Washington, DC "megalopolis" for its high density, containing 20% of the human population in 1960s. He argued that this region started to take on characteristics of a single city, Jean Gottman, *Megalopolis: The Urbanized Northeastern Seaboard of the United States* (The Twentieth Century Fund, 1961).

4 Gail Radford, *The Rise of the Public Authority: Statebuilding and Economic Development in Twentieth-Century America* (Chicago, IL; London: The University of Chicago Press, 2013); Amy C. Offner, *Sorting Out the Mixed Economy: The Rise and Fall of Welfare and Developmental States in the Americas* (Princeton, NJ: Princeton University Press, 2019).

5 Radford, *The Rise of the Public Authority*, 4–7.

6 See Chapter 1 "Decentralization in One Valley," in Offner, *Sorting out the Mixed Economy*; Radford, *The Rise of the Public Authority*, 5.

7 Ibid,14.

8 Caley Horan, *Insurance Era: Risk, Governance, and the Privatization of Security in Postwar America* (Chicago, IL: The University of Chicago Press, 2021) 39; Jane Berger, *A New Working Class: The Legacies of Public-Sector Employment in the Civil Rights Movement*, America (Philadelphia, PA: University of Pennsylvania Press, 2021).

9 See Chapter 3 "Beginnings," in Gary Gerstle, *The Rise and Fall of the Neoliberal Order: America and the World in the Free Market Era* (New York, NY: Oxford University Press, 2022).

10 Keeanga-Yamahtta Taylor, *Race for Profit: How Banks and the Real Estate Industry Undermined Black Homeownership* (Chapel Hill, NC: The University of North Carolina Press, 2019).

11 Mia Bay, *Traveling Black: A Story of Race and Resistance* (Cambridge, MA: Harvard University Press, 2021) 3.

12 Offner, *Sorting out the Mixed Economy*, 9.

13 Judy Attfield, *Wild Things: The Material Culture of Everyday Life* (Oxford, UK: Berg Publishers, 2000) 51.

14 Diane Harris, *Little White Houses: How the Postwar Home Constructed Race in America* (Minneapolis, MN: University of Minnesota Press, 2013) 2.

15 Eugene Reybold, "Progress in Highway Construction & Design," *National Defense Transportation Journal* 8, no. 4 (1952): 26.

16 Arthur Warren Meixner, "The New Jersey Turnpike Authority: A Study of a Public Authority as a Technique of Government, 1949–1965" (Dissertation, New York University, 1978), 527.

17 Big Bond Issue Planned by Jersey for Turnpike," *New York Times*, July 5, 1949; Radford, *The Rise of the Public Authority*, 4–6.

18 Lizabeth Cohen, *A Consumers' Republic: The Politics of Mass Consumption in Postwar America* (New York, NY: Vintage Books, 2003).

19 Gillespie and Rockland, *Looking for America on the New Jersey Turnpike*, 26.

20 Arthur Warren Meixner, "The New Jersey Turnpike Authority: A Study of a Public Authority as a Technique of Government, 1949–1965" (Dissertation, NYU, 1978), 1–20, 64, 676; 1949 Annual Report of the New Jersey Turnpike Authority, January 1950, t931949, New Jersey Turnpike Authority Collection, New Jersey State Library, Trenton, NJ, 7 [1949 Annual Report]; "Toll Road Action Due," *The New York Times* (August 12, 1948).

21 This critique was not unique to New Jersey, but was a widely negotiated point of contention in the Authority model across the United States. See Radford, *The Rise of the Public Authority*, 2; Meixner, "The New Jersey Turnpike Authority," 5–10.

22 "Jersey Courts Backs Turnpike Authority," *New York Times*, December 6, 1949.

23 "Seeks Turnpike Payments," *New York Times*, February 11, 1951.

24 Committee on Planning and Design Policies, A policy on safety rest areas for the national system of interstate and defense highways of 1958, American Association of State Highway Officials (April 30, 1958).

25 "Turnpike Authority is Created in Jersey," *New York Times*, October 28, 1948; 1949 Annual Report, 1–5.

26 "Big Bond Issue Planned by Jersey for Turnpike," *New York Times*, July 5, 1949; 1949 Annual Report, 8–11.

27 1949 Annual Report, 11; Revenue and Engineering Cost Estimates: New Jersey Turnpike, September 1949, New Jersey Turnpike Authority Collection, New Jersey State Library, Trenton, NJ, 11–18.

28 Gillespie and Rockland, *Looking for America on the New Jersey Turnpike*, xii.

29 1949 Annual Report, 11; 1951 Annual Report, 55, 81; Revenue and Engineering Cost Estimates, New Jersey Turnpike Authority Collection, 11.

30 Andy Lanset, "Artist and Architect A.G. Lorimer Captures WNYC's Old Transmitter Site From Two Perspectives," *New York Public Radio*, NYPR Archives and Preservation, April 15, 2011.

31 Roy Sheldon and Egmont Arens, *Consumer Engineering: A New Technique for Prosperity* (New York, NY: Harper and Brothers Publishing, 1932); Jeffrey L. Meikle, "Machine Aesthetics," in *Twentieth Century Limited: Industrial Design in America 1925–1939* (Philadelphia, PA: Temple University Press, 2001) 19–21; Christina Cogdell, *Eugenic Design: Streamlining America in the 1930s* (Philadelphia, PA: University of Pennsylvania Press, 2004).

32 1950 Annual Report, 25.

33 Christine Macy, "The Architect's Office of the Tennessee Valley Authority," in *The Tennessee Valley Authority: Design and Persuasion*, ed. Tim Culvahouse (New York City, NY: Princeton Architectural Press, 2007) 33, 30–40.

34 1950 Annual Report of the NJTA, 25; 1951 Annual Report of the NJTA Collection, 55; Charles Noble, "The New Jersey Turnpike" (paper presented at 37th Annual Road School, Purdue University, March 1951) 10.

35 Macy, "The Architect's Office of the Tennessee Valley Authority," 37–40. David Raizman, "Modernism: Design Utopia and Technology," in *History of Modern Design* (London, UK: Laurence King publishing, 2010) 181; Shannan Clark, "When Modernism Was Still Radical: The Design Laboratory and the Cultural Politics of Depression-Era America," *American Studies*, 50, no. 3/4 (Fall/Winter 2009): 35–61.

36 Macy, "The Architect's Office of the Tennessee Valley Authority," 37–40.

37 See "Rendered Whiteness," in Harris, *Little White Houses*, 83–111; For Levittown discrimination, see Dr. Dan W. Dodson's *Crisis In Levittown, PA* (New York City, NY: Center for Human Relations and Community Studies, School of Education, New York University, 1957) https://www.youtube.com/watch?v=oIPos4YYXnk.

38 Radford, *The Rise of the Public Authority*, 14; Revenue and Engineering Cost Estimates 1949, New Jersey Turnpike Authority Collection, 18; 1950 Annual Report, 58.

39 1951 Annual Report, 55.

40 1950 Annual Report, 58.

41 "New Jersey Turnpike: Fellheimer & Wagner, General Architects," *Progressive Architecture*, September 1954, 101.

42 Concept comes from On Barak's framing of temporalities as he investigated how Egyptians pushed back against "western time" through the use of trains and telegraphs. On Barak, *On Time: Technology and Temporality in Modern Egypt* (Los Angeles, CA: University of California Press, 2013).

43 "Business: Private Toll Roads Show the Way," *Life Magazine*, February 28, 1955.

44 1952 Annual Report, 23; 1953 Annual Report, 27.

45 1953 Annual Report, 39; Proceedings of the New Jersey Turnpike Authority January 31, 1964, Records of The Governor, Gov. Richard J. Hughes, Box 423, New Jersey State Archives, Trenton, NJ, 11–12.

46 Proceedings of the New Jersey Turnpike Authority February 11, 1964, Records of The Governor, Gov. Richard J. Hughes, Box 423, New Jersey State Archives, Trenton, NJ, 2.

47 1956 Annual Report, 18.

48 1961 Annual Report, 20.

49 Katherine C. Grier, *Culture and Comfort: People, Parlors and Upholstery, 1850–1930* (Rochester, NY: Strong Museum, distributed by University of Massachusetts Press, 1988), 10–15.

50 "New Charter Bus," *The Pike Interchange*, August 1961, Vol II. No. 12, Turnpike Collection, Box: Ms. Marie Koch, New Jersey Historical Society, Newark, NJ, 1–5.

51 Ibid.

52 See Chapter 4 "Traveling by Bus: From the Jim Crow Car to the Back of the Bus," in Bay, *Traveling Black*, 151–191.

53 Herbert Aptheker and Robin Kelley, "Interview of Herbert Aptheker," *The Journal of American History* 87, no. 1 (2000): 54.

54 Alvin S. Felzenberg, "Alfred Eastlack Driscoll (1947–54)," in *The Governors of New Jersey, 1664–1974: Biographical Essays*, ed. Paul A. Stellhorn and Michael J. Birkner (Trenton, NJ: New Jersey Historical Commission, 1982).

55 Jane Berger, *A New Working Class: The Legacies of Public-Sector Employment in the Civil Rights Movement* (Philadelphia, PA: University of Pennsylvania Press, 2021).

56 Marcia Chatelain, *Franchise: The Golden Arches in Black America* (New York, NY: Liveright), 48; Renee Romano, "No Diplomatic Immunity: African Diplomats, the State Department, and Civil Rights, 1961–1964," *The Journal of American History* 87, no. 2 (September 2000): 554.

57 Proceedings of the New Jersey Turnpike Authority June 22, 1964, Records of The Governor, Gov. Richard J. Hughes, Box 423, New Jersey State Archives, Trenton, NJ, 2.

58 Ibid.

59 Joseph Sullivan, "Turnpike Rebuff Many Cut Howard Johnson Empire," *New York Times*, August 30, 1973.

60 The New Jersey Turnpike. Cities Services. Wilding Productions. 1954. Periscope Films, 2015. https://m.youtube.com/watch?v=hSRhEJc3GHw&feature=youtu.be; 1958 Annual Report of the NJTA, 16–17.

61 Ibid.

62 Meixner, "The New Jersey Turnpike Authority," 64.

63 Ibid, 534.

64 1961 Annual Report, 20.

65 "Electronic Brain Aids Patrons" *The Pike Interchange,* August 1961. Vol II, No. 12. Folder: Ms. Marie Koch—Pike Interchange (Newark, NJ: The New Jersey Historical Society); Ruha Benjamin, *Race After Technology: Abolitionist Tools for the New Jim Code* (Newark, NJ: Polity Press, 2019).

66 Dedication Ceremony Program, November 20, 1951, Turnpike Collection, MG 1544, Box 2, New Jersey Historical Society, Newark, NJ.

67 Christine Macy, "The Architect's Office of the Tennessee Valley Authority," in *The Tennessee Valley Authority: Design and Persuasion*, ed. Tim Culvahouse (New York City, NY: Princeton Architectural Press, 2007) 28.

Bibliography

Aptheker, Herbert, and Robin Kelley. "Interview of Herbert Aptheker." *The Journal of American History* 87, no. 1 (2000): 151–67.

Attfield, Judy. *Wild Things: The Material Culture of Everyday Life*. Oxford: Berg Publishers, 2000.

Banham, Reyner. *Theory and Design in the First Machine Age*. Cambridge, MA: The MIT Press, 1960.

Barak, On. *On Time: Technology and Temporality in Modern Egypt*. Los Angeles, CA: University of California Press, 2013.

Bay, Mia. *Traveling Black: A Story of Race and Resistance*. Cambridge, MA: Harvard University Press, 2021. https://doi.org/10.4159/9780674258709.

Berger, Jane. *A New Working Class: The Legacies of Public-Sector Employment in the Civil Rights Movement*. 1st ed. Politics and Culture in Modern America. Philadelphia. PA: University of Pennsylvania Press, 2021.

Boris, Eileen. "Desirable Dress: Rosies, Sky Girls, and the Politics of Appearance." *International Labor and Working-Class History*, no. 69 (2006): 123–42.

Chatelain, Marcia. *Franchise: The Golden Arches in Black America*. New York, NY: Liveright, 2020.

Clark, Shannan. "When Modernism Was Still Radical: The Design Laboratory and the Cultural Politics of Depression-Era America." *American Studies* 50, no. 3/4 (Fall/Winter 2009): 35–61.

Cogdell, Christina. *Eugenic Design: Streamlining America in the 1930s*. Philadelphia, PA: University of Pennsylvania Press, 2004.

Cohen, Lizabeth. *A Consumers' Republic: The Politics of Mass Consumption in Postwar America*. New York, NY: Vintage Books, 2003.

Crisis In Levittown, PA. New York City: Center for Human Relations and Community Studies, School of Education, New York University, 1957.

Esperdy, Gabrielle. *American Autopia: An Intellectual: History of the American Roadside at Midcentury*. Charlottesville, VA: University of Virginia Press, 2019.

Felzenberg, Alvin S. "Alfred Eastlack Driscoll (1947–54)." In *The Governors of New Jersey, 1664–1974: Biographical Essays*, edited by Paul A. Stellhorn and Michael J. Birkner. Trenton, NJ: New Jersey Historical Commission, 1982.

Friedlander, Paul. "Highroad from the Hudson to the Delaware." *The New York Times*, November 25, 1951.

Gao Hodges, Graham Russel. *Black New Jersey: 1664 to the Present Day*. New Brunswick: Rutgers University Press, 2018.

Gillespie, Angus K., and Michael Aaron Rockland. *Looking for America on the New Jersey Turnpike*. New Brunswick: Rutgers University Press, 1989.

Grier, Katherine. *Culture & Comfort: People, Parlors and Upholstery, 1850–1930*. Washington, DC: Smithsonian Books, 1997.

Harris, Dianne Suzette. *Little White Houses: How the Postwar Home Constructed Race in America*. Minneapolis, MN: University of Minnesota Press, 2013.

Henket, Hubert-Jan, and Hilde Heynen, eds. *Back from Utopia: The Challenge of the Modern Movement*. Rotterdam: 010 Publishers, 2002.

Lauer, Josh, and Kenneth Lipartito, eds. *Surveillance Capitalism in America*. 1st ed. Hagley Perspectives on Business and Culture. Philadelphia, PA: University of Pennsylvania Press, 2021.

Life Magazine. "New Jersey Turnpike." January 28, 1952a.

Life Magazine. "Newly Opened Superroad Unravels Chronic Traffic Jam." January 28, 1952b.

Macy, Christine. "The Architect's Office of the Tennessee Valley Authority." In *The Tennessee Valley Authority: Design and Persuasion*, edited by Tim Culvahouse. New York City, NY: Princeton Architectural Press, 2007.

Meikle, Jeffery. *Twentieth Century Limited: Industrial Design in America 1925–1939*. Philadelphia, PA: Temple University Press, 2001.

Meixner, Arthur Warren. *The New Jersey Turnpike Authority: A Study of a Public Authority as a Technique of Government, 1949–1965*. New York, NY: New York University, 1978.

Offner, Amy C. *Sorting Out the Mixed Economy: The Rise and Fall of Welfare and Developmental States in the Americas*. Princeton, NJ: Princeton University Press, 2019.

Pulos, Arthur. *The American Design Ethic*. Cambridge, MA: MIT Press, 1983.

Radford, Gail. *The Rise of the Public Authority: Statebuilding and Economic Development in Twentieth-Century America*. Chicago. London: The University of Chicago Press, 2013.

Raizman, David. *History of Modern Design*. 2nd ed. London: Laurence King Publishing, 2010.

Romano, Renee. "No Diplomatic Immunity: African Diplomats, the State Department, and Civil Rights, 1961–1964." *The Journal of American History* 87, no. 2 (September 2000): 5460–5579.

Sheldon, Roy, and Egmont Arens. *Consumer Engineering: A New Technique for Prosperity*. New York, NY: Harper and Brothers Publishing, 1932.

Stellhorn, Paul A., and Michael J. Birkner, eds. *The Governors of New Jersey, 1664–1974: Biographical Essays*. Trenton, NJ: New Jersey Historical Commission, 1982.

Taylor, Keeanga-Yamahtta. *Race for Profit: How Banks and the Real Estate Industry Undermined Black Homeownership*. Justice, Power, and Politics. Chapel Hill, NC: The University of North Carolina Press, 2019.

Weingarden, Lauren. "Aesthetics Politicized: William Morris to the Bauhaus." *Journal of Architectural Education* 38, no. 3 (1985): 8–13.

Whiteley, Nigel. *Design For Society*. London: Reaktion Books, 2006.

11

BODY LANGUAGE

Alex Goldberg

My research layers art, design, and healing practices to explore methods for utilizing creativity to access embodied knowledge. Grounded in energy healing practices, I develop multidisciplinary projects that test my belief that making processes can cultivate transformation in cognition and lived experience. Over time, these processes have brought clarity that responsive practice with the environment is a direct route to dissolve mental constructs and cultivate mind-body harmony.

My original form of artistic expression was dance, and throughout my career I have continued to fold other disciplines into my research, most notably my interests in design and energy healing. The layering of these practices has informed the basis for multi-medium research that explores creative expression as a tool for balancing mind and body in pursuit of a present existence rooted in deep relationship with self, others, and environment. As I continue to actively pursue this work, it becomes clearer and clearer that it was happening naturally long before any goal orientation. It is inherent.

Dancing on the beach as a child was the beginning of my nature-guided practice. I delighted in how the ocean's force influenced my movement. This experience was one of high sensory impact. The sound of waves crashing, the taste of salt, the feeling of sand in my toes and water wrapped around my body. Hardly any clarity of thought; it was my physicality that led the way.

Dancing on the beach was how I became aware of my relationship with the natural world. How I embodied the understanding that we are not separate from the environment in which we are living. My research aims to

DOI: 10.4324/9781003457749-15

develop methods that heighten awareness of, and connection to, the inherent network in which we are all connected. In my personal experience as an artist, teaching, and working with clients, I have found that cultivation of a healthy creative practice can aid in exploring what is inherent within oneself. Combined with the awareness of absolute unity, this inherent creativity can then be utilized to take practical action in response to conflict with oneself, others, and the environment.

In 2019, I traveled to Tiznit, Morocco for an artist residency with Slow Research Lab. When I got there, I was inspired by the palm tree fronds in the oasis. My interaction with the palms guided me back to my body; my body brought me back to dance; dance brought me back to poetry.

I experienced a different mind-body relationship where my mind was being utilized to translate embodied knowledge rather than enforce mental constructs. When guided by nature, I am not questioning good or bad, right or wrong. There is no need to prove because there is no doubt. It is not about the I in artist; it is about the insight that comes from exercising creativity (Figure 11.1a,b,c–g).

Mental constructs exist due to cognitive categorization. The separation between self and other, or humans and nature, works against an understanding that we are a part of a greater network. Through deep listening and tapping into the energetic structures that connect all beings, we can move beyond categorization and experience unity at a cellular level. My ongoing research project, Body Language, explores how we can utilize our bodies and our environment to perceive beyond a rigid mind, and use that knowledge to transform behavior patterns.

In 2021, I developed the first iteration of Body Language at Byrdcliffe Colony in Woodstock, New York. In Body Language 1, I played piano and voiced some concepts: "To Desire, To Love, In Conflict, To Mourn, To Cleanse, Of Freedom." Fellow residents participated in this project by listening to the words and exploring how to process, express, and feel them within their body. The goal of this exercise was to explore how the body holds knowledge and how movement can be utilized as a creative processing tool (Figure 11.2a,b).

A large piece of organza hung from a studio rafter to soften the space. Participants enjoyed interacting with it while they activated their bodies. Allowing form to dissolve into light seemed to aid in allowing the mind to dissolve into the body.

Body Language 2 is an exhibition proposal in which a grid of organza pocket curtains hung, softening the space. A sound and meditation would play throughout the gallery space, prompting visitors to move their body and translate embodied knowledge into words. They would then place the words in the pockets within the curtains for other visitors to find and

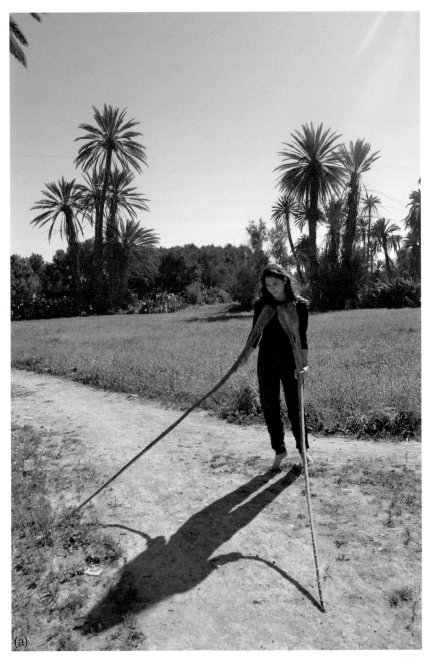

FIGURE 11.1 (a)–(g) Channeling Palms Research, Tiznit Oasis, Morocco, 2019.

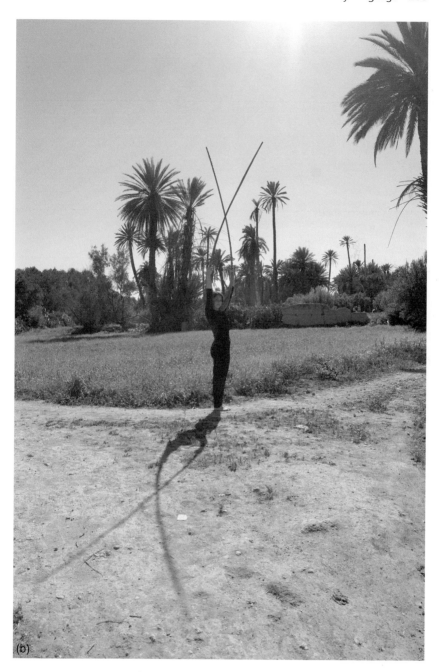

(b)

FIGURE 11.1 *(Continued)*

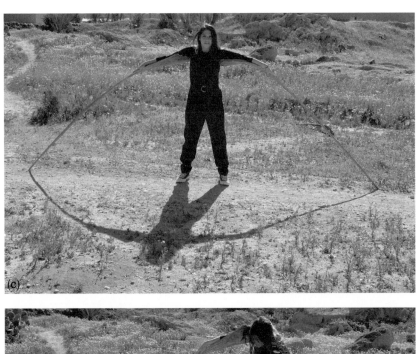

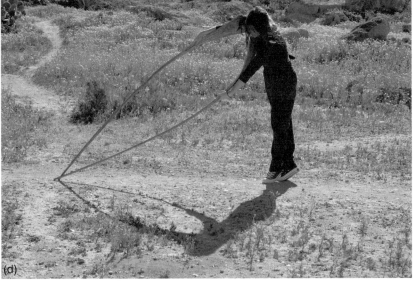

FIGURE 11.1 *(Continued)*

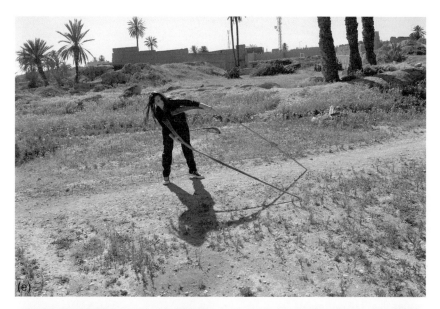

(e)

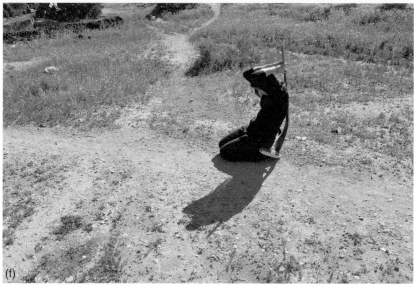

(f)

FIGURE 11.1 *(Continued)*

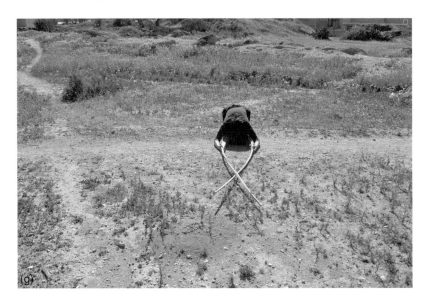

(g)

FIGURE 11.1 *(Continued)*

continue to process through movement. Participation in this experience has the potential to shift an individual's mind-body balance and in turn shift the collective consciousness within the space (Figure 11.3a,b).

This exact iteration was not realized, but I shared a portion of this proposal (Body Language 3) in May 2022 in a group research show in New York with the Enclothed Collective.

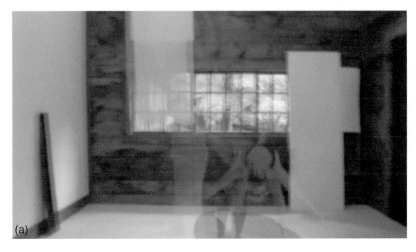

(a)

FIGURE 11.2 **(a)**, **(b)** Body Language (Iteration 1), video still, Woodstock, New York, 2021. *(Continued)*

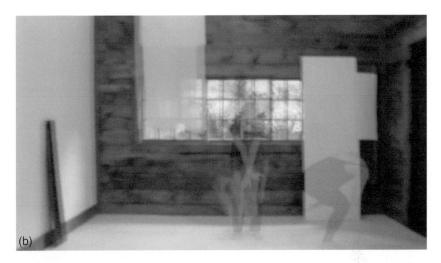

FIGURE 11.2 *(Continued)*

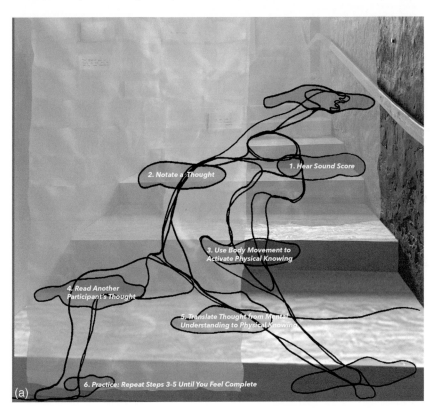

FIGURE 11.3 **(a)**, **(b)** Body Language (Iteration 2), installation proposal, 2022. *(Continued)*

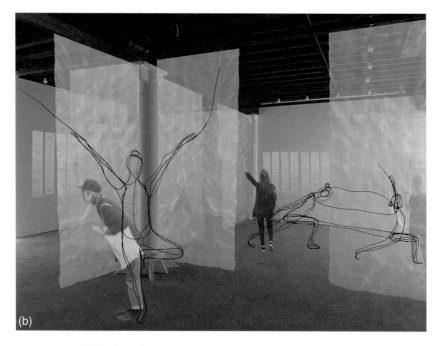

(b)

FIGURE 11.3 *(Continued)*

Insight for the planning of Body Language arrived in my mind by way of language: The mind is a self-constructed spiral. Spirals exist in constant motion. Utilize physicality to redirect yours toward embodied presence. I did not question it (Figure 11.4).

My imagination aided in processing the language. A colored textile emerged, where we can search for the message on one side or feel it through light and color on the other. This did not make perfect sense, but: I did not question it (Figure 11.5a–c).

My mind is constantly questioning the validity of the process, but I've been doing this for long enough that my muscle memory knows that I will achieve mind-body balance if I continue. My body will become engaged enough to focus the mind. The two work together in tandem.

The entirety of the process is about grasping the gift from the mind, the words, and utilizing the body and creativity to process it. If the body is not engaged, the brief mental clarity will be swallowed up by the usual mental chatter. There is a speed within which I must work so that my body is more engaged than my mind, because this is not a matter of the mind. The process is about moving away from my mind and into my body so my body can communicate instead.

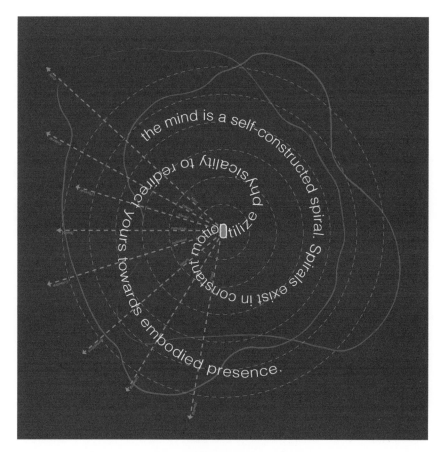

FIGURE 11.4 Body Language (Iteration 3), experience mapped, digital drawing, 2022.

And then I hit that moment where I reach embodied knowledge. Completely unplanned, my body starts to sew a spiral and I realize that this process of physical making is redirecting my spiral toward embodied presence, which was the invitation that began this whole process.

Something is unlocked and I am now able to question constraints. A mode of inquiry quite different from questioning based on constructs. The mind-body balancing has altered the way that my mind is functioning. My mind is focused, free, and expansive.

I shared this process with participants and invited them to listen to a meditation and explore how language, geometry, sensory perception, and body movement can integrate to enhance self-awareness and activate perceptual shifts (Figure 11.6a–d).

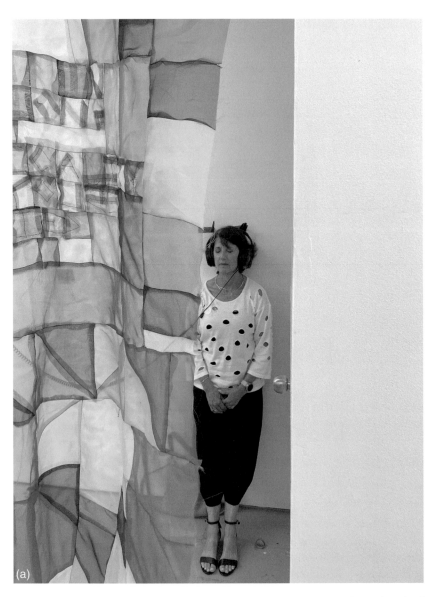

FIGURE 11.5 (a)–(c) Body Language (Iteration 3), photograph of hand quilted organza curtain, 2022. *(Continued)*

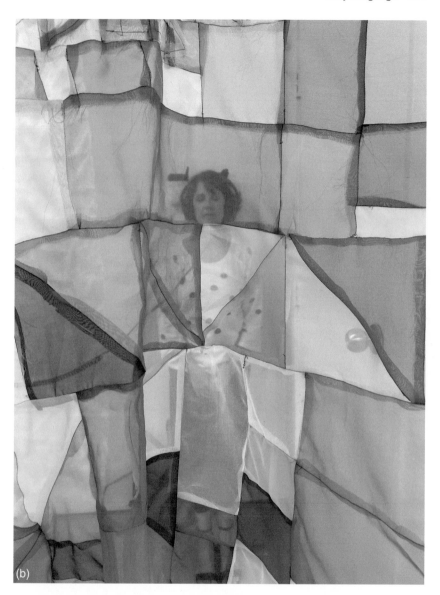

FIGURE 11.5 *(Continued)*

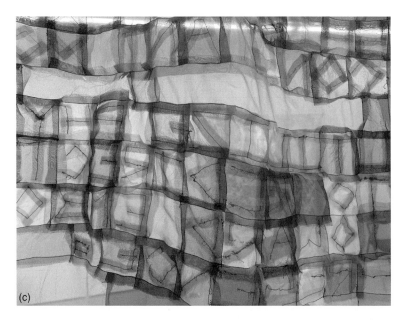

(c)

FIGURE 11.5 *(Continued)*

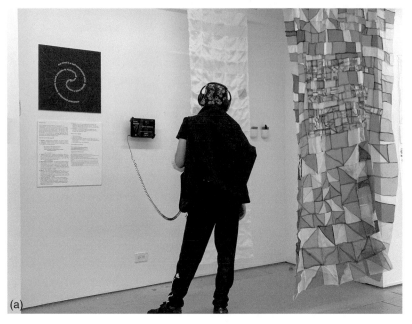

(a)

FIGURE 11.6 (a)–(d) Body Language (Iteration 3), photograph of experiential installation: recorded meditation and hand quilted organza curtain, 2022. *(Continued)*

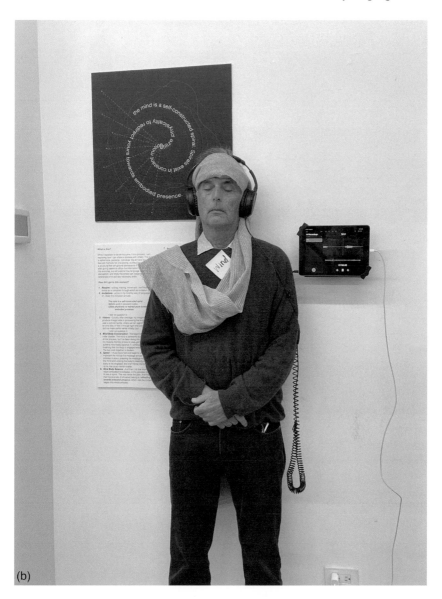

(b)

FIGURE 11.6 *(Continued)*

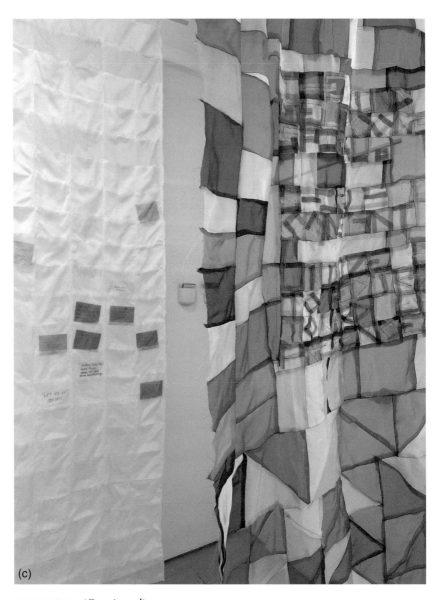

(c)

FIGURE 11.6 *(Continued)*

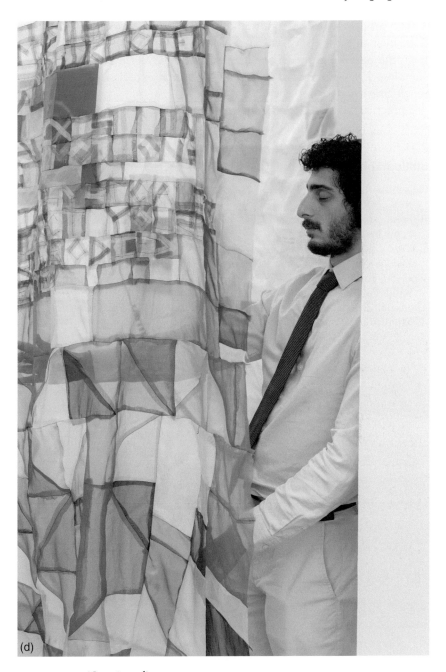

(d)

FIGURE 11.6 *(Continued)*

The process is the practice and the practice is the process. The goal is that through these processes, we can learn to accept the gifts that come from the paradoxes in which we exist. That we can live into the understanding that we are having both an individual experience and one of a much larger network.

I practice this transformation in relationship to self, other, and environment. And most importantly, I do not question it.

Bibliography

Pallasmaa, Juhani. *The Thinking Hand: Existential and Embodied Wisdom in Architecture*. West Sussex: John Wiley & Sons, Ltd, 2009.

Robinson, Sarah. *Nesting: Body Dwelling Mind*. Richmond, CA: William Stout Publishers, 2011.

Sakrison, Angela "*Rowboat Phenomenology*" in Strauss, Carolyn F., *Slow Spatial Reader: Chronicles of Radical Affection*. Amsterdam, Netherlands: Valiz, 2021.

Thanem, Torkild, and David Knights. *Embodied Research Methods*. London: SAGE Publications Ltd, 2019.

Thomson, Donna. *SourcePoint Therapy: Exploring the Blueprint of Health*. Middleton, DE: Merlinwood Books, 2015.

12
POLYATMOSPHERIC URBAN INTERIORS

Late-COVID-19 Case Studies

Liz Teston

Introduction

The polyatmospheric interior engages with contemporary issues in inhabited environments and advocates for experience-driven and ephemeral urban places. This polyatmospheric quality exists within *public interiority*, as concept covered herein. But, it's essential first to understand that polyatmospheric interiority is of the here-and-now, of this time, and a symptom of our Late-COVID-19 world. As architectural theorist Beatriz Colomina stated in a recent interview, "the most important influence of COVID-19 is that it has made the invisible city visible."[1] While in Colomina's case, the subject was accessibility and resource equity, this concept—the uncovering of the invisible city—can be transferred to polyatmospheric and revelatory urban conditions. She posits that the tuberculosis pandemic of the nineteenth century was deemed a "house problem," originating from strained living conditions and that the COVID-19 pandemic is spread within the public realm, rendering it a "city problem." Colomina predicts a radical architectural transformation of multi-use objects and spaces and an obliteration of the boundary between "the city of work" and "the city of rest." In the end, our pandemic impacts all forms of inhabitation. But, in my view, its richest areas of intervention have proven to be exterior-interiors, or conditions of pubic interiority in which medial, provisional interiors self-sufficiently exist within unrestricted exterior urban territories. Herein, this essay will explore the fundamental nature of interiority and a case study that questions how to reassemble and renegotiate neighborhood conditions of public interiority. It also explores ways people can

DOI: 10.4324/9781003457749-16

craft interiorities within fluid contemporary culture and simultaneously promote citizens' spatial rights to intimate urban experiences. Finally, we will also consider the consequences of architectural porosity and the resultant exfiltration of the interior condition into the plein air, creating atmospheric borders.

Sister Terms

At this point, you probably have encountered previous research related to interiority. Other scholars have used related terms to delineate interiority's alliance with resistance, adaptability, and experience—phrases like urban interiority, the oblique approach, promiscuous interiors, and micro-environments that are appropriated or exist beyond architecture— even the cousin of public interiority, tactical urbanism.[2] This essay stands on the shoulders of this research to further explore how ambiance, perception, everyday usage, and the public domain shape exterior-interior settings—addressing immediate and enduring needs for experiential communal places.

The Pandemic Amplifies Public Interiority

To be precise, public interiority's phenomenal interior-like traits are atmospheric, political, formal, programmatic, and psychological. They are significantly amplified during our current age. When intensified to saturation, these five traits evolve to reflect their spectacular potential—bearing like nomenclatures like polyatmospheric, hyper-political, omni-formal, multifunctional (a heightened programmatic condition), and apperceptive (an intensive psychological setting). These autonomous and pervasive descriptors of interiority require renaming because of their immense accumulation of intimate experiences unfolding in public spaces of this present age. Like the proverbial frog in boiling water, we don't yet completely understand how the pandemic has changed us. But, we can begin to understand via an adaptation of a quote by Marxist theorist Guy Debord's *Society of the Spectacle* "[The sublime and intensified attributes of public interiority and] ... the spectacle in general, as the concrete inversion of [everyday] life, is the autonomous movement of the non-living."[3] So, polyatmospheres are more volatile, dynamic representations of temporal and experience-based interior alternatives, situated in the "psychedelic phenomenological body"[4] and shaped by our uncanny pandemic era. Urbanists Libero Andreotti and Nadi Lahiji write of the phantasmagoric city and argue that "the interior today is the city itself." They describe the contemporary metropolis as a Baudrillardian Simulacra,[5] a condition

FIGURE 12.1 Dominican festival at Quisqueya Plaza, Manhattan, NY. Diagram by author, photo by Cortesía Ydanis Rodríguez.

where the "image is more realistic than the copy" and consists of hallucinogenic stimuli that "hamper its capacity to recognize the real."[6] Before the pandemic, we lived in a world where atmospheric exterior-interior boundaries were transgressed for special events and urban interactions were a matter of chance. Today, more exterior-interior borders are traversed in everyday occurrences, exposing the quotidian in the urban realm and creating an atmospheric everyday-spectacle—for example, an exercise class in the park or outdoor schools (Figure 12.1). Design scholar Rochus Hinkel describes this phenomenon as "The diminution of the accidental, the loss of the unexpected, and the moderation of uncomfortable encounters with others …." Thus, "[During the pandemic], chance encounters with others [have been] edited out or else carefully curated in highly controlled virtual spaces."[7]

Fluidity and Interior Exfiltration

The pandemic has brought public interiority to a critical discursive moment and reasserts that phenomenological, user-generated conditions are the essential framework for progressive interior thinking. This interiority drives the contemporary milieu and along with socio-political shifts of the pandemic (the pandemic, social justice, and the post-truth era), these generate the most significant societal changes of the past century. It is, therefore, no longer a given that interiors exist in a binary inside-outside circumstance. Contemporary interiority is a field condition, a tonal gradient, still working in contrast to the external context. Prior to

the pandemic, contemporary culture's binary classifications were already being challenged. The pandemic has augmented this by uncloaking this liminal condition—a flexible street can contain cars at one moment, host a block party at another moment, and accommodate an intimate conversation between friends in the next. Designer Michaela Litsardaki describes this condition "as a hybrid urban zone, [that] lay in the space in between semi-private and semi-public, where fluidity prevails as this dynamic changes over time, depending on use or socio-cultural context."[8]

Interior architectural theory often focuses on surface characteristics and sensory qualities and assumes that the building envelope is the limit of interior space. But, public interiority instead prompts designers to address the intersections between experience-based interiority and the city. Public interiority recognizes interiority's primary features—human-scaled, responsive, and phenomenologically driven spaces—and it is ambivalent to enclosure. Public interiority expands beyond the building envelope and asserts an equal claim on urbanity and the commons. The formal aspects of variegated facades and arcades that generate exterior-voids have been well-documented by scholars. But, public interiority distinguishes itself from this formalism by advocating for atmosphere-shaped interiority within the urban realm. These heterogeneous conditions are the essential design qualities shaping our decade and expand the interior architecture discipline beyond structure.

Expansion the Condensed Pandemicene Interior

The recent pandemic years have produced a novel, discreet interiority, characterized as the antithesis of urbanity and performed entirely within the domestic nucleus—never transgressing the interior edge. More than ever, we live most of our daily lives in isolated, domestic condensers, using the mediated space of Zoom to work with others. The home is now omni-functional—containing improvised spaces for work, play, and domestic living. Architect Farshid Moussavi recognizes that the pandemic has uncovered spatial inequalities in existing urban housing and advocates for new designs to accommodate dual-use domestic-work spaces. For example, spaces that can adjust to accommodate a customer in the home, a fabrication area, a Zoom meeting, and dinnertime prep. These public spaces situate the urban condition within the normative interior of home.[9] Designers and citizens alike should likewise bring interiority into the city via improvisational settings and flexible structures that spectacularize everyday life in the urban realm.

This performance of radical interiority and pandemic-influenced public behavior has evolved since the inceptions of the pandemic in early 2020. The Late-COVID-19 response has mutated into an insatiable desire for

FIGURE 12.2 Outdoor seating in Williamsburg Brooklyn, NY. Diagram by author, photo by Sarah Blesener/NYT.

public interaction and atmospheric exfiltration of the interior condition seeps into the exterior public realm. The early pandemic interior-response, a homogenous internalized state, was uncanny in its density and operated within an anemic, insular world. To further understand the borders and fields of Pandemicene interiors, we can look to Henkel's analysis of analogue and virtual conditions of interiority in the Pandemicene.[10] This essay calls for a shift away from the uncompromising pandemic-driven interior nucleus. It calls for a return to a radiant public-interior frontier, which recognizes sensory variety, adaptability, and contextuality within the safety of the outdoors (Figure 12.2).

Ecologies: Atmospheric Borders

Artist Jenny Odell writes about attentiveness and perception. She writes, "... Patterns of attention—what we choose to notice and what we do not—are how we render reality for ourselves and thus have a direct bearing on what we feel is possible at any given time." When exploring this intentionality, Odell claims that one can "escape 'the world' [or] remain-in-place while escaping"[11] This second approach espouses the here-and-now, time, and space. Polyatmospheric interiority insists on re-centering the in-between—the fluid, the non-binary—rather than escaping into the condensed interior. Humans have a limitless need for interaction and comradery and sociable empathy. Rather than isolating ourselves, as with the early COVID-19 context, this Late-COVID-19 context establishes a new normal in which we redefine polyatmospheric interiority and defiantly escape the world while remaining in place, in the urban outdoors.

FIGURE 12.3 Map of atmospheric public interiority at Morcom Amphitheatre of Rose in Oakland, CA. Image by author, photo by Calibas.

Accessible, public spaces, like Odell's Morcom Amphitheatre of Roses in Oakland, encompass "the practice … [and] architecture of nothing, the importance of public space, and the ethics of care and maintenance." In this example, she describes the architecture of doing nothing as a "contemplative space against the pressures of habit, familiarity, and distraction that constant threat to close it." This border condition relates to public interiority because it is an intimate space whose atmosphere is differentiated from its surroundings. This contrast creates a temporary state of interiority (Figure 12.3).

To be clear, the field condition of the interior is a perceptive gradient. But, it requires some contrast with the urban condition to be perceived. Sometimes that contrast is more pronounced than others. We can also claim that the fleeting architectures of spectacle are conditions of polyatmospheric interiority. For example, while Diller Scofidio's Blur Building at the 2002 Swiss Expo was shaped by mist (not a façade), the contrasting air created the pavilion. We must be unmoored from the mundane to experience the spectacle of polyatmospheric public interiority. This unmooring can be via a grand spectacle or everyday conditions in unusual settings, like a school in the urban outdoors. This reversed ground [12] resets our patterns of attention and enables us to escape the world while remaining within it.

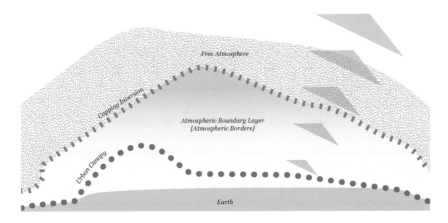

Free Atmosphere

Capping Inversion

Atmospheric Boundary Layer
[Atmospheric Borders]

Urban Canopy

Earth

FIGURE 12.4 Atmospheric boundary layer (atmospheric border) as a spatial gradient, by author.

In meteorology, there is a term called "atmospheric boundary layer"[13] (Figure 12.4). This zone slips between the free atmosphere or stratosphere, skimming the Earth's surface, and comprises of a gradient of sublayers. We can conceive of this atmospheric border as flow space, like a sinuous atmospheric river slip-sliding between more rigid zones. The polyatmospheric interiority of the urban realm takes on these qualities too. It is uninhibited and approaches intimacy through the portals of sensory variety and contextuality rather than form and enclosure. In her analysis of experience and space, Odell uses ecology as a metaphor for territories of experience. Thus, "The borders of bioregions are not only impossible to define; they are permeable … An ecological understanding allows us to identify 'things'—rain, cloud, river—at the same time that it reminds us that these identities are fluid. [These things are] slippery … at the interaction of phenomena inside and outside of the imagined 'bag of skin.'" We can use this as a jumping-off point to look at polyatmospheric public interiority—the cloud being interiority and the skin being the experiential exterior-interior threshold.

Bodies: Relative Humidity

In "Humid: Before the Rain," design theorist Christine McCarthy wrote on the difficulty of saturated air (humidity), interiority, and abjection. She describes humid atmospheres, permeating the body, gently negotiating the skin's boundary with its aqueous vapor while swelling the skin layers to the point of saturation. This tension makes our physical bodies cognizant of the viscous atmospheres enveloping us. McCarthy thus states, "Humidity hence operates within the architectural premise of enclosing space,

mediating building and the body to such an extent that buildings become a redundant architecture in the definition of interiority." Hers is a study of interior limits, its borders and boundaries, shaped by atmospheres, and existing beyond physical building construction.[14] Here we arrive at a meteorological version of polyatmospheric public interiority in which abjection, defined by philosopher Julia Kristeva as the "in-between, the ambiguous, the composite"[15] marks, but does not bind, the exterior-interior threshold territory. A metaphorical body-space engorgement and the spectacle of atmospheric urban interiority form polyatmospheres. This condition signifies the dew point, a maximum of relative interiority, within our Pandemicene Era. McCarthy predicts a fluid and transposed interiority and exteriority—for example, the thinness of chilled air creates a dilated exteriority, and the thickness of humidity creates a claustrophobic interiority, inverting our notion of inside and outside. So, immaterial stimuli like atmospheres, meteorology, and human-made weather (e.g., air-conditioning) can demarcate interiority.[16] Before the pandemic, we commonly misconceived that urban outdoor air was dirty, dangerous, and noxious. We now understand the stagnant air of the normative interior to be a threat to human health. We must now reexamine the relationship between thermal comfort, human health, outdoor air, and interiority.[17]

Spaces: Relative Interiority

Preston likewise analyzes mist as a physical manifestation of tangible, atmospheric sensory experiences and interiority. In *AD Interior Atmospheres*, she describes mist as "a rarified form of air … a spatial figure … [that is] site-specific and yet geometrically formless." Mist signals a "weathering mood … a political and cultural indicator."[18] Preston describes, "an interior is something temporal, something impermanent, unrepeatable, maybe even virtual, and when material stuff is involved, a relational encounter, something waiting to happen, or better, something always happening, just changing as it happens."[19] She calls on us to abandon the anthropocentric binaries. Preston's conception of interiority is an expansion of Rem Koolhaas' often-cited "Junkspace" manifesto on air-conditioning and from Reyner Banham's works.[20] German philosopher Peter Sloterdijk describes air-conditioning and atmospheres in the *Foams* volume of his *Spheres* series. He writes:

Modern construction culture, finally, ensured that the almost insubstantial physical content of all buildings, the encapsulated air, could be developed into a [unique] theme … all contemporary dwellings … are, in fact, air-conditioning systems … and that the true [occupiable] space is an air sculpture traversed by its inhabitants like a breathable installation …

Sloterdijk goes on, like many do when discussing atmospheric architecture, to describe Diller Scofidio Renfro's Blur Building. He sees the Blur building as a spectacle and environmental critique and states that it predicts atmospheric climate change. He describes it as follows "technically sophisticated attempt a macroatmospheric installation and an immersion … in a climate sculpture." While *Foams* was written well before COVID-19 (2004 in German), we can interpret this as a prediction of ephemeral, apperceptive public interiorities within an increasingly mediated pandemic city (containing hyper-political factors like contagions, environmental disasters) and polyatmospheres.[21]

Borders and Boundaries

Our understanding of public interiority has been influenced by Sennett's now-emblematic Harvard GSD lecture on "Interiors and Interiority," in which he describes the psychological interiority of the niqab-wearing pedestrian in Cairo, among other examples.[22] In recent talks on the "Open City," Sennett discusses the 2016 UN Habitat III conference and its publication, *The Quito Papers and the New Urban Agenda*. He describes three primary methods for creating open urban environments.[23] In this discussion, he posits that designers should "open up edges as borders, … work with incomplete forms as found opportunities, and … impose arbitrary value [by] transforming the city by design …"[24] To clarify the use of the word borders; he characterizes borders as edges that intensify activities and boundaries as edges that dispel activity. He regards Giambattista Nolli's eighteenth-century maps of Roman public space as a system of permeable and impermeable borders (not boundaries) and many interstates create dead-zones, or boundary conditions. Based on this, we should describe polyatmospheric interiority as a border condition because there is a kinetic vibration or contrast that exists between the tonal gradient of interiority and the resultant exterior context.

Recent Examples

So, we have established that the limits of the body (skin, specifically) can delineate interiority and exteriority. Atmospheres (meteorological and experiential) can create tonal gradients or atmospheric borders that contrast with exteriority—thus producing an atmospherically generated condition of public interiority in the urban realm. This atmospheric public interiority adapts into a more spectacular polyatmospheric breed of public interiority in our current Late-COVID-19 context, by virtue of its increased contrast.

We can observe instances of this polyatmospheric public interiority in cities like Frankfurt, Paris, and New York. Urban designers Janna Hohn

and Joshua Yates write about tactical urbanisms, or ad-hoc adaptive meas-
ures that activate public life in these cities. These measures can be citizen-
led/DIY, crafted from public policy, or from grassroots organizations.
For example, Hohn and Yates describe temporary city planning policies
that make exterior-interior spaces for business owners (like restaurants
expanding to the sidewalk). These are now commonly deployed in cities
across the globe. But, they uphold Frankfurt as an exemplar of pandemic
tactical urbanism (or its sister term, polyatmospheric public interiority).
They write, "Frankfurt ... has deregulated completely for the summer of
2020, allowing businesses to make sure public streetspace at will and only
intervening in specific locations where problems develop Where a shop
is close the business next door will start to adopt and activate the space in
front of it, narrow strips of unusable space along the curb are colonized
by tables, and the incidence of seating bays taking over street parking
spaces is increasing."[25] The novelty of this type of interiority is not in the
restauranteur taking over public space. But, in the deregulated, grass-roots
nature of this occupation.

Deborah Schneiderman and Liliya Dzis recently questioned the ap-
propriateness of these micro-environments in "Appropriation or Appre-
ciation: A New/COVID-19 Street View." They describe city-sanctioned
interventions which sprout from restaurant facades and overtake the adja-
cent public way (sidewalks, parking spaces, etc.).[26] While many view these
conditions of public interiority as temporary measures to support essential
local businesses, there are some questions about protecting the commons
and promote every citizens' right to intimate urban experiences.[27] It seems
that the measure of a successful framework is within the citizen-led, DIY
possibilities, and in the public support for these interventions.

A Rose by Any Other Name: Dyckman Street + Quisqueya Plaza

Dyckman Street, in northern Manhattan's Inwood neighborhood (almost
in the Bronx) produces layered climatic and experience-based atmospheres,
formed by Late-COVID-19 public policy. This block of Dyckman Street,
between Seaman Ave and Broadway, officially designates areas for din-
ing, games, and group exercise. In May 2020, the segment was designated
part of the Open Streets program, which NYDOT describes as a program
to "support economic recovery during the pandemic." The designation
helped support the adjacent businesses—mostly restaurants. In November
2020 they formed the Dyckman Gardens non-profit organization to sub-
mit an application for the NYC Plaza Program. This city program partners
with local organizations to co-manage new public plazas. The Dyckman
Gardens organization is responsible for the clean-up, event programming,

and installation and maintenance of streetscaping. Any group can apply to the Street Activity Permit Office (SAPO) when seeking a permit for activities in these co-managed plazas. According to the permit form, the NYDOT (not the partner organization) determines if the activity may take place.[28] This program is part of a larger, city-wide initiative to construct plazas in area that lack open space and with low incomes.

These privately managed public spaces do come with some restrictions—prohibiting activities like camping, taking up more than one seat, skateboarding, spitting, unreasonable noise, and others. The vague nature of the banned activities causes concern. For example, an unhoused person or protester could be seen as a camper and taking up more than one seat and subsequently a basis for removal from the plaza (as with those involved with Occupy Wall Street at Zuccotti Park in 2011).[29] Unreasonable noise is a relative measure, dependent on contrast with other exterior activities. Skateboarding and spitting, while sometimes irritating, should not be prohibited as this removes young people from the public realm. As Ed Bacon said, "[skateboarding] is a harmless thing that young people had developed strictly on their own."[30]

From April–May 2021 there were community engagement workshops to assess local interest in converting Dyckman Street into a plaza. There was a 70% positive response in favor of the plaza. Some expressed concern that if it remained an underutilized street that dirt bikes and drag racing would continue to prevail. Conversely, others were concerned about the long-term privatization of public space (restaurants seating in the public way) and parking congestion. Regardless, the plan was approved and in November of 2021 the plaza was renamed Quisqueya Plaza, honoring the Taino word for Hispaniola, the island containing the Dominican Republic and Haiti.[31] Dyckman Gardens intends to host events like multi-cultural programming, games for kids, arts and crafts, performances, food festivals, board games, and domino. Knowing this, let's determine if Quisqueya Plaza fosters open cities and frameworks for polyatmospheric public interiority. Sennett's Open Cities require activated borders, working with incomplete forms, and placing value in under-recognized places.

1 Open Edges and Borders: Quisqueya Plaza has open edges and borders, when comparing to the neighboring restaurant interiors and the adjacent neighborhood groups. Through usage and atmosphere, Quisqueya Plaza provides an open edge condition that intensifies interior-activities. However, the restrictions on some activities within the plaza create a boundary condition that dispels spatial rights for citizens and noise complaints from some residents.

2 Incomplete Forms: The plaza is open to temporal programming, creating varied enclosure levels and adaptability. However, NYDOT Street Activity Permit restrictions constrain some of these possibilities, reducing the adaptability of forms. This restriction however, when viewed within the tonal gradient of interiority, can produce increased specificity in the human experience and usage of this exterior-interior space.

3 Arbitrary Value: According to the NYDOT Plaza Program, Quisqueya Plaza is an area with low or moderate income and lacking open space. The existing adjacent NYC Greenstreets park,[32] Lt. William Tighe Triangle, contains the Riverside-Inwood Neighborhood Garden (RING) and hosts a neighborhood garden club, art classes and events.[33] The lack of open space in this predominately Dominican, moderate-income neighborhood already places a priority on the open space at Tighe Triangle. Quisqueya Plaza is an expansion of that significance. At a macro level, the increase in publicly accessible open spaces in this neighborhood meets Sennett's arbitrary value qualifier. But, on the level of human-scaled interiority, Tighe Triangle is already significant and so the new adjacent plaza may not contribute to added value. This would require depend upon resident usage and engagement.

Preston and McCarthy address interiority as and embodied experience and redundant to architecture. A mist-like experience—"something temporal, something impermanent …"[34] Expanding upon this and considering Sennett's ideas on openness, polyatmospheric interiority of Quisqueya Plaza does not always exist in the NYDOT designated boundaries of Seaman St, Broadway, Tighe Triangle and the facades facing the plaza. Instead, the instances of polyatmospheric interiority occur on a temporal cycle—when the place is activated by residents, during grass-roots initiated activities, or with mundane, everyday, neighborhood uses.[35] This in contrast to the exterior-interiors that are generated by the exterior seating at adjacent restaurants and other business-oriented installations.

A Way Forward

Designers should bring interiority into the city via flexible structures that allow locals reclaim public space for fleeting conditions of interiority that spectacularize everyday life in the urban realm. This is the most potent way to encourage intimate urban experiences and spatial rights in the urban commons. For example, perhaps NYDOT office could evaluate plazas within the NYDOT Plaza Program to make sure they have contemplative spaces, small group spaces, and an open space with multiple layouts possible for mixed uses. This analysis could be a prerequisite for successful public

space and the suggested event layouts could be available to groups applying for a SAPO permit. These designs should be a framework that allows for adaptability by local users, a variety of temporal and sensory experiences, and spectacularize everyday interiorist uses within the urban outdoors.

Notes

1 Bernd Upmeyer, "Quarantines and Paranoia: Interview with Beatriz Colomina," *MONU: Magazine on Urbanism: Pandemic Urbanism* 33 (2020, Autumn): 4–13.
2 For the Urban Interior: Suzie Attiwill, "Urban and Interior: Techniques for an Urban Interiorist," in *Urban Interior: Informal Explorations, Interventions and Occupations*, ed. Rochus Urban Hinkel (Baunach, Germany: Spurbuch-verlag, 2011), 11–26.
 For Oblique Interiors: Igor Siddiqui, "Slashed Interiors/Text Space," *Interiority* 3, no. 1 (2020): 6–20, accessed November 27, 2022, https://doi.org/10.7454/in.v3i1.73
 For Promiscuous Interiority: Christine McCarthy, "Toward a Definition of Interiority," *Space and Culture* 8, no. 2 (2005): 112–25, accessed November 27, 2022, https://doi.org/10.1177/1206331205275020
 For Micro-Interiors: Deborah Schneiderman Liliya Dzis, "Appropriation or Appreciation: A new/COVID-19 Street View," in *Appropriated Interiors*, ed. Deborah Schneiderman, Anca I. Lasc, and Karin Tehve (New York, NY: Rout-ledge, 2022), 102–13. https://doi.org/10.4324/9781003131632-11
 For Tactical Urbanism: Joanna Merwood-Salisbury and Vanessa Coxhead, "Exterior Interiors: The Urban Living Room and Beyond," in *Interiors Beyond Architecture*, eds. Deborah Schneiderman and Amy Campos (New York, NY: Routledge, 2018), 139–52. https://doi.org/10.4324/9781315647838-13
3 Guy Debord, *The Society of the Spectacle* (Oakland, CA: Black & Red Press, 2001), 2.
4 Emily Pellicano, "Psychedelic Strategies; Alternative Phenomenologies, Trans-lations, and Representations of the Human Body in Relation to Interior Space," *Journal of Interior Design* 46, no. 1 (2021): 125–42, accessed November 27, 2022, https://doi.org/10.1111/joid.12186
5 Jean Baudrillard, *Simulacra and Simulation*, trans. Sheila Glaser (Ann Arbor, MI: University of Michigan Press, 1981). https://doi.org/10.3998/MPUB.9904
6 Libero Andreotti and Nadi Lahiji, *The Architecture of Phantasmagoria* (New York: Routledge, 2017), 165. https://doi.org/10.4324/9781315707068
7 Rochus Urban Hinkel, "From Analogue to Virtual: Urban interiors in the Pan-demicene," *Interiority* 3, no. 2 (2020): 121–44, accessed November 27, 2022, https://doi.org/10.7454/in.v3i2.98
8 Michaela Litsardaki, "Balco(n)vid-19: How the Pandemic Can Be Hacked," *MONU: Magazine on Urbanism: Pandemic Urbanism* 33 (2020, Autumn): 40–47.
9 Alice Bucknell, "Dual-Use: Farshid Moussavi on Rethinking Residential Ar-chitecture in the Wake of COVID-19," Harvard GSD News, Harvard GSD, November 20, 2020, www.gsd.harvard.edu/2020/11/dual-use-farshid-mous-savi-on-rethinking-residential-architecture-in-the-wake-of-covid-19/
10 Hinkel, 121–44.
11 Jenny Odell, *How to do Nothing: Resisting the Attention Economy* (Brooklyn, NY: Melville House, 2019), xxi.

12 Josef Albers, *Interaction of Color* (New Haven, CT: Yale University Press, 2006), 18.

13 Yongling Zhao, "Buoyancy Effects on the Flows Around Flat and Steep Street Canyons in Simplified Urban Settings Subject to a Neutral Approaching Boundary Layer: Wind Tunnel PIV Measurements," *Science of The Total Environment* 797, no. 25 (November 2021): 149,067, accessed November 27, 2022, https://doi.org/10.1016/j.scitotenv.2021.149067. While the correct meteorological term is "atmospheric boundary layer" I will call it an atmospheric border here—to respect Sennett's definition of boundary (a separator where things are inactive) vs. border (a separator where things are active).

14 Christine McCarthy, "Before the Rain: Humid Architecture," *Space and Culture* 6, no. 3 (2003): 330–38, accessed November 27, 2022, https://doi.org/10.1177/1206331203251817

15 Julia Kristeva, *Powers of Horror: An Essay on Abjection*, trans. Leon S. Roudiez (New York, NY: Columbia University Press,1982).

16 Gail Cooper, *Air-Conditioning America* (Baltimore, MD: Johns Hopkins University Press, 1988).

17 Dalia Munenzon and Yair Titelboim, "Grasping for (Fresh) Air: Exposing the Inherent Conflict of Public Interiors," *MONU: Magazine on Urbanism: Pandemic Urbanism* 33 (2020, Autumn): 33–39.

18 Julieanna Preston, "In the Mi(d)st of," *AD Interior Atmospheres* 78, no. 3 (2008): 6–11, accessed November 27, 2022, https://doi.org/10.1002/ad.666

19 Julieanna Preston, "Being under, with THIS room," *Interiors* 11, no. 2–3 (2021): 234–52, https://doi.org/10.1080/20419112.2021.1962055

20 Reyner Banham and François Dallegret, "A Home is not a House," *Art in America* 2 (1965): 70–79 and Rem Koolhaas, "Junkspace," *October* 100 (2002): 175–90, accessed November 27, 2022, https://doi.org/10.1162/016228702320218457

21 Peter Sloterdijk, *Spheres: Foams: Plural Spherology*, trans. Wieland Hoban (Los Angeles, CA: Semiotext(e), 2016). Sloterdijk defines the term polyatmosphere as he elevates artist Constant Nieuwenhuys's utopic New Babylon project as the exemplar of the hypercity and contemporary society, generated by ludic stimuli. In Sloterdijk's view, New Babylon lacks an understanding of urban performance, assembly, and a position on places of "separation and immunization."

22 Richard Sennett, "Interiors and Interiority," Harvard GSD Lecture Series, April 26, 2016, video, 1:00:32, https://youtu.be/hVPjQhfJfKo

23 Richard Sennett, Ricky Burdett, Saskia Sassen, and Joan Clos, *The Quito papers and the New Urban Agenda* (New York, NY: Routledge, 2018), https://doi.org/10.4324/9781351216067

24 Richard Sennett, "Open City," Harvard GSD Lecture Series, April 23, 2017, video, 1:22:33, https://youtu.be/7PoRrVqJ-FQ

25 Janna Hohn and Joshua Yates, "Bringing About the Adaptive Street," *MONU: Magazine on Urbanism: Pandemic Urbanism* 33 (2020, Autumn): 94–101.

26 Schneiderman and Dzis, 102–13.

27 Tom Avermaete, "Constructing the Commons: Towards Another Architectural Theory of the City," in *The New Urban Condition: Criticism and Theory from Architecture and Urbanism*, ed. Leandro Medrano, Luiz Recamán, and Tom Avermaete (New York, NY: Routledge, 2021), 50–69.

28 NYC DOT, "Home," NYC DOT, www1.nyc.gov/html/dot/html/home/home.shtml. NYC DOT, "Plaza Events," NYC DOT www1.nyc.gov/site/cecm/permitting/permit-types/plaza-events.page

29 Jonathan Massey and Brett Snyder, "Mapping Liberty Plaza," *Places Journal*, September 2012. Accessed November 30, 2022. https://doi.org/10.22269/120918
30 Dan McQuade, "Watch: That Time Ed Bacon Skateboarded Across Love Park. Philadelphia," Philadelphia Magazine, Metro Corp, February 14, 2016, www.phillymag.com/news/2016/02/14/love-park-ed-bacon-skateboarding-video/
31 Gus Saltonstall, "Quisqueya Plaza in Inwood is Getting a New Name: DOT Breakdown," Patch, Patch Media, September 14, 2021, https://patch.com/new-york/washington-heights-inwood/quisqueya-plaza-inwood-getting-new-name-dot-breakdown
32 NYC 311, "Greenstreets Program," NYC 311, https://portal.311.nyc.gov/article/?kanumber=KA-01554
33 NYC Parks, "Lt. Wm. Tighe Triangle," NYC Parks, www.nycgovparks.org/parks/lt-wm-tighe-triangle/history
34 Preston (2021): 234–52.
35 Aaron Schneider, "Social Entrepreneurship, Entrepreneurship, Collectivism, and Everything in Between: Prototypes and Continuous Dimensions," *Public Administration Review* 77, no. 3 (2017): 421–31, accessed November 27, 2022, https://doi.org/10.1111/puar.12635

Bibliography

Avermaete, Tom. "Constructing the Commons: Towards Another Architectural Theory of the City." In *The New Urban Condition: Criticism and Theory from Architecture and Urbanism*, edited by Leandro Medrano, Luiz Recamán and Tom Avermaete, 50–69. New York, NY: Routledge, 2021.

Albers, Josef. *Interaction of Color*. New Haven, CT: Yale University Press, 2006.

Andreotti, Libero, and Nadi Lahiji. *The Architecture of Phantasmagoria*. New York, NY: Routledge, 2017.

Attiwill, Suzie. "Urban and Interior: Techniques for an Urban Interiorist." In *Urban Interior: Informal Explorations, Interventions and Occupations*, edited by Rochus Urban Hinkel, 11–26. Baunach: Spurbuchverlag, 2011.

Banham, Reyner, and François Dallegret. "A Home Is Not a House." *Art in America* 2 (1965): 70–79.

Baudrillard, Jean. *Simulacra and Simulation*. Translated by Sheila Glaser. Ann Arbor, MI: University of Michigan Press, 1981.

Bucknell, Alice. "Dual-Use: Farshid Moussavi on Rethinking Residential Architecture in the Wake of Covid-19." Last modified November 20, 2020. www.gsd.harvard.edu/2020/11/dual-use-farshid-moussavi-on-rethinking-residential-architecture-in-the-wake-of-covid-19/.

Debord, Guy. *The Society of the Spectacle*. Oakland, CA: Black & Red Press, 2001.

Hinkel, Rochus Urban. "From Analogue to Virtual: Urban Interiors in the Pandemicene." *Interiority* 3, no. 2 (2020): 121–144. Accessed November 27, 2022. https://doi.org/10.7454/in.v3i2.98

Hohn, Janna, and Joshua Yates. "Bringing About the Adaptive Street." *MONU: Magazine on Urbanism: Pandemic Urbanism* 33 (2020, Autumn): 94–101.

"Home." NYC DOT. Accessed November 27, 2022. www1.nyc.gov/html/dot/html/home/home.shtml

Koolhaas, Rem. "Junkspace." *October* 100 (2002): 175–190. Accessed November 27, 2022. https://doi.org/10.1162/016228702320218457

Kristeva, Julia. *Powers of Horror: An Essay on Abjection.* Translated by Leon S. Roudiez. New York, NY: Columbia University Press, 1982.

Litsardaki, Michaela. "Balco(n)Vid-19: How the Pandemic Can Be Hacked." *MONU: Magazine on Urbanism: Pandemic Urbanism* 33 (2020, Autumn): 40–47.

"Lt. Wm. Tighe Triangle." NYC Parks. Accessed November 27. 2022. http://www.nycgovparks.org/parks/lt-wm-tighe-triangle/history

Massey, Jonathan, and Brett Snyder. "Mapping Liberty Plaza." *Places Journal*, September 2012. Accessed November 30, 2022. https://doi.org/10.22269/120918

McCarthy, Christine. "Before the Rain: Humid Architecture." *Space and Culture* 6, no. 3 (2003): 330–338. Accessed November 27, 2022. https://doi.org/10.1177/1206331203251817

McCarthy, Christine. "Toward a Definition of Interiority." *Space and Culture* 8, no. 2 (2005): 112–125. Accessed November 27, 2022. https://doi.org/10.1177/1206331205275020

McQuade, Dan. "Watch: That Time Ed Bacon Skateboarded Across Love Park." *Philadelphia*, February 14, 2006. www.phillymag.com/news/2016/02/14/love-park-ed-bacon-skateboarding-video/

Merwood-Salisbury, Joanna, and Vanessa Coxhead. "Exterior Interiors: The Urban Living Room and Beyond." In *Interiors Beyond Architecture*, edited by Deborah Schneiderman and Amy Campos, 139–152. New York, NY: Routledge, 2018. Accessed November 27, 2022. https://doi.org/10.4324/9781315647838-13

Munenzon, Dalia, and Yair Titelboim. "Grasping for (Fresh) Air: Exposing the Inherent Conflict of Public Interiors." *MONU: Magazine on Urbanism: Pandemic Urbanism* 33 (2020, Autumn): 33–39.

Nieuwenhuys, Constant, Rem Koolhaas, Trudy Nieuwenhuys, Laura Stamps, Willemijn Stokvis, and Mark Wigley. *Constant's New Babylon.* Ostfildern: Hatje Cantz Verlag, 2016.

"NYC 311." Greenstreets Program. Accessed November 27, 2022. https://portal.311.nyc.gov/article/?kanumber=KA-01554

Odell, Jenny. *Travel by Approximation: A Virtual Road Trip.* Self-published, 2010. Accessed November 27, 2022. https://www.jennyodell.com/tba.html

Odell, Jenny. *How to Do Nothing: Resisting the Attention Economy.* Brooklyn, NY: Melville House, 2019.

Pellicano, Emily. "Psychedelic Strategies; Alternative Phenomenologies, Translations, and Representations of the Human Body in Relation to Interior Space." *Journal of Interior Design* 46, no. 1 (2021): 125–142. Accessed November 27, 2022. https://doi.org/10.1111/joid.12186.

"Plaza Events." NYC DOT. Accessed November 27, 2022. www1.nyc.gov/site/cecm/permitting/permit-types/plaza-events.page

Preston, Julieanna. "In the Mi(d)st of." *AD Interior Atmospheres* 78, no. 3 (2008): 6–11. Accessed November 27, 2022. https://doi.org/10.1002/ad.666

Preston, Julieanna. *Performing Matter: Interior Surface and Feminist Actions.* Baunach, Germany: Spurbuchverlag/Art Architecture and Design Research, 2014.

Preston, Julieanna. "Being Under, With THIS Room." *Interiors* 11, no. 2–3 (2021): 234–252. Accessed November 27, 2022. https://doi.org/10.1080/20419112.2021.1962055

Saltonstall, Gus. "Quisqueya Plaza in Inwood is Getting a New Name: DOT breakdown." *Patch*, September 14, 2021. https://patch.com/new-york/washington-heights-inwood/quisqueya-plaza-inwood-getting-new-name-dot-breakdown

Schneider, Aaron. "Social Entrepreneurship, Entrepreneurship, Collectivism, and Everything in Between: Prototypes and Continuous Dimensions." *Public Administration Review* 77, no. 3 (2017): 421–431. Accessed November 27, 2022. https://doi.org/10.1111/puar.12635

Schneiderman, Deborah, and Liliya Dzis. "Appropriation or Appreciation: A New/COVID Street View." In *Appropriated Interiors*, edited by Deborah Schneiderman, Anca I. Lasc, and Karin Tehve, 102–113. New York, NY: Routledge, 2022. https://doi.org/10.4324/9781003131632-11

Sennett, Richard. "Interiors and Interiority." Harvard GSD Lecture Series, April 26, 2016. Video, 1:00:32. https://youtu.be/hVPjQhfJfKo

Sennett, Richard, Ricky Burdett, Saskia Sassen, and Joan Clos. *The Quito Papers and the New Urban Agenda*. New York, NY: Routledge, 2018.

Sennett, Richard. "Open City" Harvard GSD Lecture Series, April 23, 2017. Video, 1:22:33. https://youtu.be/7PoRrVqJ-FQ

Siddiqui, Igor. "Slashed Interiors/Text Space." *Interiority* 3, no. 1 (2020): 6–20. Accessed November 27, 2022. https://doi.org/10.7454/in.v3i1.73

Sloterdijk, Peter. *Spheres: Foams: Plural Spherology*. Translated by Wieland Hoban. Los Angeles, CA: Semiotext(e), 2016.

Upmeyer, Bernd. "Quarantines and Paranoia: Interview with Beatriz Colomina." *MONU: Magazine on Urbanism: Pandemic Urbanism* 33 (2020, Autumn): 4–13.

Zhao, Yongling. "Buoyancy Effects on the Flows Around Flat and Steep Street Canyons in Simplified Urban Settings Subject to a Neutral Approaching Boundary Layer: Wind Tunnel PIV Measurements." *Science of The Total Environment* 797, no. 25 (November 2021): 149,067. Accessed November 27, 2022. https://doi.org/10.1016/j.scitotenv.2021.149067

13

THE DAY THE SUN NEVER ROSE

COVID-19, Wildfire and California's Relationship with Interior Air

Amy Campos

Introduction – On Edge

On edge suggests an in-between state, a precarious and transitory condition that evokes a frenetic discomfort and insecurity, a lack of definitive placement, both conceptual and physical. Interiors hold the critical role of mediating and structuring our interactions with each other and the exterior natural world, providing us with physical and psychological security, respite and control of sensory inputs – sound, temperature, scent, and light. In September of 2020, this quality of being "on edge" became viscerally felt in California. This moment took place at the height of the lockdowns in Northern California during the COVID-19 pandemic at a time of year when the weather swings hotter, the drought-plagued landscape turns drier, and wildfire becomes an unwelcome, but necessary, visitor to our ecosystem. Before recounting that day, I must first define spatial boundaries in the context of this story.

Rather than consider an interior as bound by surfaces, views, and objects, we will consider space and place as defined by air. Air can be defined, controlled, and trusted within a spatial confine. During the COVID-19 pandemic of the early 2020s, one's physical presence did not end at one's body but rather at the extent of an exhalation. It was a time of auras – an awareness of one's physical effect beyond the objective edge of the physical body. Our experience of another human transformed from the body as object to a living environmental system. Proximity to each other demarcated the psychological perception of the cleanliness and purity of an occupied atmosphere. *Social distancing* became a named method of interaction with

DOI: 10.4324/9781003457749-17

guidelines for bodily distance shrinking and expanding frequently in the beginning of the pandemic. At first ten feet was suggested for conversation, then thirty feet when running or exerting oneself, forcing a takeover of the streetscape by anyone venturing out to exercise. Then we landed at six feet generally in conversation or in line at the grocery store or post office. This expansion of our physical awareness drastically altered the way we inhabited space and made us fully present in a sensory experience of space beyond the primarily visual. Our presence became truly atmospheric. It was as if we all could physically perceive the exhalation of breath projecting further from the body when one spoke or ran. We all responded by stepping back and speaking louder from afar or more carefully and quietly when nearness could not be avoided. Our awareness of a socially friendly environment had less to do with, say, the lighting and music of pre-pandemic times than with the open access to fresh and circulating air. Existing on the boundary of interior and exterior by opening architectural edges (windows and doors) for new air, or just by moving fully outside to socialize, allowed us to maintain social connection within the context of such physical isolation during the lockdowns.

In the mild California climate during the pandemic, sun and fog defined comfort more than the thermostat; windows and doors remained open through a wider spectrum of weather variation than we had all become accustomed to with the architectural technological advances that occurred over the past century. Fresh outside air was our primary savior, allowed to brush past architectural boundaries and welcomed through every threshold. Yet in September of 2020 California and the Pacific Northwest became engulfed in toxic air. This threat was twofold. COVID-19 was raging in a pre-vaccine era, the virus was scarcely understood, lockdowns frequently vacillated on and off and people stayed home as much as possible to avoid infection from others. Simultaneously, rampant and raging wildfires were overtaking much of the North American West's forested and populated areas, creating devastation at their source, but also emitting toxic clouds that drifted over much more terrain than their locus of ignition at the ground. Sunlight was almost totally blocked on one particularly toxic and apocalyptic day in California. The prized clear fall sunshine, crisp and clean fog-brushed ocean air was made dark, ashy and un-breathable. People were shoring up the intentional and unintentional breaks in the sealed and controlled interior environments within which they lived, wetting towels, and running air purifiers while frantically checking air quality apps and hoping for wind.

Efforts to mitigate the COVID-19 virus inside by opening windows and doors, putting on underused coats and gathering outside or on interior thresholds was negated by the need to protect from that very source of hope against the virus – the outside air. Californians were living trapped inside with an unseen killer (COVID-19), unable to engage with the safety

of the exterior because of yet another, more visible, but elusive threat (wildfire smoke). In the years following this moment, critical aspects of Californian culture bore the mark of that smoke in the bouquet of their wines, the lost crops of marijuana and the symbiotic relationship with interior inhabitation and the fresh coastal air so dearly loved in this region of the world.

Human control of and interaction with air in architecture has a motley history, from architecture as an open filter for fresh air to architecture as container and protector against contaminated air. There are binary historical conceptions of air as fresh, clean, and beneficial to health, alongside fears of air as the harbinger of disease and ill fates. This chapter will explore some global historical relationships between people and air, mediated by interior environments, from Miasma Theory and a fear of air to strategies for controlled filtration of air in architecture through the specific lens of California's conflicted state between interior contagion and exterior toxicity in September 2020.

Indigenous Practices in California of Controlled Air to Benefit Health

Prior to European settlement in the late eighteenth century, there were over 500 different cultures in what is now California, trading goods and technologies for millennia before Europeans arrived. Their evolved and careful control of fire included the propagation of certain plants that flourished post fire, the felling of redwood trees to be carved into boats as well as used in the interior of homes and sweat lodges. The indigenous cultures' adeptness at controlling fire allowed for very specifically controlled relationships with fire and interior air. These indigenous cultures typically built domestic structures with air filtration as a key design feature. Given that fire was the main source of heat and utilized for cooking inside, northern Californian cultures like the Ohlone and Miwok built circular structures with open ventilation at the center top of their homes, allowing for smoke to rise out of the structure (Figure 13.1). Redwood bark or reeds were bundled in conical form around a void big enough for a fire and a family with an opening at the top for smoke.[1] The heat rising created a stack effect that circulated in fresh air to keep these interiors fairly comfortable even with a fire inside, pulling the smoke out and controlling the heat. Also prolific among indigenous cultures across the United States, including in California, was the use of sweat lodges for healthful purification. Archaeological excavations in what is present day Northern Channel Islands have uncovered the remnants of Chumash subterranean sweat lodges, where ground was dug

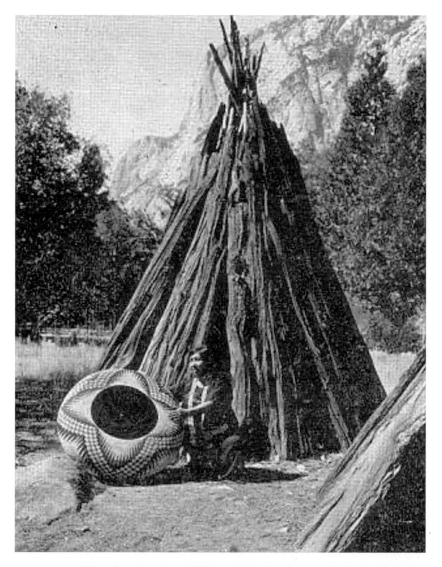

FIGURE 13.1 Miwok artist Lucy Telles, "with her largest basket." Yosemite Valley, at Yosemite National Park, 1933.

down, compressed and a roof was built on top. These roof structures had an opening at the top, like most dwellings, to control smoke and the buildings were used to heat rocks in a fire to a high temperature and burn plants and herbs to purify the spirit and body. Here, controlled interior atmospheric conditions (hot and scented air) are used to directly benefit human health.

European Settlement and Imported Conceptions of Air as Detrimental to Human Health

With European conquest in the late eighteenth century came Eurocentric conceptions about the relationship between health, air and the interior environment. To understand ideologies imported into California by the new settlers, we must understand a European lineage of conceptions of health and air. As early as 400 BCE, Hippocrates, the Greek physician considered the "Father of Medicine," wrote the book *On Airs, Waters and Places* discussing the relationship between air and health he stated:

> But such cities as lie to the west, and which are sheltered from winds blowing from the east, and which the hot winds and the cold winds of the north scarcely touch, must necessarily be in a very unhealthy situation: in the first place the waters are not clear, the cause of which is, because the mist prevails commonly in the morning, and it is mixed up with the water and destroys its clearness, for the sun does not shine upon the water until he be considerably raised above the horizon. And in summer, cold breezes from the east blow and dews fall; and in the latter part of the day the setting sun particularly scorches the inhabitants, and therefore they are pale and enfeebled, and are partly subject to all the aforesaid diseases, but no one is peculiar to them. Their voices are rough and hoarse owing to the state of the air, which in such a situation is generally impure and unwholesome, for they have not the northern winds to purify it; and these winds they have are of a very humid character, such being the nature of the evening breezes. Such a situation of a city bears a great resemblance to autumn as regards the changes of the day, inasmuch as the difference between morning and evening is great. So it is with regard to the winds that are conducive to health, or the contrary.[2]

Here Hippocrates suggests interrelationships between the sun, the air, and orientation of prevailing winds that would directly affect the overall health and sustenance of the population, defining each human body as integrally linked to its environment. Air can bring health or illness in Hippocrates' proposal. While it would be another 2300 years before germ theory emerged in its nascent form, the idea that the air itself ("vapors, mists") could cause disease persisted for millennia as Miasma Theory, named after the Greek word for "defilement." This belief established long-held habits for ventilating homes (or not) during the day or night, utilizing filtration in the form of sun, wind, vegetation and perpetuated misunderstandings

of how diseases are transferred, in addition to the creation of countless terrifying myths and fears about the night.

Miasma Theory emerged during Hippocrates' time as the belief that poisonous night air carried disease, containing "miasmas" or toxic vapor emanating from rotting organic matter and stagnant water.[3] The specific belief that disease was carried most predominantly in night air persisted into the nineteenth century. During the Cholera Epidemic of the early nineteenth century in Europe, cholera was often depicted as a cloud or skeletal death with wings and windswept hair (Figure 13.2), despite being transmitted primarily through infected water supplies, not air. We can understand today perhaps where these beliefs originated – stagnant water acts as breeding ground for nocturnal mosquitos that carry disease and rotting organic matter is a perfect home for flies, rats and other disease carrying pests. Today we understand that disease and illness spreads through germs that can be transmitted through these varied carriers, but prior to the early twentieth century when scientific advancement revealed this understanding, most in Europe and China believed that air itself was the culprit. Miasmas were imagined in the form of foggy, odorous clouds identified by foul smells (Blei 2020). The odorous was not simply an unpleasant nuisance but rather a feared source of illness and disease capable of doing harm or even killing, as described by historian Ian Mortimer recounting the faculty of the University of Paris explaining the causes of the Great Plague in 1348–1349 to the King of France:

> Such planetary alignments are thought to lead to local miasmas: concentrations of fetid air and noxious vapors. These miasmas are then blown on the wind and enter men's and women's bodies through the pores of their skin. Once inside they disrupt the balance of the "humours" (the substances believed to control the body's functions), and people fall sick.[4]

In 1610, a recorded case of unneighborly stench laid the foundation for laws about nuisance, easements, and property value preservation. In Norfolk, England, William Aldred took his neighbor Thomas Benton to court accusing Benton of making his own home unlivable by building a pigsty unbearably close to his abode. His complaint to the courts was described as "an action on the case lies for erecting a hogstye so near the house of the plaintiff that the air thereof was corrupted."[5] Here we clearly see again a conception that air itself can be a negative force, rendering a place unlivable. In the end, the court found that access to light and clean air were reasonable expectations of any homeowner.

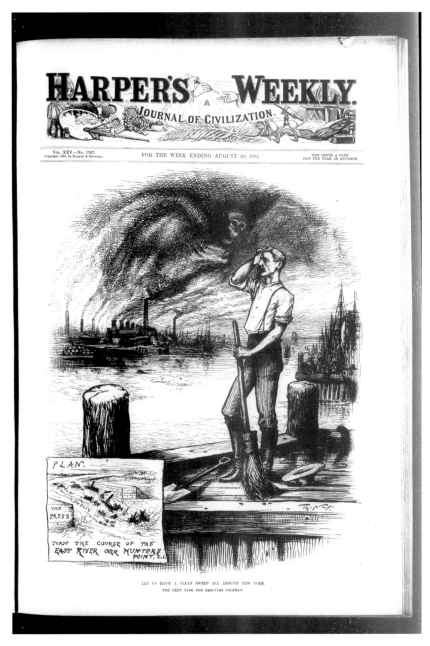

FIGURE 13.2 *Harper's Weekly* cover, 1881.

Interior as Hygienic Filter

For much of human history around the globe, the use of cultivated scent to control odors or purify was prolific. Inside, floors were often strewn with local herbs and flowers to counteract any stale or pungent air. People carried perfumed fabrics, bundles of flowers or scented tinctures to shield against the threat of a bad smell. Bathing rituals to maintain healthful personal odor across cultures rivaled the hygiene obsessions of the late twentieth century.

In the nineteenth century, American authors Catharine Beecher and Harriet Beecher Stowe advocated for fragrant plantings placed inside and outside of windows to filter miasmas, with specific species of plants like lilac outlined in their publications (Figure 13.3), including in 1869s *The American Woman's Home*.[6] Bad scent as an indicator of harm, and, equally, good scent as a deterrent of disease, became an increasingly important social phenomenon in the United States. Whole libraries of flower dictionaries emerged in the nineteenth century, beginning with the first *Le langage des fleurs* by Charlotte de la Tour published in Paris in 1819, ascribing layered meanings to the giving of flowers as a gesture of love and health. The cultivation of hybrid tea roses became a global market after 1867s introduction of the first cross-bred garden rose, "La France" cultivated by Jean-Baptiste André Guillot during the Universal Exhibition in Paris, the Société d'Horticulture de Lyon.[7]

A particularly special quality of 'La France' is that it is exquisitely, deliciously fragrant. This is a quality rarely found in hybrid teas. Its pungent blossoms exude a strong, sweet blend of damask and musk perfume with a hint of the classic "Old Rose". The intense fragrance is said to be strong but elusive and reminiscent of a fine and subtle French perfume.[7]

During this time, greenhouses became popular, as the development of glass technologies and structural innovation afforded new architectural opportunities. Greenhouses created flourishing environments for plants, and also controlled micro-climates for people to escape the pollution of the outside world in urban areas. The most famous was London's Crystal Palace of 1851 by Joseph Paxton produced for the World's Fair, imagined as a continuous indoor public space with clean fresh air that could be accessed year-round as a reprieve from the then heavily polluted London smog. Paxton and other contemporaries of his, like John C. Loudon and Henry Cole, believed that mechanically ventilated and thermally controlled glass interiors could provide a healthful public antidote to the vast and dangerous pollution of the outside air of their time.[8]

FIGURE 13.3 Figure 43 from *The American woman's home* ..., 1869.

Eventually as germ theory (the understanding that disease is spread by biological agents or microscopic pathogens) replaced miasmic theory at the end of the nineteenth century, our understanding of disease transmission evolved and our understanding of how our bodies responded to environmental conditions did as well. With the Tuberculosis Outbreaks of the

late nineteenth and early twentieth centuries, sanatoriums emerged across the world in sites much like those described by Hippocrates so long ago. Access to light and fresh air at higher altitudes became yet again a critical component of health and well-being and was believed to be a successful remedy for tuberculosis.

A Sanatorium Belt emerged in southern California luring tuberculosis patients from across the country to come gain health and renewal by breathing in the coastal, dry, warm air of California. Luxurious campuses provided plentiful access to fresh air from balconies, breezeways, interior greenhouse gardens (Figure 13.4) that promised fresh air year round much like the Crystal Palace. Open air tents and shaded hammocks provided minimal enclosure to produce interiors loosely defined, unsealed and open to abundant healthful, fresh air.[9]

Priorities for fresh air and sunlight lay the foundation for much of modern Californian wellness culture and connection with the landscape. The 1950s and 1960s saw a huge demand for breezeblock-constructed walls that provided visual privacy, sun control and captured the coastal breezes of the Californian landscape just as the region was being built up rapidly again during this post-World War II era.

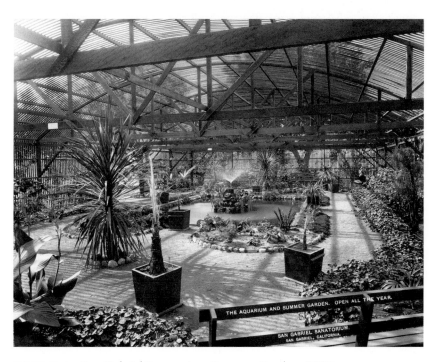

THE AQUARIUM AND SUMMER GARDEN. OPEN ALL THE YEAR.
SAN GABRIEL SANATORIUM.
SAN GABRIEL, CALIFORNIA.

FIGURE 13.4 San Gabriel Sanatorium Summer Garden, 1898.

FIGURE 13.5 Exterior of the Stanford University Medical Center, 1955.

Breezeblocks were introduced in California by the American Architect, Edward Durrell Stone.[10] In 1955, he built the American Embassy in New Delhi using his first cheap concrete breezeblock, modeled on the perforated Jaali screens he saw in use all over India, to control heat gain from the sun while allowing for air flow. He then returned to California and promptly built a new hospital in Palo Alto in 1955 using the same strategies (Figure 13.5). These affordable, efficient and stylized building components took over in the American West and their strategies of bringing fresh air through interiors for the benefit of the inhabitants. This conception of air as a beneficial tool for human health and comfort influences the California vernacular and mixes with indigenous cultures, and influences from India and similar climatic regions across the globe.

Outside air (especially cool night air) is utilized effectively in hotter and drier climates to chill and refresh interiors from the heat of the day. In northern Africa, the Middle East and Southern Asia windcatchers and Jaali (Indian) or Mashrabiya (Arabic) screens are still used for passive cooling and filtration, with documented examples depicted as early as 1300 BC in Egypt. Sloping wind scoops on the roofs of structures captured prevailing winds and circulated the fresh outside air down into the buildings. Perforated screens were used to cover and protect from sun exposure at exterior apertures while allowing for free air flow through the building in concert with the windcatchers on the roofs. These passive architectural devices are still effectively used in many parts of the world.

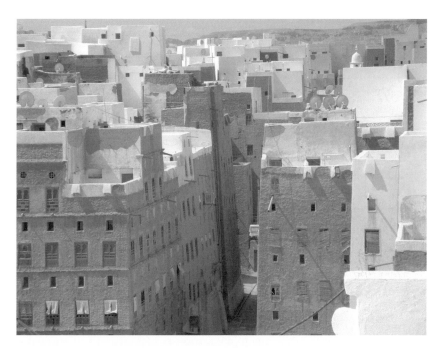

FIGURE 13.6 Old Walled City of Shibam (Yemen).

Yemen's UNESCO World Heritage-protected skyscrapers in the six-teenth-century walled city of Shibam present a brilliant complexity of engi-neering that produces sustainable, comfortable microclimates, protecting their inhabitants from extreme external conditions.[11] Essentially the entire building acts as an air-cooling device, shading, filtering and moving air to create a comfortable climate inside (Figure 13.6). The height of the buildings aid in capturing desert winds high above the city streets. Double walled building-height mudbrick shafts are filled with air blowing in and through screened openings. Evaporative cooling happens at the base of some shafts where water wells are present. These shafts insulated the in-ner spaces of the building with cooled circulating air. The interior of the buildings created comfortable micro-climates for controlled living in these more extreme landscapes.

The idea that architecture itself could protect and purify evolved as our ideas about air and health developed to a more complete understanding of pollution, smog and the need for clean air action at a global scale. In the middle of the twentieth century, the United States passed a series of Clean Air Acts.[12] As Aldred argued for in 1610 in England, the Clean Air Acts legislatively formalized the idea that humans deserved access to clean air as a fundamental right, and that the government played a critical role

in protecting that right. The Air Pollution Control Act of 1955 was the first federal regulation related to air pollution and established funding for research into pollution of the air. In 1963, the first Clean Air Act added techniques for continued research but also the first monitoring and applied strategies for controlling air pollution. The Air Quality Act of 1967 then provided for ambient monitoring, source inspections and regulations around interstate air pollution and control. By 1970, the Clear Air Act created a broad range of standards for testing, monitoring, and controlling the air. Four critical regulations were enacted: the National Ambient Air Quality Standards (NAAQS), State Implementation Plans (SIPs), New Source Performance Standards (NSPS), and National Emission Standards for Hazardous Air Pollutants (NESHAPs). The same year, the Environmental Protection Agency (EPA) was established with expanded implementation and enforcement powers. All of this legislative action parallels social anxieties about human health and the environment.

Architects, designers and artists at the time responded to these concerns as well. In the late 1960s and early 1970s, several significant performances, exhibitions and structures posed questions about the role of the interior as pure controlled space, an antidote to the polluted exterior environment, coming full circle much like responses to Miasma Theory centuries before and the intentions behind the Crystal Palace 100 years prior. In 1966–1967, the conceptual art group, Art & Language, formed by Terry Atkinson and Michael Baldwin in the UK, exhibited their Air-Conditioning Show.[13] The exhibit consisted of an air conditioner in the corner of a room, maintaining an air temperature of 60 degrees Fahrenheit. The room was otherwise completely empty leaving only the controlled air itself on display as art (Figure 13.7). The piece suggests that air itself is worthy of preservation, installed as a precious object encased in a protective interior encasement.

Around the same time, architects like Michael Webb (from Archigram) and Reyner Bahnam were experimenting with lightweight inflatable architectures made primarily of air, contained with the most minimal of thin plastic skins. The appeal of the inflatable as an architectural type was a combination of individual unspecialized skill to create built environments and the nomadic, temporary potentials of these constructions. In 1970, coinciding with the Clean Air Act and the formation of the EPA, the group Antfarm (led by Chip Lord, Hudson Marquez, Doug Michels and Curtis Schreier) created the Clean Air Pod as part of a larger agitprop performance titled, "Breathing – That's your bag" on the UC Berkeley campus. The Clean Air Pod was an inflated plastic enclosure using a pneumatic fan to fill the bag with conceptually clean air free from the toxic pollutants of the exterior world. Performers wore gas masks and white lab coats and

FIGURE 13.7 The Air-Conditioning Show, 1967.

asked passers-by to sign their own death consent form if they chose not to enter the Pod. The performance was imagined as a projection into the future, even being published in the Oakland Tribune as a prediction of a toxic future in need of architectural devices to survive.

By 1977, this renewed idea of architecture as a living breathing organism was well established with the opening of the Pompidou Center in Paris. The building expresses its ventilation, electrical, water and circulation systems on the exterior of the building as a color-coded façade backed by a glass wall visually open to the unobstructed interiors. Designed by Renzo Piano and Richard Rogers as an accessible and understandable cultural factory with the architectural functions exposed and available to the city. This sort of turning the building inside out echoes characteristics of Beecher and Beecher Stowe's vegetated, filtered domestic interiors discussed earlier in the chapter.

The history of architecture as an environmental filter, improving aspects of the surrounding environment through architectural technologies, endures from the Yemeni skyscrapers to the Crystal Palace to the Pompidou. The accompanying interior as the resulting purified retreat from the perils of the exterior world persisted during the recent massive wildfires in California.

A Geographic Interior

Returning to the American West Coast in the fall of 2020, frequent COVID-19-caused lockdowns aimed to keep people vigilant in their isolation and distanced from each other to discourage the spread of the airborne COVID-19. The only social opportunity was to gather outside or at the edges of opened and ventilated interiors. Yet this was also an historical year for dry hot conditions resulting in the worst wildfire season in recorded history. Over a hundred years of halted indigenous controlled burns, during the oppression and erasure of that cultural knowledge by the European settlers added to an immense buildup of forest duff (dry plant debris), the perfect fuel for sustained fires. As a result of these fires, toxic smoke drifted and lingered over the West Coast for weeks. The conditions outside were equivalent to smoking cigarettes continuously, a condition particularly dangerous for those with high-risk health issues, the elderly, and children.

Those living in much of the West Coast were trapped for weeks, between the threat of airborne COVID-19 inside closed spaces, and the polluted and damaging outside air. The atmospheric conditions at the time perpetuated the fires and held the smoke in place, creating a polluted and smoke-filled geographic-scaled regional interior (Figure 13.8). On one day

FIGURE 13.8 Smoke from the North Complex fire settles over San Francisco, 2020.

in September 2020, the air was so smoke-filled that the light never changed from the previous night, through the entire day, to the next night. It remained dark, as if the sun never rose, and interiors remained sealed and dark all day, in an apocalyptic suspension of circadian rhythm.

Living within a Frenetic Threshold

The early pandemic's lockdowns and social distancing and the many climatic issues leading to increasing droughts and wildfires have come to a crisis point during this decade. In recent years, the pandemic and the wildfires have forced us to this frenetic threshold between the expectations we have set for how we live in the twenty-first century and the wild destruction and resulting uncertainty and insecurity we have created in our environments and ecosystems. Our constructed and controlled habitats operate as integral ecosystems with us as an impactful component, affecting critical balances that require our management to sustain.

Hope is offered in renewed interest in indigenous environmental practices. There has been much attention recently paid to the traditional native practices of cultural burns in California and an effort to resurrect native knowledge about fire as a tool to facilitate sustained and safe regeneration in the landscape. The Karuk and Yurok tribes in Northern California are

working with the Forest Service to reintroduce annual controlled burns as a way to clear duff and undergrowth and prevent the horrendously all-consuming fires we experienced in 2020.[14]

This moment of environmental crisis is clearly not new to the human condition, but it offers an opportunity for interior designers and architects to question and reformulate again the relationship between human health and the controlled built environments and atmospheres we create.

Notes

1 Bachich, "Native Americans of the San Francisco Bay Area: The Ohlone Tribe, Part 1," accessed May 21, 2023. https://www.californiafrontier.net/ohlone-tribe-language-food-clothing/#Ohlone_Houses.

2 Hippocrates. *On Airs, Waters and Places.* Translated by Francis Adams, 400 BCE. Accessed May 24, 2023. http://classics.mit.edu//Hippocrates/airwatpl.5.5.html.

3 Baldwin, Peter C. "*How Night Air Became Good Air 1776–1930.*" Environmental History, Volume 8, No. 3, 2003, pp. 412–429.

4 Mortimer, Ian. *The Time Traveller's Guide to Medieval England: A Handbook for Visitors to the Fourteenth Century.* New York, NY: Simon & Schuster, 2010.

5 Sir Edward Coke, John Henry Thomas, John Farquhar Fraser. *The Reports of Sir Edward Coke, Knt in Thirteen Parts, Vol. 5.* Oxford: J. Butterworth and Son, 1826.

6 Beecher, Catharine Esther and Stowe, Harriet Beecher. "*The American woman's home: or, Principles of domestic science: being a guide to the formation and maintenance of economical, healthful, beautiful, and Christian homes.*" New York, NY: J.B. Ford and Company,1869.

7 Horn, Suzanne M. "*La France~The Mystery & The History of the Dawn of the Modern Rose.*" American Rose Society. March 12, 2021. Accessed May 27, 2023. https://www.rose.org/single-post/la-france~the-mystery-the-history-of-the-dawn-of-the-modern-rose.

8 Schoenefeldt, Henrik. "*The Crystal Palace, environmentally considered.*" Architectural Research Quarterly/Volume 12/Issue 3–4, 2008, pp. 283–294.

9 Morrison, Pat. "*Southern California's curious history as the sanitarium capital of America.*" LA Times, 2022. Accessed June 5, 2023. https://www.latimes.com/california/story/2022-08-30/explaining-l-a-with-patt-morrison-los-angeles-as-lourdes-by-the-sea.

10 Stone, Hicks. n.d. Edward Durrell Stone, Architect. Accessed May 23, 2023. https://www.edwarddurellstone.org/edward-durell-stone-work-1950s.html.

11 Attia, Ahmed Salah Eldin. "*Traditional multi-story house (Tower House) in Sana'a City, Yemen. An example of sustainable architecture.*" AEJ – Alexandria Engineering Journal 59, 2020, pp. 381–387.

12 EPA. n.d., *Evolution of the Clear Air Act.* Accessed May 2023. https://www.epa.gov/clean-air-act-overview/evolution-clean-air-act#:~:text=The%20enactment%20of%20the%20Clean,industrial)%20sources%20and%20mobile%20sources.

13 Copeland, Phillpot, Armleder, Perret. *Voids: a Retrospective.* Ringier: JRP, 2020. https://lukeinghamassessment14.wordpress.com/research-2/the-air-conditioning-show-1966-7/.

14 Sommer, Lauren. "*To Manage Wildfire, California Looks To What Tribes Have Known All Along.*" National Public Radio (NPR). August 24, 2020. Accessed May 27, 2023. https://www.npr.org/2020/08/24/899422710/to-manage-wildfire-california-looks-to-what-tribes-have-known-all-along.

Bibliography

Attia, Ahmed Salah Eldin. "*Traditional Multi-Story House (Tower House) in Sana'a City, Yemen. An Example of Sustainable Architecture.*" AEJ – Alexandria Engineering Journal 59 (2020): 381–387.

Bacich, Damian. "*Native Americans of the San Francisco Bay Area: The Ohlone Tribe, Part 1.*" Accessed May 21, 2023. https://www.californiafrontier.net/ohlone-tribe-language-food-clothing/#Ohlone_Houses.

Baldwin, Peter C. "*How Night Air Became Good Air 1776–1930.*" Environmental History 8, no. 3 (2003): 412–429.

Beecher, Catharine Esther, and Harriet Beecher Stowe. *The American woman's Home: or, Principles of Domestic Science: Being a Guide to the Formation and Maintenance of Economical, Healthful, Beautiful, and Christian Homes.* New York, NY: J.B. Ford and Company, 1869.

Blei, Daniela. "*In 19th-Century America, Fighting Disease Meant Battling Bad Smells.*" Atlas Obscura. April 8, 2020. Accessed May 24, 2023. https://www.atlasobscura.com/articles/public-health-bad-smells-miasma.

Copeland, Phillpot, and Perret Armleder. *Voids: a Retrospective.* Ringier: JRP. 2020. https://lukeinghamassessment14.wordpress.com/research-2/the-air-conditioning-show-1966-7/.

EPA. n.d. *Evolution of the Clear Air Act.* Accessed May 2023. https://www.epa.gov/clean-air-act-overview/evolution-clean-air-act#:~:text=The%20enactment%20of%20the%20Clean,industrial)%20sources%20and%20mobile%20sources.

Fowler, David. *A Chronology of Global Air Quality.* Penicuik: The Royal Society Publishing, 2020.

Hippocrates. *On Airs, Waters and Places.* Translated by Francis Adams, 400 BCE. Accessed May 24, 2023. http://classics.mit.edu//Hippocrates/airwatpl.5.5.html.

Horn, Suzanne M. "*La France~The Mystery & The History of the Dawn of the Modern Rose.*" American Rose Society. March 12, 2021. Accessed May 27, 2023. https://www.rose.org/single-post/la-france~the-mystery-the-history-of-the-dawn-of-the-modern-rose.

Morrison, Pat. "*Southern California's curious history as the sanitarium capital of America.*" LA Times, 2022. Accessed June 5, 2023. https://www.latimes.com/california/story/2022-08-30/explaining-l-a-with-patt-morrison-los-angeles-as-lourdes-by-the-sea.

Mortimer, Ian. *The Time Traveller's Guide to Medieval England: A Handbook for Visitors to the Fourteenth Century.* New York, NY: Simon & Schuster, 2010.

Schoenefeldt, Henrik. "*The Crystal Palace, Environmentally Considered.*" Architectural Research Quarterly 12, no. 3–4 (2008): 283–294.

Sir Edward Coke, John Henry Thomas, and John Farquhar Fraser. *The Reports of Sir Edward Coke, Knt in Thirteen Parts, Vol. 5.* Oxford: J. Butterworth and Son, 1826.

Sommer, Lauren. "*To Manage Wildfire, California Looks To What Tribes Have Known All Along.*" National Public Radio (NPR). August 24, 2020. Accessed May 27, 2023. https://www.npr.org/2020/08/24/899422710/to-manage-wildfire-california-looks-to-what-tribes-have-known-all-along.

Stone, Hicks. n.d. Edward Durrell Stone, Architect. Accessed May 23, 2023. https://www.edwarddurellstone.org/edward-durell-stone-work-1950s.html.

14

MOVING TO THE EDGE

How the Relocation of the Provincial Higher Architecture Institute in Hasselt, Belgium, Reshaped Its Interior Architecture Program[1]

Sam Vanhee, Els De Vos, and Fredie Floré

Introduction

It was September 1987. Architect and director of the Provincial Higher Architecture Institute (PHAI) of Limbourg, Adolf Nivelle, gave a speech at the official opening of the first academic year in the new campus building in Diepenbeek, which he designed.[2] In the central forum, a double-height space at the center of the building defined by concrete columns arranged in a 3 m-by-3 m rectangular grid, students and teachers of the architecture and interior architecture programs had gathered (Figure 14.1). The building bore the hallmarks of 1970s architecture and Dutch Structuralism – particularly resembling Hertzberger's Centraal Beheer in Apeldoorn – with a sitting well, gray concrete bricks and modular but complex spatial arrangements in which atria and balconies succeeded one another. Occupying an allotment adjacent to the central university building – to which it was connected by means of a corridor – the building was part of the Limbourg University Center (LUC), founded in 1971 (see location B in Figure 14.2).[3] Like many other campuses built in the same period, the LUC was embedded in an impeccable landscape on the edge of urban society.[4]

Contrary to what the move of the PHAI in 1987 to the university campus suggests, the PHAI did not grant any university degrees.[5] Founded in Hasselt in 1955 under the impulse of the provincial government, the school initially provided programs in construction drawing, graphic design, glass staining, smithing, and sculpture. In 1959, the school extended its scope by adding full-time programs in architecture and interior architecture. In 1970, anticipating the equalization of architecture education to

DOI: 10.4324/9781003457749-18

FIGURE 14.1 Central forum of the campus building in Diepenbeek, used for displaying student work. Picture by author (2021).

university level, the school split into an architecture and interior architecture school (PHAI), and an arts school (PHIKO).[6] Both institutes would coexist in the same functionalist building – designed by cleric-architect Hendrik Machiels, the first director of the school – for another 17 years (Figures 14.3 and 14.4).

During the preceding decades, there had been multiple attempts to "scientificate" the architecture discipline by seeking contact with universities.[7] This step toward universities, as sociologist Harold Wilensky argues, is part of a discipline's professionalization process.[8] Most notable within Belgium's architecture scene are the efforts by renowned modernist architect Renaat Braem, interim director at the National Higher Institute for Architecture and Urban Planning in Antwerp (NHIBS) in the

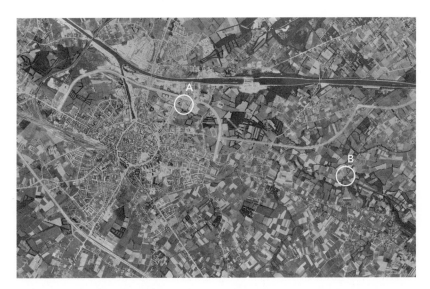

FIGURE 14.2 Indications of the locations of the two schools (A: before the relocation, B: after the relocation) on an aerial photograph of Hasselt (1971) by Digitaal Vlaanderen.

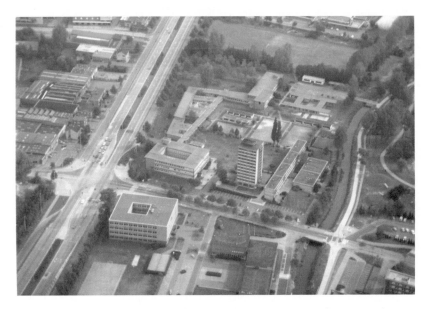

FIGURE 14.3 Aerial photograph from the late-1970s or early 1980s showing the functionalist school building in the Elfde-Liniestraat in an allotment defined by the Outer Ring Road (left), the Demer River (right), and the Elfde-Liniestraat (bottom). Author unknown.

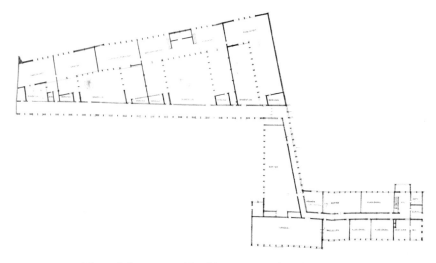

FIGURE 14.4 Plan of the original building's central and eastern wing (left and right respectively), with central corridor. By Hendrik Machiels (1969). Provincial Archives of Limbourg, Provincial Department of Buildings, Box 495.

1960s, and his successor Frans De Groodt.[9] The latter's lecture, "The Bankruptcy of Architectural Education?," at the PHIA in 1972, which argued for the absorption of architecture in the university system, suggests that their ambitions were considered valuable enough to be heard by their PHAI counterparts.[10] Belgian architecture critic and historian Geert Bekaert interpreted the plethora of exhibitions and symposia in the 1960s as manifestations of the "fundamental questioning of the profession of architect itself," suggesting that the architecture discipline in Belgium (and elsewhere in Europe) was in dire need of recalibration and redefinition.[11] It is in the wake of these events, where key figures in the Belgian architecture scene sought contact with universities to professionalize their discipline, that the relocation of the PHAI in 1987 to the university campus in Diepenbeek snugly fits.[12]

However, the oral histories with former teachers at the PHAI suggest that the aspirations of architects like De Groodt to academicize the architecture discipline were not supported by many of the PHAI's interior architecture teachers at the time. The main concerns were all related to the location of the program: joining the university campus in Diepenbeek implied both a withdrawal from the city center and adaptation to a university context. To understand why the ambitions of several key players in Belgium's architectural educational landscape provoked such grievances for many of the interior architecture teaching staff at the PHAI, this chapter examines the built

environment of the school itself. Also examined are archival documentation and oral histories in the form of retrospective in-depth interviews with former teachers and students of the PHAI. It aims to map and discuss three kinds of edges that were renegotiated through the process of the relocation: the edge between school and city (physical edge), between education and society (educational edge), and between architecture and interior architecture (disciplinary edge). While the first one is addressed as the main theme, the other two are inherently related to the first.[13]

The Societal Role of Architecture Schools?

In a manifesto from November 4, 1975, which reads as a reaction against the plans to move to Diepenbeek, former interior architecture teacher Jos Roux voiced many of the concerns he shared with other key players in the program's teaching staff. As one of the most affluent teachers from the 1970s until the mid-1990s and teacher in the Design Workshop and the Design Studio, he defined what the relationship between architecture schools and (urban) society ought to be. According to the text, an architecture school's priority should be to understand the contemporary needs of society in order to address them:

> If a program does not entail societal critique, a school does not evolve to constantly improving situations, or if one does not learn to discover the contemporary needs (within society), one neglects the societal structures one actually works with.[14]

He continues by directly criticizing the current state of the architecture curriculum, whose first two years were scientific to the degree that the school created "technicians and construction experts." Befitting the political climate of the 1970s, the alternative the manifesto provided was a self-regulating system: a "freer" and "open-minded" program in which students and teachers can choose their own specialization, be it directed toward building physics or philosophy. Requiring the abolishment of ex-cathedra pedagogy, this approach had specific spatial requirements. The school needed to be "open," both within and without:

> An open school, that is to say: the classrooms are no longer (arranged according to) year 1, 2, 3, 4 etc. They are dedicated spaces for the teachers of the Design Studio, Sociology, Current Affairs ... The two programs (architecture and interior architecture) that coexist independently, will intermingle. (...) The purpose is not to create an open school for students, teachers, the school head, or the staff, but to create a house other people can visit and walk through, where expositions

can be organized, where people can conduct interviews ... In short, where fear of thresholds belongs to the past. One could compare such an institution with the passage of a shopping street, but then in a quieter environment, or directly connected to more busy cores. (...) The city always brings in people, even if it is just a market where animals or goods are traded. The situation in which this school will be embedded, is therefore more important than its internal relations, because the relations within a city have been growing gradually over the years. In contrast, the relations within a building can be deformed and adapted in accordance with changing needs.[15]

Roux's description of an ideal architectural school is interesting for two reasons. First, he employs several typical aspects of a city center, like busy cores, shopping streets, markets, and an open house, suggesting the importance of the proximity of a community beyond the university to an architecture school. It is mainly for them that the school's alumni would be working. In the same breath, he condemns the design approach of the new campus building in Diepenbeek, which he specifically contrasts to the situation in the city. As the new campus building's preliminary design report made by Nivelle in 1980 demonstrates, the initial design process did not account for the new building's surroundings: it only contained a study of the building program, with multiple organograms investigating the relationship between functions and disciplines.[16] In contrast, Roux's manifesto did almost the opposite: it was more concerned with how the school was positioned within its broader landscape than its interior relations. These two documents represent the two most extreme positions regarding the relocation of the PHAI.

Second, Roux's manifesto essentially argues to re-evaluate the educational edge of the school by redefining its physical edge, suggesting the interdependence between both types of edges. Because of the school's physical proximity and accessibility to and from the city in Roux's description, passers-by should not only be able to walk through the school, but also engage with its education by means of, for example, visiting expositions or conducting interviews.

This debate is not specific to Hasselt, as is clear from architectural theorist Maarten Van Den Driessche's contribution in *School in de Stad, Stad in de School*, where he identifies different chronological "episodes" (i.e., periods) in the development of European school typologies. Nivelle's design belongs to the second episode of development, characterized by an urban exodus and a belief in the positive effects of natural landscapes. In contrast, Roux's plea is indebted to the third episode, characterized by

"antiauthoritarian movements of the 1970s and 1980s," critiquing institutions and advocating for a more open school network.[17] According to Van Den Driessche, the second episode generally encompasses prefabricated, land-based building typologies, while in the third episode other strategies are used for school design and construction, like the adaptive reuse of empty buildings and industrial sites.[18] To understand the specific spatial component of the debate at the PHAI, and the educational discontinuities it entailed, we will first consider the value of the center for the PHAI, before moving on to the relocation to the edge.

The Value of the Center

The first three decades of the PHAI's existence were situated on an allotment defined by the Hasselt's outer ring road to the North, the river Demer to the South, and the Elfde-Liniestraat to the West (Figure 14.3). Though the school was not located in an urban context by definition, it required only a 15-minute walk to the central square. As such, its location facilitated mobility between the PHAI and Hasselt's urban tissue. This had three educational repercussions: the city center was used as a forum, a laboratory, and an extension of the school's facilities.

1 *The city center as a forum for political activism*

Multiple teachers from the program were in some way related to the Tamera-Foundation, a socio-critical association founded in the early 1970s that set the "protection of heritage in the framework of a humane environment-policy."[19] The foundation published an independent city newspaper to challenge local urban policies, and organized protests to condemn (and even boycott) ongoing urban demolitions in Hasselt's historical tissue; this was consistent with political action common to Belgium during the 1960s and 1970s.[20] Former teachers like Jos Roux, Louis Coolen, and Huub Berger were, during their career as teachers at the PHAI, active members or supporters of the foundation's agenda. Roux served as the Tamera Foundation's chair for several years during his career as a teacher at the school, solidifying the ties between the PHAI's interior architecture program and the foundation.[21] In a context where urban demolition coincided with the wide scale construction of car infrastructure (e.g., constructing or widening ring roads) and the emergence of real estate agencies, organizations like the Tamera-Foundation lobbied for a paradigm shift, to revalue historic buildings. Former teacher Berger recalled that during his time as interior architecture student, he joined his teachers in protest actions. The political activism

of their teachers became part of their teaching, though outside of the school's physical edge. Berger recalls:

> I got into it as a student because Jos Roux was a member (of the Tamera-Foundation). We literally went onto the inner ring road and occupied several buildings. Hasselt actually had a beautiful ring road with Art Nouveau and Art Deco buildings, but a lot of those have been demolished during the 1970s. During my final year, I had a student room there. We managed to rent one of those houses, and then we occupied some of them. The city newspaper had written about that.[22]

Such political engagement and interest for the protection of historic buildings percolated through the design studios. Students from interior architecture frequently worked on designs involving existing buildings.[23] That these sites were often located within the city is not surprising. For example, Berger's graduation design from 1977 was the repurposing of the Brewery Theunissen (under threat of demolition since 1961) into an architecture school (Figure 14.5).[24] Stimulated by the Tamera-Foundation's

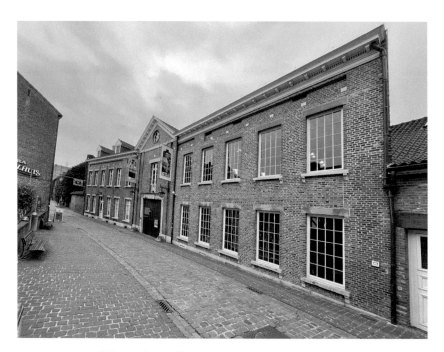

FIGURE 14.5 Building of Distillery Theunissen, which now houses Hasselt's Gin Museum. Picture by author (2021).

reaction against unbridled urban demolition in cities like Hasselt, the track of the PHAI's interior architecture program was directed toward re-use, renovation, and repurposing of urban buildings.[25] Such active involvement of teachers in the broader context of the school are essentially means to renegotiate or redefine an educational edge that goes beyond – but is facilitated by – the school's physical location.

2 *The city center as an extension of the school's facilities*

While reconceptualizing the edge between a school and its environment (both physically and educationally) in his manifesto, Roux argues for an architectural school to be open to its surroundings, creating a forum for exchange, interaction, and open debate. Such ideals imply a very democratic and open form of knowledge production. To a certain extent, the functionalist building by Machiels met these criteria (Figure 14.3 and 14.4). The site, though resembling traditional campus architecture, was not fenced in any way and the building (with its three wings and temporal extensions in the form of barracks) had multiple entrances. The plethora of windows on the ground floor, in combination with a pathway circumscribing the building, allowed for visual communication: the architecture did not hide what knowledge was being produced inside its walls. It was hence physically and visually accessible for any passersby. Furthermore, the lack of a monumental entrance de-emphasized a formal threshold between the school and its exterior.

The school had been suffering from a continuous lack of space from the mid-1960s onwards, helping to further dissolve the division between school and its surroundings, especially the city center. The school's library, for example, was described by multiple teachers as "limited" and "not much." It is likely that, given the library's limited size, students were encouraged to use other libraries available within Hasselt.[26]

In addition, the school lacked a dedicated workshop for the fabrication of models and furniture.[27] As part of the solution, Roux set up collaborations with vocational schools in and around Hasselt. A letter from Roux sent to Governor Pinxten in 1981 concerning the payment for materials for the course Design Workshop (Atelier Design), provides an overview of those vocational schools, and descriptions of that collaboration. Specifically, the older students from the Design Workshop designed their own furniture, which would then be manufactured by students from the technical schools in Maasmechelen, Sint-Truiden, Lommel and Hasselt.[28] The closest school with which they collaborated was in Hasselt, only about 500 m away. The "prototypes" made there would ultimately be used as models for the younger students to be studied, measured, and drawn.[29] According to Roux, these collaborations were

a win-win, because students from the PHAI were able to work together with people who fabricated their designs, and the students from the technical schools were trained to use other production methods than the ones necessary to produce the usual, heavily decorated, wooden Mechels furniture.[30] Also, these collaborations influenced the position of craftsmanship within the program. For example, interior architecture students did not necessarily require the skills to make a piece of furniture themselves, but their technical drawings had to be clear and very precise in order for a woodworking student to understand and produce the piece correctly. The fact that the school had no dedicated room with an extensive inventory of machines and tools for courses like Design Workshop, only stresses the importance of these kinds of collaborations.

The point here is that the PHAI used – sometimes because of a lack of alternatives – other facilities within its surroundings to support its educational programs. This is not to say that Hasselt's urban fabric was the sole source of external facilities, nor that the PHAI could only use a city's facilities when it is physically close to it. What it does demonstrate, however, is that the PHAI looked beyond its own building to ensure the type of education that proved challenging to provide on campus, essentially constituting a second way in which the PHAI's educational edge was redefined.

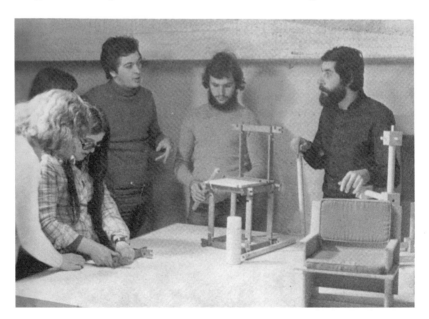

FIGURE 14.6 Furniture Design class by Jos Roux (right). Photographer unknown (1977). From Tentoonstelling Industriële Vormgeving, Provinciaal Begijnhof Hasselt

3 *The city center as a laboratory*

Berger's graduation project, the repurposing of Brewery Theunissen into an architecture school, also exemplifies the use of the city center as a locus for design and experimentation (Figure 14.5). The timing and program of his design was not a coincidence; Roux and others used design assignments to explore the possibilities of moving the PHAI to the city center. Because the brewery building contained less area than was required by his proposed program, Berger used the facilities in the site's immediate surroundings, reducing the project's footprint:

> In Distillery Theunissen, (...) we had to design an architecture school, which did not seem feasible at first. But the location also had its advantages, being in a city. At first, we said 'you cannot fit an auditorium and a library in it'. But there was an auditorium, and on the corner of the street, there is the provincial library. That was the idea, to go beyond the interior and connect (everything).[31]

The project not only embodied Roux's perspective on how the new architecture school should function, but also showcases the hallmarks of the third episode as defined by Van Den Driessche: the use of empty buildings or industrial sites as loci for schools during the 1970s and 1980s. Berger's project departed from the existing relation between the PHAI and its surroundings and made use of other facilities.[32]

The city center was used as a space for observation, analysis, and design in the architecture program as well. Hubert Froyen, former student and professor emeritus of the architecture program of Hasselt University, described his experience as a student:

> In the earlier years (of the architecture program), (...) it started off with observation exercises. You had to look around, in the little yet interesting city that Hasselt is. There are the bel-etage houses on the inner ring road and several other types of buildings. "Go and look at those buildings! Sketch them, document them, try and draw a plan. Analyze them, to start from an in-depth observation of the buildings and the surroundings." (...) In essence, the built environment as a laboratory.[33]

To conclude, Hasselt's city center assumed the role of laboratory, was a place of collaboration, and constituted a tension field in which established paradigms about practicing interior architecture and architecture could be questioned. Its location close to the center provided a climate in which the physical and educational edges of the PHAI could – and had to – be

renegotiated. Moving away from Hasselt not only impeded such exchange with its city center, but forced the programs to recalibrate both physical and educational boundaries.

The Consequences of the Edge

The relocation of the PHAI to the LUC in Diepenbeek was, in a way, a product of a paradigm shift during the preceding decades. The car was believed to be the ideal mode of transportation, the city became a place of societal unrest, and rural and suburban sites were promoted as ideal contexts for dwelling. The building in Diepenbeek appears to embody these developments: it is surrounded by several university buildings, pastures and a vast car park, safely removed from the ills of urban life. The isolated location impacted the PHAI, and in particular the interior architecture program, in three significant ways.

1 *Campus architecture as a medium of control*
 In contrast to the open character of the PHAI's previous building, the new campus building does not seem to divulge what is being produced within its walls (Figure 14.7). Keeping visitors and passersby at a

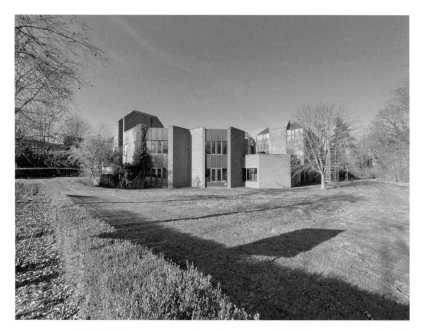

FIGURE 14.7 Hedged lawn surrounding the campus building in Diepenbeek by Adolf Nivelle (1987). Picture by author (2021).

distance by means of a hedged lawn, the building is directed inward. As Francesco Zuddas describes in his *University as a Settlement Principle*, campus buildings typically form a "sealed interior," "compensating a perceived loss of the capacity of a city to nurture social bonds," a description applicable to the building in Diepenbeek.[34] That it was further removed from Hasselt's city center directly relates to the political unrest during the 1960s and 1970s: In Hasselt (and elsewhere in the world), the city became perceived as a locus of social unrest, with people questioning and distrusting the government as a top-down institute. Universities therefore tended to remove themselves from such tumultuous context and quite literally retreated from the center to the edge. This was not necessarily an effective escape, but an attempt by higher education to maintain a form of social control. As Reinhold Martin discusses in his *Knowledge Worlds*, during the 1960s, political activism had found its way inside the school's walls.[35] In Belgium, the most notable example would be the protests of the student movement *Leuven Vlaams at* Leuven University, located within Leuven's city center.[36] That such a climate also manifested itself in Hasselt, and particularly at the PHAI, is clear from several letters between the teaching staff and the governor: they testify of student strikes and protests on the school grounds.[37]

As Bernaerts puts it – and this is also the argument of Martin and Francesco Zuddas – the university campus was a medium for crowd control. Isolated settlements were not only more difficult to reach for a large group of people but were also relatively easy to surround and isolate, impeding students and teachers to participate in protests like the ones organized by the Tamera-Foundation. Though the LUC was not walled, its landscape provided a natural barrier, with only few entrances for cars or bikes. The closed-off quality of the campus is somehow reflected in the building that showcases the architectural vocabulary of a fortress, with sturdy walls and a broad piece of grassland immediately surrounding it. Additionally, because the building was constructed in a marshy area, the grassland can physically impede movement closer to the building during rainy periods.

The building's plan expresses the importance of the building's (sealed) inner core. The central forum, ostensibly designed as exposition space, was also the place for important events (Figures 14.1–14.8). Govaerts described Nivelle's educational intentions for the central agora:

> So sketching is actually about looking, seeing, feeling, and that is actually the main subject the students get, especially in the beginning. (…) That did manifest (spatially), because you have the

agora. Nivelle had designed that for drawing classes, as a sketching room. Surrounding it, there are different workshops and theoretical courses. This was the original plan, based on the requests of several teachers.[38]

In contrast to the previous building, where teachers often had to improvise due to a lack of space, the new building eliminated the need for improvisations in some important ways. The modular platforms were a designed, formal replacement of the temporal buildings before the relocation (the platforms are the square rooms on Figure 14.8, the temporal buildings are on the top-left of Figure 14.3). The forum (Figure 14.1) became a formalized version of the central corridor (Figure 14.4), that had supported rather accidental, personal and impromptu encounters between staff and students of the various programs before 1987. Hence, Nivelle's design can be read as a means to control and orchestrate certain aspects of the workings of the school, too, by redesigning the school's physical edges.

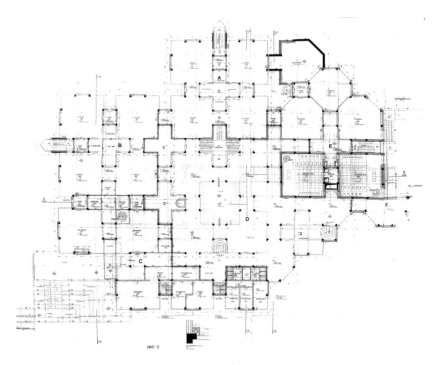

FIGURE 14.8 Plan of the building in Diepenbeek with the central forum or agora. By Adolf Nivelle (1982). Provincial Archives of Limbourg, Provincial Department of Buildings, Box 518.

2 *The campus as a settlement*

As mentioned earlier, the structuralist campus building in Diepenbeek is indebted to Hertzberger's design for the *Centraal Beheer* offices in Apeldoorn.[39] That Nivelle used references from the Netherlands is not surprising: several former teachers regularly organized colloquia at which Dutch architects like Piet Blom, Piet Mondriaan, Gerrit Rietveld and Herman Hertzberger were invited to speak, as Roux recalls.[40] In Hertzberger's description of his Centraal Beheer in *Lessons for Students in Architecture*, the building is "some kind of settlement, consisting of a larger number of equal spatial units." In the same paragraph, he quotes Aldo Van Eyck: "Make of each a place, a bunch of places of each house and each city, for a house is a tiny city, a city a huge house."[41]

Such definitions – typical for Dutch Structuralism – involve a certain dialectic between a building and a city, implying a similarity in design approach. That Nivelle's building was conceived as a small city or settlement also echoes through Nivelle's preliminary design schemes, where vocabulary such as "streets" and "forum" is adopted to describe the building.[42]

It is exactly the dialectical relation between the physical edge of the PHAI and the city that drastically changed after 1987. Once the school moved away from the city, facilities that were at hand in Hasselt's city center had to be incorporated into the new building's program, like the museum, the library, and the vocational schools. To a certain extent, these three (urban) functions were substituted with an alternative. The new building's circulation space and central forum, which according to Froyen allowed for visual communication, partially functioned as an internal exposition space.[43] Though not completely capable to supplant the use of museums like the Provincial Museum in Hasselt, the space does provide a stage for student work, discussions and colloquia. Also, the new building had a dedicated space to develop an architectural library.[44] The establishment of a dedicated workshop for manual labor is another example. While in its previous location, the PHAI relied on external facilities to produce furniture designs made by students, it gradually became possible to create one's own piece in the school workshop. Though archival material suggests that the collaborations between vocational schools continued until the early 1990s, traces of such collaborations completely stopped in the mid-1990s. At the same time, oral histories suggest that the PHAI's workshop was gradually and continuously upgraded. Most likely, the two systems overlapped to absorb the change in the production process.

The creation of a dedicated workshop was integral to the recalibration of the school's educational edge, in particular repositioning

craftsmanship within the program. When pieces of furniture are produced by a third party (e.g., students of vocational schools), there is the freedom to create more technically demanding pieces of furniture. At the same time, however, it is crucial to have clear and complete construction drawings, since they are the primary source of communication. Hence, such kinds of collaborations require developed drawing skills, but little dexterity in terms of manual labor. After 1987, the PHAI gradually provided more resources to produce furniture at the school, which not only required more insight into how materials react to certain loads, but also how it could be produced with the available tools. To support the practical side, workshop assistants were recruited to support the furniture design and construction workshops.[45] In other words, the change in available facilities at the PHAI had direct pedagogical implications for its interior architecture program.

3 The campus as a locus for scientific knowledge production

The position of craftsmanship within the program further changed in the mid-1990s, due to the fusion of different Flemish university colleges like the PHAI. These took place in the light of the reorganization of the higher education system in Belgium and Europe, with the Bologna Declaration signed in 1999.[46] From the year of the relocation up until 2013, the interior architecture and architecture program experienced a latency period: both programs were, during those 26 years, embedded in a university context but were not part of the university system: both degrees were until 2013 non-academic artistic degrees. During that period, the school anticipated the absorption into the university, resulting in adaptations in the curriculum, according to teachers of practical courses like Roux (furniture design) and Van Gompel (Color & Form):

> And then it suddenly became a university. The university decrees stated that there was no room for handcraft. That means that my studio was dissolved. That was in 1997, and it was then that I quitted. (…) I think that the artistic aspect that could have been present within architecture and interior (architecture), was being crippled. (…) Everything that was much more scientific was being invigorated. Less and less hours were allocated to the design studios.[47]

Similarly, Van Gompel saw the reduction of hours allocated to Color & Form, a practice-based course (inspired by – among others – Johannes Itten), from 16 to 8 hours a week, reportedly after 1992.[48] The scientification of the architecture program – for which figures like De Groodt and Braem had argued – involved in practice a scientification (i.e., expanding

scientific courses in the curriculum like Building Physics) of the interior architecture curriculum. And while, undoubtedly, this also had positive effects on the program, according to teachers in practical courses, it certainly diminished the importance of craftsmanship within the curriculum.

The relocation thus not only constituted an adaptation in the physical and educational edge of the school, but the debate about the relocation itself adds a disciplinary layer to the process. The relocation served the ambition of director Nivelle and the architecture program to become part of the university system, while many interior architecture teachers judged a university context unfit for their interior architecture program. And though there were mixed feelings on both sides, the two most outspoken viewpoints can be represented by Roux's manifesto and Nivelle's design report, as discussed earlier.

A Return to the Center?

The PHAI's interior architecture program has changed significantly over the years, with the relocation being one of the most impactful events in its history. The change of its physical edge prompted a redefinition of its educational edge as well. While initially collaborations with vocational schools were set up to take over the production process, the new campus building gradually eliminated the need for such relationships. The provision of a workshop within the new building also shifted the skillset required of the students. However, because of the anticipated absorption into universities the curriculum became more science-based, subsequently reducing practical courses, moving the importance of knowing-by-doing to the margins.[49]

What the move from the center to the edge has also demonstrated is that the stance of interior architecture's protagonists like Roux, Van Gompel, and others was highly informed by the specificities of their discipline. Roux's vision of an open school in close contact with people in the city center echoes the human-centeredness often associated with interior architecture.[50] That the teachers from interior architecture were very sensible to existing heritage and were inclined to move the school into a vacant building within the city, is also not surprising, given the fact that one of interior architecture's "content tendencies" – as defined by interior architecture theorist Inge Somers – is to work in an existing, architectural shell.[51] The debate about the position of the school – be it either on the edge or in the center – was hence also a discussion about disciplinary edges.

That discussion is still relevant today, as recent developments involve a move back to the city center. In 2017, more than 40 years after Roux's

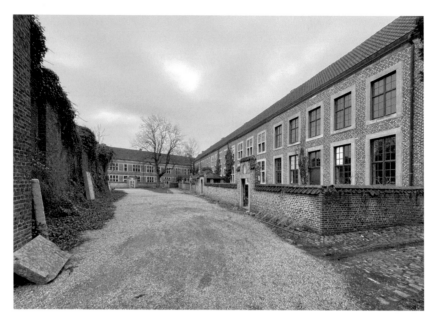

FIGURE 14.9 Hasselt's beguinage, to be repurposed into classrooms for architecture and interior architecture students Hasselt University. Picture by author (2022).

manifesto, Hasselt University – into which the architecture and interior architecture programs have been absorbed – bought the beguinage in Hasselt's city center. Since then, the beguinage has been repurposed to house a part of the architecture and interior architecture programs (Figure 14.9). At the same time, Hasselt University has been profiling itself as a "civic university" and aims to make and keep "this Region strong – a good place to build a future, a career, a business, a home, a life."[52] In their mission statement on their website, they state that "universities cannot stand apart from what is happening outside of their walls. They must assume responsibility and share knowledge." With this statement, Hasselt University implicitly critiques the relocation and seems to want to redefine the school's physical and educational edge, indirectly following Roux's plea for an open school in the city center. The question is whether this return will also have implications on architecture and interior architecture's disciplinary edge.

Notes

1 This research is funded by the Flanders Research Foundation (G050620N).
2 The name of the school in Dutch is *Provinciaal Hoger Architectuurinstituut*. Since it has been the longest-used name of the school, we will refer to the

school as PHAI if no specific period is mentioned; Interview Nivelle and Go-
vaerts, January 19, 2022, Hasselt.

3 LUC stands for *Limburgs Universitair Centrum.*

4 Francesco Zuddas, *The University as a Settlement Principle. Territorialis-
ing Knowledge in Late 1960s Italy* (New York, NY: Routledge, 2020), iv-5;
Maarten Van Den Driessche, "De Opkomst van de 'Open School': Pedagogische
Denkbeelden, Ruimtelijke Modellen," in *School in de Stad, Stad in de School,*
ed. Apostel Katrijn et al. (Brussels: University Press Antwerp, 2012), 25.

5 The school changed names several times. For clarity, we will use PHAI (Provin-
cial Higher Architecture Institute).

6 Sofie De Caigny et al., ed., *Bronnengids Architectuuronderwijs Vlaanderen*
(Antwerp: CVAa/VAi, 2012), 100; PHIKO stands for *Provinciaal Hoger In-
stituut voor Kunstonderwijs*; PHIA stands for *Provinciaal Hoger Instituut voor
Architectuur.*

7 As defined by Piet Lombaerde in Piet Lombaerde, "Architectura Sine Scienta
Nihil Est," in *Bringing the World into Culture*, ed. Piet Lombaerde and Rich-
ard Foqué (Brussels: University Press Antwerp, 2009), 125. and quoted by
Somers in Inge Somers, "Advancing Interiors. Interiorist Voices on identity Is-
sues" (PhD diss., University of Antwerp, 2017), 40; Like elsewhere in Europe,
the architecture discipline had encountered difficulties to 'define itself scientifi-
cally.' Zuddas, *The University as a Settlement Principle,* 10.

8 Harold L. Wilensky, "The Professionalization of Everyone?," *American Jour-
nal of Sociology* 70, no. 2 (September 1964): 144.

9 NHIBS stands for *Nationaal Hoger Instituut voor Bouwkunst en Stedenbouw*;
Els Spitaels and Tijl Eyckerman, "1936–1977: Het Modernisme. Architecten
voor de Moderne Samenleving," in *Van Academie tot Universiteit – 350 jaar
Architectuur in Antwerpen*, ed. Els De Vos and Piet Lombaerde (Brussels: Uni-
versity Press Antwerp, 2013), 108–9.

10 Frans De Groodt, "Failliet van het Architectuuronderwijs?," (Antwerp:
NHIBS, 1972).

11 Geert Bekaert, "Het Einde van de Architectuur," in *1951–1991, Een Tijdsbeeld,*
ed. Herman Balthazar et al. (Brussels: Paleis voor Schone Kunsten, 1991), 197.

12 The professionalization of the architecture discipline includes, among other
things, solidifying the disciplinary identity of architecture and solidifying what
knowledge is considered specific to the discipline.

13 Interior Architecture's educational histories can be employed as knowledge
bases to inform the discipline's identity debate: it allows us to understand how
the discipline grew overtime, and what were considered to be its vital elements.
Sam Vanhee et al., "Beyond Distinction-Based Narratives. Interior Design's
Educational History as a Knowledge Base," *Journal of Interior Design* 46,
no. 4 (November 2021): 8–9.

14 Voorstel tot visie in verband met de huisvesting P.H.I.A., 4 November 1975.
Private Archives, Hasselt.

15 Voorstel tot visie in verband met de huisvesting P.H.I.A., 4 November, 1975.
Private Archives, Hasselt.

16 *Plannen tot het Bouwen van het Provinciaal Hoger Architectuurinstituut op de
terreinen van de campus te Diepenbeek* (1980). Box 600, Provincial Depart-
ment of Education, Provincial Archives of Limbourg, Hasselt.

17 The first episode covers development of the school as an independent institute,
covering the second half of the 19th century up until the first half of the 20th
century. Van Den Driessche, "De Opkomst van de 'Open School'," 19–23.

18 Van Den Driessche, "De Opkomst van de 'Open School'," 23–29.

19 Tamera-Stichting vzw, "Editoriaal," *Tamera-Stichting vzw* 1, no. 1 (October 1974): 1.

20 Bekaert, "Het Einde van de Architectuur," 199; The Tamera-Foundation borrowed its name from the Latin name of the Demer River running through Hasselt.

21 Teachers that were exclusively active in the architecture program were underrepresented in the Tamera-Foundation. An important exception was Francis Strauven. Interview Roux, Hasselt, November 18, 2021.

22 Interview Berger, Hasselt, October 26, 2021.

23 At the NHIBS in Antwerp and the Municipal Higher Institute of Architecture and Urban Planning (SHIAS) in Ghent, a similar approach is observed, in which design studio teachers use their own projects as design assignments for students.

24 "De Nieuwsgierige Hasselaar" De Nieuwsgierige, accessed January 24, 2022, https://denieuwsgierige.be.

25 Interview Berger, Hasselt, October 26, 2021.

26 Several members of the teaching staff, including Jo Klaps and Suzanne Van Gompel, described the library before the relocation as 'limited' and 'not much'. Interview Klaps and Van Gompel, Hasselt, August 04, 2021.

27 According to the plans by Nivelle. *Plannen tot het Bouwen van het Provinciaal Hoger Architectuurinstituut op de terreinen van de campus te Diepenbeek* (1980), 40–42. Box 600, Provincial Department of Education, Provincial Archives of Limbourg, Hasselt.

28 Box 004, Provincial Department of Education, Provincial Archives of Limbourg, Hasselt.

29 Though the letter does not specify when this type of collaboration exactly started, it was most likely not the first time, given the brevity of the letter and the fact that the collaboration has already been set up for multiple schools. Box 004, Provincial Department of Education, Provincial Archives of Limbourg, Hasselt.

30 Interview Roux, Hasselt, November 18, 2021.

31 Interview Berger, Hasselt, October 26, 2021.

32 Other teachers have done similar endeavors, like Design Studio teacher Marcel Bernaerts, who used the provincial museum's spaces as a backdrop for design assignments. Interview Bernaerts, Hasselt, March 29, 2022.

33 Interview Froyen, Diepenbeek, November 4, 2021.

34 Zuddas, *The University as a Settlement Principle*, 7.

35 Reinhold Martin, *Knowledge Worlds: Media, Materiality and the Making of the Modern University* (New York, NY: Columbia University Press, 2021), 220.

36 Hans Righart, *De Eindeloze Jaren Zestig. De Geschiedenis van een generatieconflict* (Antwerp: Uitgeverij de Arbijderspers, 1995), 257.

37 Louis Vos, "Student Movements and Political Activism," in *History of the University in Europe. IV: Universities since 1945*, ed. Walter Rüegg (Cambridge: Cambridge University Press, 2010), 276–318; Letter from educational inspection to the Governor, 1966/02/08, Box 575, Provincial Department of Education, Provincial Archives Limbourg.

38 Interview Govaerts, Hasselt, January 03, 2022.

39 Interview Klaps, Diepenbeek, June 25, 2021; Interview Govaerts, Hasselt, January 03, 2022.

40 Interview Roux, Hasselt, November 18, 2021.

41 Herman Hertzberger, *Lessons for Students in Architecture* (Rotterdam: nai010 Publishers, 1991), 126.

42 Though Zuddas suggests that referring to campus buildings as 'small cities' is not entirely correct, we must acknowledge that at the time architects like Hertzberger and Nivelle did conceive their buildings as such. Zuddas' recent scholarship only shows that, in hindsight, these ambitions to create small-scale cities, were not completely realized.

43 Interview Froyen, Diepenbeek, November 4, 2021.

44 The exact date when such a system was put in place is not known. It is estimated to have been set up in the late 1970s or 1980s, based on the testimonies of Van Gompel and Klaps. Even though this might have been set up before the relocation, the plans to move to Diepenbeek were set during the mid-1970s, possibly providing a future perspective of having a more extensive library. Interview Klaps and Van Gompel, Diepenbeek, August 04, 2021.

45 Interview Roux, Hasselt, November 18, 2021.

46 The Bologna Process is an agreement between countries across Europe to create coherence in higher education, facilitating student and staff mobility. https://education.ec.europa.eu/education-levels/higher-education/inclusive-and-connected-higher-education/bologna-process.

47 Interview Roux, Hasselt, November 18, 2021.

48 Interview Van Gompel and Klaps, Diepenbeek, August 04, 2021.

49 This was the case for several interior architecture programs in the North of Belgium.

50 Lois Weinthal, for example, builds up different layers belonging to the interior, at the heart of which is the user's body and perception. Lois Weinthal, ed., *Toward a New Interior. An Anthology of Interior Design Theory* (New York, NY: Princeton Architectural Press, 2011), 10–11.

51 Somers, "Advancing Interiors," 146–53.

52 "UHasselt, a Civic University" Hasselt University, accessed January 2, 2023, https://www.uhasselt.be/en/about-hasselt-university/civic-university#anch-uhasselt-a-civic-university.

References

Interviews

Interview with Huub Berger, conducted by Sam Vanhee, October 26, 2021, Hasselt.
Interview with Marcel Bernaerts, conducted by Sam Vanhee, March 29, 2022, Hasselt.
Interview with Hubert Froyen, conducted by Sam Vanhee, November 04, 2021, Diepenbeek.
Interview with Gilbert Govaerts, conducted by Sam Vanhee, January 03, 2022, Hasselt.
Interview with Gilbert Govaerts and Adolf Nivelle, conducted by Sam Vanhee, January 19, 2022, Hasselt.
Interview with Suzon Ingber, conducted by Sam Vanhee, September 14, 2022, Antwerp.
Interview with Johannes Klaps, conducted by Sam Vanhee, June 25, 2021, Diepenbeek.
Interview with Johannes Klaps and Suzanne Van Gompel, conducted by Sam Vanhee, August 04, 2021, Diepenbeek.
Interview with Jos Roux, conducted by Sam Vanhee, November 18, 2021, Hasselt.

Archives

Provincial Archives of Limbourg, Provincial Department of Buildings, Hasselt.
Provincial Archives of Limbourg, Provincial Department of Education, Hasselt.
Private Archives, Hasselt.
School Archives Faculty of Architecture and Arts, Hasselt University, Diepenbeek.

Bibliography

Bekaert, Geert. "Het Einde van de Architectuur." In *1951–1991, Een Tijdsbeeld*, edited by Balthazar Herman, Geert Bekaert, Frank Vanhaecke and John Verstraete, 197–208. Brussels: Paleis voor Schone Kunsten, 1991.

Bekaert, Geert, Jo Braeken, Mil De Kooning, Ronny De Meyer, Rika Devos, Marc Dubois, Francis Strauven, Iwan Strauven, and Christophe Van Gerrewey. *Postmodernisme En Modernisme Na 1945. Van Het Atomium Tot Het Huis Van Roosmalen*. Tielt: Uitgeverij Lannoo, 2008.

De Caigny, Sofie, Annelies Nevejans, Stephanie Van de Voorde, Ellen Van Impe, and Eva Van Regenmortel, eds. *Bronnengids Architectuuronderwijs Vlaanderen*. CVAa/VAi, 2012.

De Groodt, Frans. *Failliet van Het Architectuuronderwijs?* Antwerp: NHIBS, 1972.

De Nieuwsgierige. "De Nieuwsgierige Hasselaar." Accessed January 24, 2022. https://denieuwsgierige.be.

De Vos, Els. "vanuit Het Binnenhuis de Wereld Veroveren. Een Geschiedenis Van De Opleiding Interieurarchitectuur (1941–2013)." In *Van Academie Tot Universiteit - 350 Jaar Architectuur in Antwerp*, edited by Els De Vos and Piet Lombaerde, 146–65. Brussels: University Press Antwerp, 2013.

Doucet, Nadia, Arie Kaptein, Walter Leeman, Herman Leroux, Jos Palmans, Jos Roux, and Walter Sannen, et al. *Tentoonstelling Industriële Vormgeving*. Edited by Agnes Lietaert. Hasselt: Provinciaal Begijnhof Hasselt, 1977.

European Commission, "The Bologna Process and the European Higher Education Area." Accessed May 31, 2023. https://education.ec.europa.eu/education-levels/higher-education/inclusive-and-connected-higher-education/bologna-process

Hertzberger, Herman. *Lessons for Students in Architecture*. Rotterdam: nai010 Publishers, 1991.

Lombaerde, Piet. "Architectura Sine Scientia Nihil Est." In *Bringing the World into Culture*, edited by Piet Lombaerde and Richard Foqué, 110–31. Brussels: University Press Antwerp, 2009.

Loosen, Sebastiaan, and Hilde Heynen. "Secularized Engagement in Architecture: Sieg Vlaeminck's Plea for Wooneecologie in 1970s Flanders." *International Journal for History, Culture and Modernity* 6, no. 2 (2018): 1–37.

Martin, Reinhold. *Knowledge Worlds. Media, Materiality and the Making of the Modern University*. New York, NY: Columbia University Press, 2021.

Righart, Hans. *De Eindeloze Jaren Zestig: Geschiedenis van Een Generatieconflict*. Antwerp: Uitgeverij De Arbeiderspers, 1995.

Somers, Inge. "Advancing Interiors Interiorist Voices on Identity Issues." PhD diss., University of Antwerp, 2017.

Spitaels, Els, and Tijl Eyckerman. "1936–1977: Het Modernisme. Architecten Voor de Moderne Samenleving." In *Van Academie Tot Universiteit - 350 Jaar Architectuur in Antwerp*, edited by Els De Vos and Piet Lombaerde, 100–125. Antwerp: University Press Antwerp, 2013.

Tamera-Stichting vzw. "Editoriaal." *Tamera-Stichting Vzw* 1, no. 1 (1974): 1.

UHasselt. "UHasselt, a Civic University." Accessed January 2, 2023. https://www.uhasselt.be/en/about-hasselt-university/civic-university#anch-uhasselt-a-civic-university.

Van Den Driessche, Maarten. "De Opkomst van de 'Open School': Pedagogische denkbeelden, Ruimtelijke Modellen." In *School in de Stad, Stad in de School*, edited by Katrijn Apostel, Karl Cools, Koen De Langhe, Els De Vos, Dirk Janssen, Glenn Lyppens and Leen Rams, 17–32. Brussels: University Press Antwerp, 2012.

Vanhee, Sam, Benoît Vandevoort, Fredie Floré, and Els De Vos. "Beyond Distinction-Based Narratives. Interior Design's Educational History as a Knowledge Base." *Journal of Interior Design* 46, no. 4 (2021): 13–25.

Vos, Louis. "Student Movements and Political Activism." In *A History of the University in Europe IV: Universities Since 1945*, edited by Walter Ruegg, 276–318. Cambridge: Cambridge University Press, 2010.

Weinthal, Lois, ed. *Toward a New Interior. An Anthology of Interior Design Theory*. New York, NY: Princeton Architectural Press, 2011.

Wilensky, Harold L. "The Professionalization of Everyone?" *American Journal of Sociology* 70, no. 2 (1964): 137–58.

Zuddas, Francesco. *The University as a Settlement Principle. Territorialising Knowledge in Late 1960s Italy. The University as a Settlement Principle*. New York, NY: Routledge, 2019.

AFTERWORD

Deborah Schneiderman

"It is what's inside that counts."[1] Sometimes this adage is appropriated by the field of Interior Design in order to elevate its image. Recent shifts in the understanding of interiority have caused this constriction of interiority to expand, dissipating the edges and boundaries or the discipline.

Until recently the field of Interior Design has lacked a theoretical framework and considered either a subset of architecture or a practice of decoration and taste. This general absence of a distinct discipline structure has often left the design of the interior misunderstood, and its theoretical lines challenged.[2] While scholars of the interior, since the turn of the twenty-first century have been investigating the expanding boundaries of the interior both physical and psychological, the global COVID-19 pandemic arguably transformed our perspective on Interiority. In the midst of the pandemic our interiority has become convoluted, as it caused a near elimination of typical interiors where gathering is permitted and hence shifted the parameters of interiority.[3]

Lois Weinthal regards interiority as a system of layers from the body outward,[4] referring to the textile layer of clothing as a second skin and in so doing references the work of Annie Albers, who regards this textile layer as a third skin.[5] Weinthal attributes this transition from second skin to third skin to techniques of textile construction.[6] This analysis however also can be applied to the transition from the pampering of the body (or make-up) as the second skin beneath the clothing or textile layer, including a mask, which is then a third skin (Figure 15.1). Accordingly, the mask then is regarded as a transitional interior for the porting of the body between constructed interiors protecting the pampered layer. While one might indulge

DOI: 10.4324/9781003457749-19

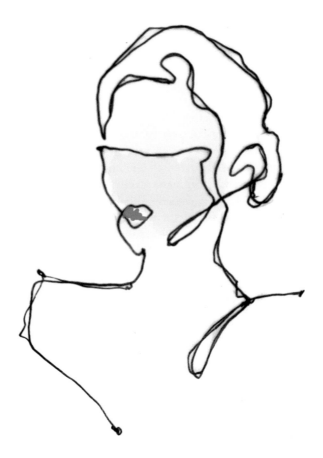

FIGURE 15.1 Mask/Lipstick Diagram. © Liliya Dzis.

in pampering seemingly for oneself, it is a critical ritual of preparing to enter the public environment. Such rituals include application of lotions, skin treatments, and the application of makeup. During the COVID-19 pandemic, interior life became mostly confined to our primary interior, the home, where such foundational layers might be abandoned as there is no public interaction. Even when entered into public life, particularly in the instance of urban environments, such as New York City – where masks are mandated when outside – parts of our bodies often continued to be left without that second skin. For some, this may be evidenced in the abandonment of the application of lipstick as masks – that third layer – which obscures its visibility. As Leslie Camhi noted when describing the intimate tie between a woman and her lipstick, "it's a bare mouth that is most telling of my mental state."[7] Quoting Maryam Nassir Zadeh, a New York-based

designer, Camhi reveals the potential power of these second and third skins, "It was my security, my identity." Lipstick bears the power to jolt her awake, Zadeh says, "When I have it on, I'm myself."[8] The shifting and dissolution of layers offered a transformed experience of the body in space.

While the conceptualization of the volume was spurred by the COVID-19 pandemic, the volume did not specifically require that chapters address it. However, current events affect the directions of research and culture, and the influence of the events of 2020 has generated a new lens through which to analyze both historical and current interior praxis and theory, its influence cannot be overstated. The research contained in this volume evidences a trajectory comprising change at many levels: social practices and everyday life, approach to materiality and material behaviors, shifting climatic conditions, the relationship between the architectural object and the human subject. The chapters have explored the manners in which interiors upset or institute our edges across history and at present, whether physical, conceptual or psychological, imagined, implied, necessary or discriminatory. Arguably the COVID-19 pandemic instigated a global shift in human occupation of the interior. Interior became exterior and exterior became interior. These themes and shifting perspectives are not novel to the recently expanding body of knowledge in Interior Design but they have been accelerated.

The interior has always been a mutable yet resilient site of enactment, one that readily transforms as needed. The interior, both in theory and practice, can be defined as binary and dialectical. It is historically defined against what it is not: the outside world, the public realm, the structural and hard, rational surfaces of the discipline of architecture, and objective technological investigations. These binary categories have historically caused a diminished significance of interiors, which privileges the formation of the outside over the inside.[9] In this contemporary context exacerbated by the COVID-19 pandemic, an expanded practice and theory of interior design has come to readily incorporate non-traditional interior environments, one where exterior is interior and interior is exterior. The Interior is now what it once was not.

We acknowledge that much of the research in this volume was developed during or in response to the COVID-19 pandemic, and hence potentially from a position of privilege. We however recognize this work to be a testament to the human spirit, developing new knowledge in reaction to adversity.

Notes

1 The adage traditionally referred to humans, not interiors, to ascribe one's true personality is more important than their exterior appearance. It has been appropriated to elevate the appreciation of Interior Design.

2 Kent Kleinman, Joanna Merwood Salisbury, and Lois Weinthal, *After Taste: Expanded Practice in Interior Design* (New York, NY: Princeton Architectural Press, 2012) 9.
3 Deborah Schneiderman and Liliya Dzis, "Appropriation or appreciation: A New/COVID Street View," in *Appropriated Interiors*, eds. Deborah Schneiderman, Anca Lasc, and Karin Tehve (Abingdon, Oxon and New York, NY: Routledge, 2022) 102–113.
4 Lois Weinthal, "Foreword," In *Interiors Beyond Architecture*, Eds. Deborah Schneiderman and Amy Campos (Abingdon, Oxon and New York, NY: Routledge, 2018).
5 Annie Albers, "The Pliable Plane; Textiles in Architecture," *Perspecta* Vol. 4, 1957, pp. 36–41.
6 Lois Weinthal, *Toward a new interior: An anthology of interior design theory* (New York, NY: Princeton Architectural Press, 2011).
7 Leslie Camhi, "One *Vogue* Writer on the Transformative Power of Lipstick— Even in the Mask Era," Vogue, November 13, 2020. https://www.vogue.com/article/the-transformative-power-of-lipstick-even-in-the-mask-era?fbclid=IwAR2oGkzSZk1mdFyBCrUlSdcp33KVM-H7xAajo7Wx9MHe9x3eoUHTi9g_g_g
8 Ibid.
9 Alexa Griffith Winton and Deborah Schneiderman, "Introduction," Textile, Technology, and Design: From Interior Space to Outer Space, eds. Deborah Schneiderman and Alexa Griffith Winton (London and New York, NY: Bloomsbury, 2016) 9–16.

Bibliography

Albers, Annie. "The Pliable Plane; Textiles in Architecture." *Perspecta*, Vol. 4, 1957, pp 36-41.
Camhi, Leslie. "One *Vogue* Writer on the Transformative Power of Lipstick—Even in the Mask Era." *Vogue*, November 13, 2020. https://www.vogue.com/article/the-transformative-power-of-lipstick-even-in-the-mask-era?fbclid=IwAR2oGkzSZk1mdFyBCrUlSdcp33KVM-H7xAajo7Wx9MHe9x3eoUHTi9g_g_g
Kleinman, Kent, Joanna Merwood Salisbury, and Lois Weinthal. *After Taste: Expanded Practice in Interior Design*. New York, NY: Princeton Architectural Press, 2012.
Schneiderman, Deborah, and Liliya Dzis, "Appropriation or Appreciation: A New/COVID Street View." In *Appropriated Interiors*, Eds. Deborah Schneiderman, Anca Lasc, and Karin Tehve. Abingdon, Oxon and New York, NY: Routledge, 2022.
Weinthal, Lois. *Toward a New interior: An Anthology of Interior Design Theory*. New York, NY: Princeton Architectural Press, 2011.
Weinthal, Lois. "Foreword." In *Interiors Beyond Architecture*, Eds. Deborah Schneiderman and Amy Campos. Abingdon, Oxon and New York, NY: Routledge, 2018.
Winton, Alexa Griffith, and Deborah Schneiderman. "Introduction." In *Textile, Technology, and Design: From Interior Space to Outer Space*, Eds. Deborah Schneiderman and Alexa Griffith Winton. London and New York, NY: Bloomsbury, 2016.

INDEX

Note: *Italicized* page numbers refer to figures and those followed by "n" refer to notes.